TIGERS FOREVER

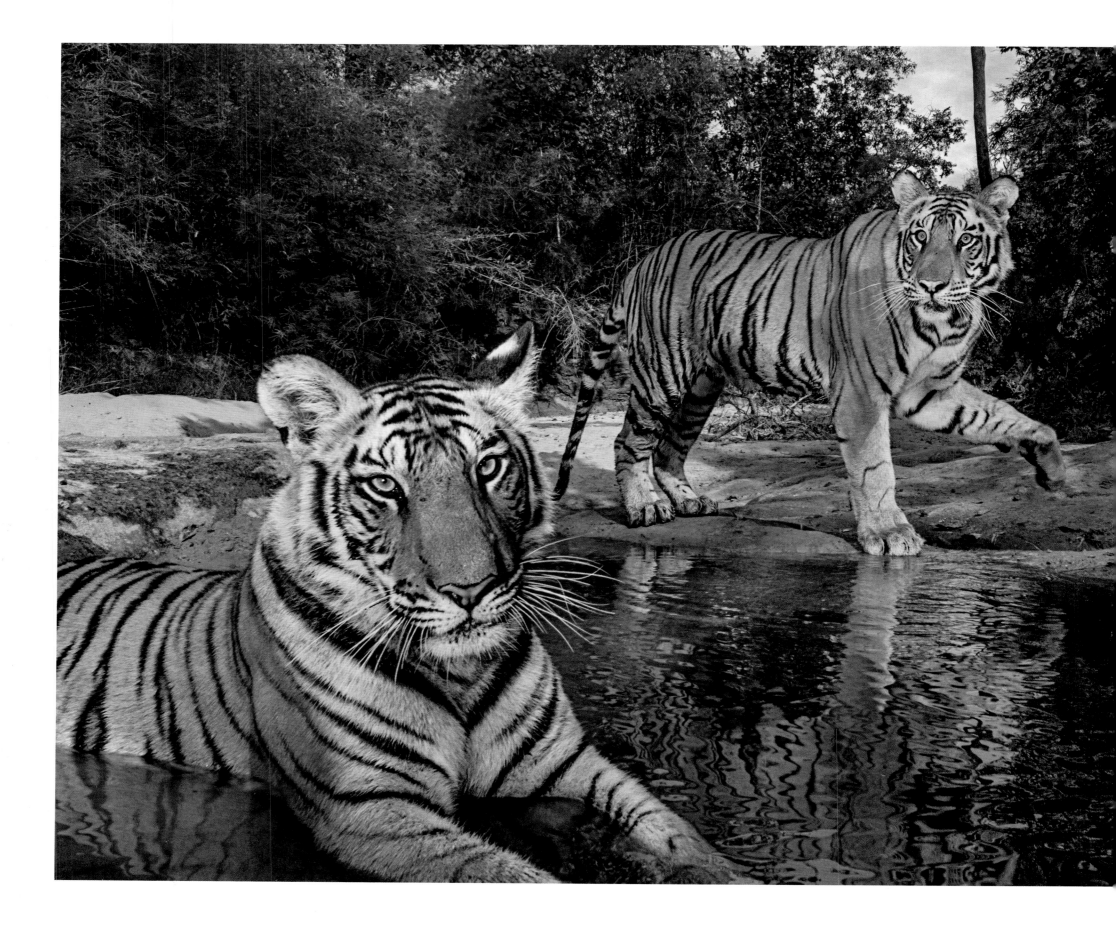

TIGERS FOREVER

SAVING THE WORLD'S MOST ENDANGERED BIG CAT

STEVE WINTER
SHARON GUYNUP

NATIONAL GEOGRAPHIC

WASHINGTON, DC

PANTHERA
LEADERS IN WILD CAT CONSERVATION

NEW YORK, NY

CONTENTS

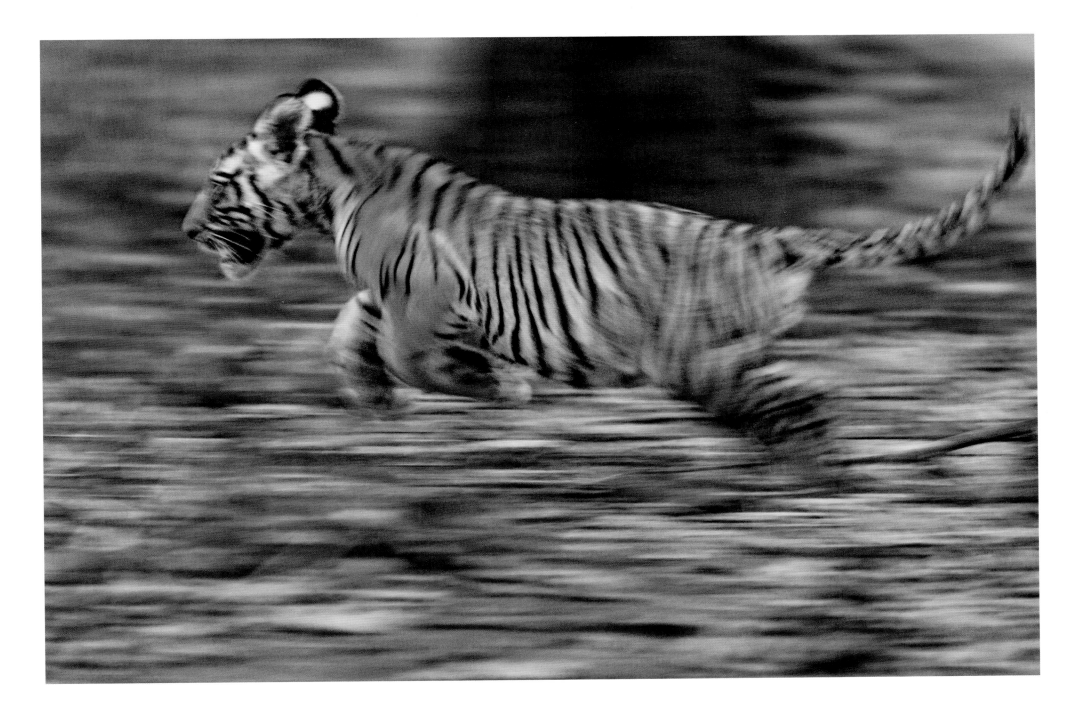

A young cub dashes after its mother near dusk. Bandhavgarh National Park, India. PREVIOUS PAGES: Fourteen-month-old tiger cubs cool off in a watering hole. Bandhavgarh National Park, India.

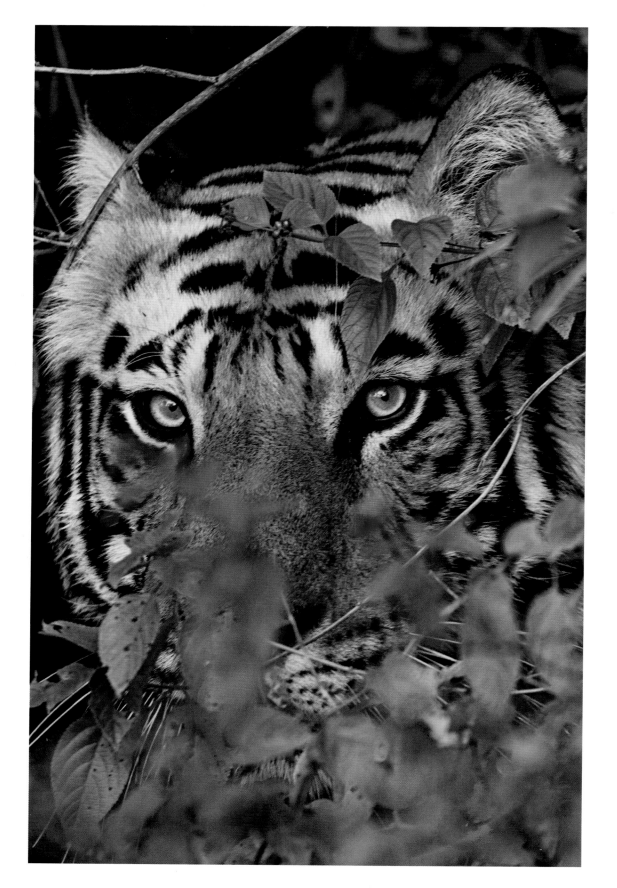

A tiger crouches
in the brush near a
village outside India's
Bandhavgarh
National Park.

TALKING TIGER

LET'S TALK TIGER. Tiger conservation, up until four years ago, was a spectacular failure. The number of tigers has stayed neutral or declined across all of Asia. We are now down to roughly 3,200 wild tigers from Russia all the way down to Indonesia. There are 12,000 in cages in the United States alone. People have tried hard: There has been a lot of press, fund-raising, meetings, and passionate people. It just has not worked. Some of the very best results were in projects Alan Rabinowitz, one of the world's top big cat experts, was instrumental in establishing, including a model site in Thailand. But even the few successful sites needed to expand.

I have supported Alan's work for ten years; five years ago we both agreed that the approach being taken in 2007 would *not* work. At one point Alan asked me how I solved problems in the businesses we create. That question was the spark that led to the creation of Tigers Forever, the world's leading global program in tiger conservation, a first ever collaboration between leaders in business and leaders in conservation to aggressively act at the ground level. The core of that partnership is a solution to the most long-standing, difficult problems facing tigers.

That requires:

- A solution that creates value for all the important constituents.
- A combination of great talent, methods, and technology.
- Intense measurement and rigor to fix problems and continually improve.

Various tiger conservation efforts across Asia were not coordinated back in 2007. NGOs competed with each other and had fundamental gaps in management of each tiger stronghold. For example, very few rigorously measured tiger numbers, or had the technology to do it. Realistically, you can't manage something if you cannot even measure it.

My expertise is innovation. I've created ten cutting-edge companies, reinventing movie ticketing at Fandango, reinventing employee health at

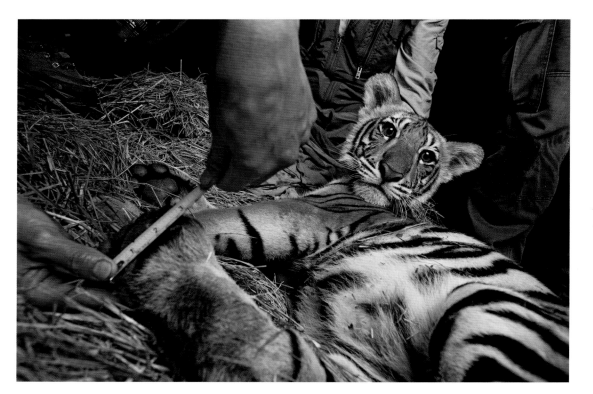

Biologists measure a cub whose mother was satellite-collared for a study on female tigers. Huai Kha Khaeng Wildlife Sanctuary, Thailand.

Accolade, and reinventing working virtually from home with Arise. Each required a mission; a new, thoughtful solution; extraordinary, talented people; rigorous execution—and sufficient capital. In these ventures I've been very realistic about what will *not* work—an approach that allows us to keep pushing ourselves to be creative and to find something that will work. Necessity *is* the mother of invention in many cases. I believe you must be passionately relentless to solve difficult problems. There are never silver bullets.

So what is Tigers Forever? It is a program that focuses on filling gaps in protection and monitoring at specific sites in the most important long-term landscapes for the tiger. That means finding the right people and inventing and putting in place necessary methods and technology. That means coordinating these sites to share best practices at least annually and visiting them on a constant basis to provide technical support and assistance. And that means *rigorously* measuring threats to both tigers and their prey, and analysis of what is—and is not—working. Simply put, if any of the top five executing companies in the world or, say, Seal Team Six, dedicated themselves to saving the tiger, what would they do? That is what we aspire to do with Tigers Forever.

The pictures in this volume would not be possible without what Tigers Forever and its partners have already done. But honestly, we have a long way to go to be successful in our mission. Tiger conservation is a really hard problem. A dead tiger is worth $100,000 in street value in China. Unfortunately, very few people want to pay to protect a live one in the wild until it is too late. And the one flaw in all this is that the tigers cannot pay. And that is where you could help. With you we cannot fail. ◊

Please donate and learn more at:

www.panthera.org/programs/tiger/tigers-forever

SAVING TIGERS

THE TIGER IS IN DESPERATE STRAITS. The world watches from the stands as perhaps the most iconic species on the planet slides inexorably toward extinction, not because we are incapable of saving it, but because we appear stymied by human behavior that values the idea of the tiger more than the animal itself. As you will see and read in the pages that follow, the tiger's basic needs—land and food—have already been severely depleted throughout the species' historic range. But the most onerous threat to the tiger is the taking of the tiger's most basic right—its right to life. Two million years of evolution is being cut short as poachers relentlessly seek to kill the one species whose body parts have become some of the most valued items on Earth. This could be the tiger's death knell. Mahatma Gandhi expressed the sentiment clearly: "Earth provides enough to satisfy every man's needs, but not every man's greed."

Saving tigers is not an easy task. The tiger lives in some of the poorest, most highly populated regions on Earth. Poaching of tigers and their prey is highly lucrative and ultimately driven by consumer demand. Ending such demand, relating to practices dating back thousands of years, will not occur simply by shifting cultural norms. Instead, governments must endorse and enforce clear actions that would largely eradicate the trade in tiger parts if carried out properly. Continued government rhetoric about the tiger crisis, paired with the creation of laws that are not seriously enforced, is the worst offense against the tiger. This creates a veneer of good intent and an assumption by the public that tigers are being saved while, in most places, they continue their slide toward extinction.

But hope remains. The tiger is incredibly resilient. There are many people—from heads of state to the poorest of local villagers—who care about whether tigers continue to survive. The dedicated scientists and conservationists who strive to save tigers understand what tigers need to survive, and what threatens their existence. Most important, we know that tigers and people can live together in a way that, while not always harmonious, can be beneficial to both. Like everything worth accomplishing in

life, saving tigers is a difficult task. But it can be done, and we know how to do it.

Some of my earliest childhood memories are of watching tigers at the zoo, fascinated by their size and strength, yet saddened by their plight. They paced the confines of their cages, back and forth, seemingly waiting for the moment when they could once again become what they were born to be. I realized then that tigers and other animals need a human voice to speak for them. I thought one day, maybe, I could help be that voice.

When I was 21 years old I listened to my father talk excitedly about the 1975 play-off game between the Dallas Cowboys and the Minnesota Vikings. With less than 30 seconds on the clock, the Dallas quarterback, just before getting tackled, threw a long, improbable pass from midfield that, remarkably, was caught on the five-yard line and carried into the end zone for the game-winning touchdown. The quarterback later called it a Hail Mary pass, a phrase that entered the modern-day lexicon to describe a desperation play with little chance of success. The improbable happened that day, not because of luck, but because desperation sometimes brings out the best in people, especially when those people are creative and highly skilled in their craft.

It has been almost four decades since that day with my father. And I have spent most of those years studying and trying to save tigers and other big cats. If there was any epiphany that occurred during the intervening years, it was the realization that the tiger world might be deemed insane—conducting the same activities year after year, expecting different results as tiger numbers continued to decline. Einstein's words that "no problem can be solved from the same level of consciousness that created it" resonated loudly and frequently in my mind. We had to do something different, more strategic. We had to give the world a clear, comprehensible, relatively simple plan that, if followed, would save tigers. If the plan was diluted or compromised, we would continue to lose tigers. There could be no excuses. Thus emerged Tigers Forever, a protocol and a program for saving tigers and tracking increases in tiger numbers—guaranteed.

We are desperate. Tigers Forever is our Hail Mary pass. The clock is running out, and the odds are stacked against us. We are still far downfield, but the quarterbacks and receivers of the tiger world are highly skilled, passionate, and creative individuals who know their craft. The time is now, and the opportunity is ours to take. The ball is in the air . . . ◊

THE SHRINKING WORLD OF TIGERS

A century ago, more than 100,000 tigers roamed the Asian continent. But the deadly combination of habitat loss and poaching has decimated tiger populations. Today, an estimated 3,200 tigers remain in the wild. Less than a third are the breeding females that hold the future of the species. Tigers have disappeared from 93 percent of their historic range; that range shrank by almost half during the first decade of this century. Preserving important tiger landscapes is key, along with protecting source tiger populations and their prey with strong enforcement— and providing safe passage between breeding areas.

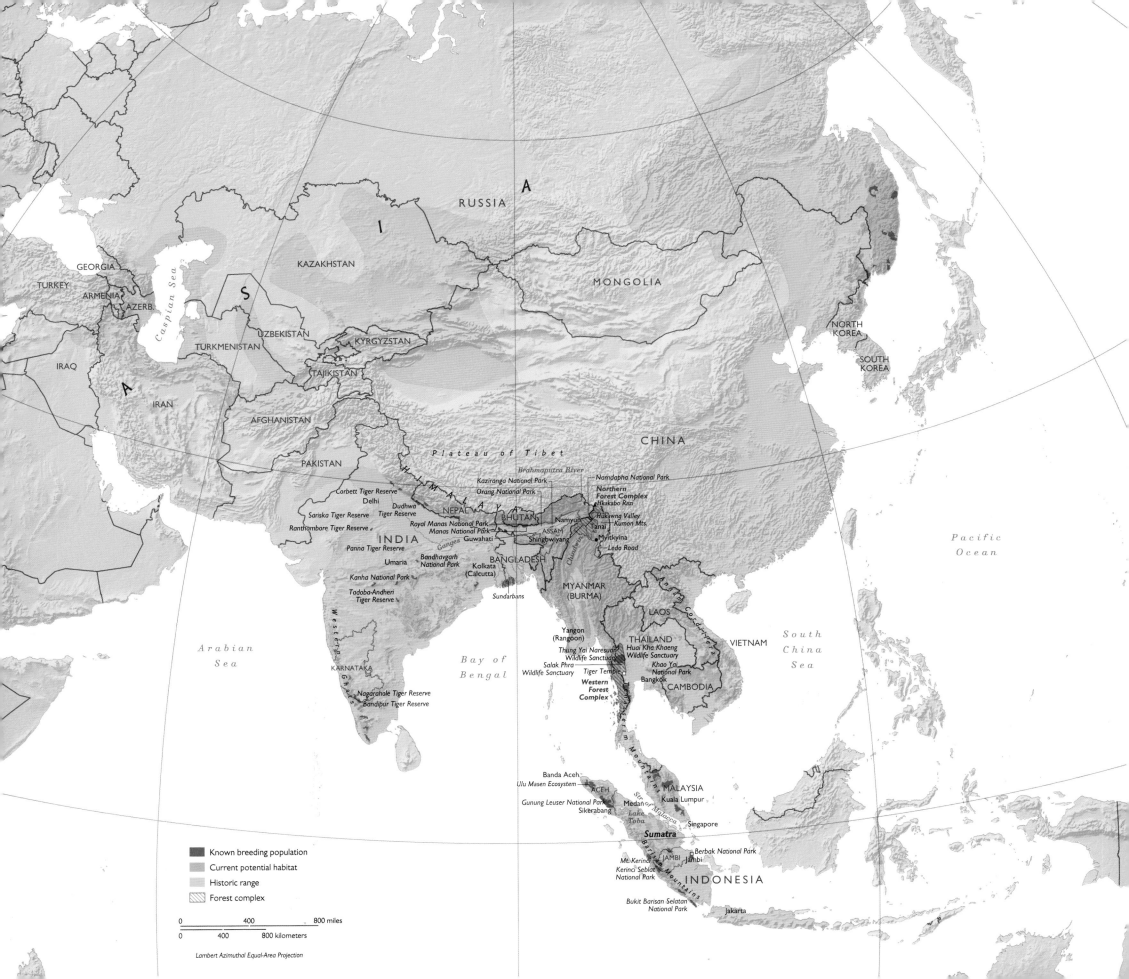

RUSSIA

GEORGIA
TURKEY
ARMENIA
AZERB.

S

Caspian Sea

KAZAKHSTAN

MONGOLIA

NORTH
KOREA

SOUTH
KOREA

UZBEKISTAN

TURKMENISTAN

KYRGYZSTAN

A

TAJIKISTAN

IRAQ

IRAN

A

AFGHANISTAN

CHINA

Plateau of Tibet

Pacific
Ocean

PAKISTAN

H
I
M
A
L
A
Y
A

Brahmaputra River

Namdapha National Park

Corbett Tiger Reserve
Delhi
Dudhwa
Tiger Reserve
Sariska Tiger Reserve
Ranthambore Tiger Reserve

NEPAL

Kaziranga National Park
Orang National Park

Northern
Forest Complex
Hkakabo Razi

Royal Manas National Park
Manas National Park
Guwahati

BHUTAN

Namyun
ASSAM
Shingbwiyang

Hukawng Valley
Kumon Mts.
Tanai
Myitkyina
Leda Road

INDIA

Ganges

Panna Tiger Reserve
Umaria
Bandhavgarh
National Park

Kanha National Park

Tadoba-Andheri
Tiger Reserve

Kolkata
(Calcutta)

BANGLADESH

Sundarbans

MYANMAR
(BURMA)

LAOS

VIETNAM

South
China
Sea

Arabian
Sea

Western Ghats

KARNATAKA

Bay of
Bengal

Yangon
(Rangoon)

THAILAND
Huai Kha Khaeng
Wildlife Sanctuary

Thung Yai Naresuan
Wildlife Sanctuary
Salak Phra
Wildlife Sanctuary
Tiger Temple

Khao Yai
National Park
Bangkok

Nagarahole Tiger Reserve
Bandipur Tiger Reserve

Western
Forest
Complex

CAMBODIA

Banda Aceh
Ulu Masen Ecosystem
ACEH

Gunung Leuser National Park
Sikerabang

MALAYSIA

Kuala Lumpur

Medan
Lake
Toba

Singapore

Sumatra

Berbak National Park

JAMBI
Jambi

Mt. Kerinci
Kerinci Seblat
National Park

INDONESIA

Bukit Barisan Selatan
National Park

Jakarta

Known breeding population

Current potential habitat

Historic range

Forest complex

0 400 800 miles

0 400 800 kilometers

Lambert Azimuthal Equal-Area Projection

A young male tiger walks through elephant grass.

Kaziranga National Park, India.

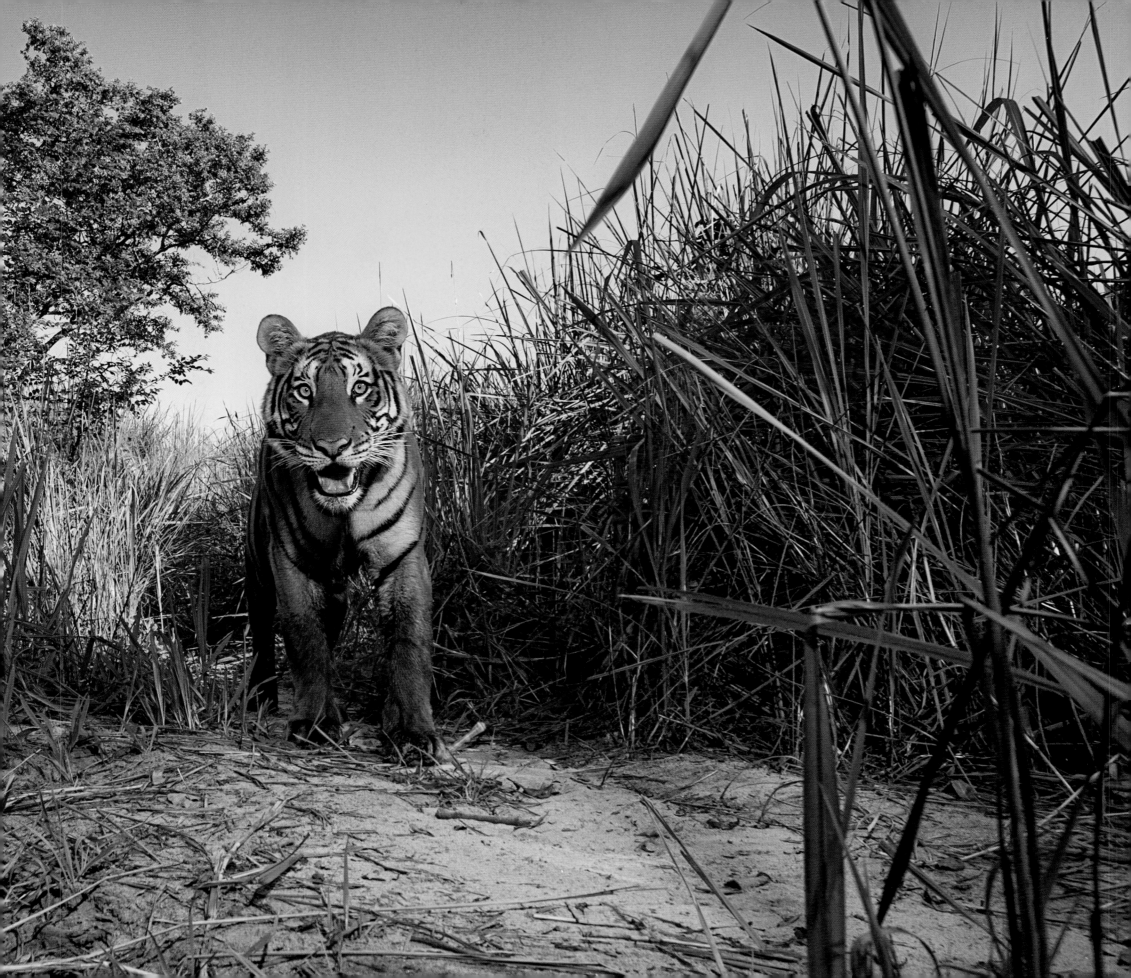

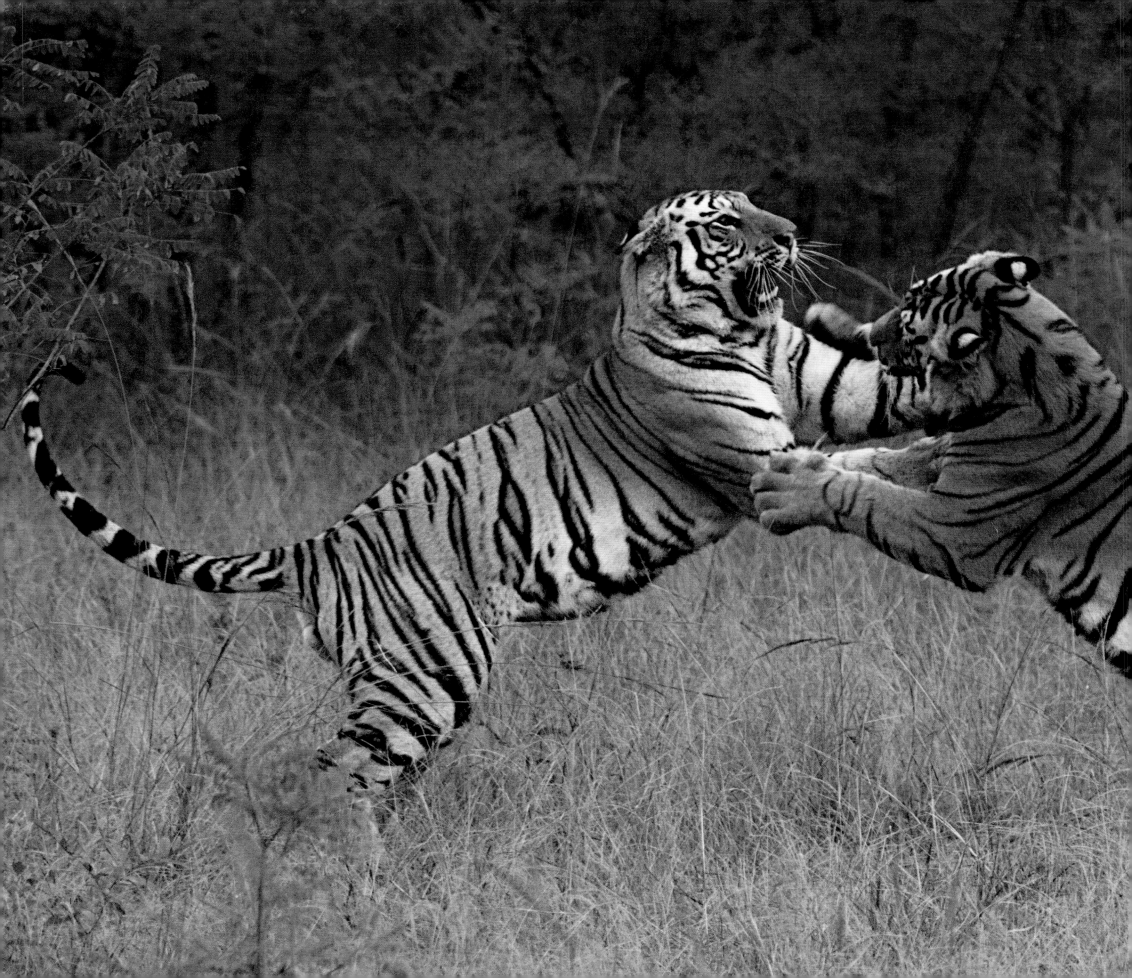

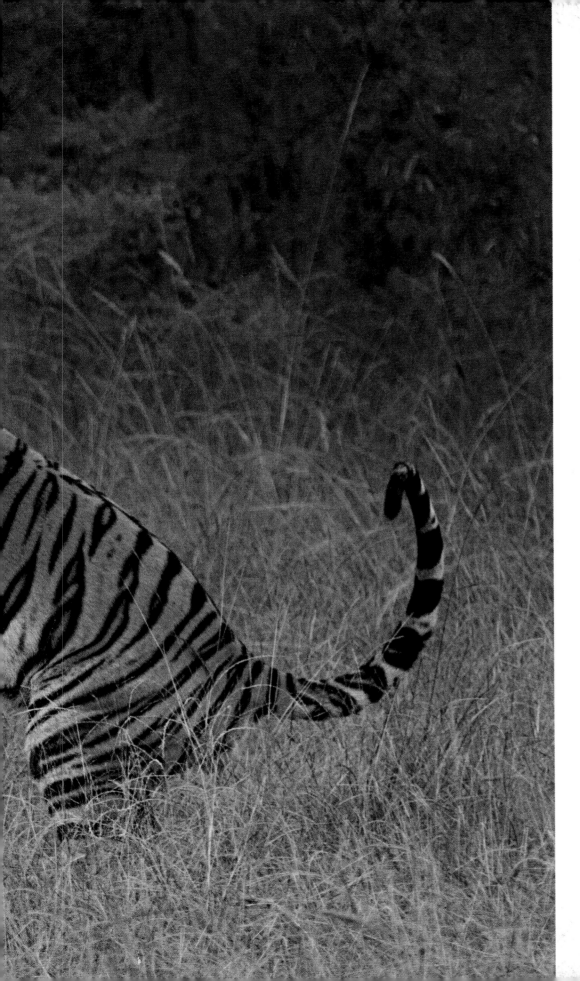

Nearly grown siblings spar in play that hones their fighting skills.

Bandhavgarh National Park, India.

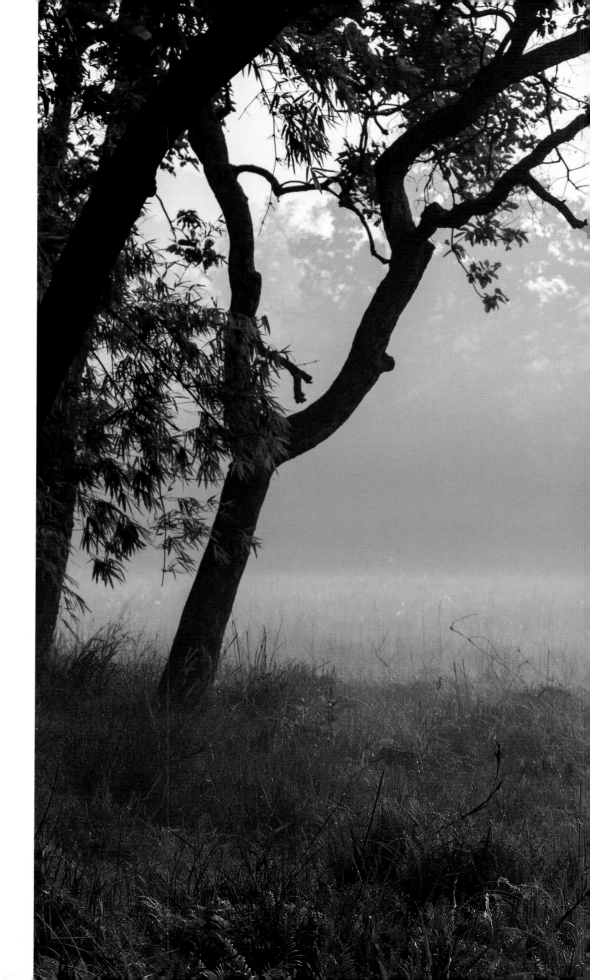

A male tiger crosses open grasslands in early morning.

Bandhavgarh National Park, India.

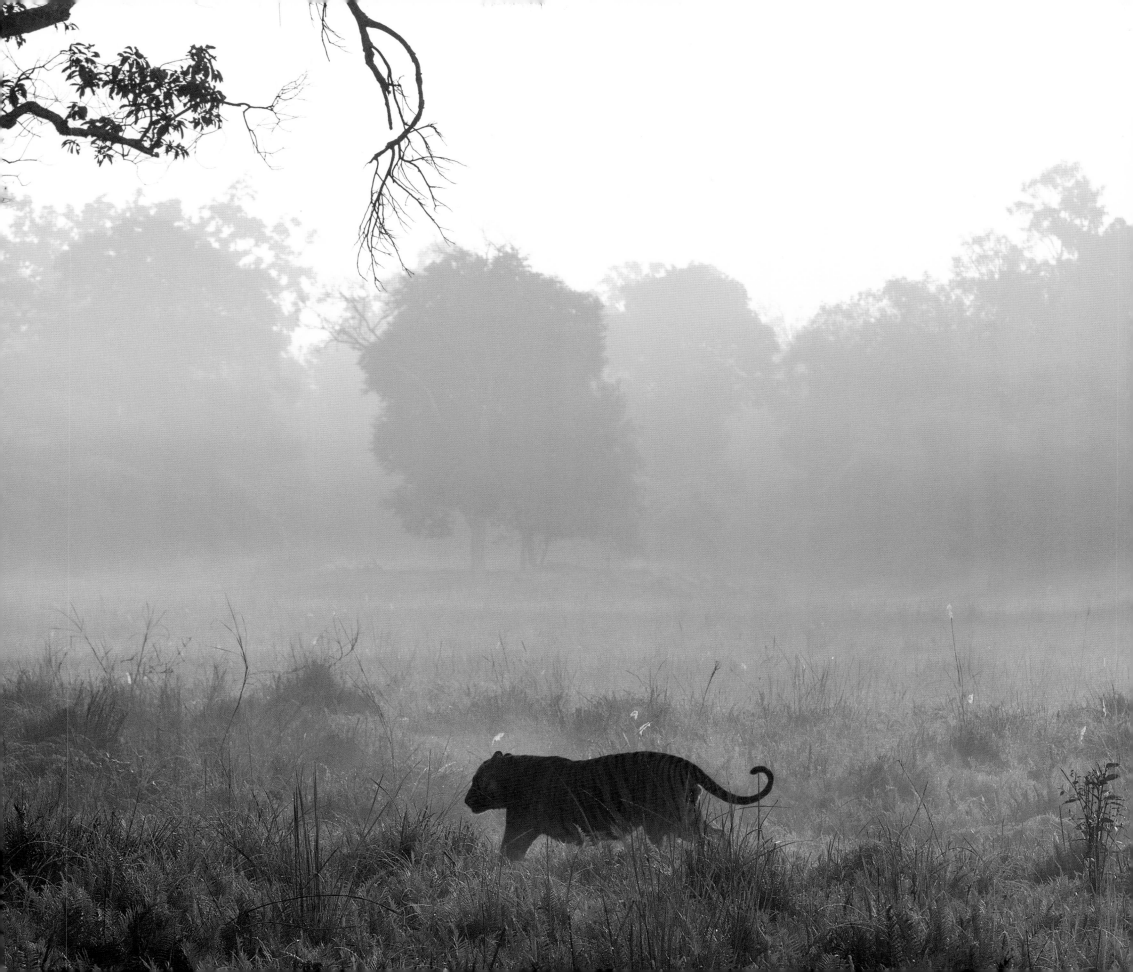

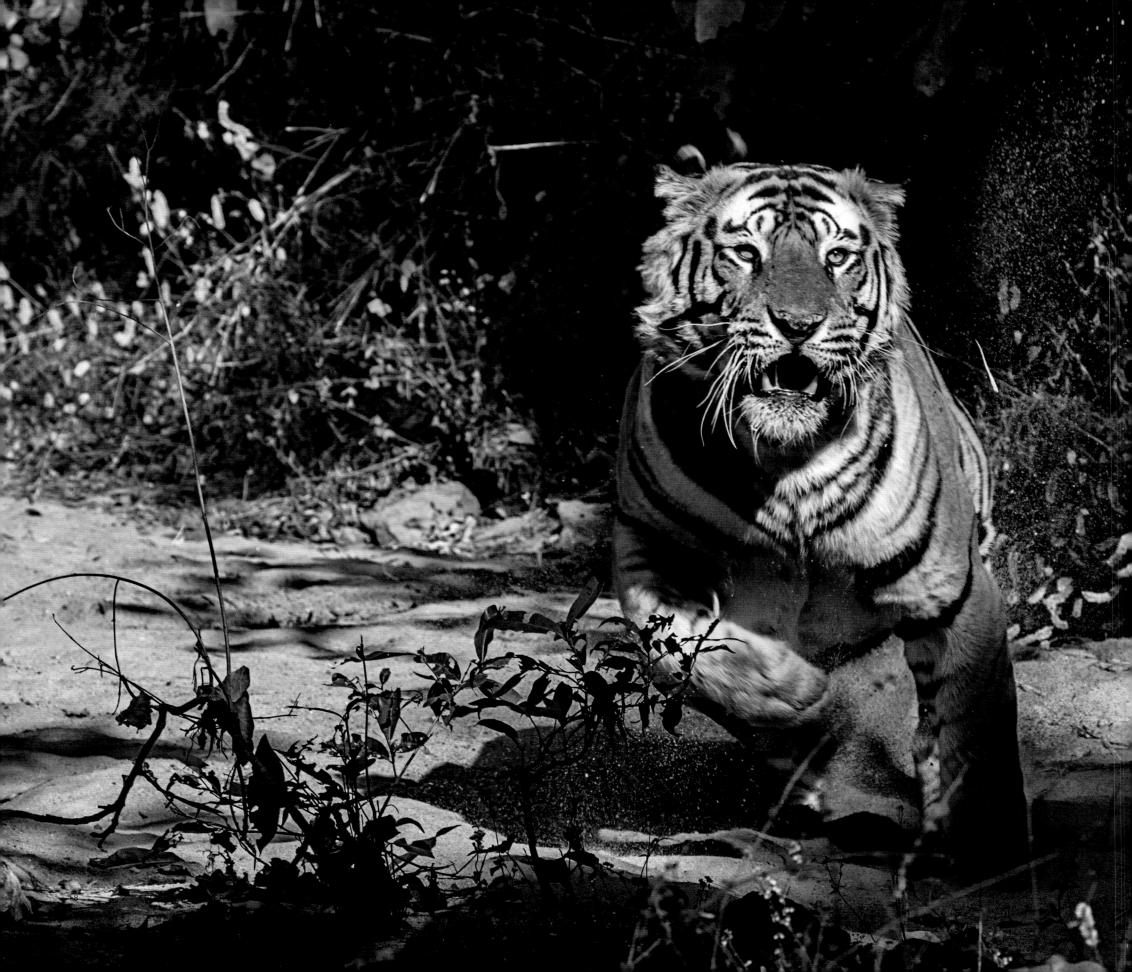

A tiger charges an intruder.

Bandhavgarh National Park, India.

A tigress cools off in the shade on a 120-degree day.

Bandhavgarh National Park, India.

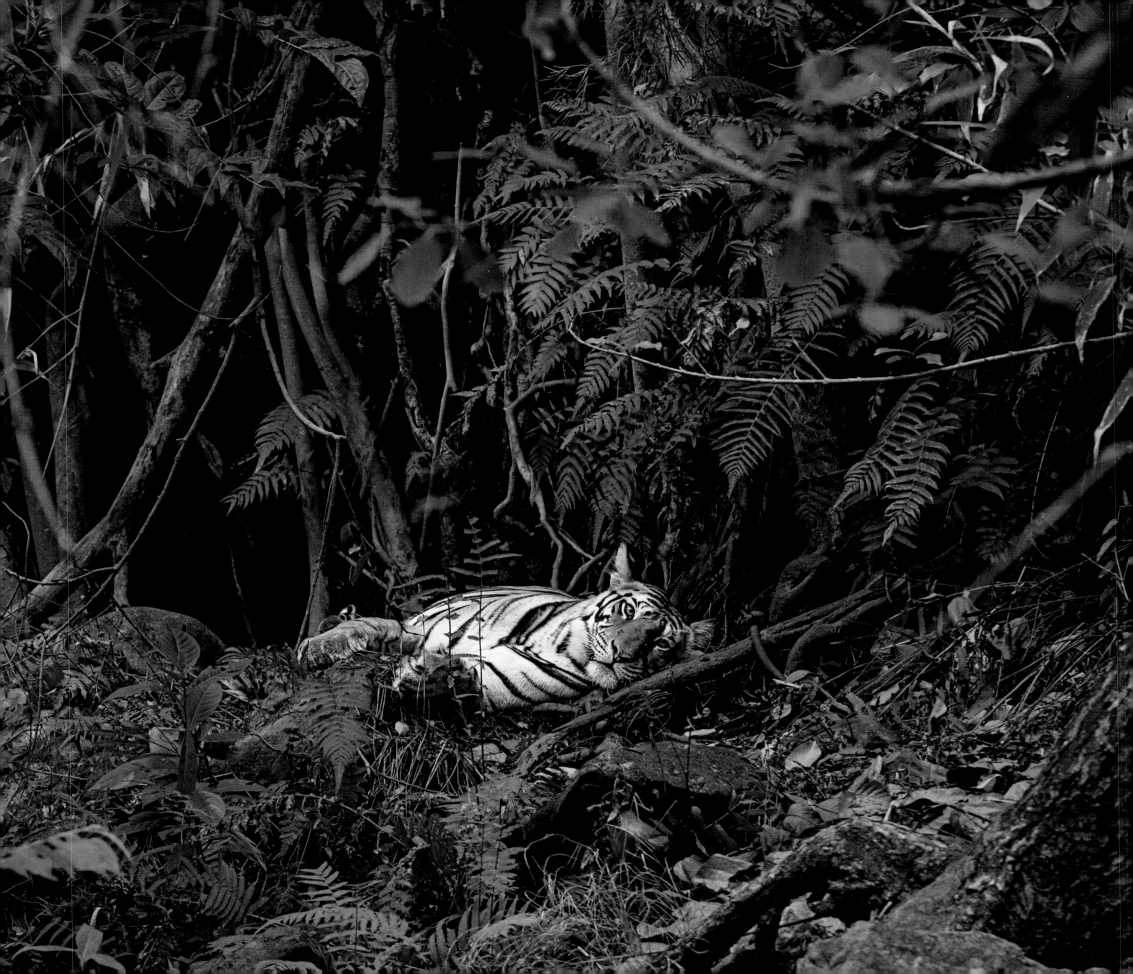

An adolescent cub leaps into a pond.

Bandhavgarh National Park, India.

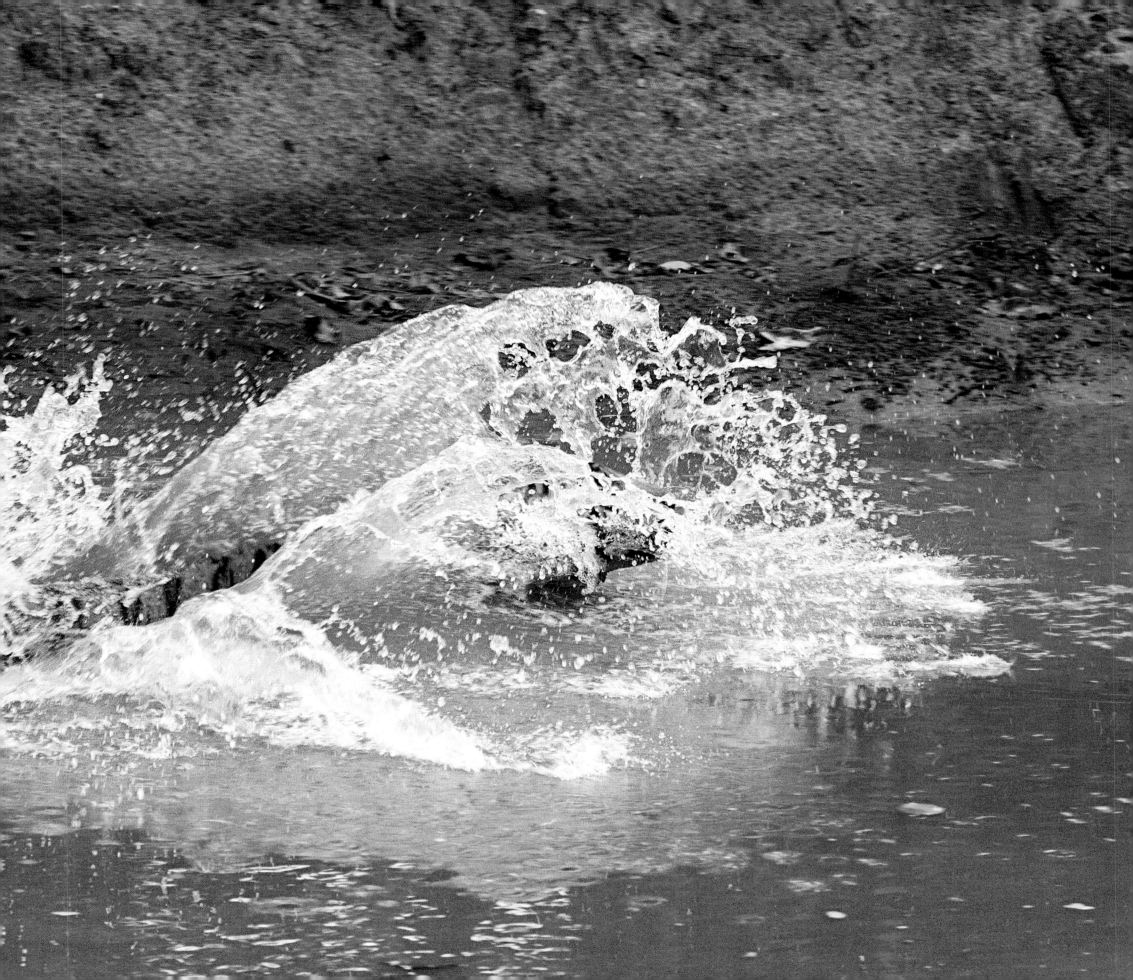

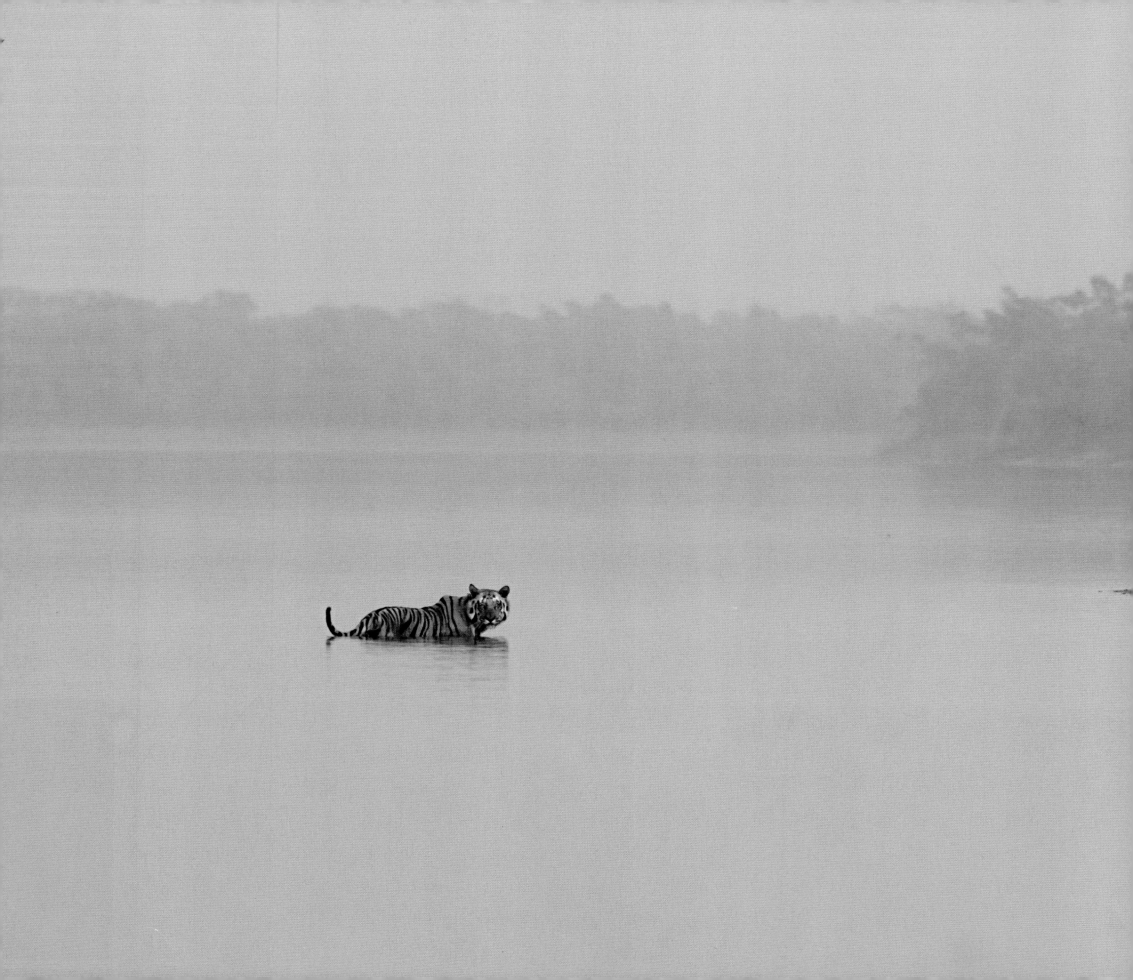

A male tiger crosses a Bay of Bengal channel
in the Indian Sundarbans.

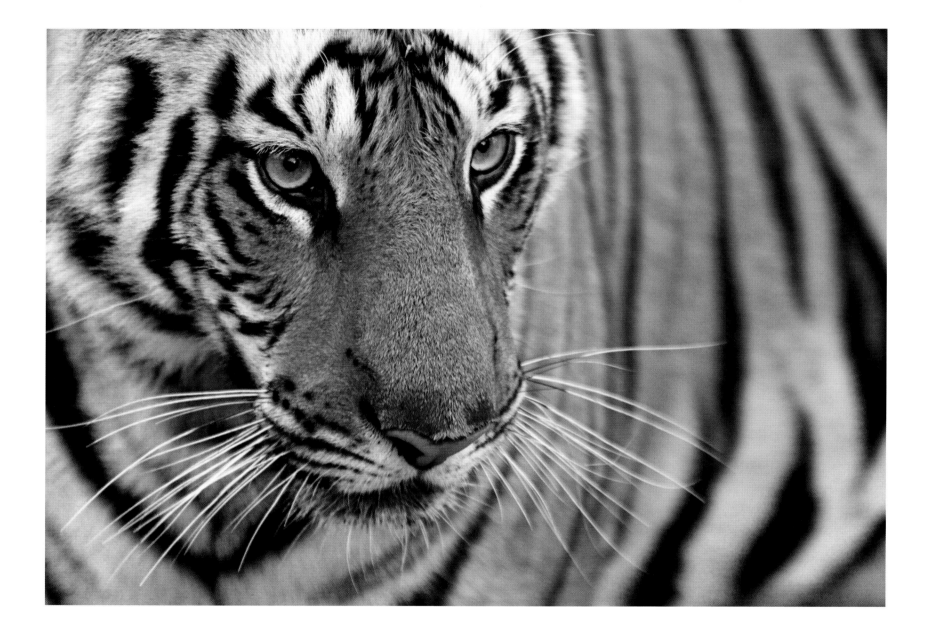

A male tiger in Bandhavgarh National Park, India

INTRODUCTION | GEORGE SCHALLER

A VIEW OF THE TIGER

HALF A CENTURY AGO, I sat at the edge of a ravine in India's Kanha National Park, where I had come with my family to gain knowledge of the tiger and its prey. My back against a boulder, I watched a partially eaten cow below me that had been killed by a tiger when it strayed from a nearby village. It was almost dusk. Behind me, a dry leaf rustled. Slowly I turned and looked into the amber eyes of a tigress on the other side of the boulder. Her facial stripes were familiar: We had met before. Calmly, she turned and ambled away, looking once back over her shoulder at me.

There is magic in such an encounter. Meeting a tiger in the serenity and solitude of a forest turns the cat's flaming beauty into memory. Entranced by an experience such as this, I have wandered many shadowed forest paths in India and other countries, always seeking at least a glimpse of a tiger striding along on velvet paws, radiating power, dignity, and vitality. Usually I fail. Mine was the first scientific study of tigers at a time in the early 1960s when others studied the species mainly along the sights of a rifle. No one knew then how many tigers survived, but already there was concern for their future.

Except in a few protected areas, experiencing a wild tiger is becoming more and more difficult. Humankind is in awe of the tiger and respects and exalts it, transforming it into myth and legend. But it has been dammed as

well as exalted. Vermin or icon? The tiger's forests are rapidly being transformed into fields, the deer, wild pig, and other prey are killed by local people for subsistence, and the tiger itself is shot, poisoned, and trapped, both in retaliation for its attacks on livestock and people and for the lucrative market in bones and other body parts used in traditional medicines.

Tigers and humans are coming increasingly into conflict as natural habitat vanishes. In 2012, I visited the Tadoba-Andhari Tiger Reserve in central India with Ullas Karanth, Asia's premier tiger ecologist and activist. Tigers had killed 71 people and injured 61 in this area between 2005 and 2011. We have a moral obligation to help the tiger endure as a living monument to the future, but we must also mitigate such conflict to assure the lives and livelihood of those whose home is in tiger country. Conservation

ultimately depends on the knowledge, interests, and participation of such local communities.

What should be done with "problem" tigers, a basic conservation issue that has barely been addressed? Communities should somehow benefit economically for coexisting with large and potentially dangerous predators. When a protected area is established, villagers are usually deprived of access to forest products, another economic loss. They pay a price, whereas outsiders from far away derive only benefits, whether from tourism or clean streams for drinking and irrigation. Solutions must be found. To protect the tiger, we need to provide it with safe and peaceful forest tracts containing ample prey where it can raise its young. Such sites need a buffer, with few people and little development, connected by suitable habitat through the human-dominated landscape to other safe havens. India, for example, has designed such tiger landscapes and offers voluntary relocation to households out of remote forests.

Thoughts such as these were far from my mind when we lived in Kanha National Park and tried to unravel the tiger's mysterious life. Once I found the tigress Cut-Ear, named for an obvious recognition mark, with her four large cubs on a gaur she had killed. Considering the gaur weighed perhaps 1,500 pounds with a shoulder height of nearly six feet, I admired Cut-Ear's strength and determination in subduing such a massive animal. I climbed into the low branches of a nearby tree to observe the tiger family. The hours passed, and the gorged tigers slept. At 7 p.m., it was dark. Perched above me in the tree were several vultures, ruffling their feathers and waiting too, though perhaps more comfortably than I. The tigers ate off and on at night, only a sliver of moon casting faint light. At 8 a.m., a large male tiger, the lord of this forest, arrived. For several minutes, the six tigers mingled peacefully, rubbing cheeks in greeting. Then the male ambled off, his visit merely designed to keep in touch. Tigers are not unsociable and solitary, as they had generally been viewed, a valuable insight for me from a night spent in a tree.

Tigers once roamed through 24 countries, and they still survive in 13. But their light is blinking out in more and more countries, most recently in Cambodia. I have walked for months through tiger forests in Myanmar, Laos, and Vietnam, to mention just three, and found little evidence of the cat. Some 93 percent of their former range is now devoid of tigers, and only an estimated 3,200 animals persist in the wild. (Five times as many are in captivity, mainly in China and the United States, living dead who never will savor a forest trail.) Half of all wild tigers are in India, where 1.2 billion people register about 60,000 births a day. Since 1995, the country has lost 25 percent of its natural forests to agriculture, exotic tree plantations, and development such as major roads and coal mines. The Hindu goddess Durga rides a tiger to rid the world of evil. Environmental destruction is a great and accelerating evil, and Durga surely has a busy century ahead.

As more and more people crowd cities, they become remote from nature. Wild animals become a separate reality, far removed from a tiger's fate and ours. However, *Tigers Forever* opens the eyes of the world to what is happening to the tiger, one of its greatest natural treasures.

This book has an informative and eloquent text and photographs of unsurpassed beauty, often of places that I have never seen. It reminds us that tigers and humans share this planet with many other species, that all of us are an integral part of the ecological community upon which we depend for survival.

The tiger must be allowed to exist without justification solely for its own sake. Future generations will never forgive us if we have so little foresight and compassion that we permit the tiger, this wonder of nature, to descend into the dark abyss of extinction. Greed and ignorance have decimated the tiger, but we know how to save it. Steve Winter's stunning photographs demand a silent promise from us all to continue the fight for the tiger's survival in the wild with passion, purpose, and everlasting dedication. ◊

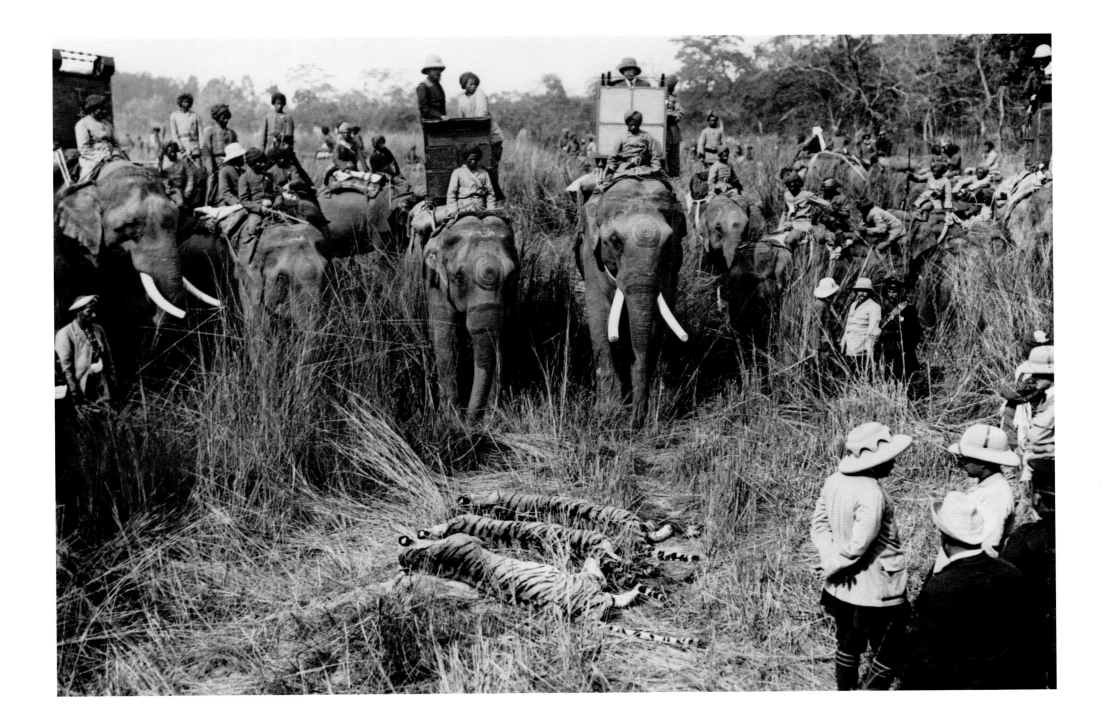

Thousands of tigers were killed in elaborate hunts by Indian and British nobility before hunting was outlawed by the Indian government in 1971.

REVERED

Few living mammals have been so deeply woven into culture, religion, and folklore as the tiger. Throughout history, tigers have been worshipped and credited with powers beyond those of any worldly animal. Tibetans believed the cats held the key to immortality. The Hindu goddess Varahi, opposite, vanquished a monster-demon while astride her ferocious mount, a tiger. Shamans are thought to transform into tigers to move between worlds. But as the fabric of traditional culture unravels, these beliefs are fading.

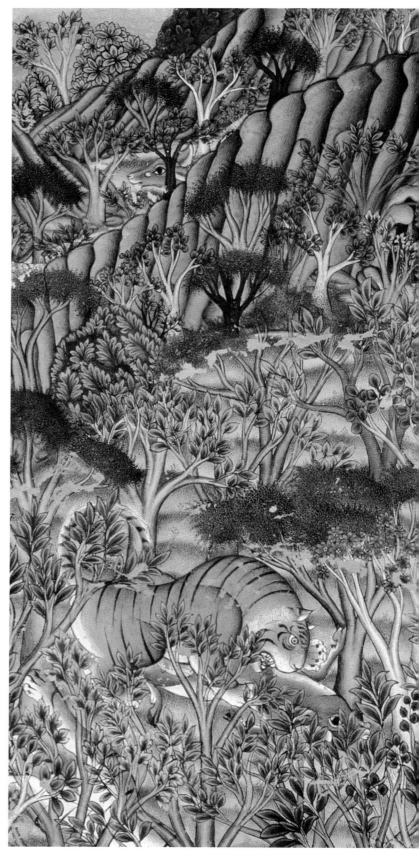

FEARED

It's no wonder that tigers have long been feared: In every ecosystem they inhabit, they are the dominant predator—huge, stealthy, and muscular. They possess fearsome teeth and claws and a roar that resounds for miles. As human populations explode across Asia and habitat continues to disappear, there is growing conflict between people, their domestic animals, and tigers. Tigers wander into villages and through pastures; they sometimes eat livestock, occasionally injure or kill people—and often end up in the crosshairs.

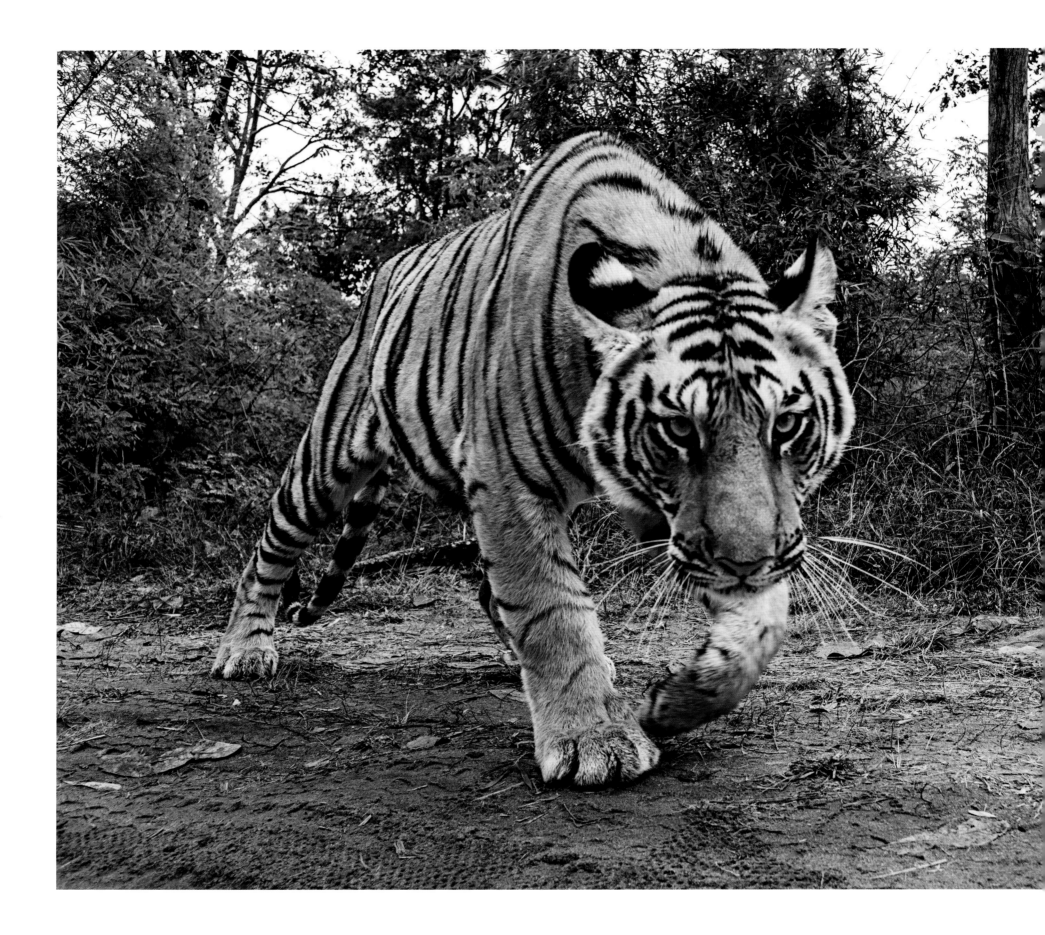

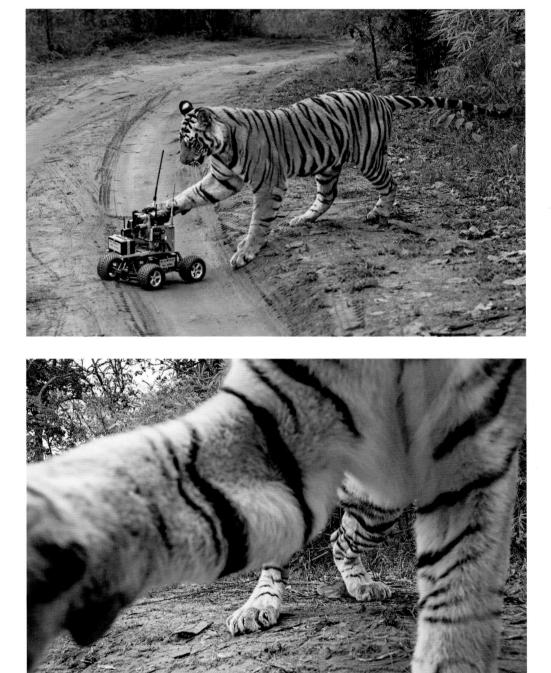

CURIOUS

A remote-controlled "camera car" piques the interest of a cub. Experts in National Geographic's photo engineering department built the device to allow close proximity to tigers. This 16-month-old male first stalked the car, then swatted and played with it.

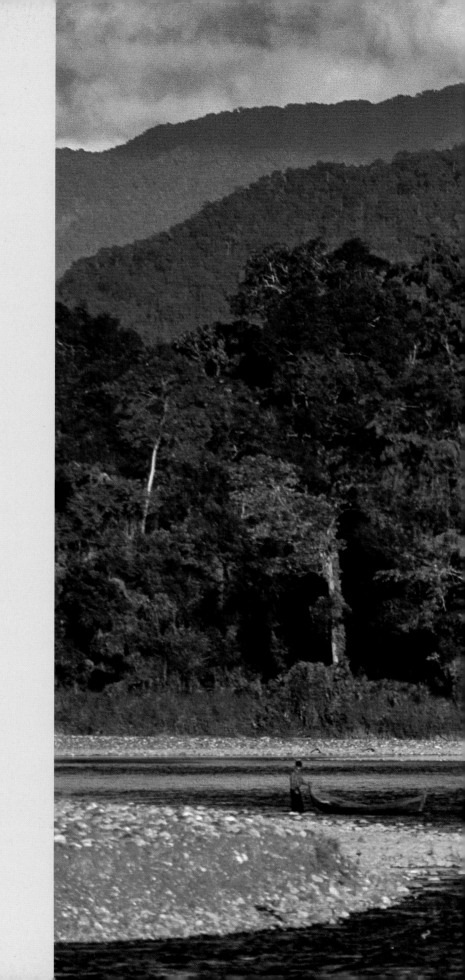

IN THE VALLEY OF DEATH

A hunter and itinerant miners cross the Tarung River, part of a gold rush that brought

150,000 people to Myanmar's Hukawng Valley.

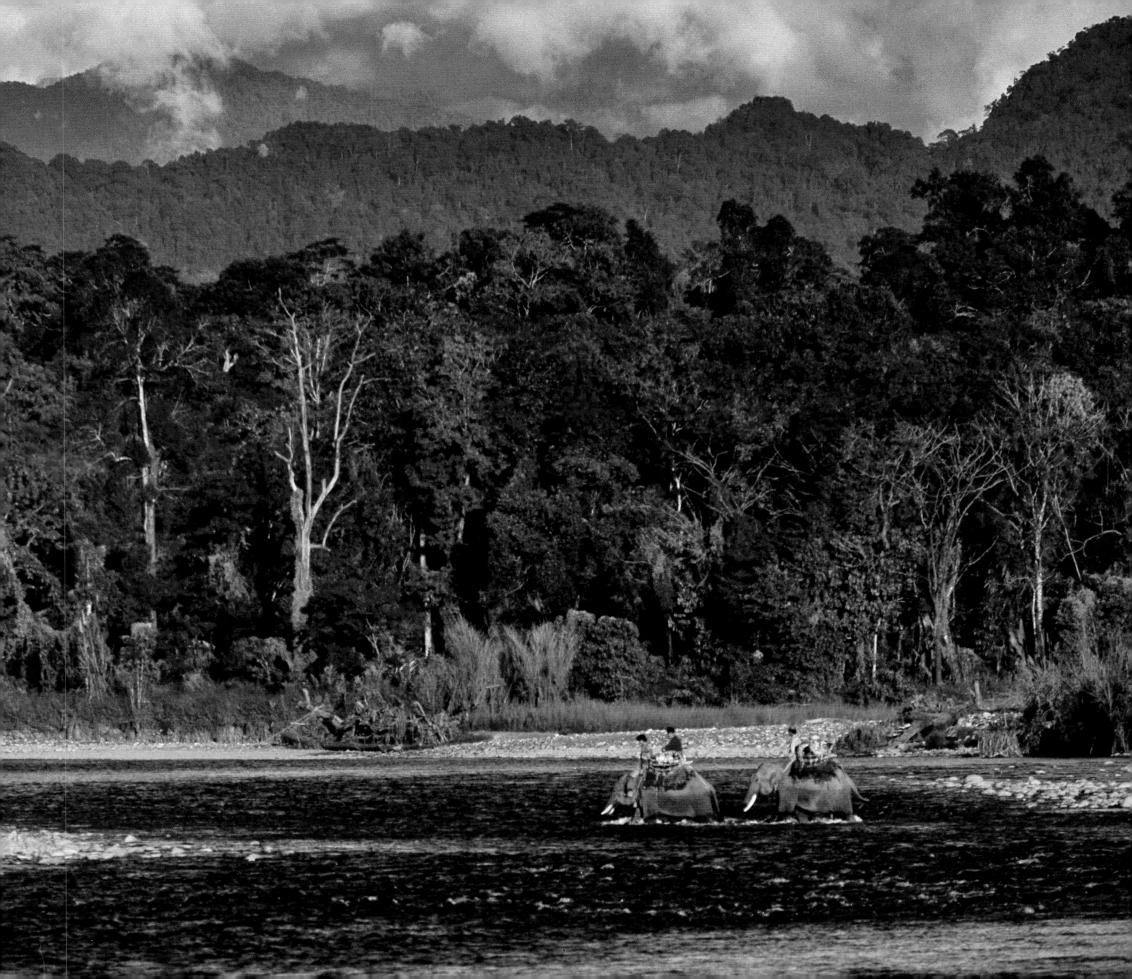

W

E'D TRAVELED BEYOND HUMAN SETTLEMENTS.

Animal trails slowly replaced footpaths as we crisscrossed the Tawang River, walking through fields of high grass, nearly impenetrable stands of bamboo and razor-sharp rattan—and towering forests with canopies so thick they shuttered the sun. ¶ Fresh tiger tracks marked the trail. This was the animal that had brought me here, the king of the big cats. I froze, my initial rush of excitement tempered by the creeping realization that I was on foot. U San Hlaing, the guide assigned to me by the military government, had never set foot in the jungle and possessed no knowledge of wildlife. The four elephants carrying my gear were far ahead—and

they, not the two soldiers who accompanied us—provided the best protection. I hustled to catch up.

We were a few hours out of Tanai, a frontier town in the heart of the Hukawng Valley in northwest Myanmar. Though I'd photographed for years in the tropics, this was my first time working in Asian jungles where elephants and tigers roamed. It was November 2002, and I'd come to shoot a story for *National Geographic* magazine on the Hukawng Valley Wildlife Sanctuary, just recently created at the time. The area was home to animal species that were dwindling or that had disappeared elsewhere—clouded leopards, sambar and barking deer, Asian elephants, and Himalayan bears—but the sanctuary had been created specifically to protect one species: Myanmar's last remaining Indochinese tigers *(Panthera tigris corbetti)*.

Forestry staff had warned me that photographing in the so-called "Valley of Death" wouldn't be easy. Though hunters had used the valley for

centuries, it's a remote, rugged land, a floodplain cut by steep gorges and ringed by high peaks. It was largely unexplored.

The valley earned its ominous nickname during World War II. Thousands of British refugees perished there fleeing Japanese forces alongside 1,100 U.S. soldiers and many more locals who died building the 500-mile Ledo Road, a military supply route to China. The victims succumbed to malaria, typhus, wildlife attacks, and snipers, littering the landscape with bones. I was among the first Westerners to travel that road since 1945.

We tracked the tiger prints for an hour until they eventually disappeared and followed the river for two more days until we reached our destination: the "tiger team" camp. The team's leader, Dr. Tony Lynam, greeted me, along with the sanctuary's new warden, Myint Maung. In a joint initiative, 35 men from the New York–based Wildlife Conservation Society (WCS) and Myanmar's Ministry of Forestry were identifying which animals—and how many tigers—still survived in the valley.

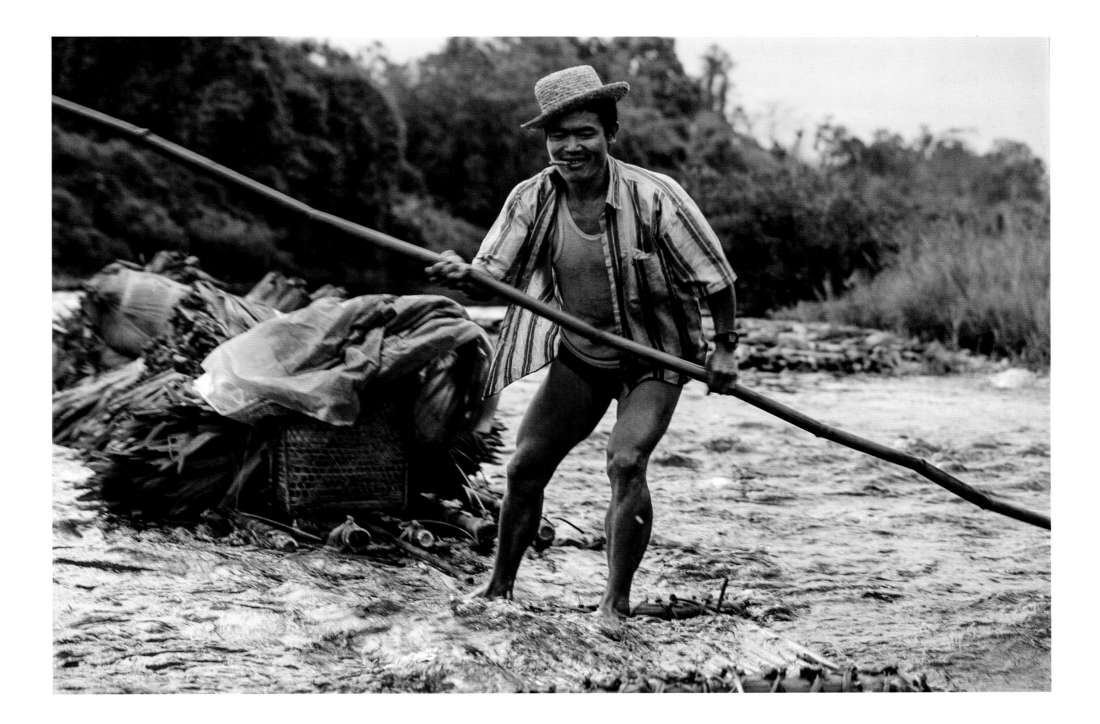

A man transports palm fronds down the Tarung River. The fronds, collected from once isolated Hukawng Valley jungles, will be sold to make roofs. Locals use forest resources required for daily living—even within designated protected areas.

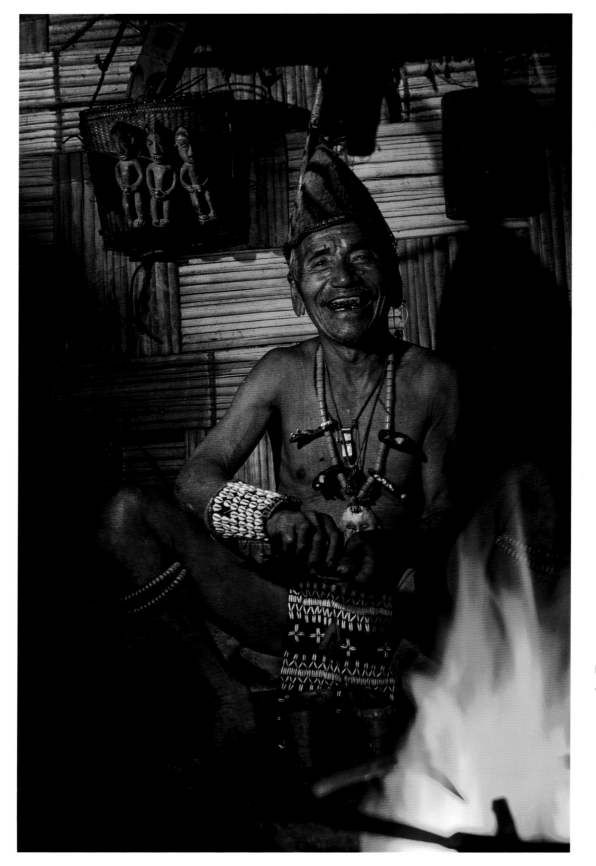

A Naga shaman wears
a tiger skin hat and tiger
tooth necklace, which
are considered to be
powerful talismans. Tigers
were traditionally revered
by Naga and
killed only as part of
rituals or ceremonies.
Naryang, Myanmar.

The men were setting up a network of 70 camera traps throughout the sanctuary to photograph animals walking along trails or drinking at watering holes. When something moved in front of a camera, a heat sensor tripped the shutter and it snapped the equivalent of an ID photo. These pictures would distinguish individual tigers that passed through; their distinctive stripe patterns are as unique as a fingerprint. The team helped me formulate a game plan on how to find and photograph tigers and other elusive species here.

I'D FIRST COME TO MYANMAR IN 2000. I'd joined Dr. Alan Rabinowitz, (then director of WCS's Science and Exploration Program, now CEO of Panthera), on a five-week expedition into the icy, uncharted Hkakabo Razi Mountains. We'd worked together years before on a jaguar story for National Geographic.

The Myanmar Forest Department had enlisted his aid identifying wild areas in need of protection. Hkakabo Razi was one; on our flight back to Yangon, Alan pointed out the window at another. A sprawling slab of green extended to the horizon—the Hukawng Valley. He'd recently launched a study there, gathering data he hoped would convince the government to protect it. This led to the creation of the sanctuary in 2001.

After that, Alan was summoned to Yangon, where ministers complained that he'd protected *too little* of the valley. They suggested tripling the size of the sanctuary as part of a larger Tiger Action Plan. The tiger team's camera trap study would determine whether there were enough tigers left to warrant such an effort. When Alan shared these developments, I began researching a possible story that he would write on the Hukawng— and I started reading about tigers.

Panthera tigris, the largest of the world's cats, is the heart and soul of Asia's jungles. It's the dominant predator in both the valley and every ecosystem it inhabits, stealthy, walking silent and unseen, like a shadow, but possessing fearsome teeth and claws and a roar that resounds for miles. It's

no wonder tigers have long been feared and worshipped across their range. For millennia, they've stood as iconic symbols of power and courage, woven into culture, religion, folklore, and ritual. Neolithic cave paintings are the earliest existing depictions, images etched into rock walls across the Indian subcontinent some 8,000 years ago.

Asian cultures have deified this cat, bestowing powers beyond those of any worldly animal. In Tibet, tigers held the key to immortality. In 13th-century China, tigers protected both the living and the dead by frightening away threatening spirits. In Indochina and elsewhere, many were reluctant to kill them; it was widely believed that when a tiger killed a human, the human's soul entered and inhabited the cat's body. The Hindu goddess Durga vanquished a monster-demon while astride her ferocious mount, a tiger. Legend from various countries describes shamans transforming into tigers to move between worlds or people shape-shifting into werecats to harm others. Many tribes, including the Naga in Myanmar and India, only killed tigers as part of powerful rituals or on ceremonial occasions. When the Europeans arrived and trophy hunts began, those who helped or acted as guides faced harsh punishment from village elders. But as the fabric of traditional culture unraveled and guns proliferated, tiger slaughter grew common.

What I didn't realize until I dug into research was that today, tigers hover closer to extinction than any of the big cats. They face a deadly cocktail of threats. With diminishing prey, widespread poaching, and conflict with humans who live too close to their ever shrinking habitat, one of the world's most iconic species is careening toward the edge.

A century ago, more than 100,000 of these majestic cats roamed Asia's rain forests, savannas, and mountains. They ranged across 24 nations, from Turkey eastward to Siberia, south through China and Indochina to the tip of Indonesia. They are the national animal of six nations, but have vanished from two of them, North and South Korea.

Only about 3,200 wild tigers survive, and of those, less than a third are breeding females. They're gone from 93 percent of their historic range;

that range shrank by almost half during the first decade of this century. Tigers hang on in just 13 countries in scraps of habitat sandwiched amid an exploding human population. In 2010, they were declared extinct in Cambodia. (In contrast, at least 4,000 captive tigers are privately owned in the United States alone, living in people's backyards, lost to the wild and often living miserable, caged lives.)

Though they're quickly disappearing from the region, their presence here dates back millions of years. All modern cats originated in Southeast Asia. The great roaring cats, *Panthera*—a group that includes tigers, lions, leopards, jaguars, and snow leopards—were the first to branch off the cat family tree 10.8 million years ago.

The earliest tiger fossils are two million years old. That ancestor eventually evolved into nine subspecies, slowly adapting to Asia's various landscapes, prey, and climate. Three of them blinked into extinction over the last 80 years. The Bali tiger died out during the 1940s; the Javan and Caspian tiger both disappeared in the 1970s. Six subspecies remain: the Bengal, Indochinese, Malayan, Sumatran, Amur (Siberian)—and the South-China, which now exists only in captivity, gone from the wild. All are endangered. In 1996, the Sumatran tiger was reclassified as critically endangered, one step from oblivion, and the Indochinese tigers that roam Myanmar and neighboring countries are approaching that same precipice.

The species has always faced challenges. Genetic studies revealed that tigers were almost annihilated 73,000 years ago when a massive volcanic eruption at Lake Toba, Sumatra, wiped out scores of Asian mammals. The species rebounded from just a few individuals to repopulate Asia.

Today, viable breeding populations exist in 42 known locations, or "source sites." Tigers are in the emergency room, but they're a resilient species. There is enough remaining habitat to support tigers, and if both the cats *and* their prey are given boots-on-the-ground protection, there's hope. But only committed, targeted action and creative strategies will bring them back from the brink.

I HAD NO INKLING that this Hukawng Valley assignment would launch a decade of work documenting tigers—capturing their flaming beauty, their behaviors, the diverse environments they live in, and the prey that sustains them. My first face-to-face encounters came in September 2007, when I began work on a five-month *National Geographic* story on India's Kaziranga National Park. It's a small reserve in the Brahmaputra floodplain that teems with life—and is home to the highest concentration of tigers anywhere in the world. By then, I'd fallen under the cat's spell, the fire in its eyes, its power and dignity, its unchallenged rulership of the jungle. Then, in 2009, I returned to Asia to begin a tiger story for the magazine, focusing on three subspecies in three countries: the Sumatran tiger in Indonesia, the Indochinese tiger in Thailand, and the Bengal tiger in India. My goal was to reinvigorate a passion to protect these iconic cats.

But not all of my images are easy to look at. As a wildlife photojournalist, my job is to tell the story, and today's reality for tigers is sometimes graphic and disturbing. With their ultimate survival in question, I could not in good conscience only make and publish beautiful cat pictures. If I were photographing a war, would I just bring back portraits of adorable children who lived within a battle zone?

In addition to shrinking habitat, poaching, and disappearing prey, tigers face specific challenges in each of the locations I photographed. With limited space in an island landscape, these issues are greatly magnified on Sumatra. Although Thailand's Huai Kha Khaeng Wildlife Sanctuary is one of the most successful tiger recovery projects outside of India, the struggle now is to make huge adjoining forests safe for young tigers. And though India is the stronghold—with about half the world's remaining tigers scattered from the Himalayan foothills to the base of the subcontinent—poaching is heavy and 1.2 billion people compete for land and resources. Taken together, these locations illustrate the complexity of tiger conservation today.

During the month I camped with the tiger team, I never spotted a tiger nor made a single photo of one. That held for the entire four months

Global big cat expert and conservationist

In March 1999, the Ministry of Defense granted Alan Rabinowitz permission to travel to the remote Hukawng Valley in northern Myanmar. He'd spent much of the previous five years assessing the country's wildlife and helping the government identify wilderness areas worthy of protection. On that expedition, he walked, boated, and rode elephants 150 miles, traveling up the nearly impassable World War II Ledo Road. He was escorted part of the way by machine gun–toting soldiers ordered by the military government.

Rabinowitz discovered plenty of wildlife there. Most importantly, he found evidence that tigers still roamed these jungles, though they were mostly gone elsewhere. The country was in danger of losing them. He proposed the creation of a 2,500-square-mile sanctuary zoned only for wildlife. Exactly two years later, it was approved.

Soon after, he was summoned to Yangon to meet with the head of the Forest Department. Khin Maung Zaw shocked him with a request: He wanted him to push for protection of the entire 8,500-square-mile valley as part of a larger Tiger Action Plan. Never before in his career had Rabinowitz been accused of trying to protect *too small* an area.

It was an overwhelming prospect. The Hukawng was home to 100,000 people from four ethnic groups. Inside were six towns, a prison, a plantation, and the insurgent Kachin Independence Army (KIA) headquarters. But the opportunity to conserve an entire landscape was too powerful to ignore: This was conservation at an appropriate scale for the tiger, a wide-ranging predator. Rabinowitz placed the proposal before Aung Phone, the top minister. He asked for three years to gather information. Then he lost a year dealing with a health crisis.

In the meantime, the government had rebuilt bridges, opening the Ledo Road that had lay in ruin since 1955. A tidal wave of humanity poured in, sparking unbridled pillage of timber, wildlife, minerals, and especially, gold.

Rabinowitz initiated extensive surveys to count tigers and their prey, using camera traps that captured pictures of anything passing by. It was crucial to identify the most important "core areas" for tigers and strongly protect them. Other regions could be used, under strict guidelines, by people.

A stack of four-by-six-inch photos combined with computer models told the tale. There were 25 to 50 tigers in the sanctuary core, perhaps 80 to 100 in the valley. Despite widespread hunting, there was still enough favored prey—deer and wild pig—to feed them. It was far less than Rabinowitz hoped for, but enough to justify protection. It also provided a crucial link between forests in northeast India and those in Thailand and Malaysia.

For the reserve to succeed, he needed local cooperation. Rabinowitz navigated a political minefield

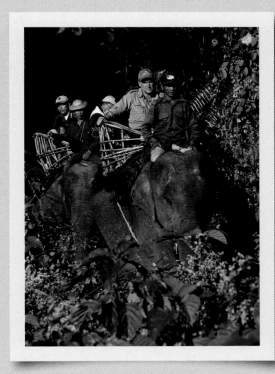

to meet with the KIA commander and spoke with village headmen from Naga and Lisu hill tribes.

In March 2004, five years after he first stepped foot in this jungle, it was declared the Hukawng Valley Tiger Reserve. It was larger than 45 of the world's nations. Now it would require vigilance: good management, protection, and careful monitoring for tigers to thrive.

There was no guarantee that a protected area of this magnitude and complexity could succeed. But as Rabinowitz writes in *Life in the Valley of Death,* his book about the reserve, "Only those who set goals beyond what is obviously achievable make a real difference in this world." ◊

I worked in the Hukawng on two separate trips. Every day, we walked the riverbanks and hacked our way through punishing forest, so ripped up by the spiky rattan and covered in leeches that we arrived back in camp at night looking like we'd been in a knife fight. I often brought Ah Puh with me because of his uncanny tracking skills; he was a Lisu tribesman hired by WCS who held a legendary reputation as a tiger hunter. It was obvious from the skittish behavior of the few animals we encountered—macaques, huge, elk-like sambar deer, jittery hornbills, and other birds—that hunting was too common. Humans were to be feared, and avoided.

On my way into the valley, I'd seen some of the reasons why wildlife was so scarce. In the year and a half since the sanctuary was created, it had become a different place from the one Alan first described to me. When he'd conducted his first wildlife surveys three years prior, just 5,000 people lived there. Since then, the government had rebuilt or jury-rigged washed-out bridges along the mighty Chindwin River, sometimes just lashing together wooden rafts or scraps of WWII wreckage. This allowed them to reopen the long-defunct Ledo Road. With access to the valley, centuries of local, small-scale gold panning exploded into an all-out gold rush. Burmese magazines advertised quick riches, and at least 150,000 people streamed in from across the country. Most came for gold, but some sought other resources: bamboo, wood, palm, rattan, or amber.

We took the Ledo Road to Shingbwiyang, the site of the largest mine. The road was open, but it was horrendous. Our Hilux trucks were jacked so high that we needed a ladder to get in. We fishtailed the entire way, frequently sinking to the wheel wells in the viscous muck.

Much of Shingbwiyang was a wasteland, the forest razed. High-powered water hoses blasted away the soil, carving craters into a denuded moonscape. It was a muddy, seven-square-mile warren of pits and sluices, devoid of life. Rivers ran brown, loaded with silt and poisoned with the mercury and cyanide used to extract gold from ore. But that was only part of the problem. There are no supermarkets in the jungle.

With access from the newly opened Ledo Road, miners poured into the Hukawng Valley. They razed forests, and sluice mining operations blasted away soil into mercury- and cyanide-laced ponds where gold was separated out, leaving a toxic wasteland.

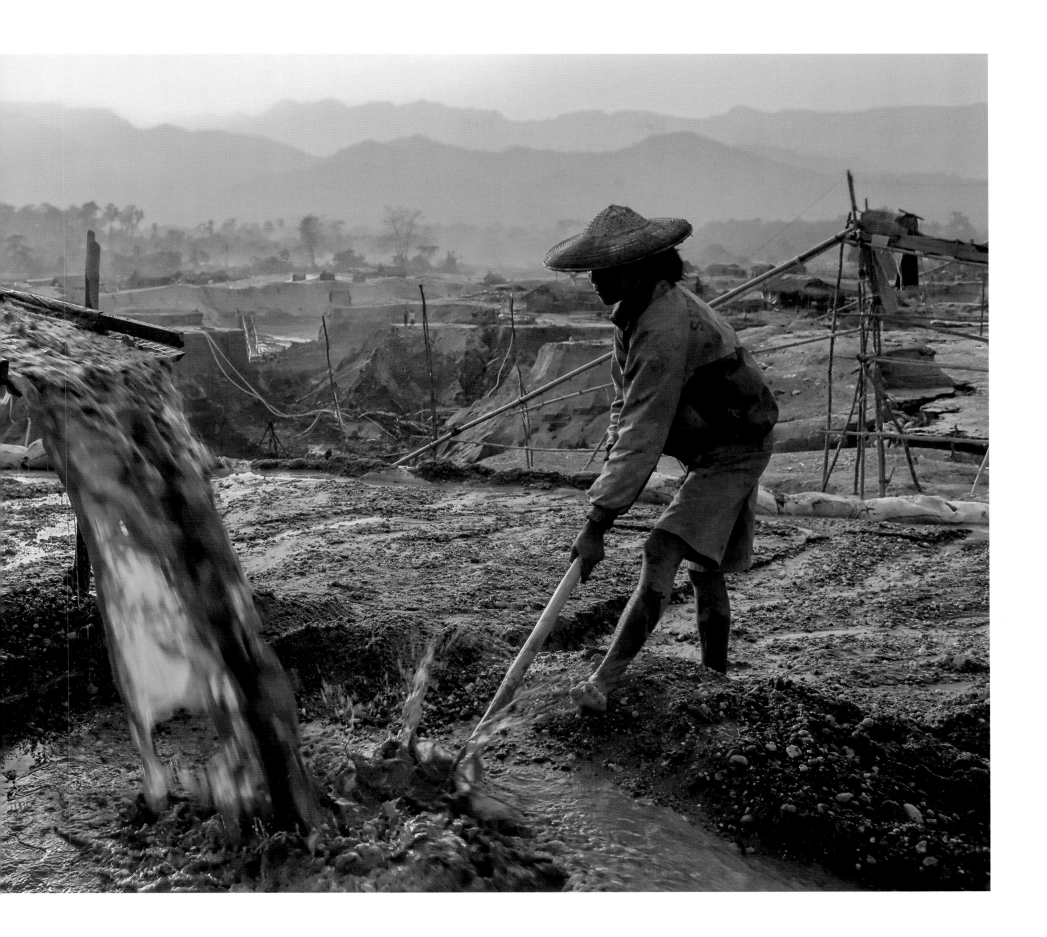

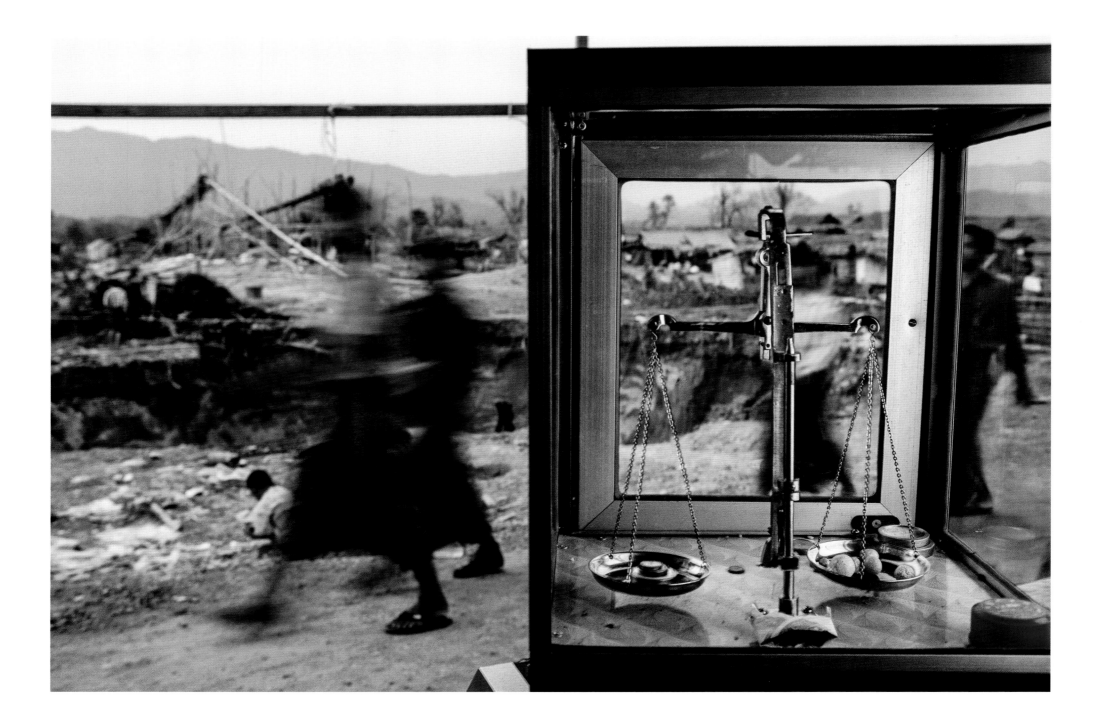

Gold scales hang in a roadside shop in Shingbwiyang, a once sleepy town overrun by migrants from across Myanmar who came seeking riches. Many miners ended up making just a few dollars a day.

Suddenly, thousands of people were eating whatever they could hunt from the forest. They targeted the sambar deer and wild boar that are also the tiger's favored food. Wild meat was cheaper than the farm-raised chicken and pork that had to be trucked in from Myitkyina, the nearest city. A tiger needs to eat about 45 to 50 deer-size animals a year; a mom with cubs needs more, closer to 70. Rampant hunting was wiping out the prey tigers relied on to survive.

The focus of my story had suddenly changed. It was no longer just about the tigers, the ecosystem, and the scientists studying it all: I needed to document these huge assaults on the valley. Instead of small-scale, local hunting, there was now a massive commercial market for bush meat. Mining operations and slapdash settlements had leveled chunks of forest. How was this huge influx of humanity impacting tigers?

It wasn't until I returned in February 2003 that I realized the Ledo Road had also brought in smugglers who were illegally trading in endangered wildlife. My first inkling came when I landed in Myitkyina. While gathering provisions to bring into the interior, I found street vendors everywhere selling traditional medicine: both plants and various animal parts, dried or floating in liquid. When I passed through in November, I'd seen just one small display with far fewer items. Now tables overflowed with skulls, horns, bird bills, unknown powders portioned into glassine, scraps of skin, insects, unrecognizable animal parts—and packets containing quarter-inch pieces of tiger bone. I headed into the valley wondering what I'd find.

Tanai, the gateway to the valley, now pulsed with humanity. People poured in, trying to grab whatever they could before seasonal monsoon floodwaters inundated the landscape. I heard stories of trails littered with metal snares and steel-jawed tiger traps, of trip-wire traps that shot poison arrows—and of a small army of men armed with flintlock black powder rifles. They were no ordinary hunters.

I met two of them while camping on the Tarung River during another unsuccessful attempt to photograph wildlife. They were escaped convicts with prison tattoos on their forearms who had just killed a bear. They'd aimed badly and shot it through the stomach, damaging the valuable gallbladder: Bear bile is used in traditional Chinese medicine (TCM). The only parts they'd be able to sell were the paws, netting maybe $2 each. It was an $8 bear.

These men were just a tiny part of a huge pipeline shipping wildlife to East Asia, particularly to China. Animals were vanishing across the region and the world into an illegal trade run by international crime syndicates. The Hukawng Valley had become an easy source. The appetite for animal parts used in traditional medicine has skyrocketed in tandem with China's expanding industrialization. This insatiable demand is primarily fueled by newfound wealth among some of its 1.3 billion residents, with some use in Vietnam, other Asian countries, and in cities across the globe with Asian populations, including the United States. China became a huge importer of tiger products; from 1990 to 1992 it exported 27 million items containing tiger to 26 counties and territories, according to data from the Convention on International Trade in Endangered Species (CITES).

It's been a deadly combination. Ingredients include a wide range of plants, minerals—and parts from more than 1,500 animals, including endangered species. Many are used in the same ancient remedies that have been prescribed for nearly 4,000 years, concoctions compiled in *Pen Ts'ao Kang Mu (The Great Herbal)* in 1596 during the Ming dynasty. Demand for the most highly prized items, including rhino horn, pangolin scales, and tiger parts, has nearly hunted these creatures off the planet.

For millennia, medicine men across Asia have ascribed magical powers and healing properties to the tiger, and, somehow, the cat became a universal apothecary. Nearly every part, from nose to tail—eyes, whiskers, brains, flesh, blood, genitals, organs—is used to treat a lengthy list of maladies. Tiger parts are believed to heal the liver and kidneys and are used to treat epilepsy, baldness, inflammation, possession by evil demons,

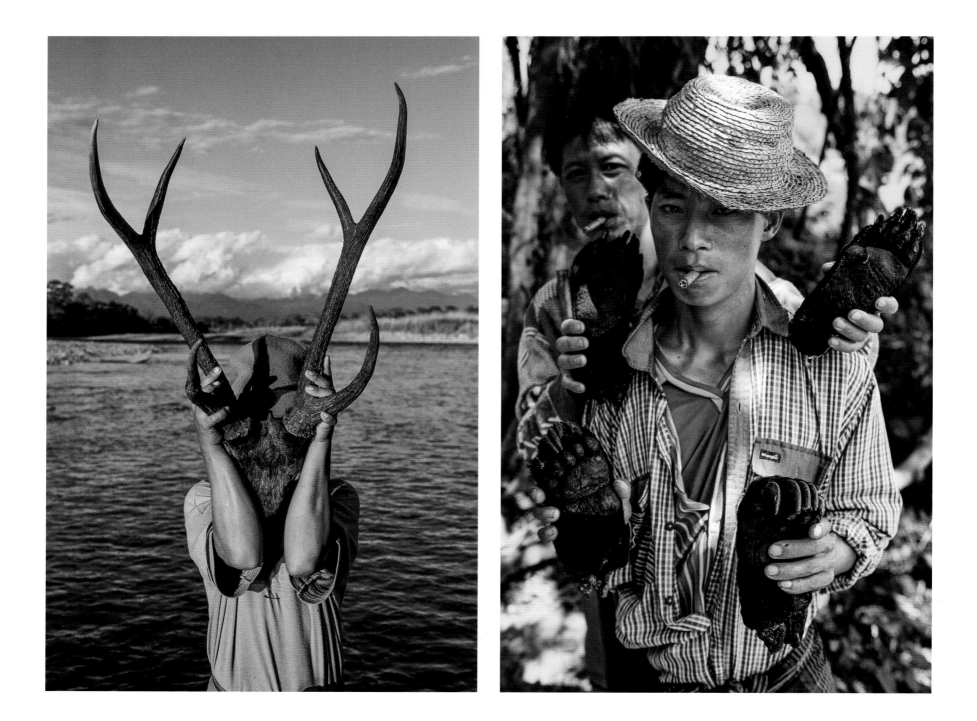

Left: With no supermarkets in the jungle, thousands of gold miners survived on sambar deer and other tiger prey, leaving tigers with little to eat. *Right:* Poachers streamed into the valley, shooting tigers, bears, and other wildlife. Prized parts were sold to smugglers and trafficked to China for use in traditional Chinese medicine. This bear was killed for its paws, which fetched eight dollars.

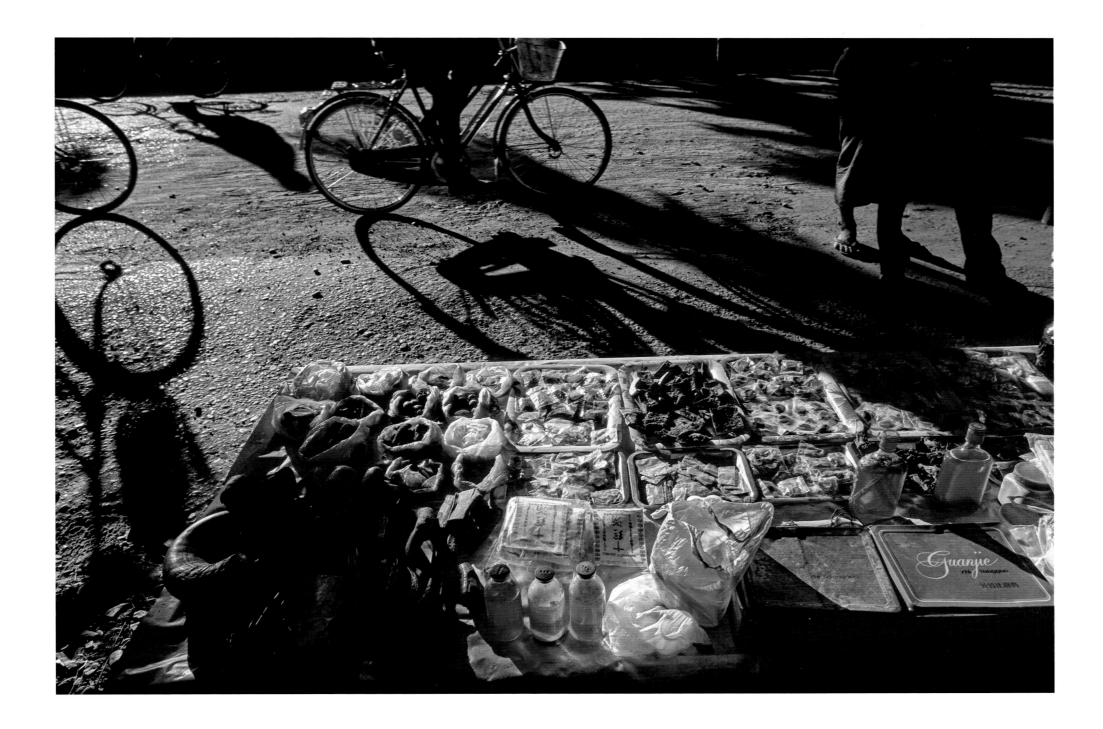

A street vendor in the northern city of Myitkyina displays animal parts used in traditional Chinese medicine, including horns, elephant skin—and tiger bone. Nearly every part of the tiger is used in this 4,000-year-old apothecary; skyrocketing demand from China is hunting tigers off the planet.

toothaches, malaria, hydrophobia, skin diseases, nightmares, laziness, fevers, and headaches.

The bones are considered powerful medicine. Newborn babies are bathed in bone broth so they will grow up disease-free. There is a growing, demand for tiger bone wine, a tonic made by soaking a tiger carcass in rice wine. It is thought to cure arthritis and muscle pain, to stimulate blood flow and *qi* (the life force the Chinese believe inherent in all things), and to impart the animal's great strength. Since 1994, a few Chinese practitioners have repudiated the efficacy of tiger remedies, with little result.

It wasn't until three decades ago that scientists realized that TCM was responsible for a precipitous decline in tiger numbers. As tiger populations in China plummeted, professional poachers fanned out, snaring, trapping, and shooting their way across Asia, targeting locations where corruption was rife, enforcement weak—and where there were few other economic opportunities. Poachers hired local tribal people to hunt the cats or act as guides. Then they ran prized parts over borders to Chinese TCM manufacturers.

Tigers were classified as globally endangered in 1986. The next year, an international treaty banned cross-border trade in tiger parts, driving the market underground. China banned domestic tiger bone trade in 1993, though shadowy networks remain. Although tiger hunting is illegal everywhere, the killing has accelerated. Prices for tigers, dead or alive, continue to soar as populations collapse. Poaching for TCM (and to a lesser degree, for their skins) has become a primary threat to their survival.

INTERPOL agents informed Congress in 2008 that the same sophisticated underworld crime networks that run illicit gun, drug, and human trafficking operations also mastermind the wildlife trade. With high profits and low risks, it has become one of the fastest growing and most profitable types of international organized crime, growing into an estimated $20 billion a year business that helps purchase weapons, fund civil wars, and finance terrorist activities. Still, most governments view wildlife crime as an "environmental" issue, keeping it low on the priority list.

Police and customs agents do make arrests and seizures, but penalties are light and few poachers or smugglers see jail time. In 2010, INTERPOL launched an Environmental Crime Programme to coordinate transnational investigations and police actions, including a "Project Predator" program focused on tigers. Achim Steiner, who heads the United Nations Environment Programme, called for a global crackdown in 2013. Whether these actions effectively bust up smuggling networks remains to be seen.

To understand the complexities of protecting tigers in the Hukawng, I needed to document the local people and their traditions: the Kachin and Lisu in the lowlands, and the Naga in the high mountains.

The Kachin have been fighting for autonomy since 1961, when the Kachin Independence Army (KIA) was formed. To deter government troops, they blew up the few remaining WWII bridges that had survived monsoon floods. Skirmishes continued until they brokered a cease-fire in 1994. The KIA still controls part of the valley from headquarters that lie within the wildlife sanctuary, so any successful conservation initiative would need their blessing. In theory, the Kachin maintained strict regulations against killing wildlife, but they also ran gold mining camps and hired hunters to feed the workers. Camera traps had captured images of KIA soldiers carrying dead animals.

I went with Alan to gain state permission to visit KIA headquarters, which they granted him. For security reasons, the Kachin wouldn't allow me to join him, but I was able to photograph soldiers out on patrol.

In a meeting with the KIA camp commander and senior officers, Alan explained the state of tigers and the need to protect their prey. "If the tiger's food is wiped out, you might as well put a bullet into the head of the tigers themselves," he told them. When they blamed the Lisu for the spike in hunting, he produced four-by-six snapshots of soldiers hunting. The commander agreed to take action, but reminded him that his people needed to eat—and they needed money for their cause.

Biologist and Northern Forest Complex coordinator, Myanmar

In Myanmar, the tiger is a symbol of strength and power, the apex of all creatures, says Saw Htun. "If we can save this spectacular keystone species, we can ensure healthy ecosystems and protect the entire assemblage." Tigers are the inspiration behind his conservation work.

After graduating from Oxford and studying wildlife in Myanmar's rugged northern mountains, Htun accepted a post coordinating the region's five huge parks and sanctuaries for the New York–based Wildlife Conservation Society (WCS) in 2005. This "Northern Forest Complex" included the new Hukawng Valley Tiger Reserve. Poaching was commonplace, and if the tiger—or anything—was going to survive, it needed protection. Tony Lynam, who headed WCS's Thailand program, teamed with Htun to train newly minted park rangers. They particularly recruited local people who would be essentially protecting their homes. They taught the men the basics of systematic patrolling, focusing limited manpower within the pristine core of the sanctuary. Even a standing army couldn't patrol the whole area, which is roughly the size of Vermont.

Once the guard force was established, Htun provided state-of-the-art technical training. The rangers learned to collect and input field data, working with

a GPS to track, map, and monitor threats: from the presence of campfires and human footprints to remnants of poaching camps. In monthly meetings, they analyzed that data to plan the next month's patrols.

But controlling hunting would take far more than 50 guards on the ground. It also required an intelligence network and the cooperation of people living within the reserve. Chief among them are the Kachin Independence Army (KIA), which headquarter there and controls part of the Hukawng, and Naga tribesmen who live in the mountains that ring the valley.

Their support came through a long-term relationship with Alan Rabinowitz, the big cat expert who'd convinced the government to create the reserve. Saw Htun guided and interpreted for him on numerous expeditions deep into dense, thorny jungles and remote peaks. Periodic meetings with KIA commanders resulted in stringent restrictions on troops hunting bush meat and illegally trading wildlife. The headmen of Naga villages were also receptive to conservation plans: They respect tigers deeply, believing that they carry the spirits of their ancestors.

Many villages didn't even know the land had been designated a reserve, so Saw Htun and his men began working with these communities. While recognizing their rights to farm, graze their animals, collect bamboo, rattan, and other resources, they defined the rules: There could be no poaching. Forest products were for their own use, not for sale. And the sanctuary core was inviolate. He gained public support. Much of the logging and the explosive gold

PHOTO: RATI NAM KHIN

rush that were ravaging the land—with hoards hunting wildlife—were closed down.

But in June 2011, a 17-year cease-fire between the government and the KIA collapsed. A year and a half later, the war is escalating, with heavy shelling and air attacks. A huge concern is that both sides are riddling the valley with land mines. Most of Htun's current activities are planning for after the peace when they can resume research and conservation efforts. His men are conducting minimal patrols along the main road, but it's too dangerous to enter the forest. The hope is that the fighting is also keeping hunters out.

Htun says that before the war, wildlife was no longer disappearing, though tiger numbers were low. "Have they been killed—or moved into rugged mountains or remote floodplains?" he asks. They should know soon. ◊

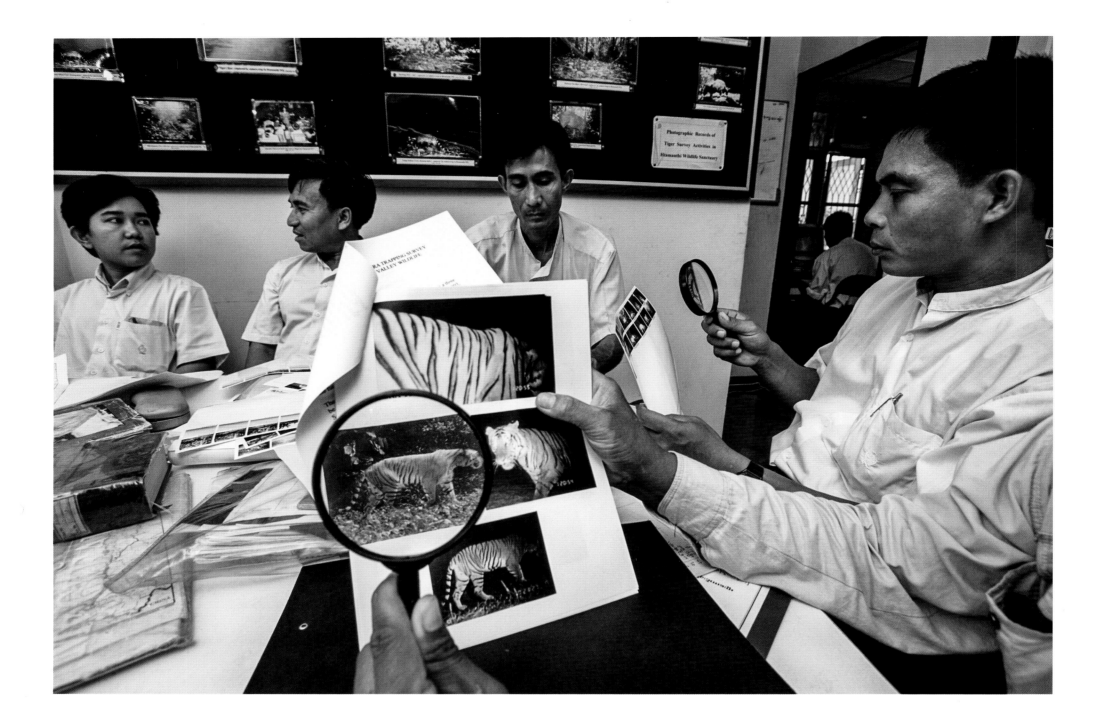

After three months of field research, Burmese biologists review camera trap photos to estimate the Hukawng Valley's
tiger population. Individuals are identified by their distinctive stripe pattern, which is as unique as a fingerprint.

TO PHOTOGRAPH THE NAGA, I tagged along with Khin Htay and Nilar Pwint in April 2003 on a trip to Namyun. It was a remote village located high in the mountains near the Indian border, a place never visited by Westerners. Htay and Pwint were working with WCS, methodically visiting the 50 settlements inside the sanctuary, surveying villagers about animals they saw in the forest and which ones they hunted, ate, or sold. Naga tribesmen had a fierce reputation. They were renowned warriors, and until just a few decades ago, were headhunters who sometimes practiced human sacrifice. Oddly enough, they were also known for their great sense of humor. Now they lived sequestered amid rugged peaks that kept out intruders.

We arrived in Namyun on my birthday. I was taken to the home of the village shaman, who ducked into his bamboo and palm hut. Minutes later, he leaped out, screaming, thrust a spear at my chest, and stood there looking ferocious, dressed in a beaded loincloth, a pointy tiger skin hat, and a tiger tooth necklace that hung nearly to his navel. Then he doubled over and laughed himself silly. I was welcomed into the village, shown around, and fed. Later, the shaman posed for portraits beside his cook fire, singing songs I couldn't understand. It was my birthday party.

Tiger hunters hold great status, and the tiger claws, teeth, and skin they wear are considered powerful talismans. The cats sit at the pinnacle of Naga lore. In a popular myth, man and tiger are brothers, one human, the other striped. Some tribes still believe tigers carry the spirits of their ancestors.

The villagers told us that they hadn't seen one in 20 years, but deer and small animals remained plentiful.

I WAS NEARING THE END of my assignment, but wanted to go out with Lisu hunters. Their great skill made them the greatest concern from a conservation perspective. So we floated down the Tarung River on a homemade bamboo raft and headed out to the Ledo Road.

There I was apprehended by an army officer. "We found the Westerner," he barked into an ancient crank radio. I hadn't realized that I'd become a wanted man. My permit wasn't extended as promised, and the authorities had been looking for me. The officer shipped me back to Tanai.

So I sequestered myself in my hotel, pretending to be ill, and then slipped away in the dark to a nearby Lisu enclave. The village headman invited me to stay with him. Inside, most of the wall was dominated by a bamboo trophy board covered in sambar, barking deer, and macaque skulls. Traditional Lisu believe that praying to the spirits of the animals they've killed bestows luck in future hunts.

The next day, the headman sent me out hunting macaque with his 30-year-old son. I asked him if they had hunted for reasons other than food in the past. No, they hadn't. Did he have a trophy board like his father's? Again, no. His generation sold those skulls to the Chinese.

We didn't find any monkeys that day.

THE LISU ARE FAMED TIGER HUNTERS, but they are far from the only ones. Tigers were once so numerous in Burma that between 1933 and 1936, the government put a bounty on their heads. Official records tallied 1,100 kills, but the death toll was probably far higher. Half a century later, the Forest Department declared that 3,000 tigers were left. By 1996, tigers had not been seen in many areas for years, but an unsubstantiated guess (based on populations in neighboring Thailand) put numbers between 600 and 1,000.

Although I never photographed Myanmar's Indochinese tigers, the WCS tiger team had. They completed their survey and reported back to Alan: They estimated that somewhere between 70 and 100 tigers lived in the valley, about two to three per hundred square miles. A safer estimate could have been half that. A viable tiger population is 80 to 100 tigers, with at least 20 breeding-age females and eight to ten males, the rest being transients, old or young females, and cubs.

Similar habitats in India had ten times that density; the number was high enough to justify enlarging the reserve. Alan delivered the news to government officials, and on March 15, 2004, the military government created the Hukawng Valley Tiger Reserve—the world's largest tiger sanctuary. It protected 8,500 square miles of sprawling wilderness, one of the largest forest tracts left on the continent, larger than 43 of the world's nations. It was an initiative unlike any other because of its massive scale. The area could support hundreds of tigers, though it probably never will.

But the new reserve would have to work for both wildlife *and* people. Tigers needed ample prey and a safe place to live and breed. Local people needed a way to survive.

More than 100,000 people lived in the valley. There were six townships. KIA-controlled lands. Naga insurgents. Gold mining interests. Plantations. A prison. Military bases. A monastery. But Alan had designed the reserve with all this in mind. The original sanctuary remained an uninhabited core zone connected to four wildlife corridors where tigers should, if protected, be able to safely live and breed. The most populated areas became "multiuse" areas. Banning all hunting, fishing, and forest harvesting wasn't possible or realistic; the volume of people surviving on forest products was apparent in the many camera trap images of people carrying knives, baskets, bags, or guns. Allowing personal—not commercial—use offered a fine balance. The plan offered economic incentives to curb hunting, including programs to raise chickens and pigs, to farm rattan and bamboo, and to establish eco-tourism. Hopefully, these initiatives would work, mining operations would be shut down, slash-and-burn agriculture would be curtailed, and locals would inform forest officers of illegal activity. As long as people followed the rules, 8,500 square miles could be big enough for everybody.

Despite tremendous efforts over four decades, tigers have continued to disappear. Most reserves are small and isolated, confining the cats to small forest pockets. But tigers cannot survive long term without roaming distance to hunt, mate, and establish a home territory. Planning at the Hukawng's massive scale helped Alan understand the need for a new paradigm, one that secured key breeding tiger populations and the prey to sustain them within inviolate core areas that are embedded within and connected to larger, connected habitat. These wide-ranging cats must be able to move to hunt and breed. Successful conservation requires genetic exchange. Isolated animals become inbred—an almost sure road toward extinction, spawning weak offspring with health problems and lowered immunity. Just a couple of new individuals breeding with residents per generation is enough to maintain genetic vigor.

The tiger landscape grew later in 2004, when another reserve was approved, an area straddling the Kumon Mountains along the Hukawng's eastern border. Four protected areas now form Myanmar's massive Northern Forest Complex that joins across the border with India's largest tiger reserve, Namdapha National Park. This 14,000-square-mile block has become a nexus point, a crucial link between northeast India and the Indo-Malayan realm for Indochinese tigers.

AFTER OUR STORY APPEARED in *National Geographic* in April 2004, the government cracked down on the gold rush. At least two-thirds of the miners left and guns grew scarcer.

But any conservation effort, especially one of this magnitude, is at constant risk in an ever changing, resource-hungry world. Any accomplishments are fragile, requiring constant vigilance.

In June 2011, the 17-year cease-fire between the Myanmar Army and the KIA collapsed. Fierce fighting, including aerial bombing, has made it too dangerous for park rangers to enter the valley. Both sides have riddled the landscape with land mines. Conservation is on hold.

But the fight for tigers is also a fierce one. The reserves could help repopulate tigers to parts of Indochina. And by saving the tiger we're saving everything else in its kingdom. ◊

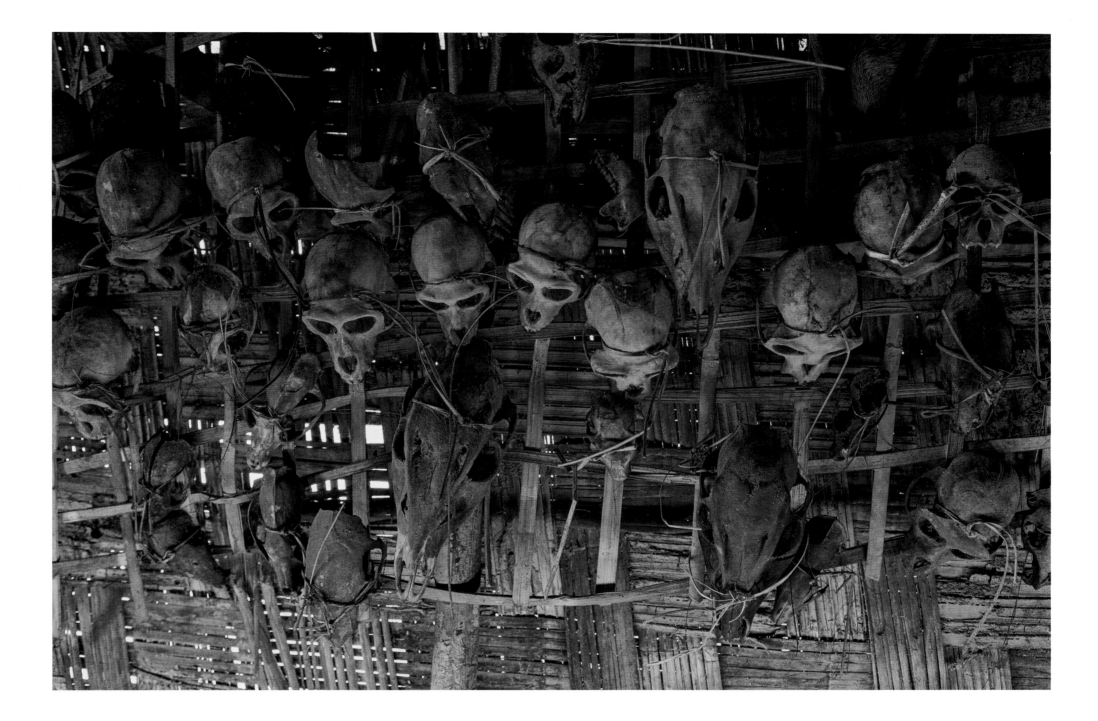

A trophy board hangs in a Lisu hunter's home. The ethnic Lisu hunted only for food, praying to the spirits of animals they had killed to ensure hunting success. Today, Lisu also kill for profit, selling wildlife on the black market.

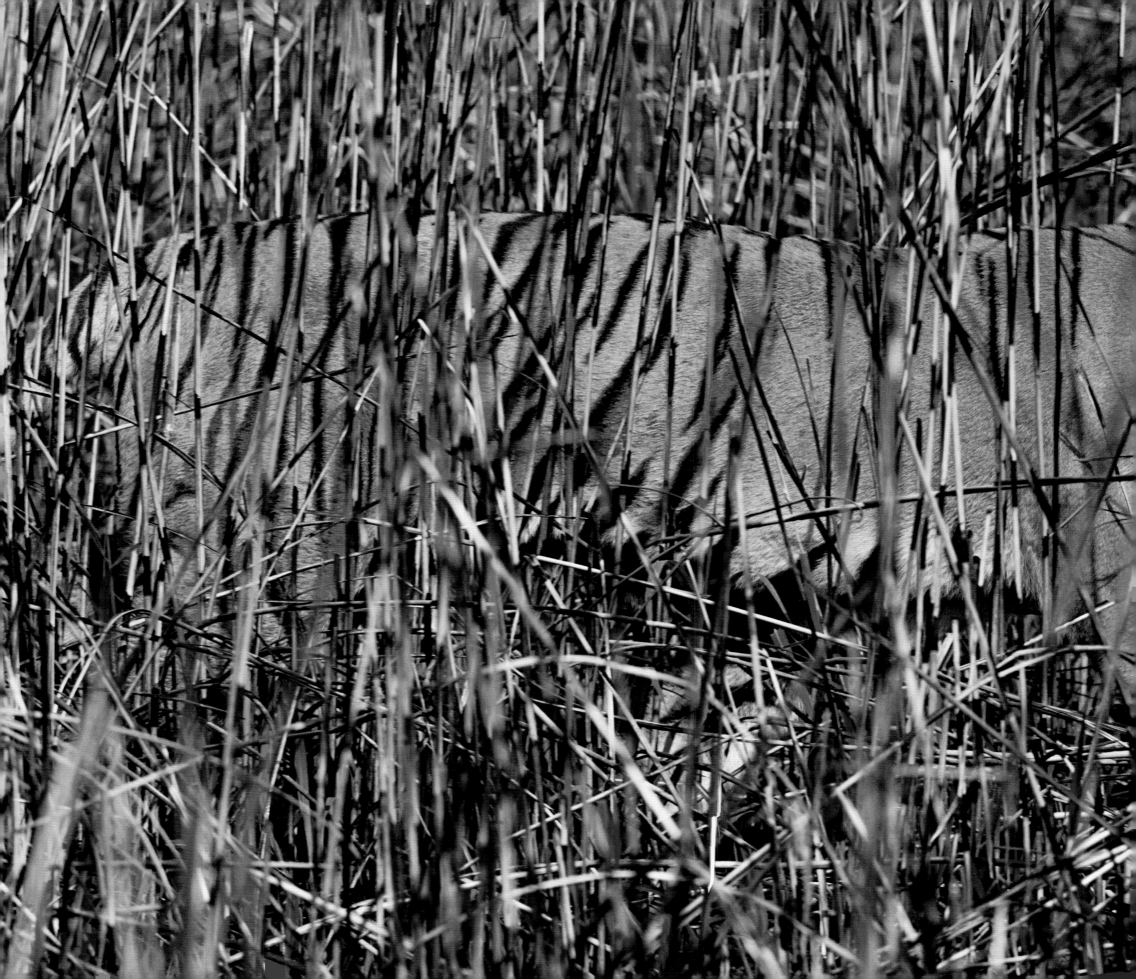

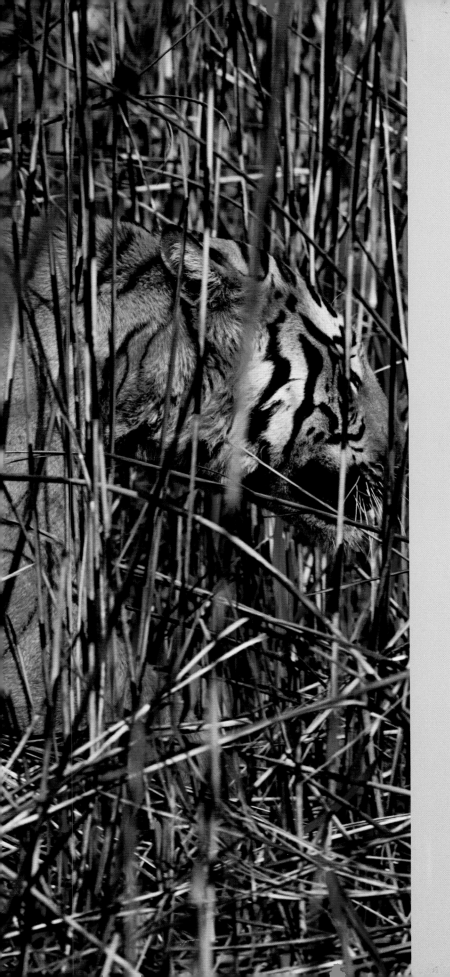

DODGING BULLETS

A tiger moves nearly invisibly through Kaziranga's tall reeds. Though we tend
to think of tigers as a jungle species, they are perfectly adapted to grasslands,
where their striped camouflage raises the odds for a successful kill.

57

A<small>N ANEMIC SUN PEEKED THROUGH THE EARLY</small>

morning mist. I was perched on the roll bar on top of our jeep attempting to fix a camera trap. I'd attached it high on a tree, shooting downward, hoping to get a picture of a tiger using it like a giant scratching post. Yet another elephant had smashed the setup. They seemed to hate camera traps. Suddenly, Ajit Hazarika, one of the forest guards accompanying me, yelled "Tiger! Rhinos!" Three animals appeared like apparitions from the fog, framed by the towering grasses that flanked the dirt road. A mama rhinoceros and her small calf were charging our way, chased by a young tiger. ¶ The cat quickly veered off and disappeared. But 5,000 pounds of rhino came thundering at us. I jumped

down into the back of the jeep and braced myself. She bashed us with the force of a Mack truck. The door crumpled. Hazarika fired his ancient rifle at the ground to scare her off. She circled and hit us again, this time from behind. Eight warning shots later, she took off. My guide, Budheswar Konwar, floored it. We skidded along the muddy wreck of a road with a brown wake flying behind us, fleeing to a nearby guard outpost to assess the damage, drink chai, and calm down.

The baby rhino called for her mother for 45 minutes. When she stopped, we watched the pair run off down the dirt road together. Ten seconds later, the tiger followed.

It got the calf that night. The guards found it the next morning.

T<small>HIS WAS THE FIRST TIME</small> I'd ever seen a tiger, and it was only a glimpse. Its enormous size, rippling muscles, its beauty almost took my breath away—and at the same time, the sight of it sparked a deep, visceral fear.

It was September 2007, the end of monsoon season, and the land was still sodden from months of rain. I was on assignment in Kaziranga National Park in Assam, a scrap of northeastern India sandwiched between Bangladesh, Bhutan, and Myanmar. It's one of Asia's few remaining strongholds for a staggering variety of wildlife, including many endangered species. This park is the antithesis of the Hukawng Valley: Instead of a sprawling landscape with few animals, here animals are crammed into a postage stamp–size Noah's Ark in numbers usually only seen on the African savannah. I'd come to shoot a story documenting this abundant ecosystem and the reality of trying to protect it amid an exploding human population that, in some places, lived literally on its borders. I'd spend five months here in all, with help from two assistants, Jonathan Fleming on my first trip and Gabe DeLoach when I returned in January 2008.

Bengal tigers *(Panthera tigris tigris)* sit atop the food chain here. Though they continue to decline elsewhere across India, Kaziranga's tiger population

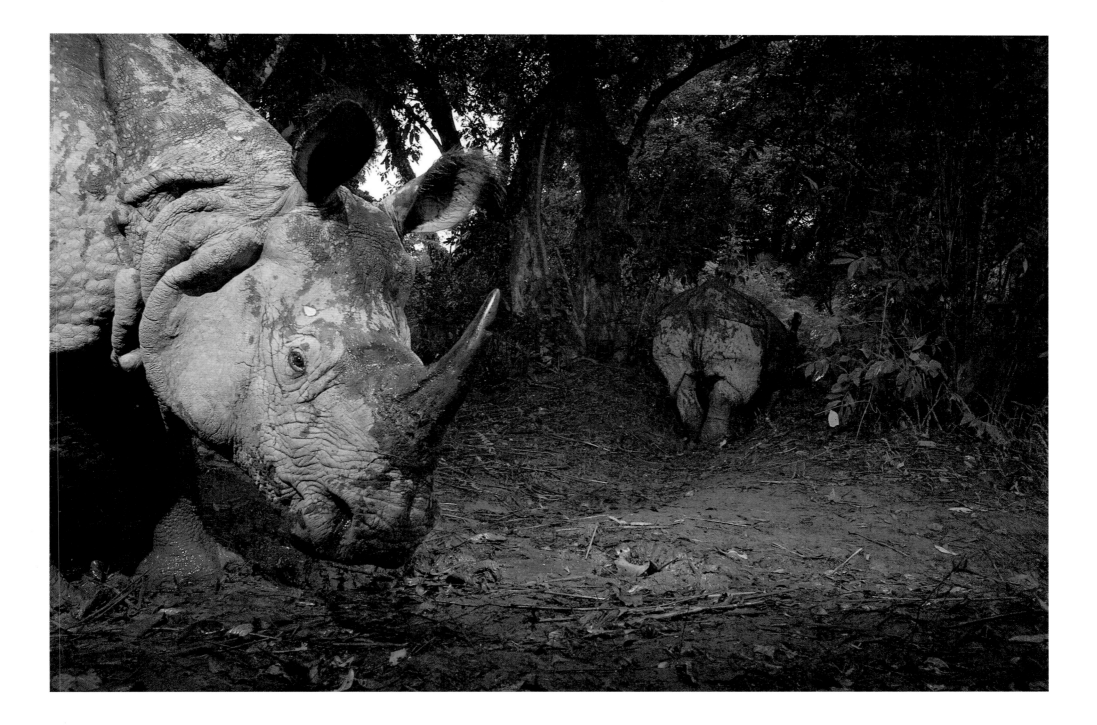

This male rhino carries the blood of a rival or mate—possibly the female in the background. Kaziranga harbors three-quarters of all remaining Indian one-horned rhinos; their calves are among tigers' favorite prey.

is thriving. Aaranyak, an Assam-based conservation organization, counted them over a three-year period by setting up 100 cameras outfitted with motion detectors and flashes. In 2011, they estimated that about 100 tigers live here—one of India's largest populations. That works out to about 28 tigers per 38 square miles, the highest density of tigers anywhere in the world.

On my first drive through the park, I watched the fleeing blur of miniature, rust-colored hog deer and larger swamp deer panicked by our intrusion. It was obvious why the big cats thrive here. Kaziranga is a grazer's paradise. These lush grasslands provide perfect habitat for tiger prey: wild boar, Asian water buffalo, the calves of both Asian elephant and Indian one-horned rhinos (tigers claim about 15 percent of the rhino calves born here), three species of deer, and so much more. Tigers have a relatively low hunting success rate—about one kill for every ten attempts—so an abundance of large prey allows more time to breed and plenty of food to feed cubs.

The reserve is essentially an island of grassy swamp and forest that lies in a fertile floodplain, tucked between the undulating Karbi Anglong hills to the south and the mighty Brahmaputra River to the north. The river is the source of life here: Each year, summer monsoon rains swell the Brahmaputra to a raging torrent, inundating the valley with repeated flooding that coats it in rich sediment. When the waters recede, the plain is carpeted with vast swaths of sedge and 15-foot-tall elephant grasses, ideal food for the large prey that is more abundant here than anywhere in India.

THIS STORY PRESENTED UNIQUE CHALLENGES. I'd never before done a wildlife assignment where I wasn't allowed to stay in the place I was shooting. S. N. Buragohain, the park director, thought it too dangerous. I understood why. That early incident with the female rhino proved to be the norm. It seemed that with so many rhinos packed together in a relatively small space, they charged far too often. They were a constant concern, but so were the elephant and water buffalo herds—and the tigers.

About 2,290 Indian one-horned rhinos live in India's Kaziranga National Park, up from a few dozen when the park was created under the British Raj in 1905. Their protection has allowed tigers to thrive. Here, a rhino emerges from the wetlands at dawn, captured by a remote camera.

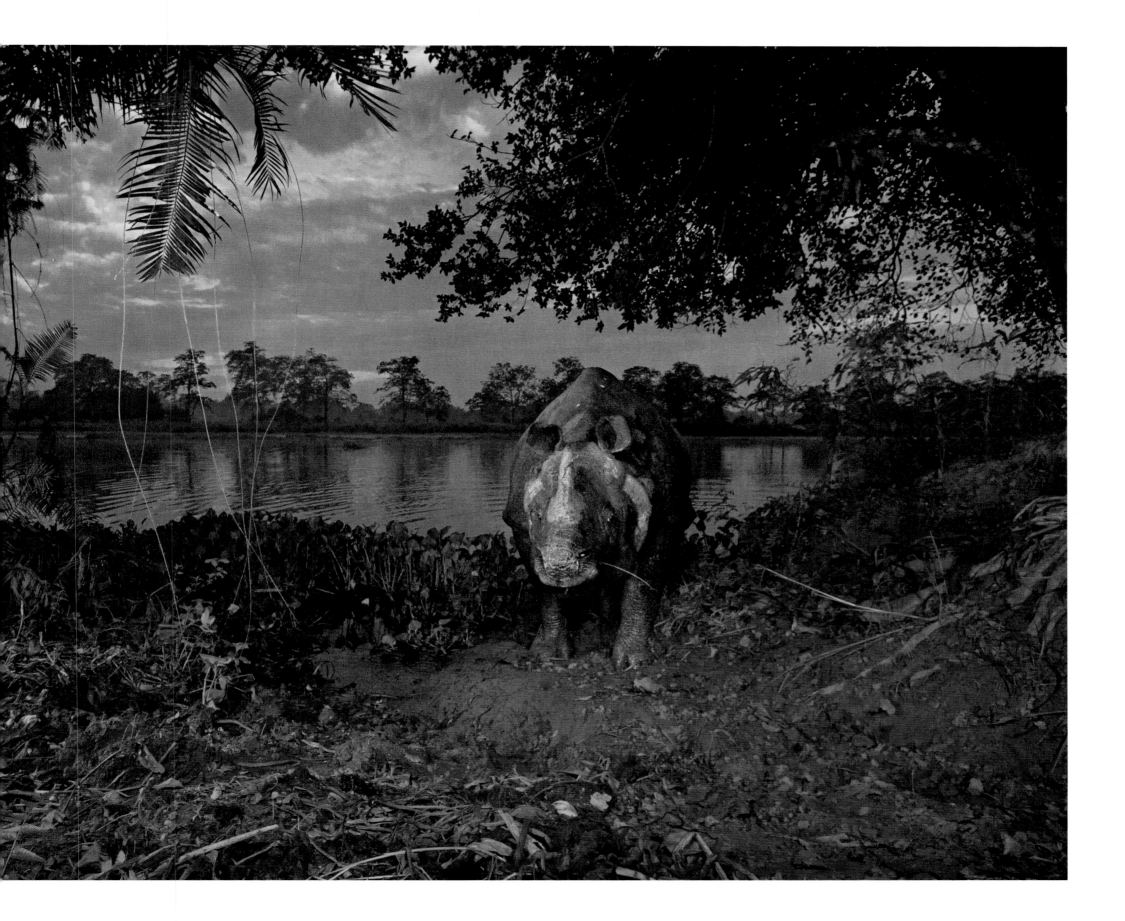

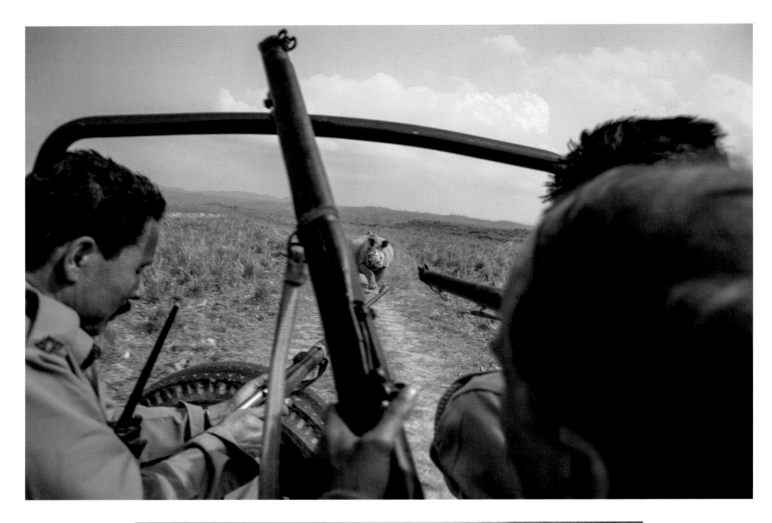

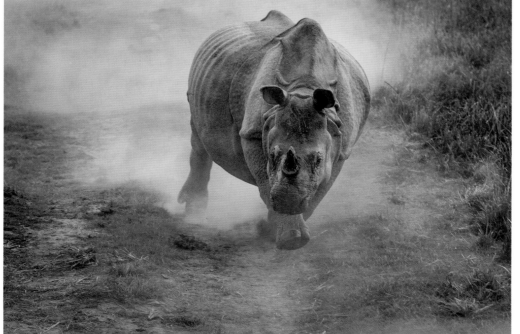

Kaziranga's rhinos live in abnormally high concentrations. They're aggressive—frequently charging vehicles and guards on elephant back—and dangerous, topping 30 miles an hour over short distances and weighing up to 6,600 pounds. Guards fire warning shots to scare them off.

Initially, I photographed from an open jeep or from elephant back. I was granted access to the entire park, including vast areas that are off-limits to the 80,000 or so safari tourists who visit each year. The only condition was that an armed park guard always accompanied me. But I also wanted intimate pictures of animal behavior, of difficult-to-see animals, and images shot at eye level, photographs that would expand our vision of these creatures and move people to care about their future. The only way to get them was to use camera traps, but Buragohain wouldn't allow me to be on the ground rigging up cameras. After some convincing he relented, and I deployed 14 camera traps throughout the park. I chose locations along heavily used wildlife trails and places where we discovered fresh pugmarks or hoofprints tracked into soft mud. With much of the land still flooded from the monsoon, I placed cameras along the few passageways linking dry areas, paths the animals were forced to walk.

Two guards came along to protect us during setup, which was particularly dicey in grass so tall it could hide an elephant. Rigging up a camera trap takes hours. I place a camera and three flashes inside waterproof cases and then secure them to trees or posts that we pound into the ground. Here, we tried to position them where they wouldn't be kicked by rhinos or where elephants wouldn't rip them apart with their trunks. Then we wired it all to a TrailMaster transmitter and receiver and camouflaged the equipment with foliage. Any movement that broke the transmitter's infrared beam fired the camera and the flashes.

Tigers are difficult to find in that landscape, but we found signs everywhere. We saw long scrapes on the ground and deep scratches etched into trees. Some areas were thick with their musky scent. These calling cards help the solitary cats find a mate, advertise their presence, and mark territory. It's a way to avoid surprise encounters that could prove fatal. Their markings also pointed out prime spots for me to set up remote cameras: trails, rocks, caves, or trees that I hoped the cats would return to. Sometimes they did. The trap where the rhino smashed our jeep captured an image of a big male standing on his hind legs, mid-scratch, looking right at the lens.

Once the camera traps were up, I spent each day making safari-style loops through the park. Midday, when the light was too bright to shoot, I'd check the traps, change batteries, switch out the memory cards, and fix damaged equipment. Downloading those images always yielded surprises: A wet elephant carrying an "elephant apple." A tiger with leeches on his face. A monitor lizard. A male rhino following a female, his face bloody from mating scuffles. Fifty photos of a branch that was blowing in front of the receiver. Three baby sloth bears perched on their mother's back. An image of a young male tiger emerging from a wall of grass, panting in a way that makes him look like he's smiling.

One of my favorite places to shoot was Bahubeel, a section of the park where a huge lake straddled a wide, open plain. The short grass drew hundreds of hoofed animals, including big herds of deer and elephant that made it almost feel like the Serengeti. To get there, we drove through mixed landscapes. Marshes gave way to forest in an explosion of green, with great buttressed trees wrapped in vines, some winding like huge serpents, thick as my thigh. The trees thinned and disappeared until we wound through towering walls of golden grass. As beautiful as it was, it was always nerve-racking. We never knew what was around the next bend. Of greatest concern were the charging rhinos (they're very territorial, and with their strength and heft, could easily flip the jeep), elephant herds (extremely protective of their young), and lone male elephants in musth (a yearly hormonal surge) that can be dangerously aggressive.

On one of those drives, Konwar rounded a bend, stopped short, and killed the engine. He whispered, *"bagh,"* Assamese for tiger. A big male lay in the road sleeping. Just beyond, 28 elephants munched away in a field of shiny, palm-leafed rattan. Three times, when the cat slipped into the grass, the herd quickly formed a protective circle around the calves, his target. The matriarch charged, trumpeting, and he returned to the road, napping until his

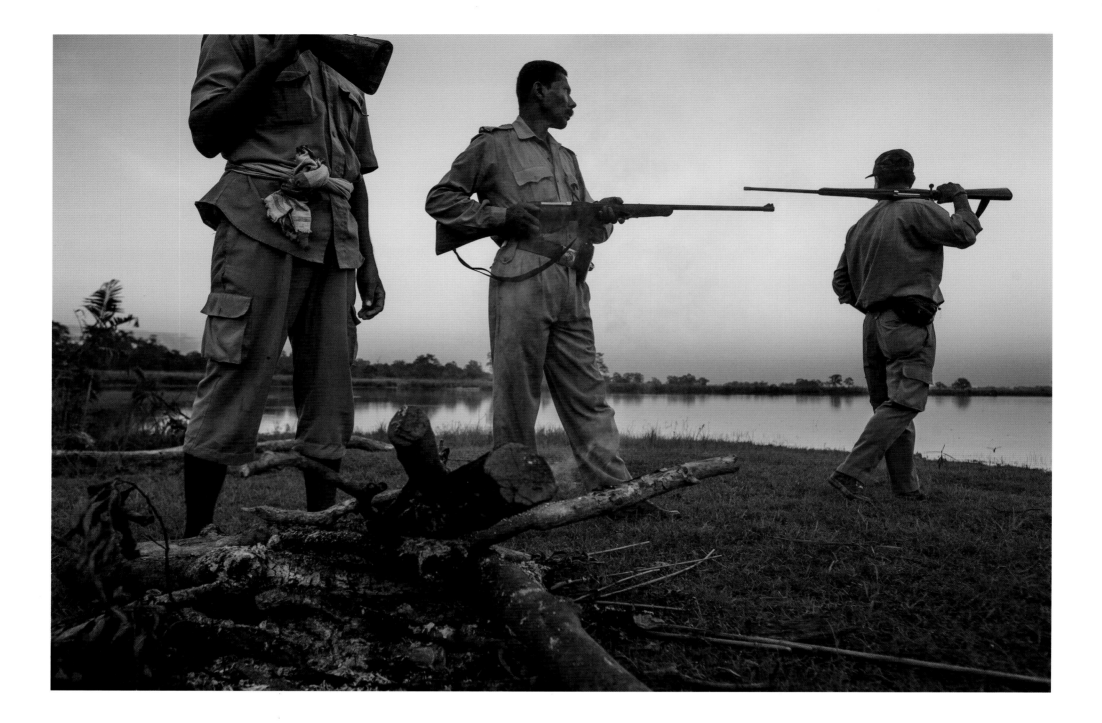

Poachers have taken down about 700 rhinos over the past 40 years. Rhino horn brings huge sums on the black market, used, like tiger parts, as an ingredient in traditional Chinese medicine. The quest has sparked a war, with park guards engaging in regular shoot-outs with heavily armed poachers.

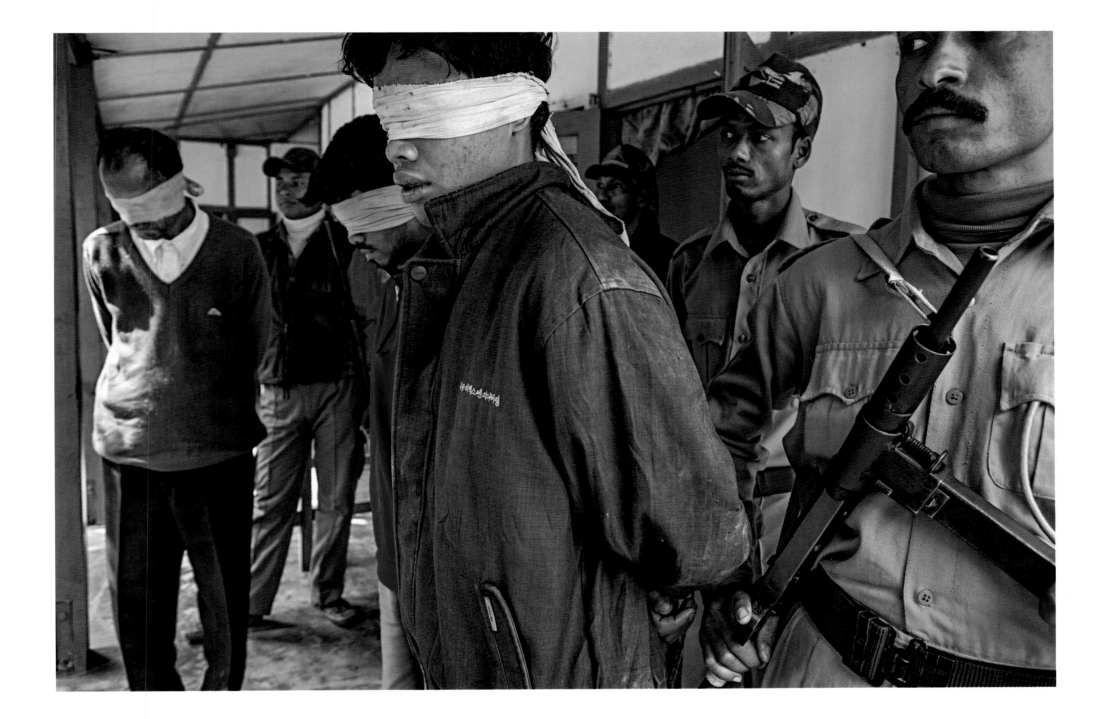

Suspected rhino poachers are blindfolded for interrogation at Kaziranga's Baguri ranger station. They were later released. Few wildlife cases ever reach the bench in an overburdened court system. Of 885 tiger-related incidents tried from 1974 to 2010, there were convictions in 16 cases involving 41 people.

next halfhearted attempt. It was my first real opportunity to watch a tiger up close, to really see the intricate markings on his face, his mammoth paws, his golden eyes, the reddish amber sheen of his coat, slashed by random stripes. Two hours later, he gave up. As he walked away, I photographed him, those stripes melting into the landscape, perfectly camouflaged in the elephant grass.

WHILE SPEAKING WITH RANGE OFFICERS at one of the park's headquarters, I learned that Kaziranga's tigers have been protected through an odd twist of fate that involves both the British Raj and Indian rhinos. But prior to that, many animals died. In 1826, when Assam was assimilated into British India, the sahibs favored the Brahmaputra Valley's prime trophy hunting grounds. Thirty years later, the slaughter intensified when the government offered huge bounties on wild animals, with special rewards for killing tigers. The large mammals all but disappeared.

Just a few dozen rhinos still survived when Lady Curzon, wife of the British Viceroy to India, came to see one in 1904. She begged her husband to save them. The area was named a forest reserve the next year and all hunting was banned a decade later. In 1974, Kaziranga became Assam's first national park; it was named a World Heritage site in 1985, and has doubled in size over the last 40 years, growing from 167 to 333 square miles.

But the cats are thriving here for another reason, one that's bloody and deeply disturbing. Elsewhere in India, tigers are in the crosshairs. But, as range officer Pallab Deka explained to me, they are difficult and dangerous to hunt. Most poachers capture tigers in a snare. The cat then roars and thrashes for at least a day until they can get near enough to club or shoot it, skin it perfectly, dissect valuable organs, remove the bones, and then carry out the heavy load. But Kaziranga offers an alternative. "Rhinos are relatively easy to kill for a lazy poacher," Deka said: a gunshot or two and a few minutes to hack off the two- to five-pound horn before running off with it in a plastic bag. It's literally worth its weight in gold on the black market,

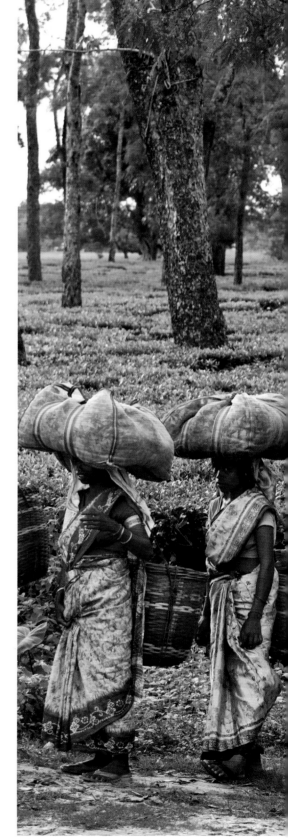

Plantation workers carry freshly picked tea leaves to be processed at the end of a workday. Much of Kaziranga is bordered by tea estates, farmland, and villages; when tigers wander outside the park, conflicts arise. Tigers that prey on livestock are often poisoned with pesticide used on plantations.

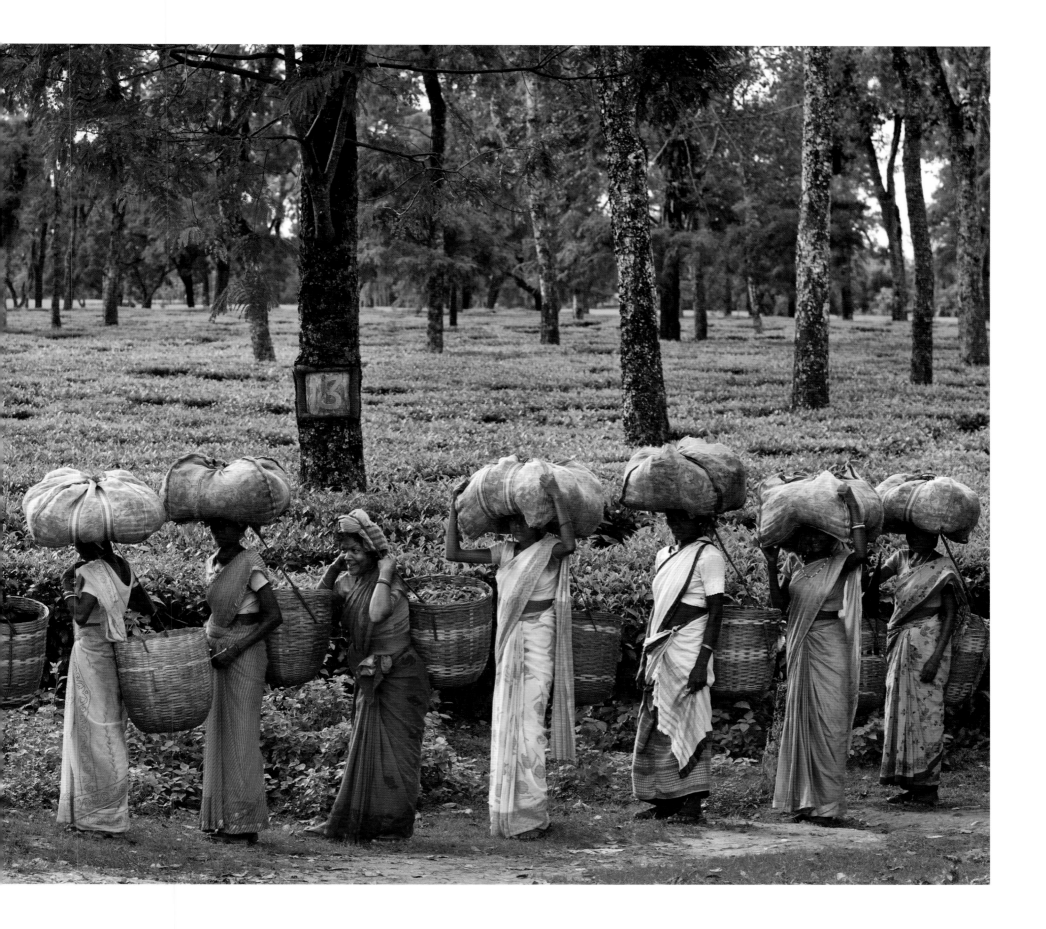

used, like tiger parts, in traditional Chinese medicine—though lab studies have shown it only an ineffective fever reducer: When injected in large quantities, it lowered high temperatures in rats. Yet the quest for horn has brought down about 700 rhinos in Kaziranga over the past 40 years. Wildlife, including tigers, killed in India for illicit trade are usually smuggled overland through Nepal and Tibet or through Myanmar, headed for China.

Deka took me to meet his colleague, range officer Dharanidhar Boro. In his office, Boro fished out a photo album of faded, moldering four-by-six-inch black-and-white photographs, gruesome snapshots documenting what he called "the rhino wars."

This jungle became a killing field during the 1980s and early '90s when a rhino died nearly every week. Since then, a combination of patrols by 562 forest guards, military-style enforcement, and a far-reaching network of informants has slowed the slaughter—though it spiked again in 2012 and 2013. Rangers have killed more than 90 poachers in shoot-outs since 1985, arrested another 600, and confiscated a small mountain of arms, ammunition, and sophisticated equipment supplied by international smuggling operations. Among that cache are Russian-made night vision glasses, AK-47s, and other assault weapons. This is one reason why it's so hard to fight them, Boro said: "We're outgunned." Most guards carry antique .315 sport rifles, a variation on the Lee-Enfield .303s that British soldiers carried while patrolling the Khyber Pass. At least a dozen guards have been killed in the line of duty.

Boro flipped through his photos, reminiscing about his 21 years on the front lines as a ranger. He and his men pose proudly beside piles of weapons. Sullen prisoners hold blackboard slates chalked with their name and the word "poacher." There are pictures of dead rhinos, dead tigers—and dead poachers crumpled on the ground. Many of them are Naga, members of a notorious hunting tribe who have been fighting for independence for more than 60 years. Theirs is a smoldering insurrection funded partially through smuggling of guns and wildlife.

Villagers chase a herd of elephants from their fields. Forested corridors that once connected Kaziranga with nearby highlands are gone, making it dangerous for migrating elephants, dispersing young tigers, wandering rhinos, and other wildlife to leave the park.

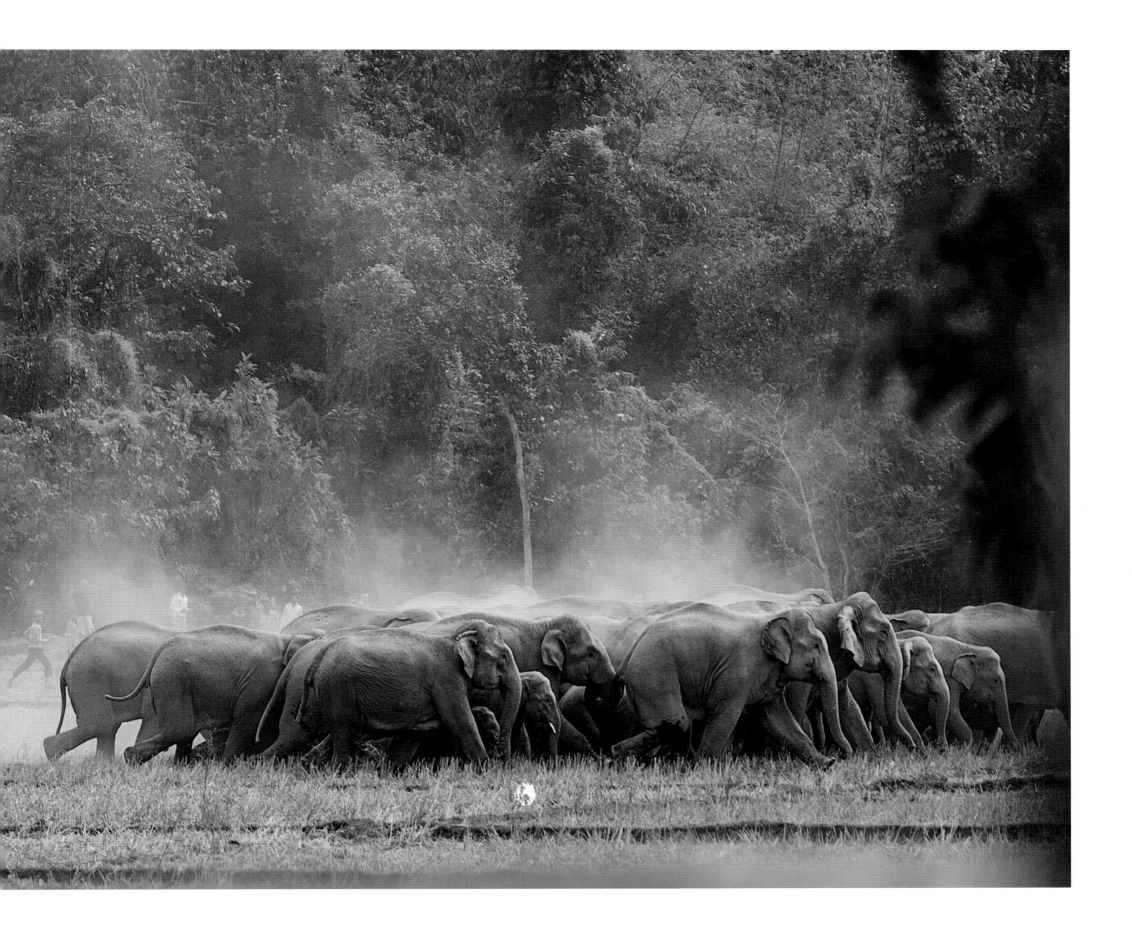

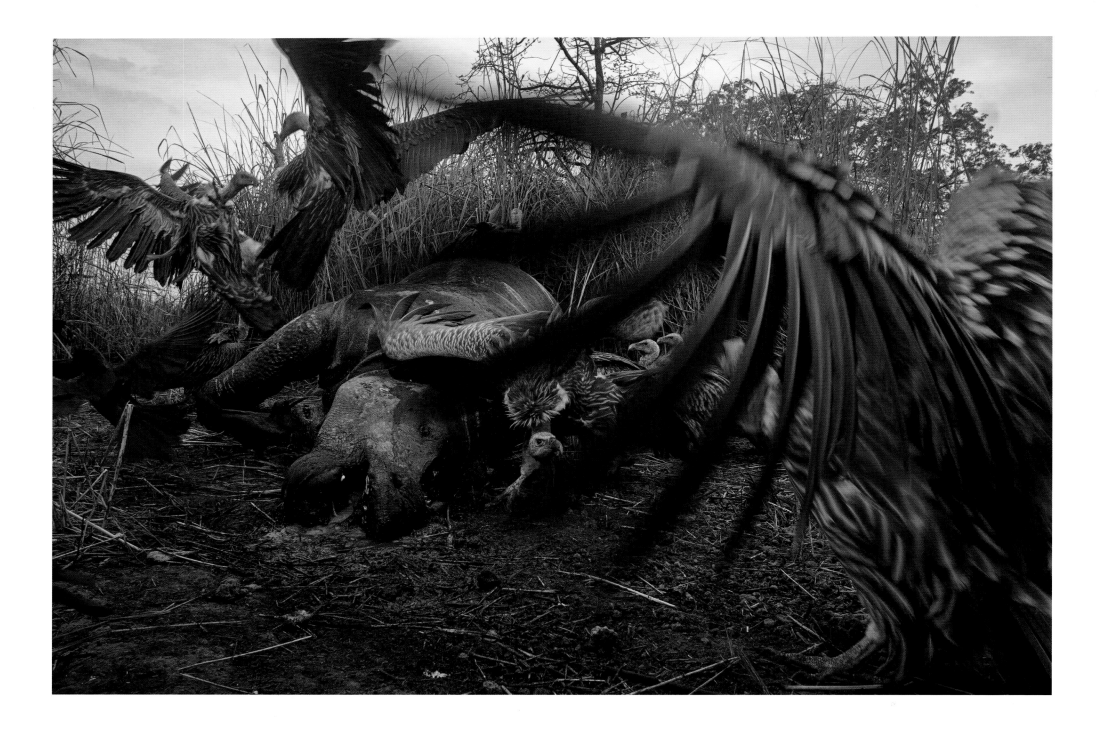

Himalayan griffon vultures feed on a female rhino killed by tigers while giving birth. Park guards removed her horn to prevent poachers from taking it and selling it on the black market to be used in traditional Chinese medicine.

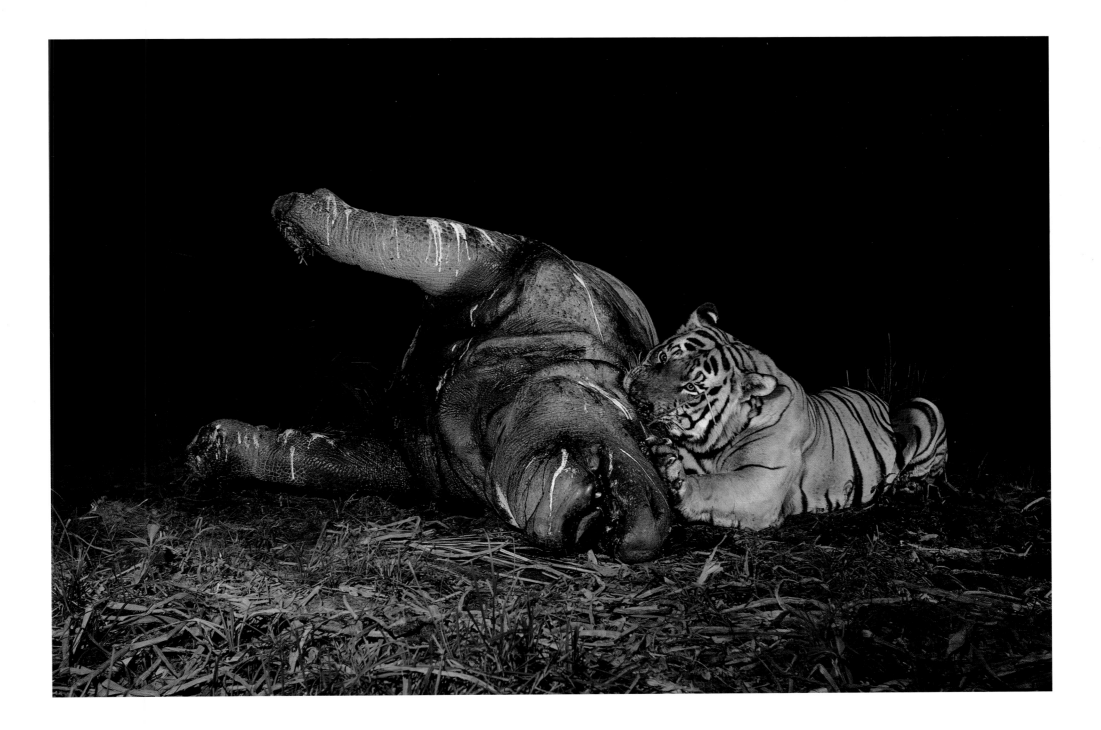

Tigers sometimes feed on carrion. This rhino, killed by poachers, provided a meal for a tigress, her two eight-month-old cubs, and the large male pictured here. Two camera traps set up nearby snapped 428 pictures of this cat in 32 minutes.

Tiger researcher and conservationist, Assam, India

While M. Firoz Ahmed was studying amphibians in Assam, in northeast India, tigers were dying around him. The cats were fighting to the death over limited territory in the 30-square-mile Orang National Park. Sometimes they were poisoned by villagers when they strayed outside and took down a cow. Ahmed approached his colleagues at Aaranyak, the local wildlife conservation group where he works as a senior wildlife biologist. "Why can't something be done for these animals?" he asked.

At the time, no one knew how many tigers were in Assam, where they went, or how much they had to eat. It's crucial baseline science needed

PHOTO: CLINTON S. BROWN

to effectively protect them. So after the next monsoon season, Ahmed was on the ground in nearby Kaziranga National Park, doing reconnaissance. He was planning a comprehensive camera trap tally of tigers and their prey. This lush floodplain, fed by the mighty Brahmaputra River, teems with life.

In 2009, Ahmed and his team installed 100 cameras fitted with flashes and motion detectors throughout Kaziranga and placed 70 more across the river to the west in Orang. They paired the units to photograph both sides of any tigers that passed by. Because their stripes are as unique as fingerprints, this guaranteed accurate estimates. They placed the units inside 30-pound reinforced metal boxes so they'd survive attacks by the elephants and rhinos that regularly stomped them—and checked them daily. They also collected scat and noted territorial scratch markings and other signs of tigers.

Ahmed and his colleagues organized hundreds of thousands of photographs into a massive database on tigers and their prey, the largest of its kind. When they analyzed those images and crunched data, the results were shocking. About 100 tigers live in Kaziranga, a huge number for this skinny expanse that lies sandwiched between the river and the Karbi Anglong hills. It's among the country's largest remaining tiger populations—and they are concentrated here at the highest density ever recorded anywhere, about 28 tigers per 38-square-mile quadrant. "We didn't know so many tigers could live in one place,"

Ahmed says. Here, the cats can live in close proximity to one another without confrontation by hiding in the thick grasses. Wetlands like these are herbivore heaven, nurturing an abundance of the large hoofed animals tigers thrive on. And Kaziranga's military-style armed guards form a strong frontline force against the poachers that usually target rhinos over tigers.

Ahmed has continued camera trapping, expanding the studies into other parks in Assam: Orang and Manas to the west and Namdapha on the Myanmar border. The ultimate goal is to keep these wide-ranging predators from being imprisoned within isolated forests, trapped amid a sea of humanity with nowhere to go. Toward that end, Aaranyak has proposed a protected riverine landscape. It would string together a series of wildlife sanctuaries, islands, and reserve forests that lie between Kaziranga and Orang along the Brahmaputra, giving tigers room to move.

Another focus is to the south. The Karbi Anglong hills provide the only high ground for Kaziranga's animals during extreme monsoon floods. Ahmed has convened meetings with the forest department and a council representing the Karbis, the tribal inhabitants, discussing a possible community-patrolled reserve that would funnel cash back to local people. It's controversial, with much of the backlash coming from hunters. It may take years to sort out, says Ahmed. "But we have to stop forest destruction. We need to work hard to save these areas." ◊

Some photos showed poacher's corpses carefully displayed in front of park headquarters. It's a tactic, Boro said, to deter others. "You must understand, we are fighting a war. If we don't fire, they'll kill us." The guards are empowered by a state-sanctioned shoot-on-sight policy, one of only two reserves in the country with that authorization.

During the five months I spent in Kaziranga, I visited the guards nearly every day. I shared meals with them, joined them on patrols, watched them cook, do laundry, and tend to their patrol elephants. Documenting all of this, I learned how hard their daily lives are. They live away from their families for months at a time, on duty 24/7 in any of 153 isolated, primitive antipoaching camps, housed in wood and bamboo structures with corrugated tin roofs. The structures are perched atop 12-foot cement pillars to protect from wild animals and monsoon floods and the windows have no screens. Each rough-hewn bed is hung with a mosquito net and topped by a bamboo mat. The men lack access to plumbing, and cook over open fires. The only electricity comes from a single solar panel that charges their walkie-talkies.

The guards are up at 5:00 a.m. for predawn patrols, back out at dusk often until 10 o'clock at night, covering many miles, mostly on foot. They are routinely chased, maimed, or killed by the animals they are sworn to protect—while essentially involved in jungle warfare with poachers.

It's a ragtag army, paid a pittance and lacking adequate gear, from threadbare uniforms and 70-year-old rifles that frequently misfire to flickering flashlights and poor footwear. Still, somehow they maintain an improbable dedication. "These animals are like our family," Boro explained. "We protect them from hunters like we would protect our own children." And he added, most of them are willing to die doing it. About a dozen have.

With protection over the last century, Kaziranga's rhinos became a conservation success story, rebounding to 2,290 at last count, nearly three-quarters of all that remain on the planet. Armed protection has also allowed tigers and other species, including their prey, to thrive.

When Kaziranga was named India's 32nd tiger reserve in 2006, funding poured in, including US $1 million in desperately needed federal funds. That money is finally starting to funnel down. Guards will soon carry new automatic weapons and the state plans to deploy both high-powered "electronic eye" cameras and drones to track the movements of people entering the park. No one is allowed to enter on foot. If someone is walking, they're up to no good.

IT'S HARD TO BELIEVE that a century ago this land was mostly unbroken forest, a malarial backwater, its only inhabitants about 15 tribes and the workers brought by colonial enterprises. Today, much of Assam is a patchwork of rice paddies, crop fields, sprawling tea plantations (it's the world's top tea producer), quarries, oil fields, and settlements.

Kaziranga is being squeezed on three sides—east, west, and south—by an encroaching human population. In 1991, about 45,000 lived near Kaziranga; now ten times that number live in some 200 villages, says Assamese conservationist Manju Barua. Many are Bangladeshi immigrants who have planted nearly every scrap of tillable land in this economically depressed corner of an otherwise booming country. Their flimsy bamboo-walled huts lack windows and running water, and families can barely feed their children. At the time of independence in 1947, Assam was among India's richer states. It's now one of the country's poorest, plagued by massive unemployment, yearly flooding that has intensified with a changing climate, and low-grade separatist insurgencies that periodically erupt in terrorist attacks or clashes with the army and police.

The new settlers have eaten away at habitat that once acted as a buffer between humans and wildlife. When tigers come in contact with people, both often suffer. In some places, with one step over the park boundary line, they're smack in the middle of a crop field, pasture, or village. Domestic animals make an easy meal for an old or injured cat or a mom with cubs—and cattle, goats,

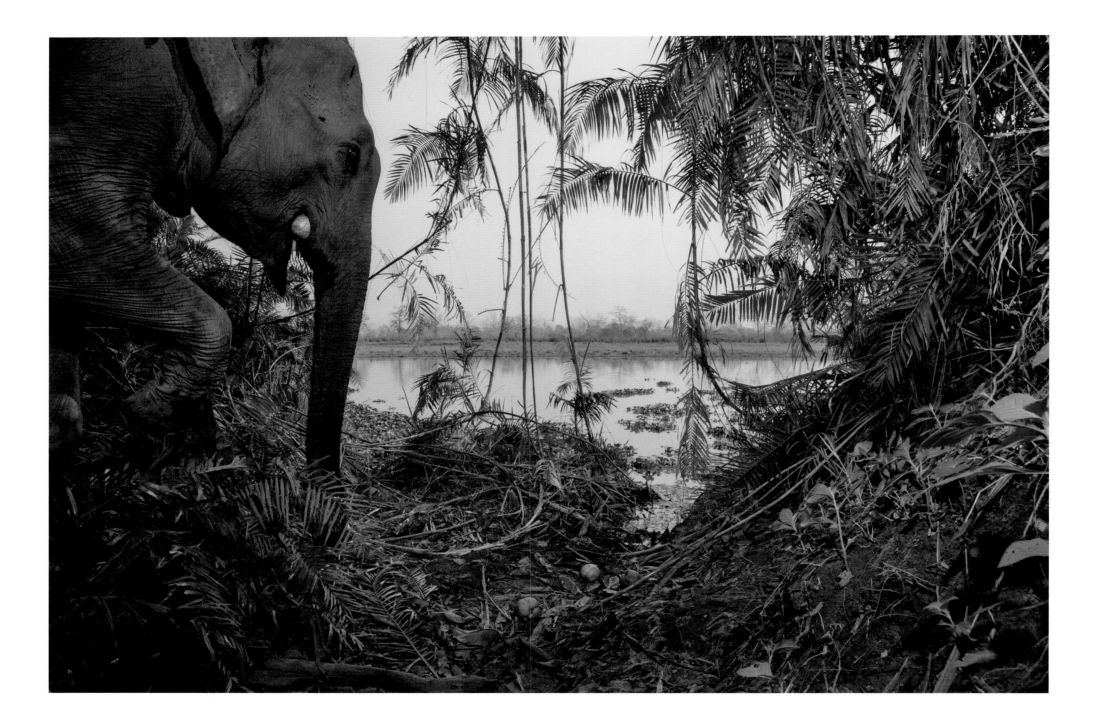

A camera trap captures an Asian elephant eating an "elephant apple." The fertile Brahmaputra River floodplain is a grazer's
paradise, providing perfect habitat for one of India's few remaining large elephant herds. But during monsoon season,
heavy flooding forces animals to flee to higher ground.

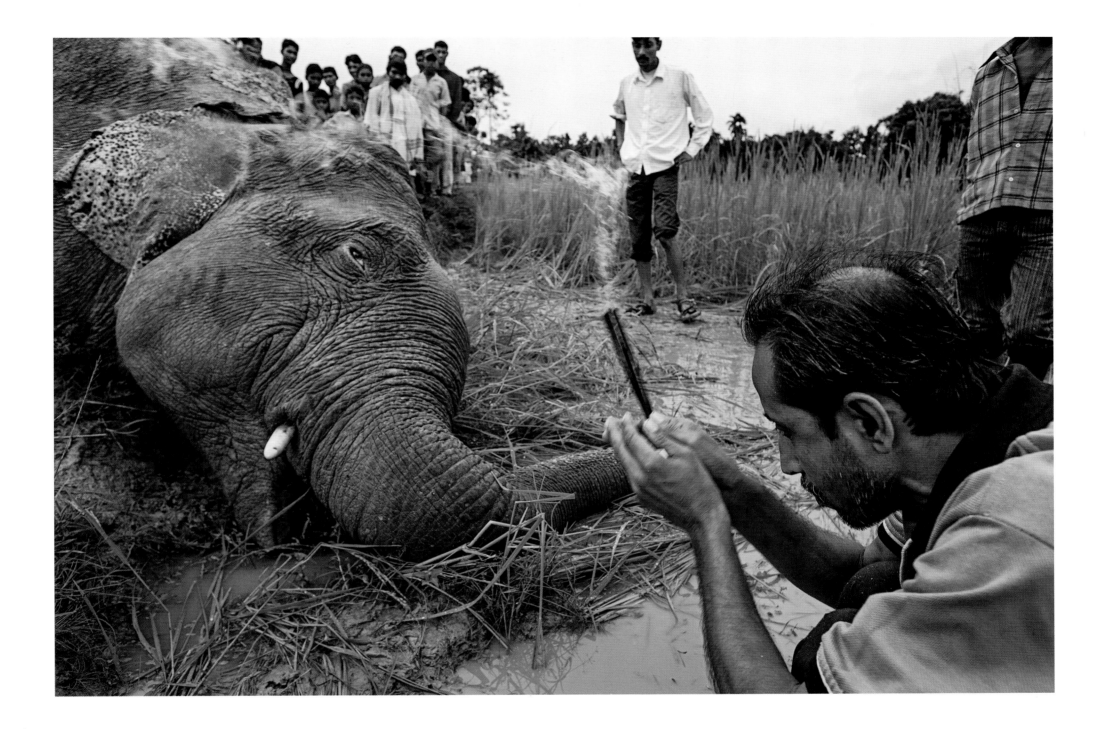

A villager prays over an elephant, a sacred animal in India. Ganesha, half-human, half-elephant, is among the most widely worshipped Hindu gods. This animal was shot with a bullet dipped in acid while raiding a rice paddy near Kaziranga National Park. It later died of septic poisoning.

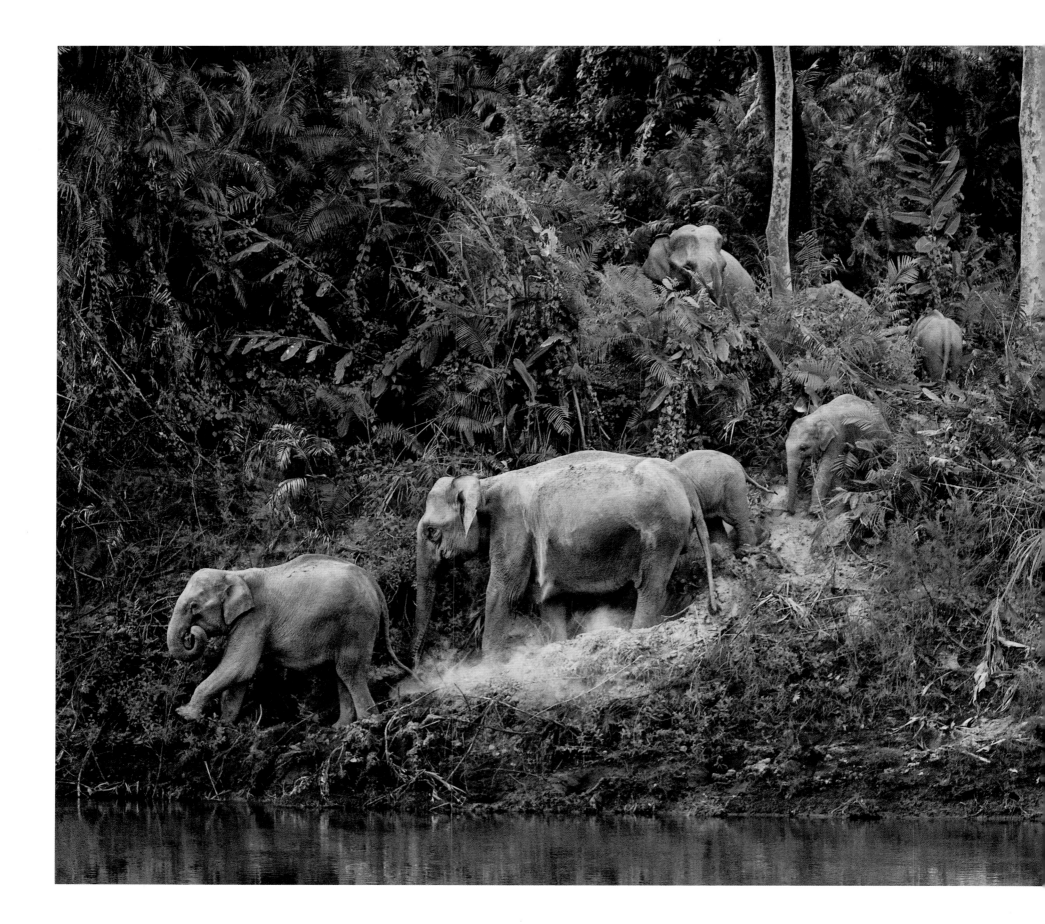

Kaziranga is home to about 1,300 elephants, one of few such refuges left in India. At certain times of year, herds migrate to the nearby Karbi Anglong hills, searching for food or fleeing monsoon floods; the journey is growing more difficult with expanding human settlements.

and buffalo are literally grazing under their noses. It's a huge loss for a family: Milk from domestic animals provides both food and income. Most years, Kaziranga's tigers kill about 150 cows, which is quite low compared to other reserves with less prey. The government pays just $45 for a slain cow though the market price is three times that. Villagers may never receive a rupee. Some kill the offending tiger, usually by poisoning it.

Just after I arrived, I visited a cub that was being cared for at the non-profit Centre for Wildlife Rehabilitation and Conservation. The seven-month-old male hissed and growled as I approached his fenced enclosure with veterinarian Anjan Talukdar. He explained that when a worker at the nearby Hathikuli Tea Estate spied movement beneath some tea bushes, he discovered this cub writhing in convulsions beside his dead sister. A half-eaten buffalo lay nearby, the same animal that the cubs' mother had killed two days before. Its owner retaliated by stealing pesticide from the plantation (where he worked) and lacing his animal's carcass with the poison. When the tigers returned to feed, they ate it. There was no sign of the tigress; the live cub was brought to the center for medical treatment. Anjan tells me that Indian law prohibited his return to the wild. He'll spend his life caged at the Assam State Zoo.

MUCH OF ANJAN'S WORK HAS FOCUSED on conflict between wildlife and humans: Straying animals are the ones he's summoned to save. But tigers rarely leave the park to kill livestock because they have so much else to eat. The problem is space. Kaziranga is a small, skinny strip so stuffed with tigers that they live in far closer quarters than is normal. And because they're territorial, lots of tigers die from infighting. Kaziranga is at full capacity. With 20-plus breeding females giving birth to a few cubs every two years, adolescents need somewhere to go. Anjan told me that tigers were migrating south into the adjoining Karbi Anglong hills. They were hunting on islands in the Brahmaputra and heading north, crossing

the river and the state line into the jungles of Arunachal Pradesh. Anjan told me that I should speak to M. Firoz Ahmed, a wildlife biologist with Aaranyak, studying where the young tigers go.

According to Firoz, tigers could be following a chain of Brahmaputra islands west, all the way to Orang and Manas National Parks and across the Bhutan border into an adjoining reserve. I called Alan Rabinowitz with the news. Since we'd worked together in the Hukawng, he'd signed on as CEO at Panthera, a New York–based wild cat conservation organization launched by entrepreneur Tom Kaplan in 2006 that has since become the world's largest such organization. In a meeting with leading tiger experts, Alan and Michael Cline (a founding Panthera board member) had created a new initiative to address the growing tiger crisis. Not long before I'd come to Assam on this assignment, he'd described their new "Tigers Forever" program. The initiative would focus on tiger strongholds that lie within larger landscapes, partnering with government agencies and other organizations to protect the cats and their prey with strong enforcement while monitoring their numbers. His work in Myanmar had sparked an understanding of the proper spatial scale needed to truly save tigers. On the phone, I told Alan that Kaziranga might be an important breeding "source site." He was as excited as I was, and we vowed to return together.

The problem is that once tigers leave Kaziranga, they're no longer protected. Wildlife crime expert Belinda Wright notes that tigers frequently end up in poachers' hands once they stray from protected areas. These deaths are rarely noticed or reported and are increasing. According to park director Buragohain, the incidence of human–tiger conflict here has been rising in tandem with shrinking habitat.

KAZIRANGA'S WILDLIFE DOESN'T ALWAYS LEAVE the park voluntarily. Floods have always been part of life in Assam, but the combination of deforestation and climate change has made intense flooding the new norm. The summer monsoon lashes the landscape with 80 or more inches of rain. Raging floodwaters from the Brahmaputra and its tributaries engulf the land, forcing rhinos, elephants, tigers, and other species to flee to higher ground. Along the way, some are stranded on the few hillocks that poke above water, some drown, and others are flattened crossing the main east–west highway. Still others are killed by villagers or poachers. During floods, even animals within the park are vulnerable. Enforcement becomes impossible.

This is a dynamic landscape sculpted by the annual deluge. The river erodes considerable chunks of parkland, lakes expand and dry up, tributaries change course, and the grasslands give way to forest. On my second trip to Kaziranga in January 2008, it was hot and dry: burning season. I watched rangers methodically set fire to the tall grasses, creating moving walls of flame in a yearly controlled burn intended to kill off saplings and keep the forest at bay. Within days, delectable new shoots sprouted, fresh salad for the herbivores.

Long-term survival for tigers means that they must be able to move safely into other suitable habitat to breed. The challenge is to keep Kaziranga from becoming isolated, linking up forest remnants as much as possible. Five small "habitat bridges" now connect Kaziranga with Karbi Anglong, and authorities are slowly extending the park's southern boundary toward those hills. That means a number of villages—most of them recent settlers—must relocate as part of a paid initiative that also offers better access to schools and health care. But in 2011, the first eviction notices sparked ongoing protests.

In April 2010, Alan and I traveled to Kaziranga. Our explorations of the park were limited: The monsoon had come two months early and whole areas were underwater. We spoke with local experts and met with Firoz and Aaranyak staff in Guwahati, the state capital. Poring over the maps they had created, it was obvious that tigers were, indeed, moving throughout the northeast. Alan was impressed. Firoz wrote up a proposal, Panthera supplied them with 250 camera traps that have monitored tigers in Manas and Kaziranga for the past two years, and the two groups are brainstorming ways to partner and save Assam's tigers. ◊

TIGERS OF KAZIRANGA

I made the first of my two trips to Kaziranga National Park at the end of the monsoon season. The park was still closed, inundated under flood-waters from the nearby Brahmaputra River. I set up remote cameras to make intimate photographs of tigers, placing them on the few high-ground trails where animals would be forced to walk. Once the waters receded, I photographed from an open jeep and from an elephant back, capturing a tiger hunting elephant calves and tigers stalking through tall grass.

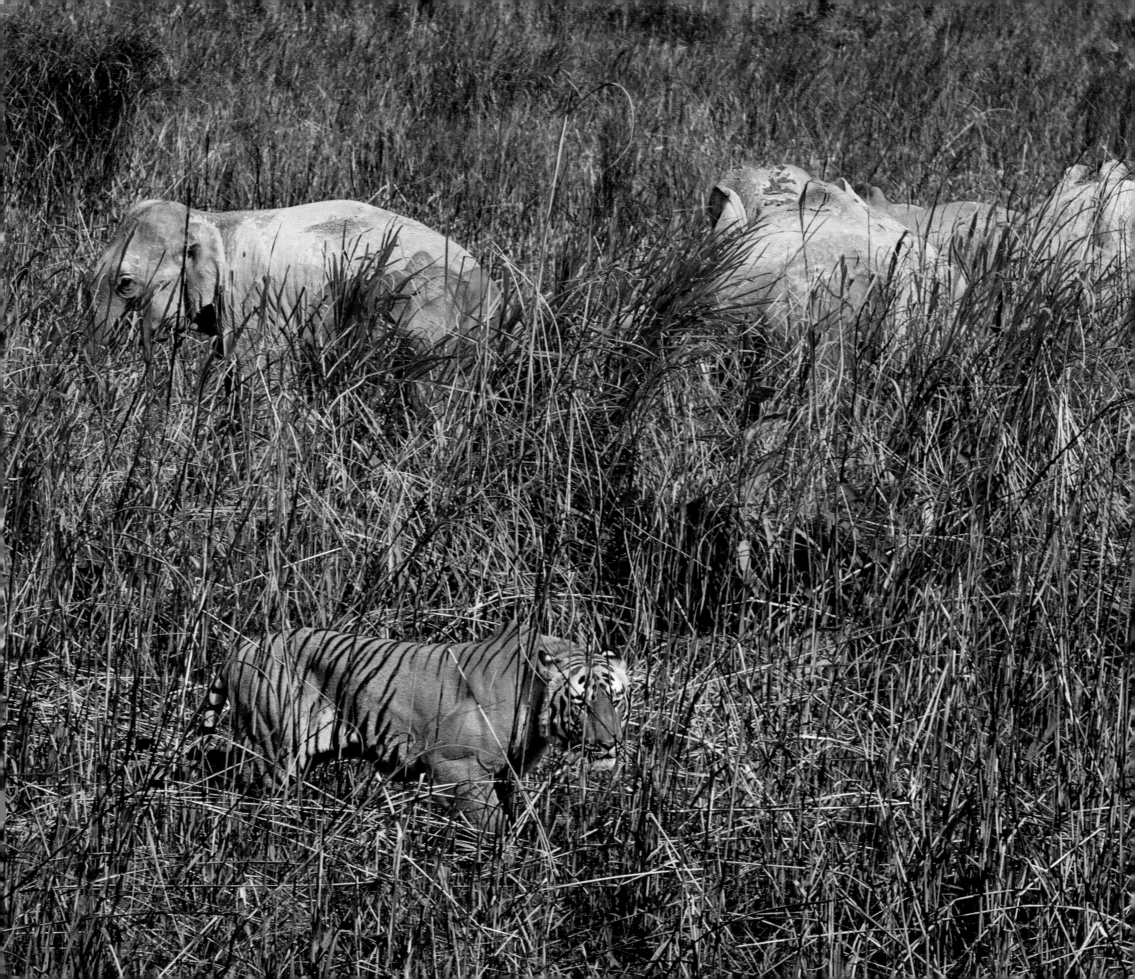

KAZIRANGA'S LUSH WETLANDS host a stunning array of wildlife and provide perfect habitat for tiger prey that includes wild boar, Asian water buffalo, Indian one-horned rhino, and three species of deer. Tigers have a relatively low hunting success rate—about one kill for every ten attempts—so an abundance of large prey allows more time to breed and provides plenty of food for feeding cubs. The park was created to protect the rhinos that were hunted nearly to extinction, and rhinos, not tigers, are still targeted by poachers. Armed frontline protection has benefited the cats that live here in higher density than anywhere in India.

A Bengal tiger stalks an Asian elephant calf through tall grass. With each attempt, the herd circled and protected the young, and the tiger left hungry.

This tiger, who had been sleeping, was startled by park
guards patrolling by elephant. He growled, rose, and
sauntered off into the tall grass.

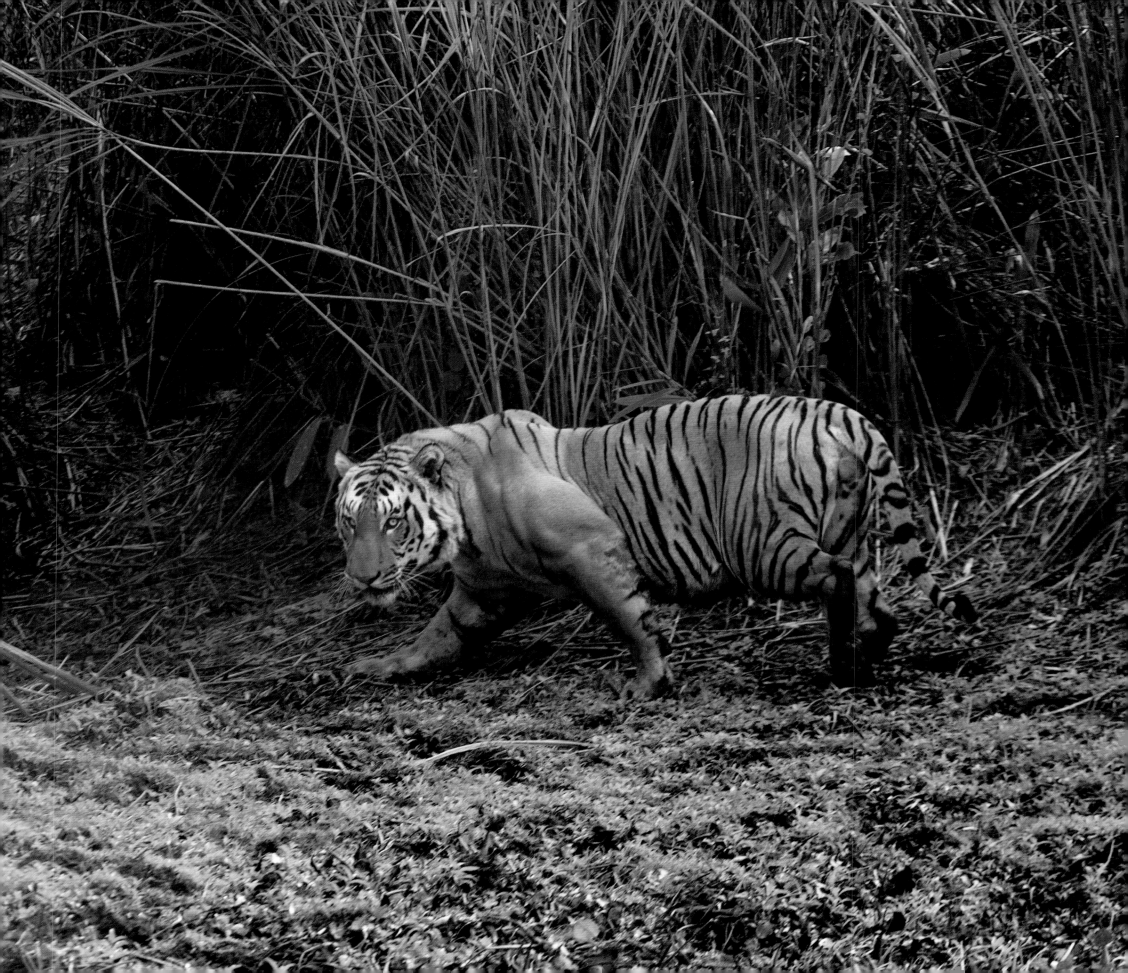

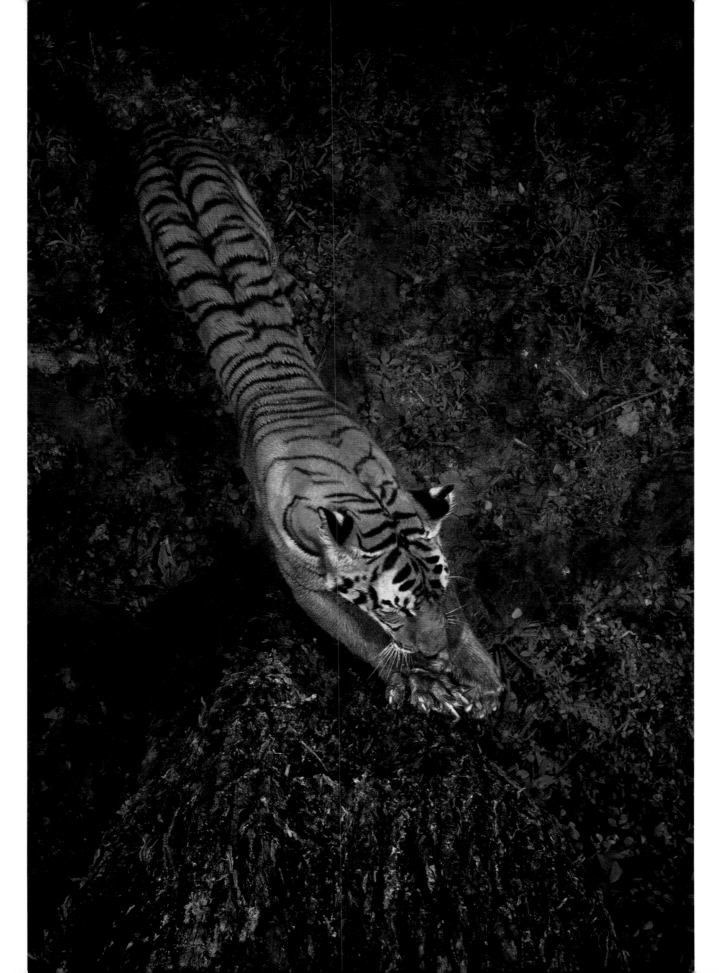

A remote camera
bolted to a tree
15 feet off the ground
captured this image of
a tiger raking long
scratches into the bark,
demarcating territory.

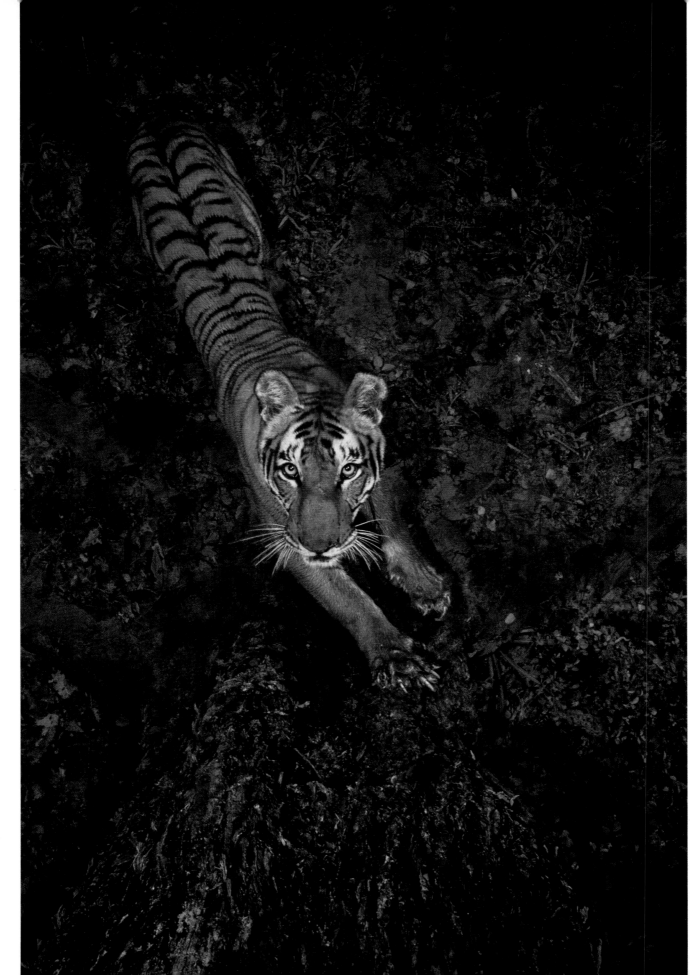

Tigers scratch, spray,
scrape, rub, roll, and roar
to mark boundaries or
advertise their presence,
all to find a mate—or
avoid surprise encounters
that could prove fatal.

A male tiger triggers a camera trap while hunting at the end
of monsoon season. At that time of year, flooding restricts
animal movements to a few high-ground passageways
that link dry areas. Muddy trails made it possible to track
tigers and locate places to set up remote cameras.

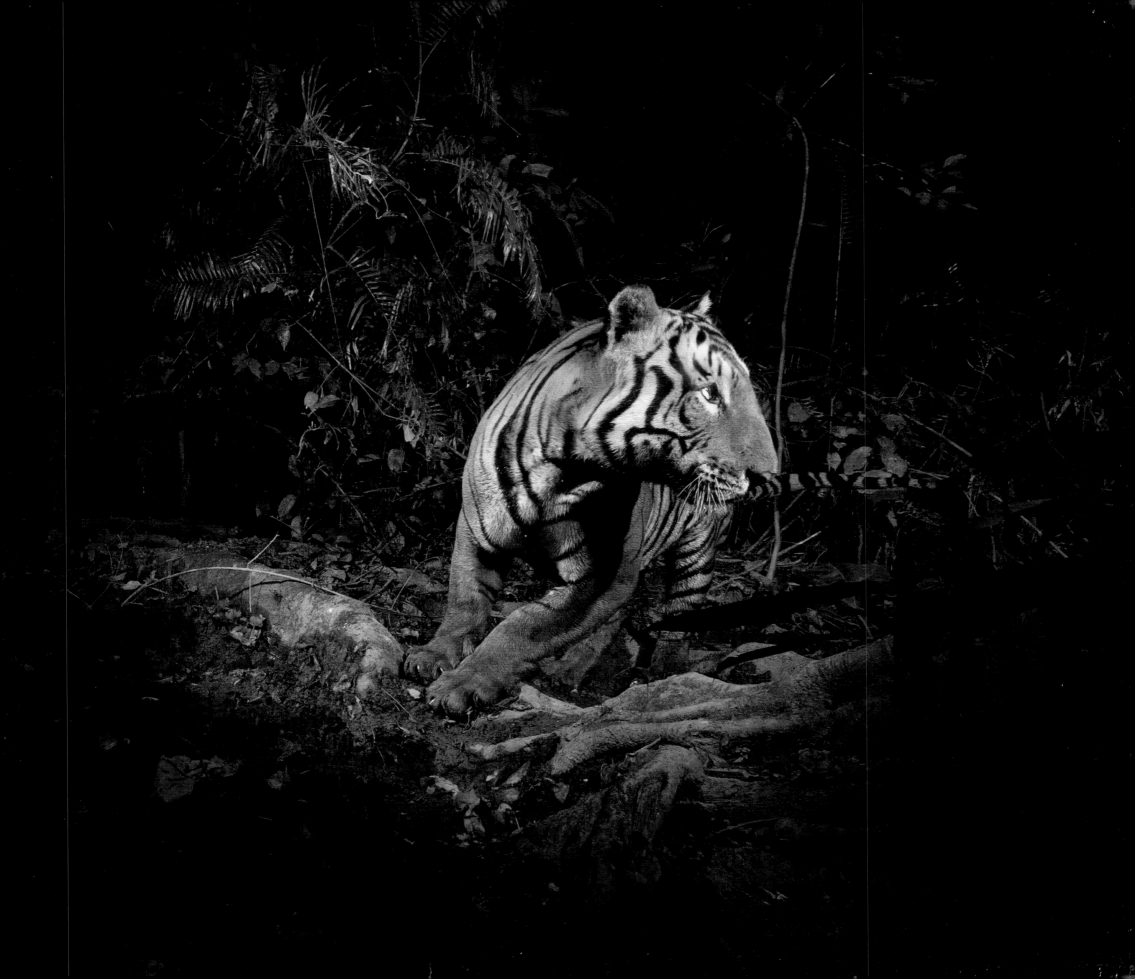

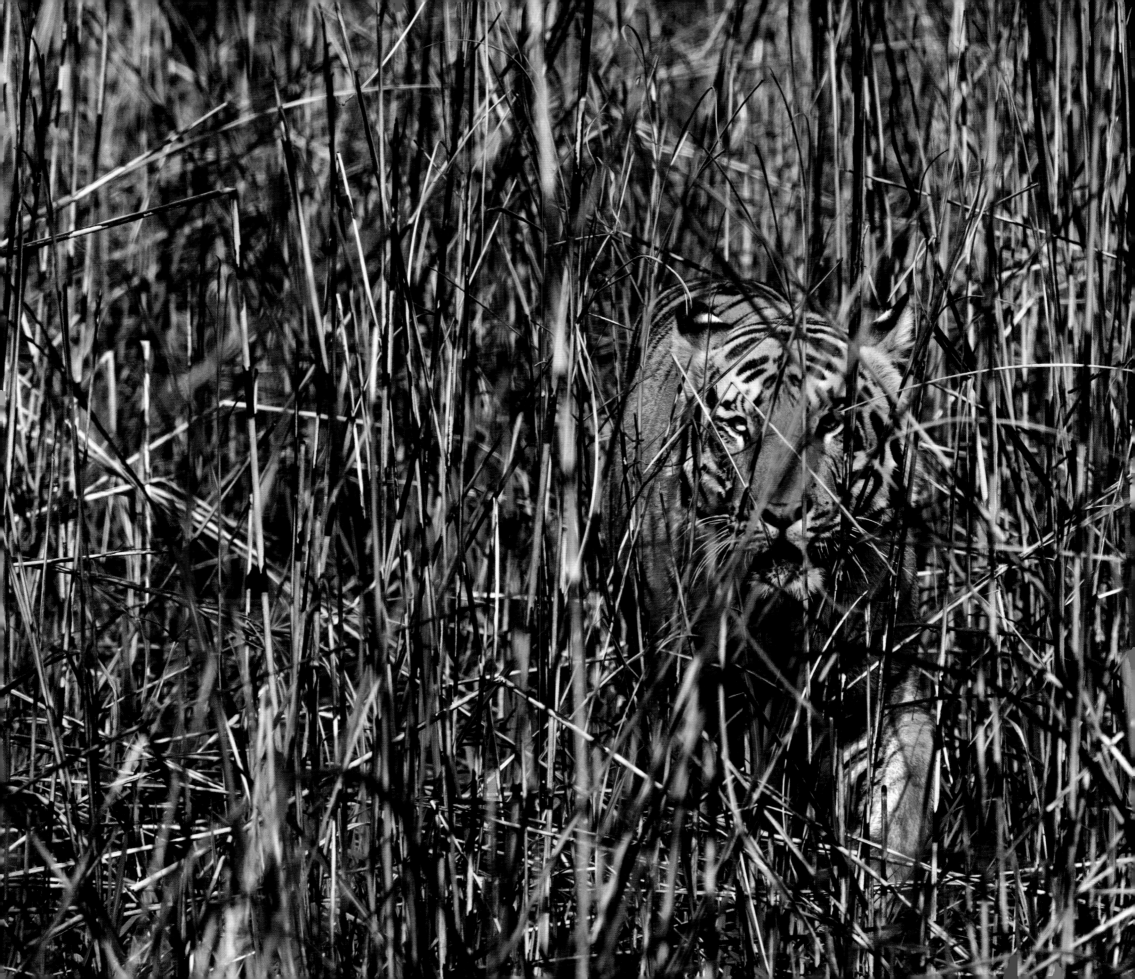

A tiger stalks through elephant grass, nearly invisible.
Tigers are stealthy ambush predators that rely on the
camouflage their stripes provide.

WHEN I FIRST REQUESTED permission to set up camera traps in Kaziranga, the park director wouldn't allow it: He said it was too dangerous to spend hours on the ground rigging up equipment. After some convincing, I deployed 14 units throughout the park. I chose locations along heavily used wildlife trails and places where we discovered fresh pugmarks or hoofprints tracked into soft mud. But I needed special dispensation from the park director to place a trap in grass-lands like those in this image—and I needed protection from four armed men.

A camera trap captures a young male tiger in elephant grass.
As the camera and flashes continued to fire, he looked from
side to side, slowly backed away, and disappeared into the
reeds. It took a month to get this image.

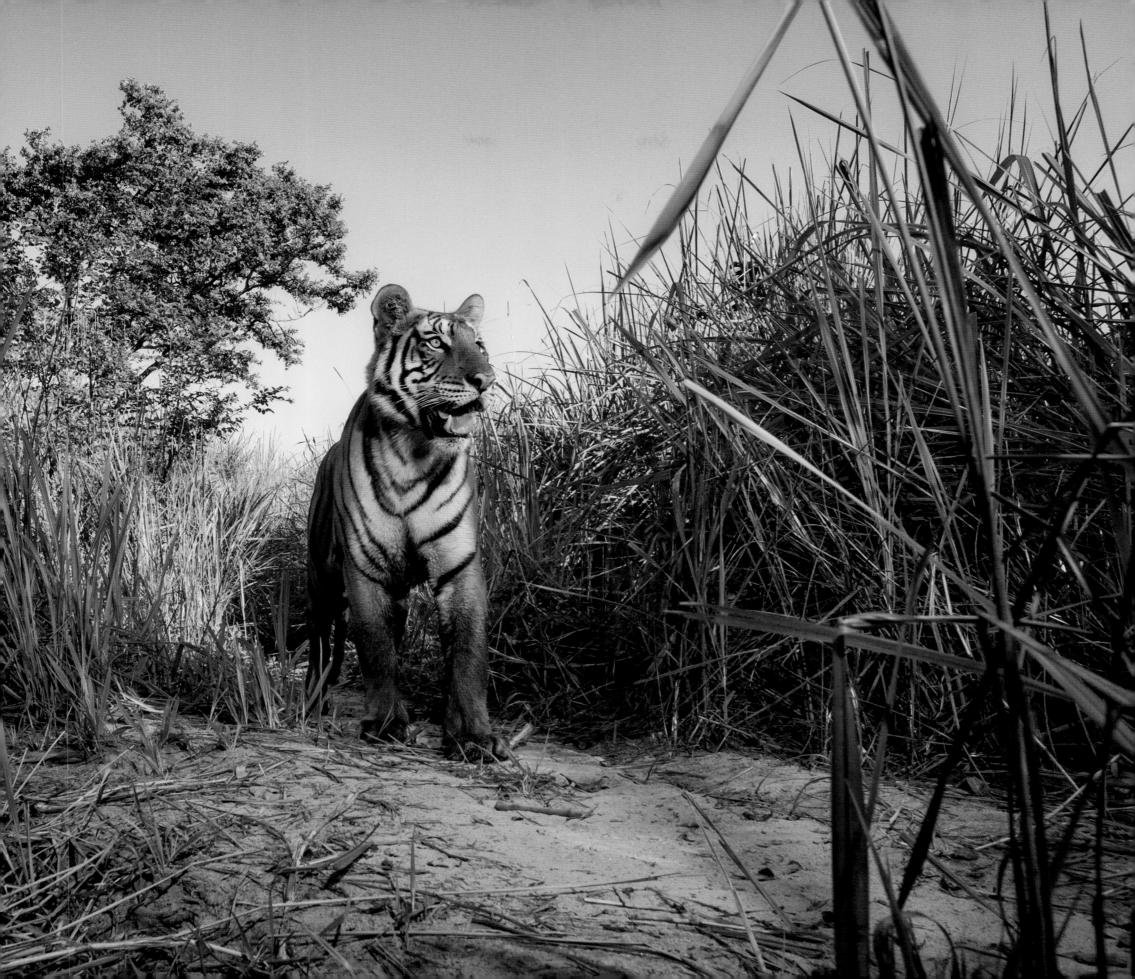

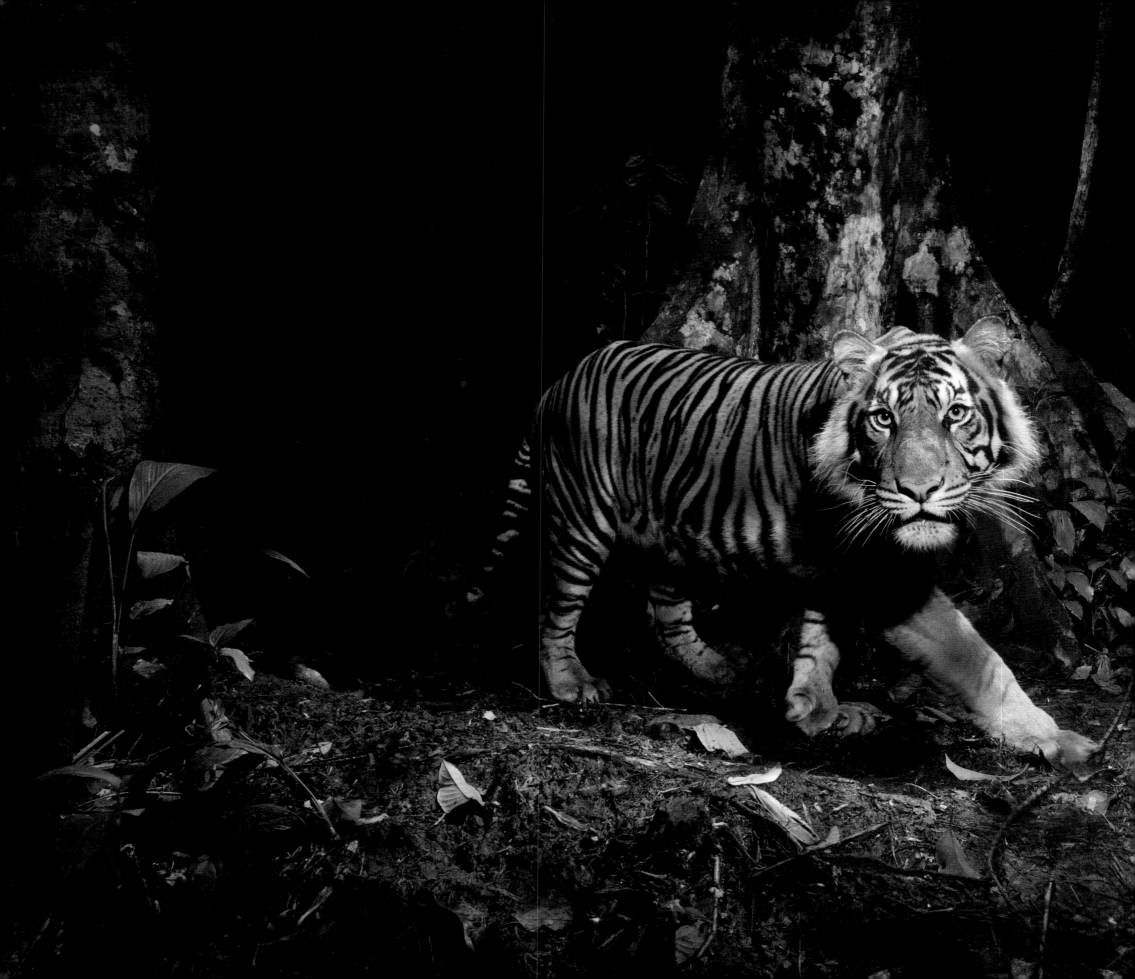

WITH SUMATRAN TIGERS

A tiger peers at a camera trap it triggered while night hunting in the
forests of northern Sumatra, Indonesia.

In July 2009, I headed to Sumatra to begin a *National Geographic* story on tigers and the threats they face. One of the big problems was obvious before I'd even stepped foot off the plane. On the flight from Jakarta to the northern city of Medan, I flew over much of this huge volcanic land that straddles the Equator just off the southern tip of mainland Indochina. Swaths of unbroken rain forest poured down the volcanoes and cloaked the mountain spine that runs the length of the island. But a patchwork of crop fields and plantations engulfed much of the lowlands. I knew that finding the shy, elusive Sumatran tiger wouldn't be easy in such an intensely human-dominated landscape. Under the best of circumstances, they are rarely seen; in fact, most existing photos and film footage are images of captive animals. I needed pictures from the wild.

Sumatra separated from mainland Asia between 6,000 and 12,000 years ago as sea levels rose and the Pleistocene gave way to the Holocene. The subspecies created by island isolation, *Panthera tigris sumatrae,* is the smallest among tigers, differentiated from the others by a distinctive white bearded mane, a darker rust-colored coat, and a profusion of thicker black stripes. The cat's unique genetics have sparked debate over whether it deserves its own species classification. But for now, it's still grouped with *Panthera tigris,* along with its mainland "cousins."

This magnificent cat is the last of Indonesia's three tigers. Both the Javan and Bali tigers have been lost forever; none are even left behind bars in a zoo. The Sumatran tiger faces a murky future: Intense poaching threats and relentless assaults on its forest home raise serious concern about the cat's ultimate survival. In 1996, the International Union for Conservation of Nature (IUCN) listed them as critically endangered—the last category before extinction in the wild—and lists their "population trend" as decreasing.

Nobody knows how many there once were. At the dawn of the 20th century, Dutch colonists described them as a "plague," so many and so bold that they sometimes entered plantation owners' estate compounds. How many are left is also unclear. The current estimates were conjured back in 1994, a time when fieldwork in Sumatra was still in its infancy. There was little data, and species conservation still ranked low on the government's priority list. A group of people from various nongovernmental organizations (NGOs) sat around a map and essentially guessed how many tigers were on different parts of the island. They based their guesstimates on remaining habitat and average densities in that type of ecosystem, ultimately settling on "400 to 500." Since then, that number has been repeated as gospel by biologists, governments, NGOs, and the media. "In reality,

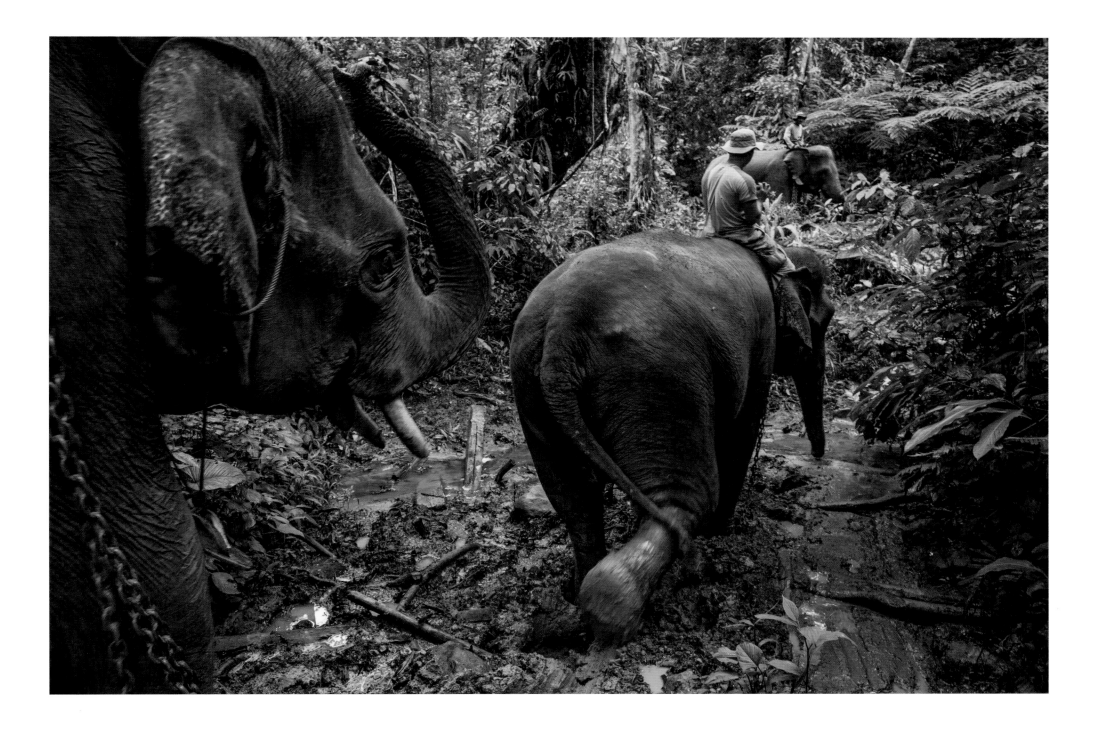

Community rangers patrol the jungles of northern Sumatra's Ulu Masen Forest Complex; 380 former poachers and loggers use their extensive knowledge of the forest to thwart illegal activities and protect wildlife.

we really don't know how many tigers survive on Sumatra," says Joseph Smith, director of Panthera's Tigers Forever program.

To find out where tigers were, nine conservation organizations partnered with the Indonesian Ministry of Forestry in 2007, embarking on a two-year, island-wide survey—the most comprehensive ever done. Researchers divided the island into quadrants about the size of a male tiger's home range. Then they searched for signs of the cats, mapping their presence—and absence—from Sumatra's sea-level peat swamps and the alpine wilderness ringing 12,000-foot Mount Kerinci to a huge block of jungle in the far north.

The team was surprised by the results. Tigers were far more widespread than they'd thought and were discovered in unexpected places. "That gives us hope," said Smith. The survey highlighted the urgency of their work, pinpointing areas most in need of protection. Eight of the world's 42 known breeding populations are here. Recently deforested areas were essentially devoid of tigers, like the southern province of Riau that offered a sobering example of what happens when the land is essentially stripped bare, covered in plantations.

The exercise encouraged collaboration among organizations that hadn't worked closely in the past. That's been a major problem: Many talented people are working hard across the island without a coordinated strategy. As Alan Rabinowitz constantly reminds me, tiger conservation cannot be done piecemeal: All threats need to be addressed simultaneously or tigers end up without a place to live, food to eat—or they end up dead.

So how many tigers are there in Sumatra? They're very difficult to count, especially in the rugged, island-long Barisan Mountain chain that provides the largest areas of habitat. It's a tenuous, fragile population, but some believe there may be as many as 700 Sumatran tigers left, or even 750, making it the second largest remaining subspecies after India's Bengal tiger. "We may be fighting the battle for a larger population than we originally thought," says Smith.

Though huge swaths of wilderness remain, Sumatra has lost 48 percent of its forests since 1985, leaving a fragmented patchwork. Without safe forest corridors connecting breeding populations, young tigers setting out to establish their own territory face an uncertain future.

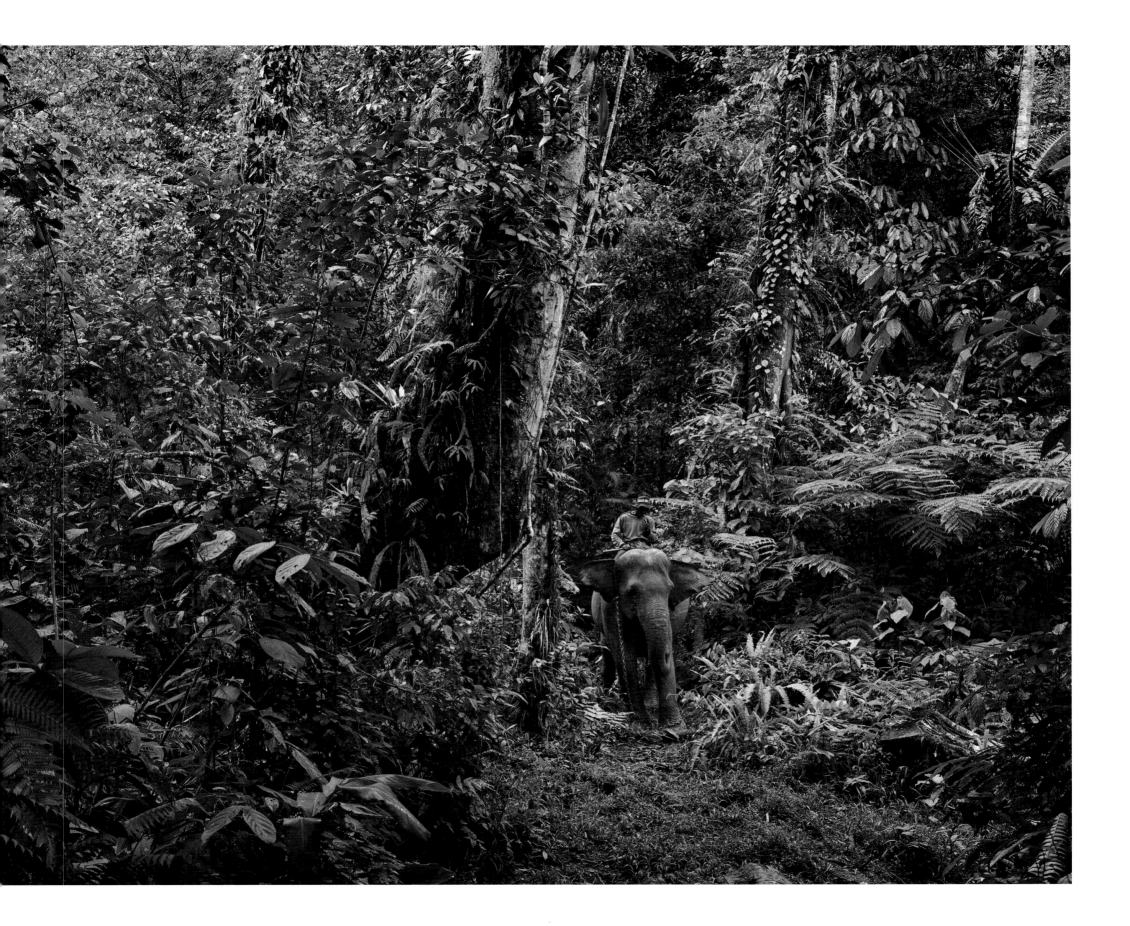

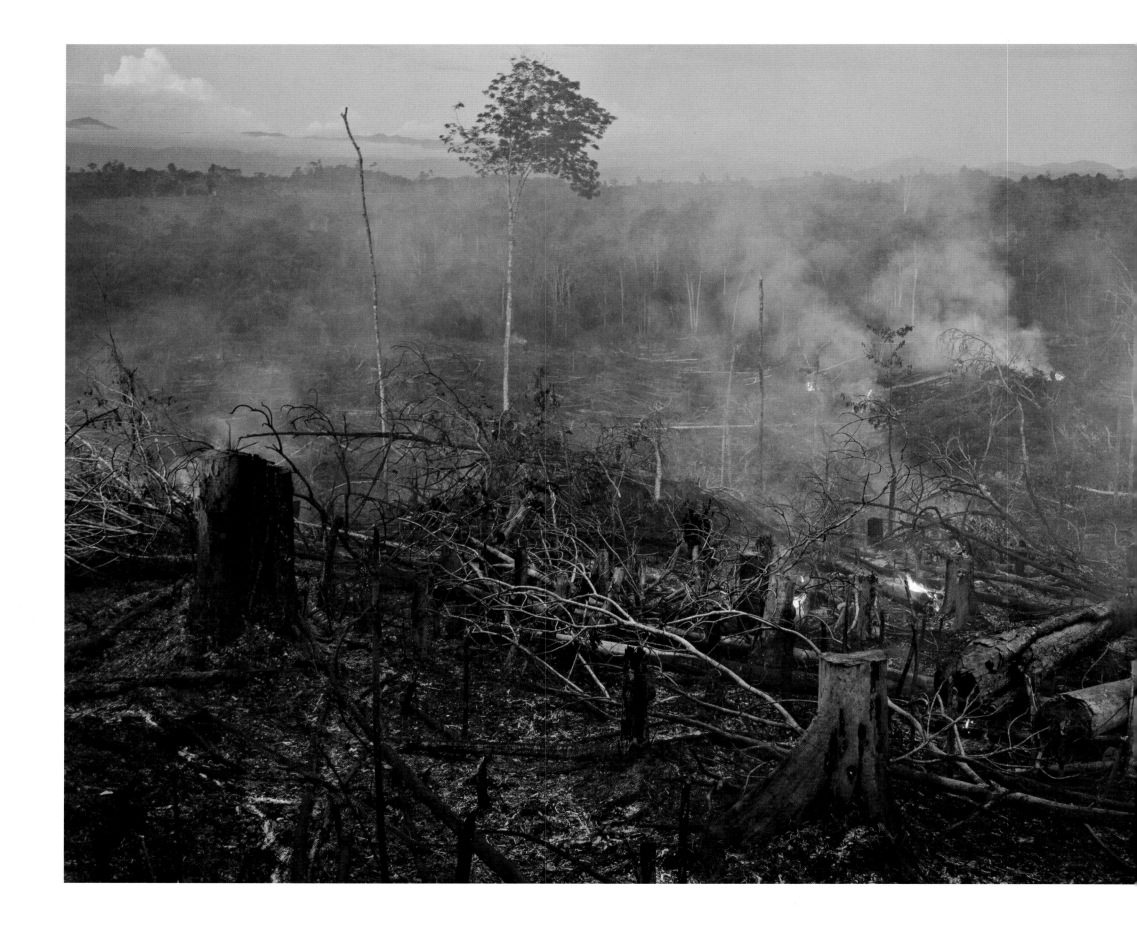

Across Sumatra, tiger habitat is being razed for industrial-scale plantations and for small plots doled out to new settlers as part of a nationwide government relocation scheme.

WHEN I ARRIVED IN MEDAN in the summer of 2009, I didn't know that I'd hit the ground running. Munawar Kholis, a veterinarian who was then working with the Wildlife Conservation Society's (WCS) Wildlife Response Unit, met me at the airport. He'd just received news, a text, that someone had been arrested trying to sell a tiger skin. We threw my 18 bags and cases into a van and drove directly to the Medan offices of SPORC, the country's elite forest police unit. The officers on duty showed us the skin of a young tiger they'd confiscated in an undercover operation. Its desiccated head was misshapen, the skin crudely processed. If the seller was convicted (with solid evidence, they always are), it could mean jail time and a hefty fine under the country's tough Conservation Act of 1990. First offenders rarely get less than two years in prison.

But despite strict laws, Kholis informed me that poaching is rampant. There's a long-standing domestic market for tiger parts that are used in folk medicines and collected as talismans, trophies, or curios. Tiger skins are sometimes bestowed upon high-ranking military officers or police by junior personnel trying to climb the ladder—or businessmen closing major deals. Tigers are also coveted as prestigious pets. Throughout Indonesia, owning a rare, protected species is a status symbol, marking sufficient power and influence to circumvent federal laws.

Some tribal groups still hang on to ancient beliefs that tigers hold magical powers. They wear the tiger's three-inch canines for protection and use whiskers to shield against malevolent curses. Tiger skin is thought to safeguard against black magic, and sorcerers use the skin to cast spells on others.

But the tendrils of the trade reach far beyond Sumatra's shores. According to customs import records, Indonesia was a leading global supplier of tiger bone from the mid-1970s through the early 1990s. One example comes from South Korea. More than half of their imports came from Indonesia during that period, 8,201 pounds in all. That adds up to the bones of some 500 tigers. Indonesia, however, shows no record of tiger exports from 1979 on. That's when it signed on to the Convention

**Director, Tigers Forever
program, Asia**

Five years studying the small, fragile tiger population that moved between plantations, logging concessions, and wildlife sanctuaries in Sumatra's Jambi Province taught Joe Smith some hard lessons. Cats there in 2003 had disappeared by 2005: They hadn't moved on, they were dead. In those jungles, chain saws shrieked, the air was smoky from slash-and-burn agriculture, and, Smith says, "Hunting snares seemed to sprout everywhere."

From 2007 to 2008, Smith surveyed heavily developed areas as part of a larger island-wide effort to identify where tigers remained. Though few were found in newly deforested areas, tigers proved more widespread than expected and the study identified key sites needing protection.

After a brief stint in England completing his PhD, Smith returned to Sumatra in 2009 to work with Panthera supporting the Tigers Forever program. He collaborated with Hariyo Wibisono of the Wildlife Conservation Society to protect and monitor tigers in prime breeding areas of the vast northern forests. They built a strong GPS-based data collection system now used by community rangers on patrol with software that pinpoints threats.

The next year, his focus expanded across tiger range. He now scours Asia for potential new Tigers Forever sites. He's searching for places "where we have a reasonable chance of maintaining a breeding population over the long term, areas with enough tigers, space, prey, strong enforcement, and willing partners to kick-start tiger recoveries."

In northeast India, he's investigating three parks: Kaziranga, Namdapha, and Manas. His recon there has required interviews with tribal communities and camera trap surveys that count tigers and prey with their NGO partner, Aaranyak. Manas Tiger Reserve is a strong candidate. It forms a significant piece of tiger real estate, and connects to Royal Manas National Park across the border in Bhutan. Other promising options include grasslands and forests that

straddle the Nepalese-Indian border and Malaysia's southern jungles.

Working in Thailand's Salak Phra Wildlife Sanctuary would expand an Indochinese tiger stronghold, Huai Kha Khaeng. It's part of a larger plan to establish "spillover" areas for young tigers to disperse into, creating new "satellite" sites.

Smith also works with existing project teams to hone law enforcement and wildlife monitoring. One of those, Kerinci Seblat National Park, is protected by a slick multi-agency patrol team launched in 2000 by Debbie Martyr of Fauna & Flora International. Smith wants to help focus thinly spread patrols on two or three well-defended core breeding sites. Here and elsewhere, they'll bring in law enforcement specialists from outside the wildlife domain to offer advice and support for teams on the ground.

The ultimate plan is to establish a network of protected core areas in huge parks across Sumatra and elsewhere: Without this, it's impossible to effectively police such massive landscapes. "Because tigers naturally live at low densities, we need multiple core areas in these big parks to protect them over the long term," says Smith. Part of that strategy is to cluster these areas so the occasional tiger can move between to share genes, even if that means passing through a patchwork of plantations, jungle, and villages under the cover of darkness.

"Resources need to go into the breeding populations at this stage of the game. We must lock down those sites," he says. ◊

on International Trade in Endangered Species of Wild Fauna and Flora (CITES), which prohibits cross-border commerce in rare animals.

Medan, the country's fourth largest city, is a hub for both domestic and international wildlife trade. It's situated within striking distance of the northern Leuser-Masen forest complex, one of Sumatra's largest tiger strongholds. It's also not far from Singapore, which lies to the southeast across the Strait of Malacca. Singapore has historically been one of the region's major tiger smuggling centers. Evidence from TRAFFIC, a wildlife trade-monitoring network, documents tiger parts illegally imported there from Indonesia and reexported to China and other parts of Asia. Huge shipments of tiger products have also come from China; one report tracked import of more than 26,000 vials and bottles of traditional Chinese medicines and tonics in 1991-1992.

Efforts by Asian governments and conservation organizations during the 1990s beat back the bone trade, but Sumatra was singled out as a place where it continued fairly undeterred and pretty much out in the open. Since then, it's grown into a shadier, more surreptitious—but very active—enterprise. Undercover investigations, with tips from local informants, offer the only glimpses into the scale of the trade. "Poaching is always going to be an issue," says Matthew Linkie, a program manager with Fauna & Flora International (FFI).

Direct hunting is responsible for the majority of all Sumatran tiger deaths, but there's a new and worrying development, says John Goodrich, senior director of Panthera's tiger program. There have been reports of Chinese and Vietnamese nationals tiger shopping in Medan and South Sumatra, looking for the next source as commodities of Indochinese tigers dwindle on the mainland. Up until now, poaching has been a local game. But foreigners moving in spells trouble.

I SPENT MY FIRST WEEK in Sumatra touring communities in the north with Kholis, who was working with locals to preserve their forests and wildlife. He sat down with farmers and projected environmental films on the sides of buildings at night. He met with local leaders, urging them to call him if they encountered problems with tigers. In some Sumatran villages, people coexist with tigers relatively well. The cat still holds a revered place in their cosmological framework as village guardian, vessel of an ancestor's spirit, or arbiter of justice that punishes those who break cultural rules.

Then I flew to Thailand for an international tiger meeting. I promptly regretted the decision. A few days in, Kholis sent me an email: A five-month-old male cub had been caught in a wire snare in Sikerabang, a small village in the north.

I would be photographing a tiger within days, but the pictures I'd be taking were far from the lyrical images I was hoping to make of this animal in its jungle home. I returned as quickly as I could on hops from Bangkok to Kuala Lumpur to Banda Aceh, at the northernmost tip of Sumatra. By then, Kholis had driven 18 hours on horrendous roads to Sikerabang and had arrived in time to save the cat. He sedated the small cub with a tranquilizer gun and then removed the wire from his mangled right front paw, doing what his mother had been unable to. The tigress had hovered nearby for the three days her baby was trapped, unable to extricate him.

Kholis loaded the cat into the car and drove 20 hours to Syaih Kuala University in Banda Aceh. There, he and a veterinary team operated. They were unable to save his leg. The next day, en route to the regional Forestry Ministry offices where the cub would recover, he chewed out his stitches.

I met up with Kholis at the ministry. The compound was littered with small cages containing animals that had come in conflict with humans, animals that would live out their lives in captivity. I walked past three cages holding sad-looking sun bears and a tiger that had already been there for three years, living in an enclosure not much longer than she was.

The terrified cub crouched in the furthermost corner of his cage as I approached, hissing and growling until Kholis anesthetized him using a dart and blowgun. The team rigged up a makeshift operating room in an

office where the surgeons resewed his stitches. I photographed the whole thing. They were very hard pictures to make.

He survived. Two months later, a young female snared in the same region wasn't so lucky. She died on the operating table. Kholis was able to release another cub that was stuck inside a stable and reunite it with its mother.

Once he recovered, the cub was shipped to Taman Safari Indonesia, a zoo that houses a few tigers with permanent injuries. They've started a "frozen ark," cryogenically preserving Sumatran tiger sperm in liquid nitrogen. It's a supposed genetic insurance policy for an uncertain future. However, Alan described the reality of what he'd seen when he visited: The "frozen ark" is a small, sparse room attached to another room filled with stuffed animals. Staff told him that the power had gone out several times and they weren't sure if their specimens were any good.

KHOLIS AND I RETURNED TO SIKERABANG to explore why this had happened. Most of the area's residents were transplants who had come as part of a long-standing "transmigration" program. It's an ongoing initiative that dates back to 1905, transporting residents of Java and other overpopulated islands to Indonesia's forested outer islands—especially to nearby Sumatra, the second largest island in the archipelago. According to government tallies, the program had resettled five million people by 1989, with at least two to three times that many moving on their own. A series of World Bank loans between 1976 and 1992 facilitated the process. That support was later condemned by a consortium of conservation organizations as one of the World Bank's "Fatal Five" projects with the most egregious environmental impacts.

This village served as a perfect example why: whole chunks of forest were gone and animals were scarce. Some residents had been there for years, others were newcomers, but all had been lured by the government's promise of 12 acres of farmland. Upon arrival, they cleared their plot, used

Villagers bathe and swim in a river in South Aceh against a backdrop of palm oil plantations. Indonesia is the largest palm oil producer, pumping out 18 million tons in 2012.

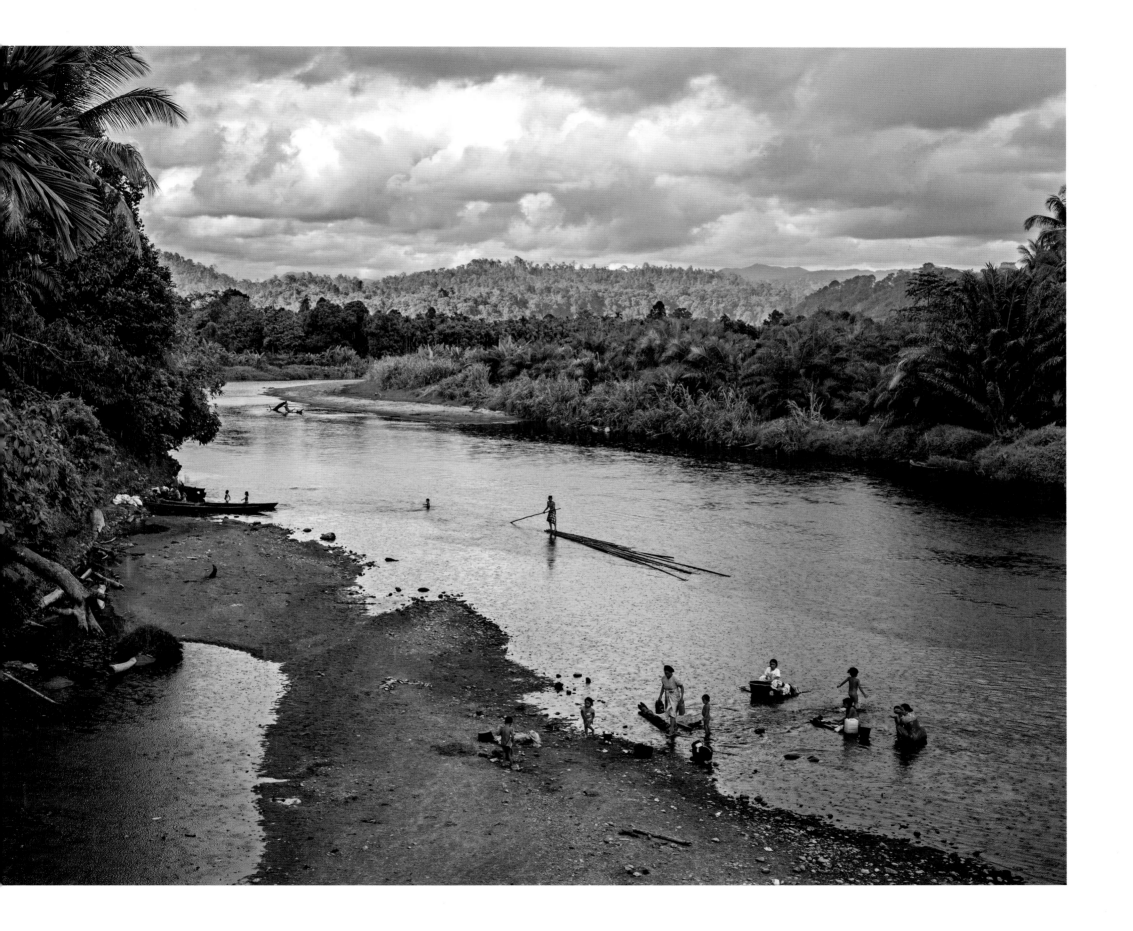

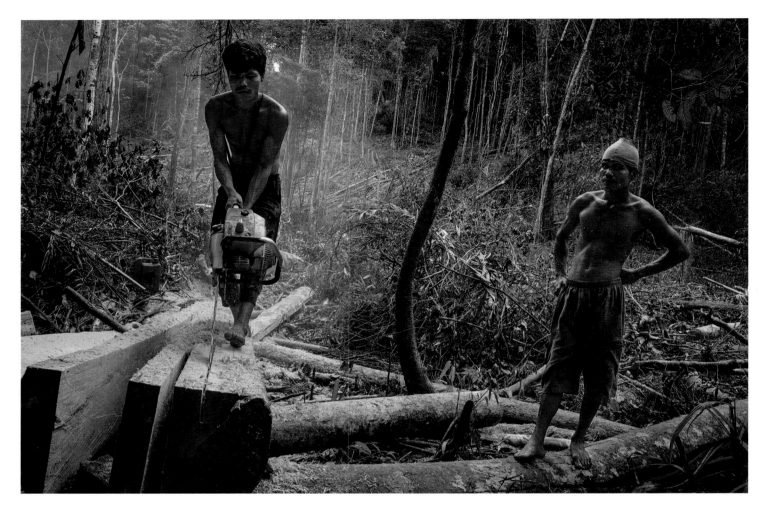

A resettlement program to relieve overpopulated Java provides families with land on Sumatra. Above, Bahardi and Idek Gajah clear their newly acquired plot to plant oil palm. Below, a man loads palm oil fruit harvested from a small-scale plantation.

some of the lumber to build their homes, and sold the rest. Then they planted crops or oil palm trees. Until their first harvests (which for some crops, like palm oil, could take five years), some labored on large farms or plantations for pitiful wages, but all had lived off the land and most still did to some degree. Everywhere we walked, we found fields and forests littered with snares set for small animals and deer. In crop fields, they doubled as pest-control devices rigged for wild pigs and other crop raiders. Kholis said it was far worse on industrial plantations where the land is literally mined with snares.

These traps are indiscriminate, catching anything that walks by. Some of the collateral damage includes tigers, usually young ones that are easily caught because of their small paws. It's far from a rare occurrence, but there's also a larger toll. When rampant snaring and hunting targets the tiger's main food sources, hungry tigers stray into the world of humans and prey on livestock. And as wilderness falls to the axe, villagers push ever farther into tiger territory and conflicts increase. It endangers people and rarely ends well for tigers. A decade ago, the *Jakarta Post* reported that human–wildlife conflict, particularly involving tigers and elephants, had reached "a critical level."

It's a problem that has sparked an original, controversial, and rather scary experiment. Maverick millionaire Tomy Winata adopted nine "conflict" tigers that were living in cramped cages in a government facility, a place dubbed "Tiger Alcatraz." Some of them were known man-eaters; others had killed domestic animals. In 2008, five of them were radio-collared and released into the wild on Winata's private estate, which adjoins the vast Bukit Barisan Selatan National Park on the southern tip of the island. This jungle has plenty of prey and a small, private force provides serious protection—but 170 villagers also live there. The tigers have settled in, a female birthed a litter—and there have been no attacks on humans. So far. The hope is that these tigers will help repopulate the park.

THE VILLAGERS IN SIKERABANG were happy to learn that Kholis had been able to save the cub. In two prior incidents when they called the military, soldiers shot the cubs. Without tranquilizer guns, there is no safe way to free them. But the man who had set the trap was distraught when we told him that the cub had lost its paw. We followed him into the forest and watched him take down all of his snares.

On the drive to Sikerabang, there were places where we could barely see the road. The air was blue, much of the landscape shrouded in smoke. Whole tracts had been recently logged, then torched to burn back the underbrush. It was scorched earth, still on fire. In the two months I spent in Sumatra, it became an all-too-common sight. Over decades, huge tracts have been razed for settlements, logging operations, and plantations. Since 1990, Indonesia has lost more forest cover than any tropical nation except Brazil.

Sumatra's fertile lowlands have been almost entirely denuded to produce rubber, coffee, paper, acacia—and especially palm oil. The crimson-and-yellow fruits of the oil palm tree are the source of the world's most popular oil, often labeled as "vegetable oil" and used in everything from pizza and energy bars to soap, makeup, and increasingly, biodiesel fuel. Indonesia is now the world's largest producer, pumping out 18 million tons of palm oil in 2012, and an additional 1.4 million tons of biofuel. The government intends to up that by 60 percent over the next seven years.

To crank out that much oil, industry plantations have chewed up the island, leaving the disconnected green patches I'd seen from the air when I flew in. Conventional wisdom has assumed that those fragments offered refuge for tigers trying to survive amid a human-transformed matrix. Although that's a lovely idea, says Joe Smith, he learned otherwise while doing research in the southern province of Jambi in 2003. In a snapshot assessment, the few tigers living amid plantations and logging concessions appeared to be doing fine. Some were even breeding. But within two years, they were gone. The future for cats living in the fringes of disconnected forest is ultimately bleak, he says.

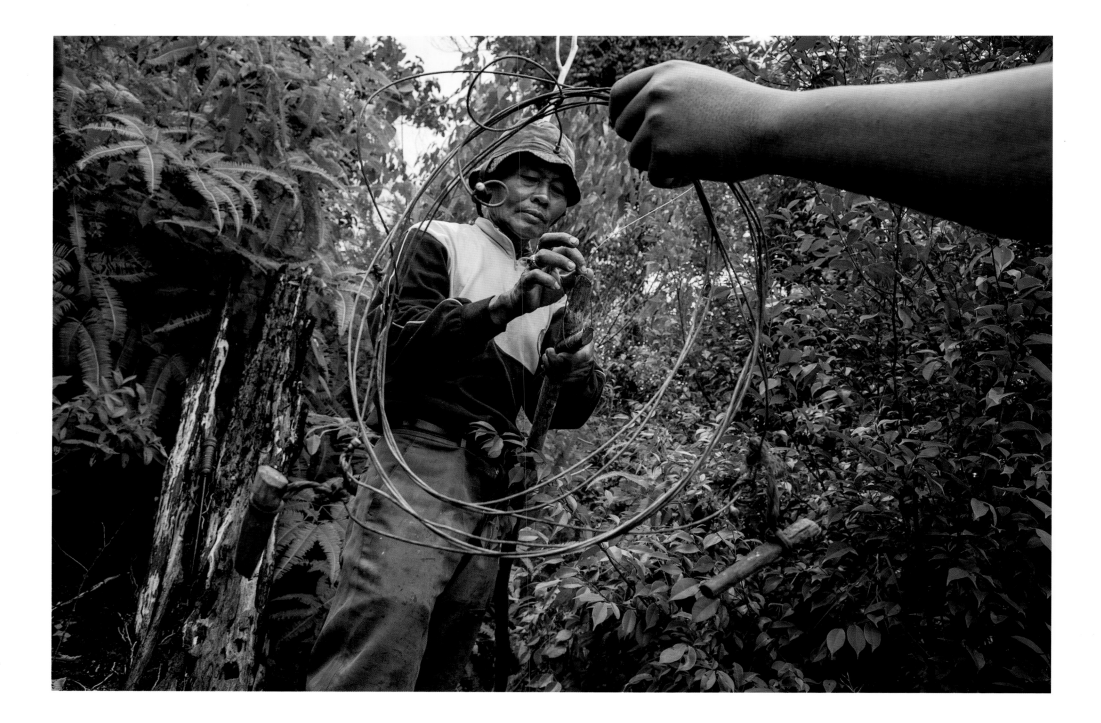

A man dismantles snares he had set for game that caught a tiger cub near a village in northern Sumatra.

During the five years it takes to grow their first crop, new palm oil farmers turn to the land for food. Snare

traps are indiscriminate, catching anything that walks by.

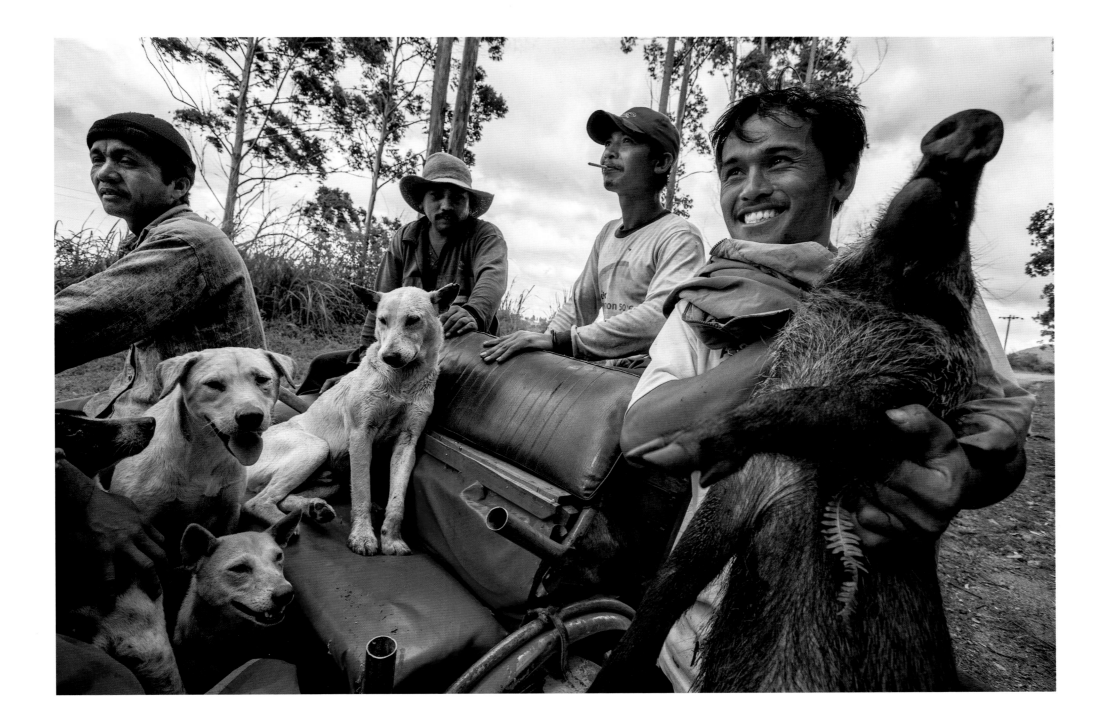

Nover Sryadi displays his quarry, a wild pig, near Lake Toba, Sumatra. Villagers set snares to catch the pigs that raid their crops. Because these largely Muslim communities don't eat pork, they sell the meat to local Chinese or bury the animals. The smell attracts tigers that get caught in those same snares.

With easy access, people log and hunt, and development inexorably devours these tracts. But they can act as important stepping-stones between protected areas, particularly for young dispersing tigers. Cubs typically strike out on their own at 18 to 24 months. Young females often move in next door to their mothers. But adolescent males often roam great distances, crossing roads, tracking across farms, moving through villages and other areas that put them in great danger—which is why those forest remnants are so important.

But healthy, breeding tiger populations live within massive forests that still blanket the island. Sumatra is the antithesis of Kaziranga: There is lots of space and there's a green, connected weave of habitat. However, researchers haven't pinpointed exactly where the main populations lie. For tigers to thrive within these big parks, breeding areas will need hard-core protection much like Kaziranga's. The most important areas include Kerinci Seblat in west-central Sumatra and Bukit Barisan Selatan in the southwest. Another is the Gunung Leuser–Ulu Masen landscape, a northern jungle block that forms Sumatra's largest contiguous forest estate. Together, these parks cover an area nearly the size of Ireland, incorporating sections of remote, inhospitable mountain terrain that cannot be easily carved up. It's a place that tigers could survive long term.

The 2007 survey found lots of tiger sign in Leuser-Masen, making it a global priority for conservation. It's among the richest, most biodiverse areas left in Asia and a last Sumatran tiger bastion. Part of the complex has survived relatively intact because of a protracted civil war in Aceh Province. This wilderness provided cover for insurgents in the "Free Aceh Movement" who fought for autonomy for 29 years. They surrendered in 2005.

But now, a quarter of that forest is on the block, with the province's new governor discarding previous protections. Another scary prospect: There's gold in those mountains. Mining companies are poised to move in. Historically famous deposits have proved to be legend based on fact, with one mountain's projected worth in the billions.

This young male cub lost his right paw after being trapped in a snare for three days. After he recovered, he was shipped to a Javan zoo that houses injured tigers.

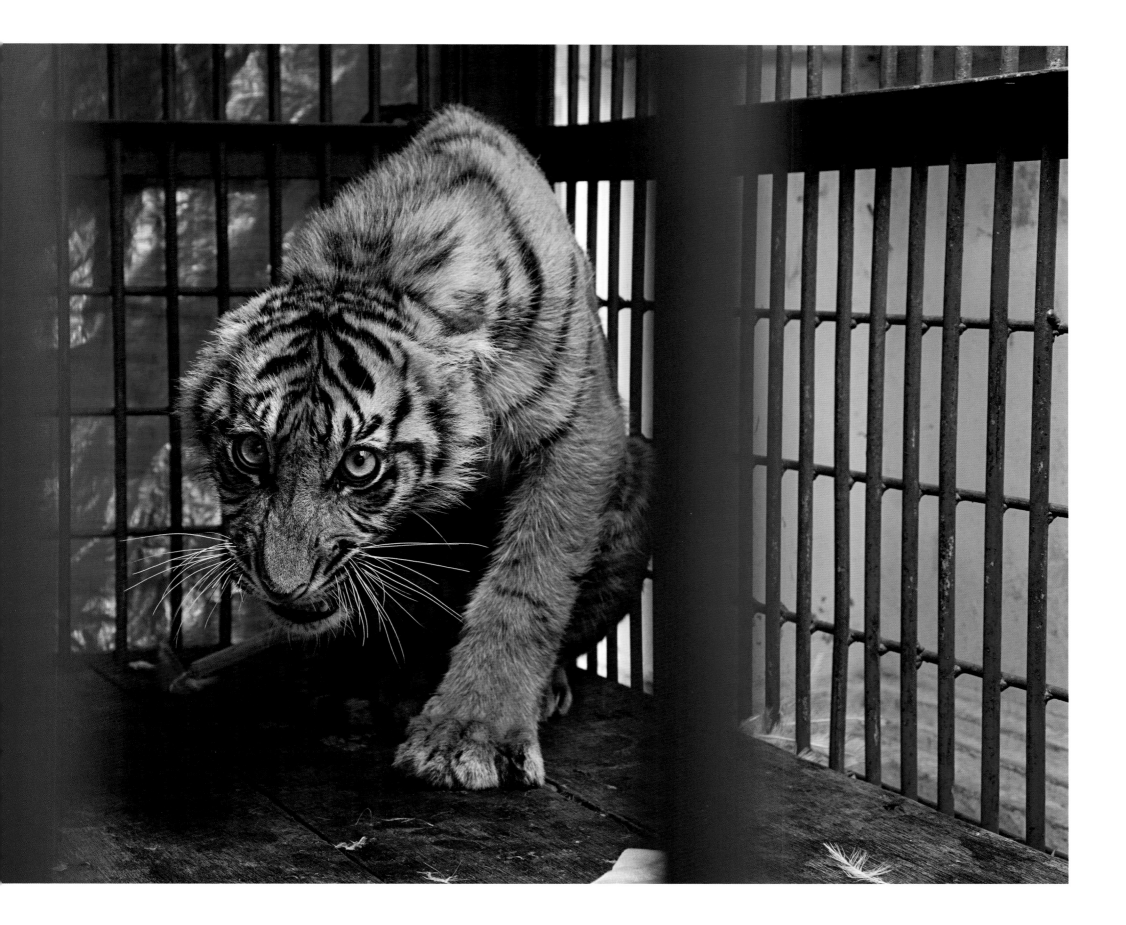

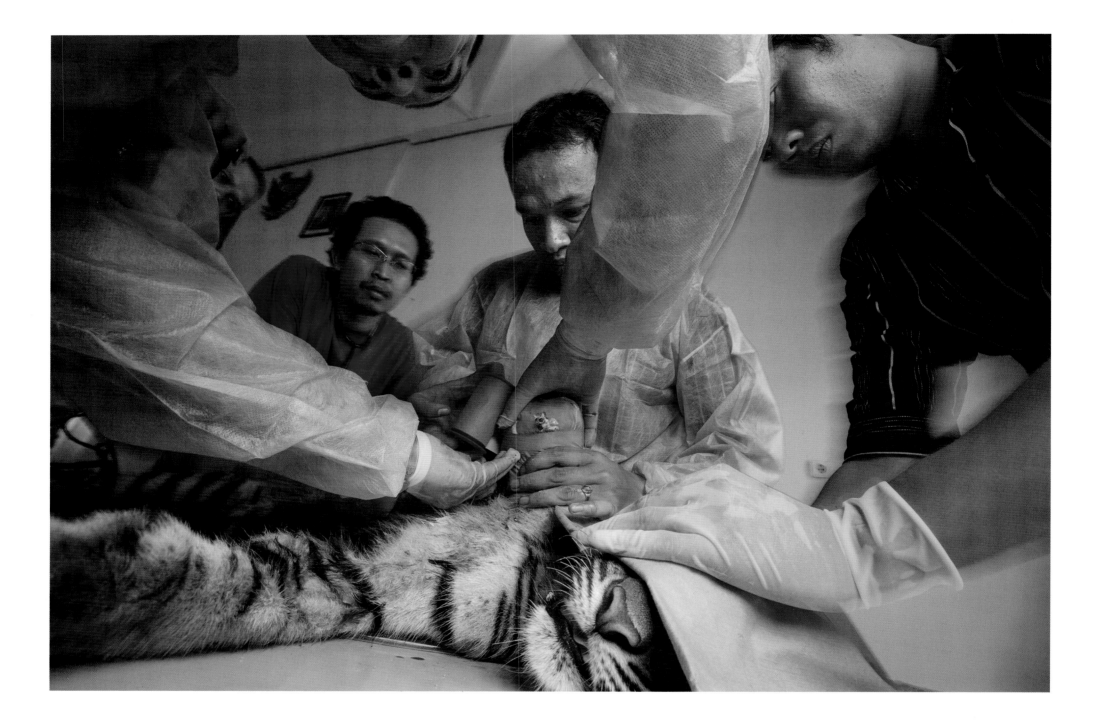

This young cub chewed through a bandage on its amputated paw; wildlife vets from Syiah Kuala University in Banda Aceh restitched the wound.

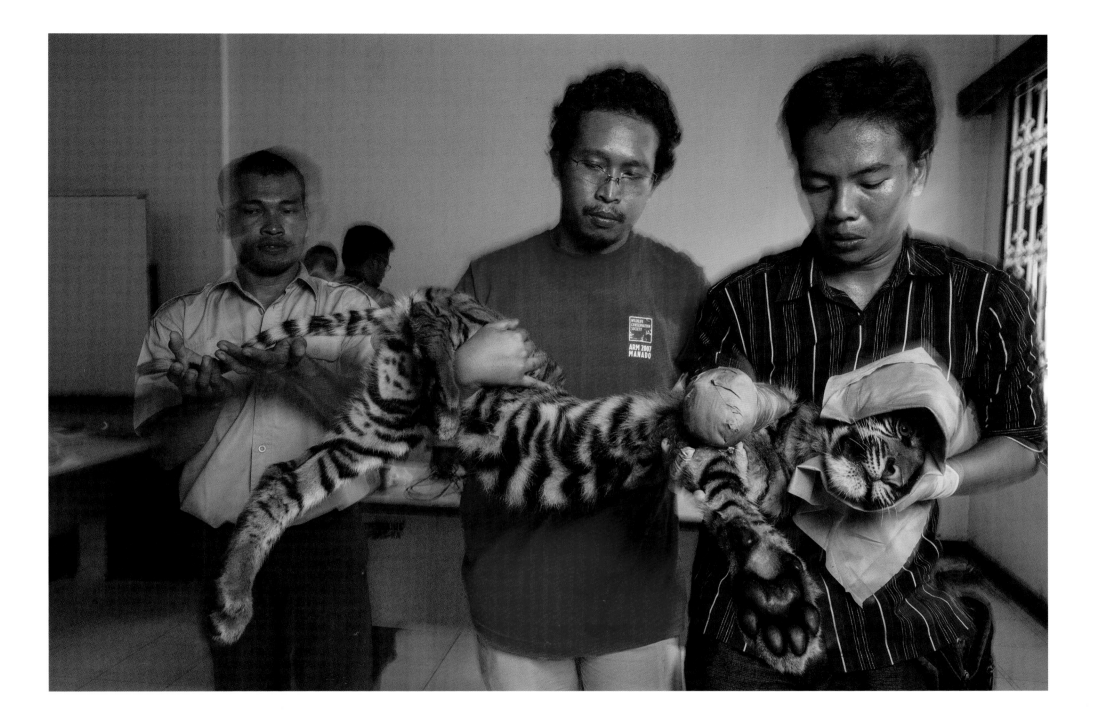

Two veterinarians and a forest ranger hold a tiger cub after surgery. Munawar Kholis (center) saved him from a wire snare in northern Sumatra. He tranquilized the cub and drove it 20 hours to Banda Aceh, where his leg was amputated.

I'D SPENT THE FIRST PART of this trip working near Medan with Kholis, but I wasn't going to find tigers there and didn't have a clear picture of where I would. I always work closely with field scientists, NGOs, and government agencies on wildlife stories, but on Sumatra, information was spotty and a slew of groups were working on conservation projects across the island. I had to start somewhere, so I traveled south to Berbak National Park, an immense wilderness of peat and swamp forest in Jambi Province. The only way in was by cargo boat, a two-day trip circumnavigating small inlets. They dropped me off at the park's "research station": two small buildings used by scientists. I spent three days setting up camera traps on animal trails, three still and one video, that would remain there for a few months. I hired a graduate student who was working there to download pictures and change batteries for me, and caught the next boat out.

From there, I went to the SPORC offices in Jambi City to meet up with a platoon of wildlife police. I'd been given permission to join them on patrol in a nearby reserve where illicit logging was a huge problem. Some months before, there had been multiple tiger attacks on illegal loggers camping in that forest. Seven men died. That acted as a deterrent for a while, but the word was that loggers were back. SPORC was sent to investigate.

We loaded into four trucks. There were 20 uniformed machine gun–toting officers in the convoy with a few more following on dirt bikes. We bumped along a winding, muddy dirt track until it dwindled to a thin trail. Then we walked, with the bikes in the lead.

Perhaps the noise scared them off. We stumbled into a small logging camp, just a few well-built cabins and a sawmill. A quick search showed that it was deserted, so a team split off to hunt further. I stayed behind, photographing the guards as they carefully inspected the site, then set fire to the buildings. We left a few men to monitor the blaze and pushed on.

Within minutes, we heard gunshots nearby. A call came over the radio: The patrol found another camp. They captured three skinny men, one barely more than a boy, all of them dressed in ragged clothing. Others had escaped.

After questioning, the guards made them take a chain saw to the towering stacks of cut boards that filled the clearing. It seemed an odd choice to me. The Forestry Ministry could have used the money from sale of that timber. Sometimes they couldn't even afford gasoline to drive patrols or make raids. But there was a good rationale: If they didn't destroy illegally logged lumber, it would probably end up being bought by the same gangsters it was intended for in the first place, And they might even end up paying less for it.

The guards burned that camp, too. They took the prisoners back to headquarters, where they interrogated them for a day. Then they let them go—they were just low-paid workers. They were after the men who ran the operation.

ON OUR WAY BACK TO TOWN, an officer received a text alerting him of a poaching incident. Sometime between when Jambi's Taman Rimbo Zoo closed on Friday and keepers arrived on Saturday morning, there had been a break-in. The intruders had drugged Sheila, a beloved 18-year-old female Sumatran tiger using meat laced with a sedative. They gutted her, left her entrails, and took the rest.

I couldn't believe someone would actually poach a tiger *out of a zoo*. Somehow I needed to document this tragedy. When I arrived, police swarmed the area. Through an interpreter, I asked a detective where I could find Sheila's keeper. He pointed me to his residence, which was within eyesight of her cage. The keeper looked shell-shocked. He told me he'd cared for her for eight years.

I asked him for a photo of her and he went inside and loaded a snapshot onto a CD. It was the only way I could think of to show what had happened. I went into town to have it enlarged and when I returned, I met an eight-year-old girl, Dara Arista, who stood staring into the empty cage. She'd come with her family that day to see the tiger. I photographed her holding

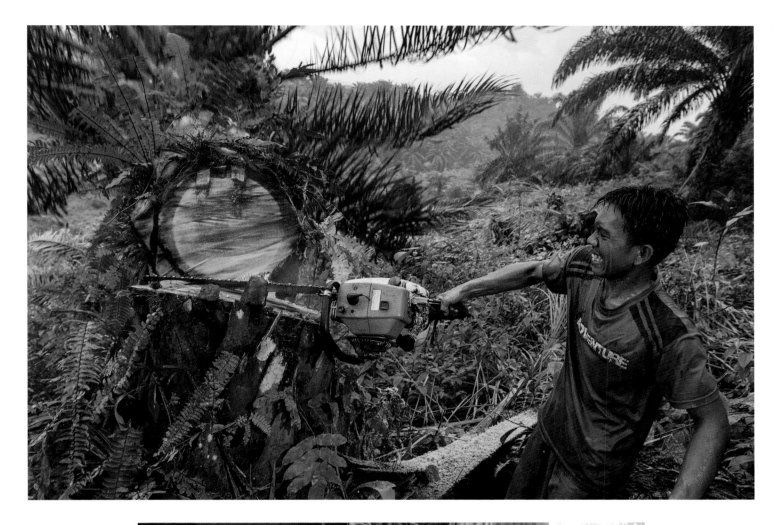

Above: Saiful Anwar levels part of an illegal 328-square-mile palm oil plantation, planted inside Leuser National Park 15 years ago. *Below:* Elite wildlife police burn down an illegal logging camp in Berbak National Park; they also detained several loggers.

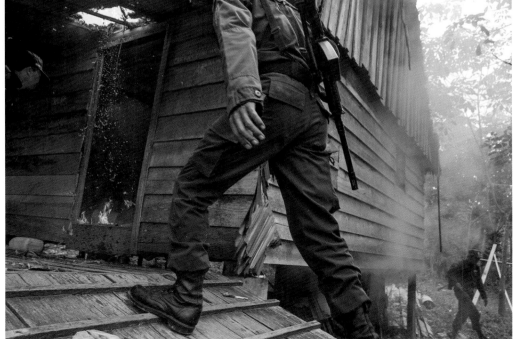

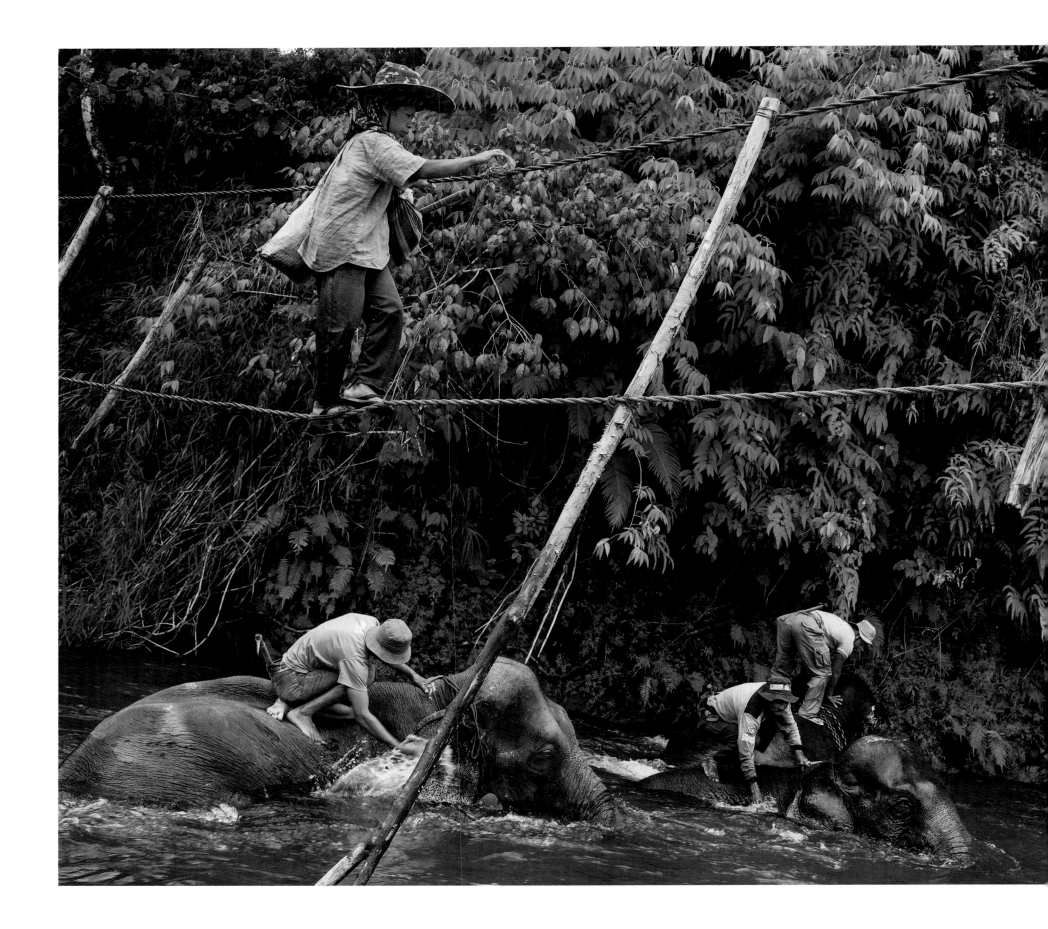

A woman crosses a tightrope bridge while community rangers bathe their elephants after a day's patrol near Banda Aceh in northern Sumatra.

Sheila's picture in front of the enclosure where the animal had eaten and slept, which was now cordoned off with police tape, a crime scene.

The poacher was captured on a bus carrying Sheila's parts and confessed to killing her. He'd been paid $100.

I HEADED NORTH to set up camera traps near Banda Aceh and went directly to the offices of Fauna & Flora International to meet with Matt Linkie. When I checked my email there, I found a single, awkward-looking tiger photo sent by the researchers in Berbak. It was the only photo I received before fishermen stole the camera from the only productive location. They took the video camera, too.

Matt introduced me to Madhi Ismail. He had been a successful businessman before losing everything in the 2004 tsunami that devastated Aceh. After spending a year helping people rebuild, he decided to work full time in conservation and signed on with FFI.

In 2009, Madhi helped establish a program to train former poachers, loggers, and ex-combatants as community rangers in Ulu Masen. It's given 380 men a steady legal income, men who know these forests well. It's their neighborhood. FFI also trains mahouts hired by the government to "drive" the domesticated elephants sometimes used on patrols. Madhi took me out with them. We climbed on elephants and headed into lush rain forest. I photographed the men as they learned to handle their animals and at the end of the day, we went down to the river. The elephants eagerly ran in, drinking and spraying water over their backs. On command, they lay in the water, lounging while the mahouts climbed over them, scrubbing them down. The men enjoyed it as much as the elephants, splashing and clowning.

Training to be a community ranger is grueling. Recruits camp out without bathing or changing clothes for ten days, up at 5:00 a.m., not in bed until 10:00 p.m., their sleep interrupted by scheduled night watches. Sometimes they're rousted in the wee hours for simulated poaching raids

**Veterinarian and
tiger conservationist**

The calls could come at any time. Those who needed his help were not geographically far away, but it could take Munawar Kholis a day to reach them, driving along rutted, rural dirt roads. Part of his role as a veterinarian with the Wildlife Conservation Society was to save tigers and other wildlife that were trapped in hunting snares near villages in northern Sumatra.

These wire traps are indiscriminate. Though they're set to hunt game—or to keep deer and wild pigs from foraging in crop fields—they readily capture tiger cubs. Villagers rarely summoned Kholis right away, usually calling after a cat had been

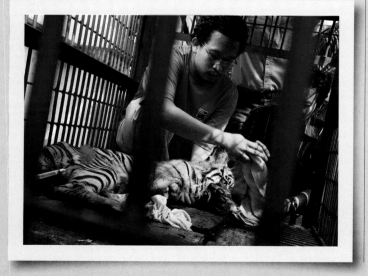

ensnared for days. If the cubs survived, they often lost a paw and ended up in a cage for life. He was experienced in this wildlife EMT role: He'd previously spent a few years working with the Cikananga Wildlife Center rescuing endangered species from illegal owners and traffickers.

Kholis had been working closely with community leaders to prevent these tragedies. Most of the distress calls he received reported tigers preying on livestock or roaming near villages. With shrinking forests and encroaching human settlements, tigers were losing access to both shelter and food, bringing them into more frequent contact with humans. Losing livestock is a huge economic hardship. People may be in danger and they retaliate by shooting or poisoning tigers. It's a lose-lose situation. Kholis brokered a deal with village headmen in high-conflict areas. They would be rewarded if they notified him instead of harming tigers that came near their communities or killed their animals.

Having free-grazing animals at the jungle periphery is a recipe for disaster. A tigress with cubs and disabled or elderly animals will welcome an easy meal. The only way to mitigate predation is to lock up farm animals before dusk—when tigers hunt. Over a four-year period, Kholis and his team built 120 barbed-wire, tigerproof corrals. He led discussions on husbandry and vaccinated farm animals. Because disease is a leading killer of livestock, preventing illness more than makes up for the occasional cow or goat felled by a tiger.

Between 2007 and 2008, 13 "conflict" tigers were killed by locals or removed from this northern enclave. Simply relocating problem animals isn't easy. The cats establish strict territories, so moving them around can trigger infighting, often with deadly results. By 2011, and again the next year, there was tangible proof that mitigation was working. Not a single tiger died in a retaliatory killing, nor were any relocated. When Kholis visits, he is treated like an honored guest.

With this experience, he says, "I realized that my vet expertise only saves tigers one by one, and many of them couldn't go back into the wild." That wasn't enough. He wanted to have a wider conservation impact. He's recently signed on with Fauna & Flora International. Their "community ranger" program in northern Sumatra hires former loggers and poachers to protect the forest. In just a few months, Kholis has trained 300 of them to remove wire snares in five districts. It's a necessary initiative. Poaching is rampant. He's negotiating directly with locals to stop hunting for bush meat in protected areas and to stop killing tigers. In meetings with village elders, he's requesting that they call him about problem tigers. And he's asking for their vigilance to help fight poaching. Economic incentives include funding to buy livestock, construct safe enclosures, set up freshwater aquaculture, and more. The only way to stop the slaughter, says Kholis, is to help people build new livelihoods—and to maintain strong protection. ◊

MATTHEW LINKIE

**Tiger program director,
northern Sumatra**

Matthew Linkie began studying tigers in Kerinci Seblat National Park's steamy rain forests in 1999. He lived in a small farming village, speaking no Indonesian, while mapping how much lowland forest had been razed. His graduate research (through the Durrell Institute of Conservation and Ecology) would chart his life's work studying and protecting critically endangered Sumatran tigers, Asian elephants, and the rapidly disappearing forests they inhabit.

He'd come to Sumatra to work with Debbie Martyr, a program manager with the U.K.-based nonprofit Fauna & Flora International (FFI). At the time, Martyr was brainstorming a way to combat a grim reality: Poaching for the illegal wildlife trade was wiping out Kerinci's tigers. Enough remained within the 5,200-square-mile jungle mosaic that protection was critical. Martyr recruited a local force nicknamed "Team Tiger" that works closely with the forest department and police, forging a strong enforcement and intelligence network. Linkie's role in this new initiative was not only to monitor forest loss, but also to provide information on tigers and their prey: where they were, how many, and whether numbers were stable or declining.

Linkie installed more than 150 camera traps throughout the forest to capture images of animals as they moved along trails. As he built this monitoring system—which continues to this day—he trained young conservationists in the technique. Armed with these data, Team Tiger dispatches patrols to areas where tigers or prey have dwindled, areas needing greater protection and investigation. Evidence from camera trap surveys has also helped defeat proposals for roads that would have carved up the landscape and provided access to intruders—and prompted the Indonesian Ministry of Forestry to increase official protection of key tiger sites. The result: Tiger numbers stabilized and tigers now roam over 80 percent of the park.

Until 2007, there had never been a comprehensive assessment of where Sumatran tigers lived. Linkie was instrumental in partnering nine nonprofits with the forest department on the first-ever island-wide survey. The study, which he co-wrote, found that the cats were far more widespread than anyone imagined. It also forged a more powerful coalition among both groups and individual scientists who had never worked together before.

One surprise was that the far northern forests in Aceh Province were packed with tigers. Linkie had just signed on there as program manager with FFI. He secured recognition of the area, which is larger than the state of Maryland, as a global conservation priority. The ruggedness of this landscape had sheltered tigers and kept people out—but so had 29 years of civil war that had recently ended.

Linkie launched a community ranger program, training ex-soldiers, illegal loggers, and ex-poachers to guard the wilderness they know like their own

PHOTO: J. E. MCKAY

backyards. Today, 380 rangers run patrols, pull out snare traps, and mediate with communities who come in conflict with tigers and elephants. Rangers and police trained with an FFI module on combatting illegal logging and have busted 145 people. Currently, he is setting up Indonesia's first-ever specialized police units to tackle the black market tiger trade.

Linkie works with tigers because they are "the heart and soul of the forest." He cannot imagine allowing such an animal to disappear. But, he says, "Tiger conservation is a full-time job and you never really get to an end, the point where you say, 'we're winning.' You're always going to be fighting the good fight for tigers. You can't take your eye off the ball." ◊

or wildlife rescues. The training culminates near midnight on the last night with a powerful ceremony: Their trainer dunks the men in the river, still clad in their sweaty, bloody, leech-ridden training clothes. As they emerge, they don clean, crisp community ranger uniforms. Many of the recruits burst into tears. About 40 people line the shore, which is lit by flaming torches; they sing Islamic songs, their voices echoing across the water. The crowd is a mix of FFI staff, village leaders, forest department officers, and community rangers, everyone waiting to welcome the men into the ranger family. It's an important ritual that helps build needed trust. These men had been outlaws and the Aceh civil war had left many communities shrouded in suspicion, never sure whose side their neighbors had been on.

As rangers, these men exhibit extraordinary commitment. Linkie calls them the unsung heroes, and Pk Norman Bin Cut, an older, grizzled ex-poacher, ranks high among them. Madhi first met him six years earlier at a poaching camp where he was smoking sambar deer on racks to preserve it for transport. He was the guy you wanted to throw in prison, the guy doing more damage than ten others put together, Madhi said. He learned that Bin Cut had no land or resources, needed money, and took the only opportunity he had—poaching. Now he's one of their most committed rangers.

Madhi and Bin Cut took me out on an overgrown logging road looking for camera trap sites. At one point, Bin Cut wordlessly disappeared, off tracking. When he reappeared an hour later, he simply said, "yes" and led me down a small animal trail. He pointed to tiger tracks amid the snaking roots of a buttressed tree. I set up a camera there. It would make a beautiful backdrop for a photo.

Madhi recruited some villagers to help us find other locations. Deep in the jungle, we heard a dog yelping and followed the sound. We found a puppy tied in a small bamboo corral looped with razor wire. Tiger bait. There was one entrance, with a snare set inside. I wanted to free the dog and take it back to town, but it would have interfered with an ongoing investigation. I love dogs and had two rescue mutts at home; it killed me

to leave that puppy. We decided it was too dangerous to install cameras there. Some months later, back at home, I heard that the men suspected of setting those traps were arrested, a 57-year-old man and his son who were suspected of killing more than 100 tigers over decades.

Enforcement has grown stronger thanks to Pk Rahmad Kasia, FFI's forest crime investigation coordinator. Sometimes he disappears, resurfacing a week or two later with evidence of a guy trading in deer parts or illegally cut timber, someone who killed a tiger or was looking for skins. He's a local who fits in, hangs around, rides the buses, engages in small talk, and listens to gossip. In the process, he's built a growing informant network. Because of those inroads, community leaders regularly show up at FFI's offices offering information. Now the media have focused attention on government agencies, prompting hundreds of arrests and convictions. They're mostly loggers. Post-tsunami, there's been a huge demand for wood needed to rebuild. And a special unit is now working with police, focusing on known tiger poachers and dealers.

Law enforcement in many of Sumatra's national parks is nearly non-existent. Far more manpower and law enforcement resources are needed, says Smith. One notable exception is Kerinci Seblat. It's the best-policed park in the country, home to an important tiger population, but it still has its share of problems. Much of its buffer zone has been shredded by people living in hundreds of villages along its borders. Many of them also hunt, mine, farm, and fell trees inside the park. In spite of those challenges, tiger numbers in Kerinci have been holding steady because of strong protection from "Team Tiger," aka the Tiger Protection and Conservation Units.

These "feet on the ground, eyes in the forest" patrol teams, established in 2000, were the brainchild of FFI program manager Debbie Martyr. The program was developed, she says, "over months of late-night sessions with mates from the park," sparked by feeble enforcement. On two occasions, she reported people selling tiger pelts, and each time, nothing happened. Kerinci's rangers were poorly trained and ill-equipped, with no expertise in preparing

Dara Arista holds a portrait of Sheila, a beloved 18-year-old Sumatran tiger, in front of her cage at Taman Rimbo Zoo in Jambi.

Two nights before, a poacher broke in and killed her in her cage. He was captured on a bus and confessed to killing her for $100.

A community ranger in Aceh, Sumatra, discovered this trap, which used a barking puppy as tiger bait. The resulting investigation led to the arrest of a father–son poaching team who are thought to have killed over 100 tigers.

evidence or accessing undercover information. "Because the park had never responded to poaching incidents," says Martyr, "I think police assumed it was tolerated. It was a low-risk, high-reward activity." And with the park overlapping four provinces, jurisdictions between government agencies were too fuzzy for focused action. Martyr realized the need for a specialist force similar to those guarding the island's few remaining Sumatran rhinos.

Within 18 months, FFI had recruited local villagers as new rangers and embedded them on patrols alongside park officers and forest officials. Two months later, they apprehended their first tiger poacher.

Since then, Team Tiger has built strong informant webs and regularly orchestrates sting operations. They've tallied 32 arrests for killing or trading tigers, with far more apprehended on other environmental charges. In April 2012, the team made national news when they busted a pair of rogue headmen from villages bordering the park. These were men who had outwardly supported conservation efforts, often housing park officers in their homes when they passed through—while funding and directing poachers and selling tiger parts to urban dealers. The team even busted a local parliament leader, a bold move that would have been impossible a decade ago.

Both the rangers and Martyr work undercover to monitor suspects and secure criminal evidence. About ten years ago when Martyr was staying in a hotel a few hours from Kerinci, she overheard two men debating how to safely smuggle out a tiger skin. That conversation led to two arrests. A few years ago, she overheard a very different conversation in a hotel lobby. Two men were complaining that tigers were difficult to come by. "Then their boss called," Martyr says, "and I had the blissful experience of hearing these two rogues tell him 'Boss, you don't understand. It's not like it used to be here. Lots of people have been arrested. People are scared to poach tigers now.'"

Over the last dozen years, Team Tiger has pulled a whopping 4,590 game snares and 139 tiger snares from the forest floor. Kerinci's tigers have bounced back to about 166 individuals, up from between 136 and 144 in 2006. But Team Tiger is a small frontline force. Just 24 unarmed rangers defend a 5,300-square-mile national park against escalating poaching threats. Last year, the team destroyed 20 carefully laid, camouflaged tiger snares, the most in a decade. Panthera is now collaborating with Martyr to identify Kerinci's two or three most important breeding sites for beefed-up protection. The plan includes upgrading software to better process intelligence data and careful monitoring of tigers.

Team Tiger is a model that needs to be replicated in other tiger bastions, and soon, says Smith. "If we don't step up the protection level right now, there's not going to be much left to work with." The U.S. Fish & Wildlife Service has championed forest guards with more than a decade of funding, and additional international funding may come in 2014. Panthera channeled a half million dollars toward monitoring and intensive tiger protection in Leuser-Ulu Masen, Kerinci, and Berbak in 2012.

Smith emphasizes that efforts must focus on areas with enough tigers to fuel a wider population recovery, places that can realistically be protected over the long term. "At this stage of the game, our resources need to be invested protecting viable, healthy breeding populations if we're going to save tigers in the wild," he says. That means some hard decisions, choosing populations that have a reasonable chance—and mobilizing all the resources required to secure their future. "In many ways," he adds, "we're now fighting a last stand for Sumatran tigers."

AFTER TWO MONTHS TRAVELING back and forth across that huge island, I left without a publishable photograph of a Sumatran tiger. Five weeks after returning home, I received an email from Madhi with two files attached, images from the camera trap Bin Cut and I had set. I was scared to open them—and I almost cried when I did. A full-maned male tiger stared directly at the lens. The pictures were shot at night, framed in front of that sprawling buttressed tree. He was a stunningly beautiful creature.

I had to laugh: It was an ex-hunter who had finally found me a tiger. ◊

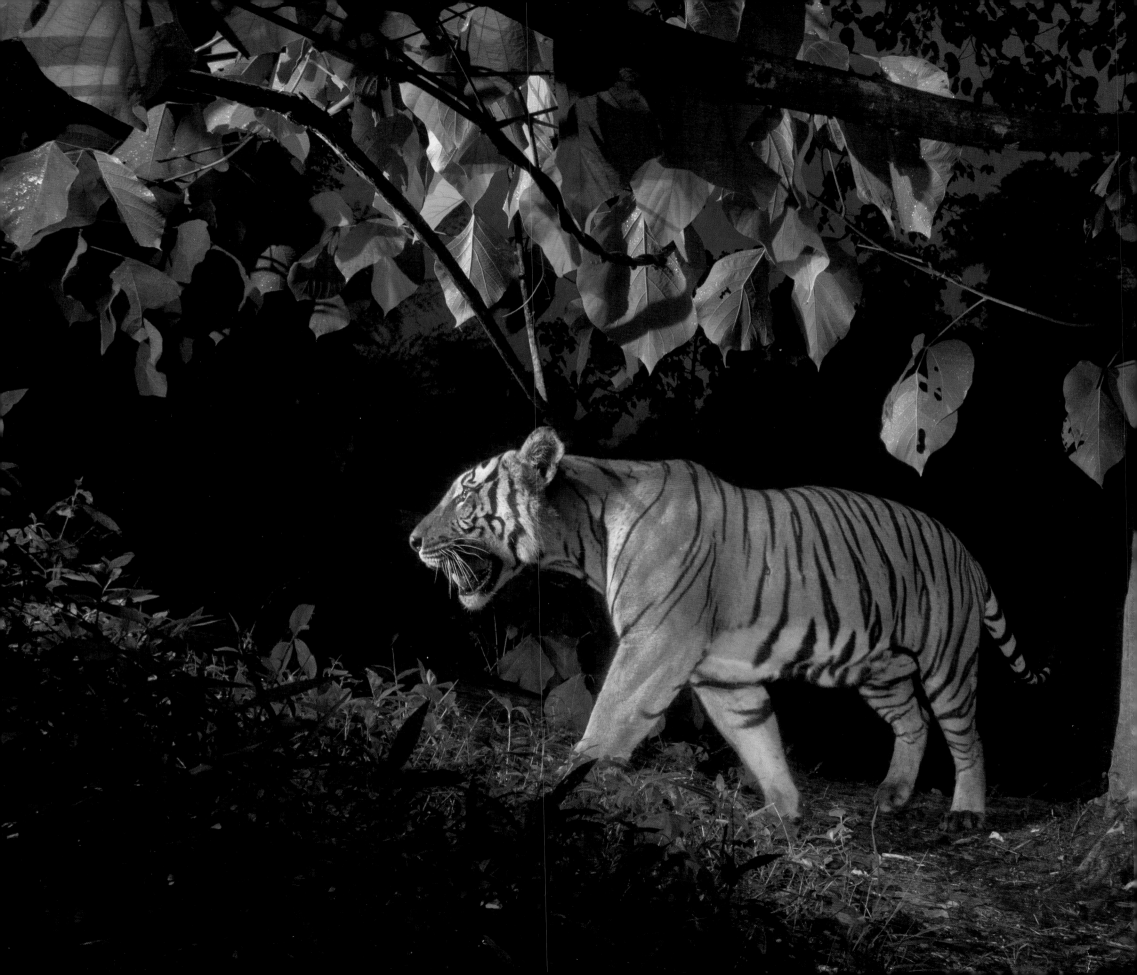

TIGER SCIENCE

A camera trap captures an Indochinese tiger as it prepares to spray on a tree,

a place where other tigers had marked their territory.

A tigress had killed the cow. The day before, researchers had tethered it in a clearing as bait. After it was dead, they circled it with snares. Now we waited for news that the cat had been caught when she returned to the carcass to feed, as tigers do, until the best parts are eaten. ¶ It was the end of another 110-degree day and I lingered in camp after dinner, seeking the relative security of the fire. My assistant, Joe Riis, and I sat with members of the Thai Tiger Team, a group of researchers led by the husband–wife duo of Saksit and Achara Simcharoen who work here in Huai Kha Khaeng Wildlife Sanctuary. My gear lay piled in the back of a pickup with a mound of veterinary equipment. Ready.

Saksit had radioed us around noon to tell us about the cow. Within minutes, we were in a jeep, bumping along a rutted dirt track through tropical forest and grassland meadows, trying to arrive before the cat did. Two hours later, we were pitching our tents. Camping in tiger territory is always dicey, but elephants were the greater worry here, especially one very dangerous rogue male who had recently killed five people, including a young researcher. He regularly ambushed people and vehicles and went after farmers on the park periphery.

The team made regular scouting runs, monitoring the signal emitted by the snare. If the trap had been sprung, they'd hear a rhythmic beat instead of a constant signal. A truck tore back into camp around 8:30. "We caught her!" they yelled in Thai; someone screamed the news to us in English. We piled into two pickups. Joe and I jumped in back.

As we drew near, we heard deafening roars reverberating through the forest, turning my bones to ice. Saksit trained a spotlight on the cat to make sure she wasn't just trapped by a few toes, but was firmly caught. She was. The tigress bellowed and lunged—and we quickly noticed why: She had a cub with her. Achara hung her head out of the window and loud-whispered to me. "We're on the inside. If she happens to break the snare or slip out of it, you're the ones she's going to go after." They prepared a tranquilizer dart and Achara shot it from inside the vehicle. Then they prepped a second dart with a tiny dose and sedated the cub. The mom was out cold in ten minutes. She was young, maybe four or five years old.

The eight-person team went to work, kneeling in a circle around her, their headlamps lighting the scene. Those handling her donned surgical gloves. Her tongue hung out between her pearly, three-inch canines. Under the sedative, the cat stared, open-eyed, having lost her blink reflex; someone daubed salve on her golden eyes for protection. Someone else monitored heart rate and respiration. They poured water over her again and again, and three people waved Oriental fans to keep her from overheating.

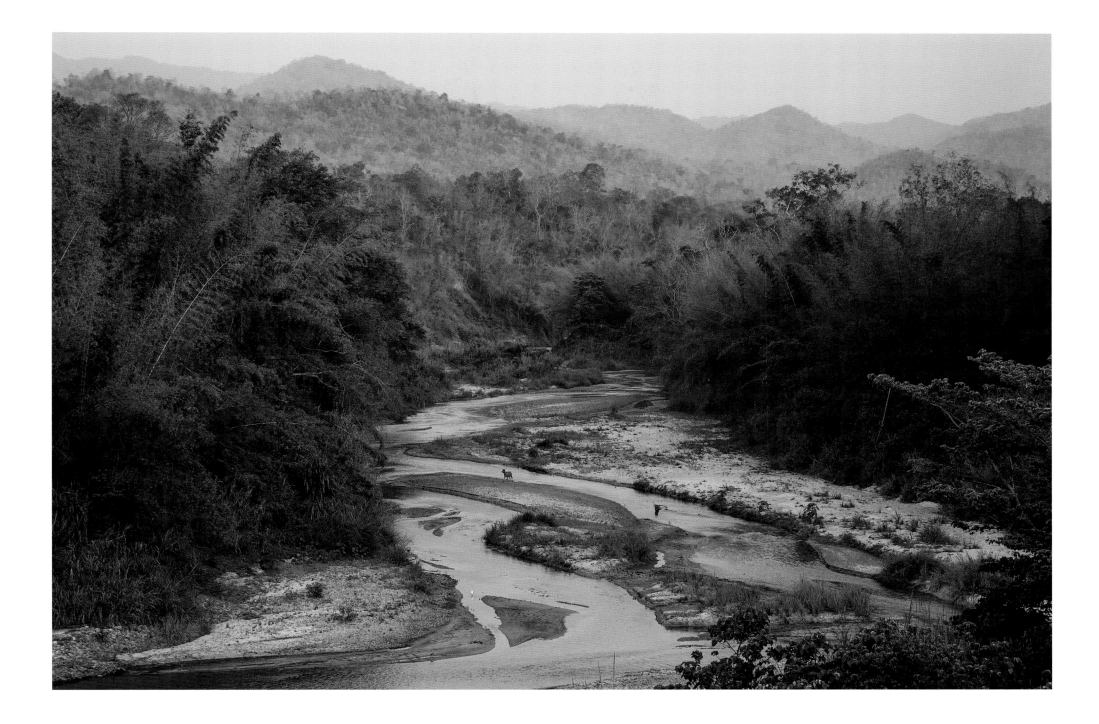

A sambar deer crosses a river channel in Thailand's Huai Kha Khaeng Wildlife Sanctuary. With sambar and other favored prey, the sanctuary is prime tiger habitat.

Though I'd seen dozens of these captures, I was impressed by the team's efficiency. They moved with the synchrony and speed of a Formula One pit crew. They drew blood and urine. Collected fur for DNA tests. They measured her length, girth, and tail, her huge paws, and massive skull.

Another group collected data on the cub. It was a male, about five months old, small but solid, weighing in at 90 pounds. As they measured him, he woke, rolled on his back, then spotted his mother lying nearby and started squirming. All he wanted was to get back to her.

It took four men to heft the tigress onto a scale to weigh her. Her one ear was nicked, but otherwise, she was fit and healthy—and stunningly beautiful, her coat flaming under the lights, her eyes shining gold. I'd never been this close to a tiger.

Then Achara fastened a thick black leather collar around her neck that carried a satellite transmitter. If all went well, the collar would transmit GPS locations every hour for about five months, allowing Achara and Saksit to track her movements on a laptop computer. It was part of their six-year study on female tigers that would correlate the size of their range with how much and what kind of prey was in that area. After one year, the collar would drop off.

The team completed their work and moved the tigress to a safe spot, then carried the cub over and laid him beside her. He snuggled into her and then didn't budge. As we climbed into the truck, I checked my watch: 42 minutes had elapsed. Others parked a vehicle next to the sleeping cat to protect her from elephants until she wakened and sauntered off into the forest.

I was hoping to photograph a daytime capture. Saksit said I should make an offering at one of the Buddhist shrines stationed throughout the park. I left the only thing I had that day—a can of soda—and said a prayer as instructed, asking for a safe capture to help us document and understand these animals. When the next cat was again caught at night, someone joked that I needed to leave an offering of a Singha (Thai beer). So I did. The next morning at 5:00 a.m., a tigress was in the snare, the sun coming up, and as they prepared the dart, Saksit turned to me. "You put a beer on the altar,

As part of the first study to identify the home range and track the movements of female Indochinese tigers, Thai biologists sedate this tigress to fit her with a satellite collar. They discovered she was pregnant, making her a valuable study animal.

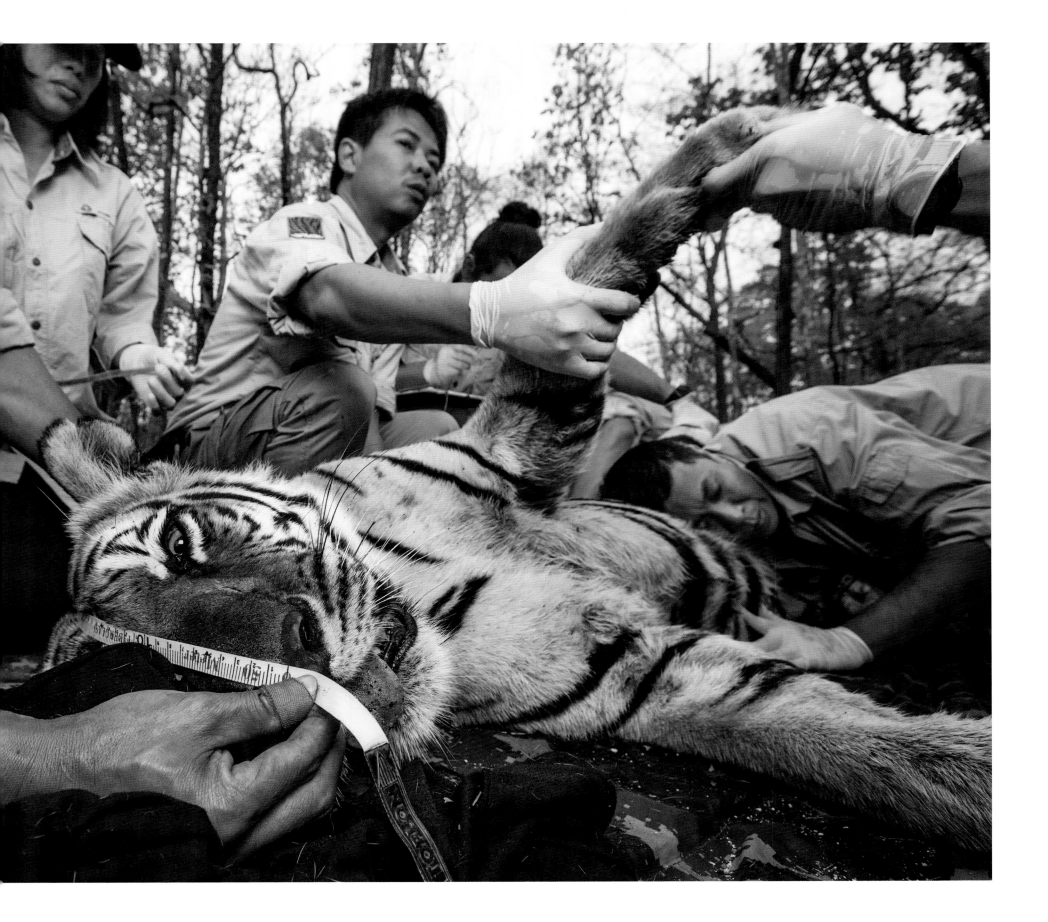

**Wildlife biologists,
Thailand**

When Saksit Simcharoen came to Thailand's Huai Kha Khaeng (HKK) Wildlife Sanctuary in 1987, it was like the Wild West. Gunshots rang out day and night. Hunters and loggers pillaged the forest and most of the surviving animals had retreated into the interior. He'd come to do graduate research with Alan Rabinowitz, a big cat expert who then worked with the New York Zoological Society. They radio-collared and tracked leopards and civets—but were never able to capture a tiger. Populations were slipping in Thailand and across Asia.

After graduation, Simcharoen was hired on by the Royal Forest Department to head the Khao

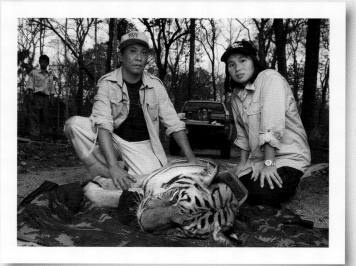

Nang Rum Wildlife Research Station in Huai Kha Khaeng. In 1993, Achara Phetdee came to work as his assistant as part of her university studies in wildlife management. That launched a lifelong partnership. They married and have teamed up on tiger research since, collaborating with renowned scientists including Indian biologist Ullas Karanth and James David Smith from the University of Minnesota. Early on, they launched camera trap surveys that are still up and running. In 2007, they estimated that there were 60 tigers in HKK and 120 across the immense Western Forest Complex that comprises 17 interconnected reserves. This region is the best hope for the Indochinese tigers' survival and might be the second largest tiger population in the world.

A few years ago, Achara decided to pursue her doctorate. There had been little research on females' "home range," and the questions she wanted to answer were: In HKK, how much territory does a mother need to feed her family? And with the available prey, how many breeding tigresses could HKK hold? To figure that out, the Simcharoens and their team assessed the abundance of tiger food and tracked the movements of female tigers.

One year in, Achara became pregnant with their third child; her other children were six and nine years old at the time. From her eighth month of pregnancy until her daughter, Nawapas, was four months old, she frequently

camped in the heart of the jungle. During that time she trapped, tranquilized, and outfitted six tigresses with radio collars. She is quite possibly the only woman researcher capturing and collaring wild tigers.

Saksit and Achara will soon publish the results of their study: A tigress's mean home range proved large, 27 square miles. It wasn't surprising, given the dearth of prey.

Although there are about 50 breeding females in HKK and they birth about three cubs every two and a half years, the population isn't rising. New research may explain why. The team is now collaring young adult tigers to learn where they go. When tigers approach the age of two, they must strike out on their own to establish territory. It's one of the least understood aspects of tiger behavior. "They have a secret life that no one knows," says Achara.

State-of-the-art "Smart Patrols" have made it tough for poachers in Huai Kha Khaeng, but adjoining reserves are not as well protected. The next step is to assess what happens when cats step over HKK's borders. In his new role as chief of research for four provinces, Saksit has launched camera trapping in two national parks that belong to the larger forest complex, among other studies, and consults widely. "This research can help protect tigers, and we're training the next generation to continue the research," he says.

"If we don't understand tiger ecology," Achara adds, "how will we conserve them?" ◊

didn't you?" He grinned. But he smiled wider when he examined the cat and discovered she was pregnant. She would be an important study animal.

From there, we went out and set up camera traps throughout the sanctuary.

I'd visited Huai Kha Khaeng (HKK) twice before for Panthera's yearly Tiger Forever meetings that bring tiger experts together from across tiger territory. HKK is one of Thailand's few remaining emerald gems. It's the largest remaining wilderness in a fast-developing nation that has reduced most of its jungle to isolated pockets. In 1961, 57 percent of the country was forested; by 1989, just 28 percent was left. The press dubbed the forest department the "Department of Stumps."

Thailand had no wildlife laws or national parks until 1960. Though there are now over 300 protected areas, few have a proper budget or efficient enforcement. Only about 25 of them have any tigers, and most have just a handful. Many of the smaller parks have become "empty forests"— gorgeous wildlands eerily devoid of life, with the large animals long gone. In 1992, a new Wildlife Reservation and Protection Act lent special protection to 15 species; somehow, tigers did not make it onto that list.

But the 2,000-square-mile HKK sanctuary is the exception with its wide array of creatures. It lies at the heart of a massive green mosaic known as the Western Forest Complex, 185 miles northwest of Bangkok. A network of 17 preserves extends virtually unbroken to the Tenasserim Mountains on the Myanmar border, adjoining another park on the other side. Together, these lands form the largest nature reserve in Southeast Asia, two and a half times the size of Yellowstone National Park.

Though HKK was in serious straits a few decades ago, today it's a conservation success story. It's home to about 60 breeding Indochinese tigers; the surrounding forest complex holds about 150. Elsewhere, after two-plus decades of intensive study, the status of Indochinese tigers is hazy. That's partly because of the region's turbulent history of war, social unrest, and political upheaval—and partly just the reality of studying these secretive animals. The last confirmed sighting of a tiger in Vietnam was years ago, though tracks have been spotted in the Annamite Mountains. They may soon be gone from Lao People's Democratic Republic. No one knows how many live in Myanmar, and they were recently declared extinct in Cambodia.

WCS biologist Tony Lynam tallies seven or eight sites total in Thailand, Myanmar, and Malaysia where more than just a couple hang on. In 2010, he calculated the cost of saving remaining Indochinese tigers in low-to-medium risk sites to be $21 million a year; governments and NGOs have come up with just a quarter of that. Despite a lot of posing, posturing, and high-level meetings, he says, there's too much talk and not enough being done. The Indochinese is the next subspecies in line for extinction.

Huai Kha Khaeng is the only park outside of India with decades of solid, ongoing tiger research. When I was there in 2010, scientists had been camera trapping for 16 years and tracking cats for 24.

Back in 1986, Alan Rabinowitz (who then worked for the New York Zoological Society) was invited by Phairote Suvannakorn to conduct the country's first comprehensive study of HKK's wild cats and other predators. Phairote was the man who fought to create the sanctuary 14 years before. Now, as deputy director of the Royal Forest Department, he found himself under growing pressure to "utilize" forests. Data on the amount of space needed by wide-ranging big cats would provide sound argument for continued protection.

New radio telemetry technology would supply that information. Alan was the first researcher to radio-collar and then track the movements of predators using headphones and an antenna that resembled a 1960s TV antenna. Though he collared leopards in his two years there, he never caught a tiger. The species can coexist, but they don't live together in large numbers. The many leopards meant there were few tigers in his study area. He found more signs of tigers in

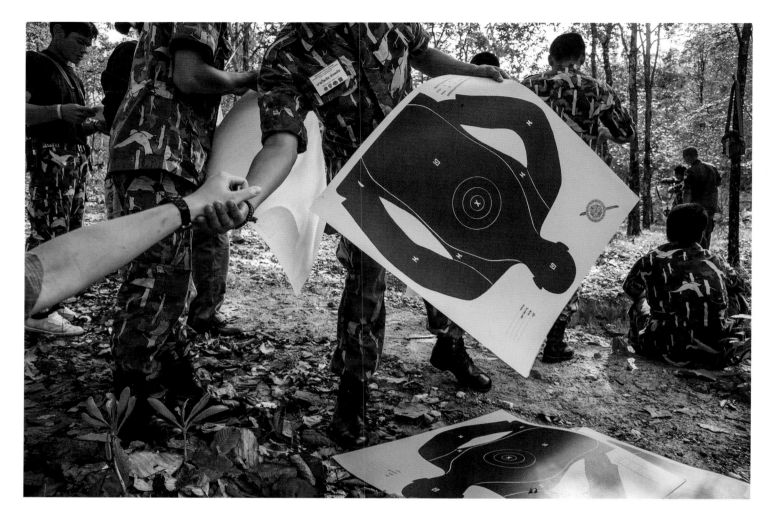

Above: Tiger killings by heavily armed poachers have grown so widespread that some countries, including Thailand, have resorted to commando-style protection. *Below:* Some poaching methods are harder to combat, such as the use of carbofuran, an odorless, tasteless purple pesticide used to poison tiger bait.

the remote river valleys where the large hoofed animals they prefer to eat hadn't been hunted out: huge sambar deer and the hefty, bull-like banteng and gaur.

A long history of hunting had put HKK on a downward slide. Well-armed outsiders—city dwellers, police, and soldiers—targeted high-priced items that included various animal parts, exotic birds, and baby monkeys for the pet trade. Loggers also hunted in the forests they cut down, shielded by the big companies and politicians who provided legal cover for "timber concessions" or "reforestation projects." The extent of the problem grabbed headlines in 1973, when a military helicopter crashed returning from Thung Yai forest (which adjoins HKK), carrying an illegal hunting party of senior military officers, wealthy industrialists, and a film star. Carcasses of endangered animals were retrieved from the wreckage. In response to the scandal, Thung Yai was quickly designated a wildlife sanctuary, with public outcry dwarfing long-standing opposition from timber and mining interests.

But another factor in the park's demise were hill tribes who lived within its boundaries. Somewhere between 3,000 and 5,000 Hmong lived there, notorious hunters who migrated from China during the 18th century, along with several thousand Karen, a group mostly centered in Myanmar. Evidence of hunting was everywhere. Macaque skulls hung over the entrance to Karen huts. Tusks and antlers graced Hmong altars. Deer and other animals smoked over cookfires.

More collateral damage came from outside villagers who felled trees and ate bush meat. Rangers suspected that at least 60 poachers roamed the park on any given day, staking out the salt licks and waterways that draw wildlife. The few park guards carried weapons so old they belonged in a museum. There was little they could do.

Alan questioned locals about the contradiction between their Buddhist beliefs and taking animals' lives. They were aware that killing didn't jibe with the Buddha's teachings on respect for all sentient beings, but they justified their actions with the conviction that wildlife was created for man's use. They didn't hunt on *wan phra* (Buddha days) that correspond with the new,

full, and quarter moons. On the days they did hunt, they didn't discuss Buddha or monks or sit in the lotus position. They "offset" some of hunting's bad karma by giving a young animal (the baby of the mother they'd just shot) to the local temple—or by placing the best cuts of meat in monks' bowls as they made their rounds for the daily meal given them by local people.

There were big markets for wildlife. Though the government vowed in 1987 to control trade in 5,000 endangered species, Bangkok's big weekend market was littered with hundreds of cages containing everything from birds and snakes to wild cats—though the Wildlife Department was two miles away. "Eating Out" sections in major newspapers still published rave reviews of restaurants serving wildlife dishes.

The situation in HKK grew ever more dangerous. Gunshots, often frighteningly close to camp, kept Alan awake at night. His collared study animals disappeared without a trace. He drove his motorcycle into a punji stick trap meant for park staff; it thrust a bamboo spike clean through his foot, a severe injury that required surgery and two weeks' recovery in a Bangkok hospital. Saksit, who did extensive fieldwork with Alan as part of a master's thesis, stumbled upon a poaching party and was forced to hide until he could slip away under cover of darkness. A forest officer who energetically pursued hunters and loggers was ambushed and murdered. Two rangers died in a gun battle with Hmong poachers; in the ensuing months, Phairote resettled many tribal villages outside the park.

But there was another more insidious, immediate threat. The proposed Nam Choan Dam would inundate 46 miles of river valley, flooding the rich lowland heart of tiger country. At the time, the prime minister's office was calling dam opponents "gunrunners, hunters, and communist insurgents." But amid a groundswell of national resistance, the government shelved the dam project, a move that had little to do with environmental protection, but was really just a façade to save face at home and abroad.

When Alan completed his research in 1989, he shared the data with Phairote with the warning that if tigers and other wildlife were to survive,

HKK must be kept inviolate at all cost. Phairote went on the offensive. He'd been promoted to director-general of the forest department; during his first six months on the job, his men tallied nearly 5,000 arrests, implicating high-ranking police officers, prominent businessmen, government officials, and politicians. He launched a controversial plan to convert the forest outside HKK into a buffer zone. And he asked Seub Nakhasathien, a senior, well-respected wildlife researcher with the forest department to clean up Huai Kha Khaeng, appointing him director.

Though Seub was on the cusp of taking leave to study wildlife biology, he agreed to take the job for a year—and dove in. He co-authored a proposal with British biologist Belinda Stewart-Cox to permanently protect the region under World Heritage status. He went after the poachers who overran the park, and when he discovered that the army was involved, he halted their "strategic training exercises" that were really hunting parties. When he uncovered a huge logging operation, he and a videographer hid out waiting for the perpetrators to return for the timber—and documented a policeman among them who was using a police vehicle. The incident couldn't be buried: The footage aired on national TV. When Seub received death threats, he bought a bulletproof vest. But he lacked money, manpower, and support from higher-ups. It was a dangerous, fetid situation, and he despaired over the disappearing jungle and the continued demise of the animals he loved. In the wee hours of September 1, 1990, the sound of a single gunshot echoed from his cabin. He killed himself.

His suicide was front-page news. Two thousand people from across the country attended his funeral, voting for conservation with their feet. A few months later, UNESCO inscribed the Thung Yai-Huai Kha Khaeng Wildlife Sanctuaries on the World Heritage List, the first in mainland Southeast Asia.

Seub became a conservation hero and his death galvanized Thailand's environmental movement. A stream of dignitaries visited HKK and the park became a focal point for King Bhumibol Adulyadej and Queen Sirikit, who erected a statue of Seub there—one of the country's few statues of anyone

"Smart Patrol" recruits train with military and police in Huai Kha Khaeng. This elite armed force fights illegal activities with roving foot patrols and uses digitally mapped field and intelligence data to monitor threats and strategize enforcement of poaching and illegal logging.

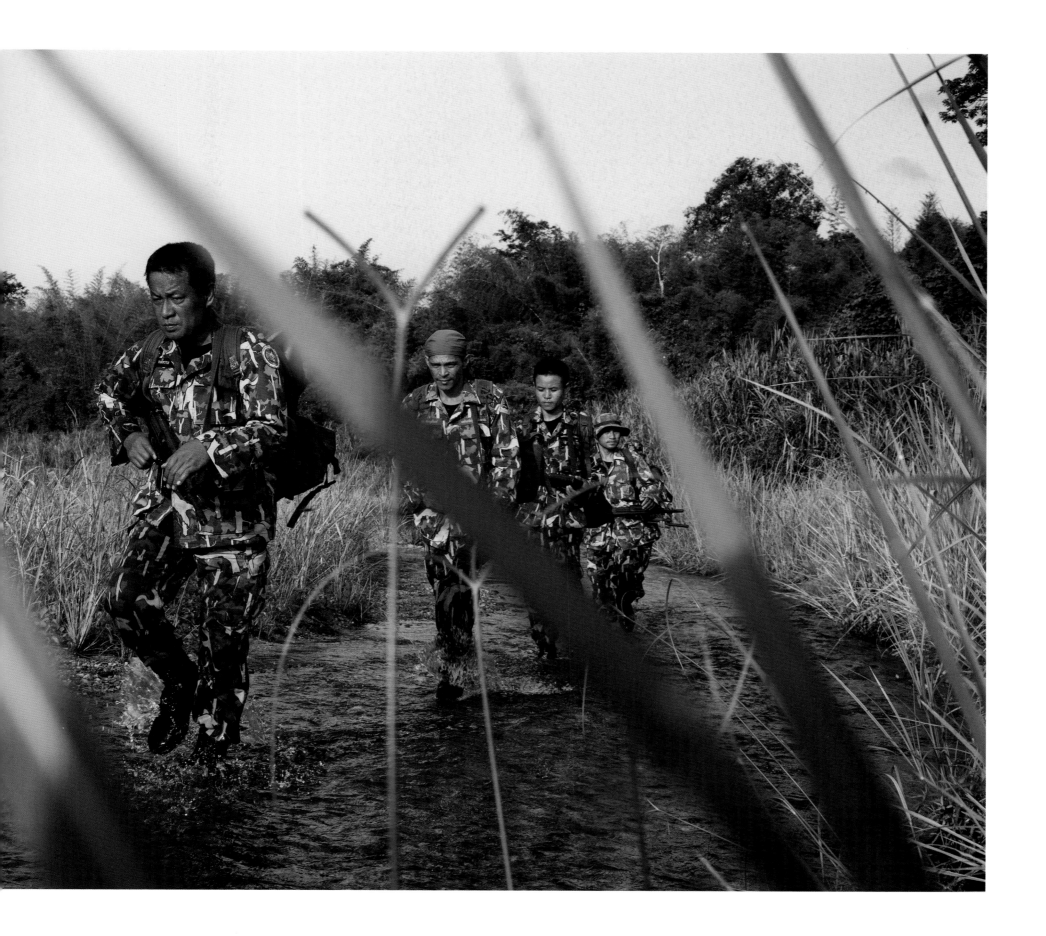

except Buddha or the king. They funneled money into the sanctuary to beef up enforcement. When a half million dollars in donations streamed in to support conservation, a foundation was established in Seub's honor.

His cabin has been kept intact, an environmental shrine. In the bedroom, where he ended his life, there is a table with pictures of his daughter, park guards, and wildlife. Beside the table sits a pair of shoes.

WITH INNOVATIVE ENFORCEMENT, Huai Kha Khaeng was a very different place by the time I arrived in 2010. I requested permission to photograph the renowned force that guards it and a few days later, near dawn, I met a six-man "Smart Patrol" at their barracks near park headquarters. This was no ragtag outfit. They were dressed in crisp, camo uniforms and spit-shined boots and were already plotting the day's route when I arrived. We'd be investigating a tip from a local informant.

We drove out the main gate, then walked into vegetable fields that abutted the sanctuary. Within 20 minutes, a guard spotted a trip wire running across a furrow. It was a jury-rigged gun trap: a slim pipe, a bullet, and black powder wired to shoot anything that came to eat the crops. Those animals then became dinner. The men dismantled six traps; one had already been tripped. They followed a trail of blood until it disappeared.

Smart Patrols began in 2006, a collaboration between the Forest Department, the Wildlife Conservation Society (WCS), and Panthera, with a Tigers Forever grant for a half million dollars. This elite, military-style force combines roving foot patrols with digitally mapped field and intelligence data to monitor threats—and strategize enforcement. Now, 190 rangers walk more than 8,000 miles a year, covering most of HKK's core territory. The Thai government pays their salaries; Tigers Forever provides uniforms, food rations, and equipment.

In the field, I watched how the system worked. As we walked along the sandy Huai Ai Yo river, we spotted a cat's pugmark, a recent campfire littered with garbage, a dead banteng beside a trail. Footprints. Shotgun shells. We checked in at a lookout blind positioned near a salt lick that drew animals, one of many secret hideouts where rangers watched for poachers. With each new find, a ranger entered a description and our coordinates into a handheld GPS device while another photographed the scene.

Back at headquarters, the team entered and mapped their data to pinpoint crime hot spots. Tips from local people (who are rewarded with a few *baht*) are also recorded: someone who was seen with a gun, wild meat for sale in a market or served in a restaurant, or trapping, logging, or other suspicious activities. These maps track incursions and help teams plot monitoring routes. It's this use of intelligence data that dubbed them Smart Patrols.

I spent two days with Thai military and police officers during law enforcement training exercises with new recruits. When I arrived in the early morning, they were doing boot camp calisthenics, then marched outside for target practice. Former soldiers and others with firearms experience quickly displayed paper targets with gaping holes in the head and heart; others missed the targets completely. All were trained to use shotguns and semiautomatic weapons and shown how to clean them; guns rust instantly in the tropics without proper care. They also learned how to disarm and handcuff a suspect, how to navigate with a compass, and how to use a GPS and mapping software.

This well-trained, well-equipped Smart force was one part of a larger Tigers Forever protocol adopted in 2006 to improve overall tiger protection. (HKK was one of the program's first field sites.) Once strict enforcement was added to decades of dedicated management and solid, ongoing research, poaching dropped, tigers increased, and prey is holding steady.

In 2004, Saksit collaborated on a camera trap survey to quantify tigers. He and his team estimated 60 adult tigers living in HKK and 120 across the Western Forest Complex. These landscapes could easily support three times that. Today, monitoring and other research continues, overseen by Saksit who now directs the Forest Department's regional research division.

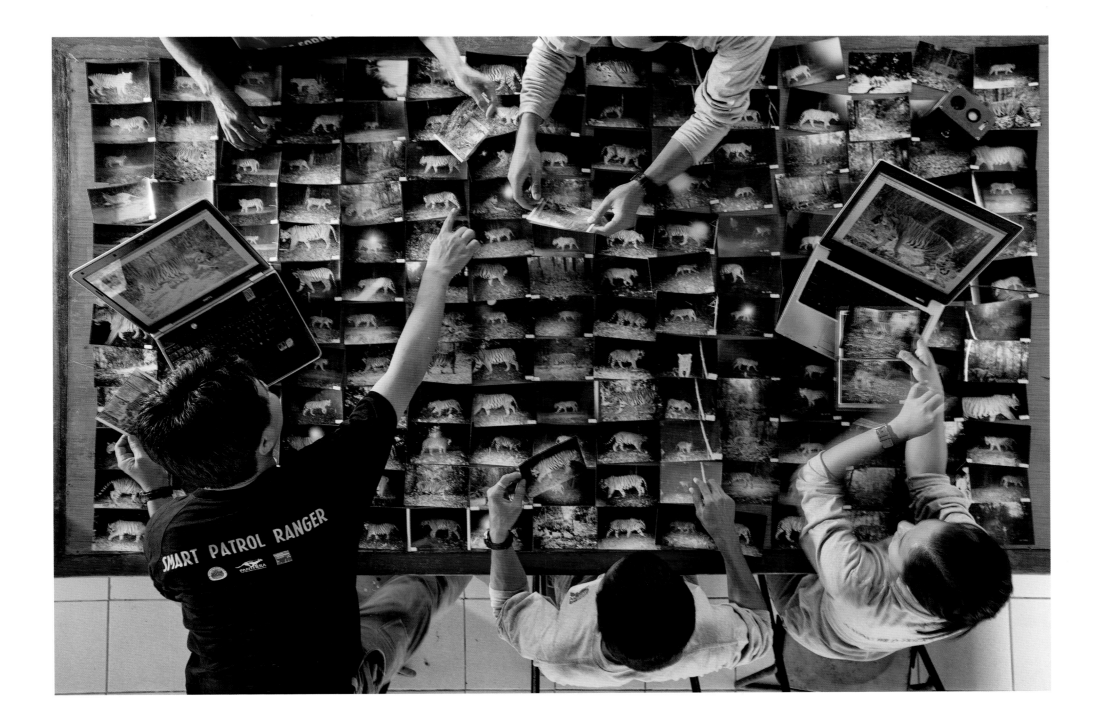

"Tiger Team" researchers examine camera trap pictures from Huai Kha Khaeng Wildlife Sanctuary. Thousands of photographs are helping to track tigers' movements—and to estimate tiger numbers and the type and amount of available prey.

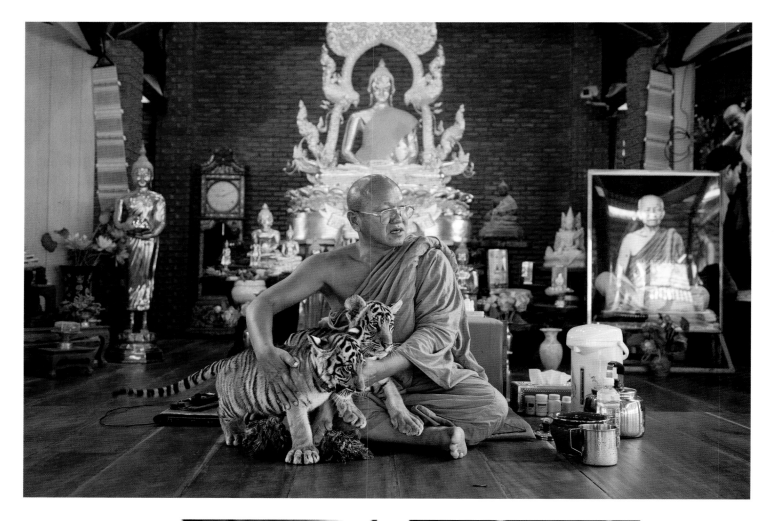

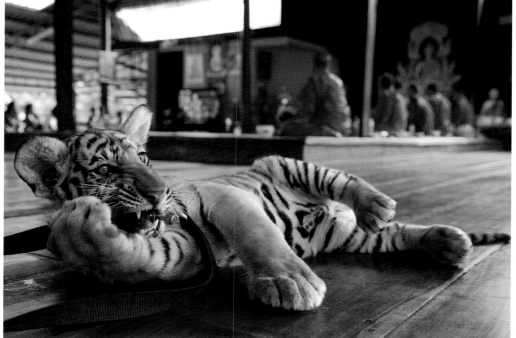

Young cubs sit with a monk, above, and one lounges, below, inside Thailand's Tiger Temple, a thriving tourist attraction. The facility illegally keeps and breeds the cats, starting from a few cubs in 1994. It now houses an estimated 130 tigers.

He and Achara are about to publish the results of the study that I photographed. They found that a female's mean home range was quite large, 27 square miles. The area a tigress needs to feed herself and her cubs correlates with how much prey is available—with less food, she needs more space, which is the case here. Counting prey also helps determine how many breeding females could survive within a specific region—and to what degree tigers can bounce back. And the tigress-to-prey ratio is a way to gauge conservation success. With too few tigers or too little prey, poachers are winning the war.

Smart Patrols are expanding into neighboring Thung Yai. Some small teams are deployed elsewhere, but poor protection in most parks means that tigers are holding ground in very few places besides HKK. The Thai government has been aware of dramatic declines across the country for decades. Back in 1993, Alan published a study documenting tigers in just over half of protected areas. "All of Thailand's tiger populations are in danger of further decline due to poor management and continued human encroachment within protected areas," he wrote.

In 1999, when Tony Lynam surveyed Khao Yai—the country's flagship national park known as "the land of the tiger"—he didn't find any tigers. When he widened his search, he found evidence of just one. Government officials were furious, insisting there were at least 25 to 30 in the park. To this day, some still stubbornly believe that Khao Yai is tiger heaven: At a recent strategy meeting among park managers, some wondered why no one was representing Khao Yai. No tigers have been seen there since 2003.

Some of the reason for this is cultural: In Thailand, politeness sometimes conjoins with strong hierarchies in a way that makes it impossible to discuss—or solve—problems. In real terms, shining a light on an issue may be treated as an attack or could cause someone to lose face: They may be transferred or lose their job. And as Seub and others have demonstrated, there is a long history of official complicity in environmental crime.

HKK has a specialized wildlife crime unit with eyes that extend outside the sanctuary. While I was working there, the unit received a tip that a nearby temple was selling small glass amulets with tiger skin inside. An agent bought one; Achara conducted DNA tests and confirmed it was indeed tiger. Action on the matter stopped somewhere up the bureaucratic ladder. The reason: Officials didn't know if the skin came from farmed or wild tigers. And, most likely, they felt they couldn't touch a monastery.

I'd never even heard of a "tiger farm," but I discovered that there are as many as 1,800 tigers in Thailand's 21 documented farms, maybe eight or nine times as many as there are in the wild. In theory, they breed tigers for zoos, but there are far more lucrative markets. Last year, two farms were investigated after a police seizure of 1,000 pounds of tiger meat. Though the owners were cleared, investigators noted that "some of the ages [listed on official paperwork] did not match the physical appearances of some tigers." According to Edwin Wiek, founder of the nonprofit Wildlife Friends of Thailand, farms and zoos ensure that the number of tigers registered with the government is correct, but they probably don't register all their cubs. This enables them to sell older tigers. "This is exactly what wildlife traffickers have told me for years; old tigers (mostly male) can't be used for shows with people, do not deliver babies . . . get aggressive and eat more than other tigers," he says. Upkeep costs at least $3,600 a year. Wiek says, "They can turn the burden into profit if this 'overstock' of animals is sold on the very profitable black market."

Other facilities like the Sriracha Tiger Zoo near Bangkok are also suspect. It's run like an amusement park but inexplicably houses hundreds of tigers, breeds the cats without a permit, and was caught illegally shipping 100 live tigers to China in 2004. Three government officials who signed the export papers (in violation of CITES, an international treaty barring trade in endangered species) were transferred to other posts—essentially slapped on the wrist. The "zoo" is still a major tourist destination.

Thailand has long been considered a wildlife supermarket. It's also the hub of Southeast Asia's commerce in tigers, with both live and dead animals and tiger parts smuggled into and out of the country across porous borders with Laos, Malaysia, and Myanmar. Between 2002 and 2009,

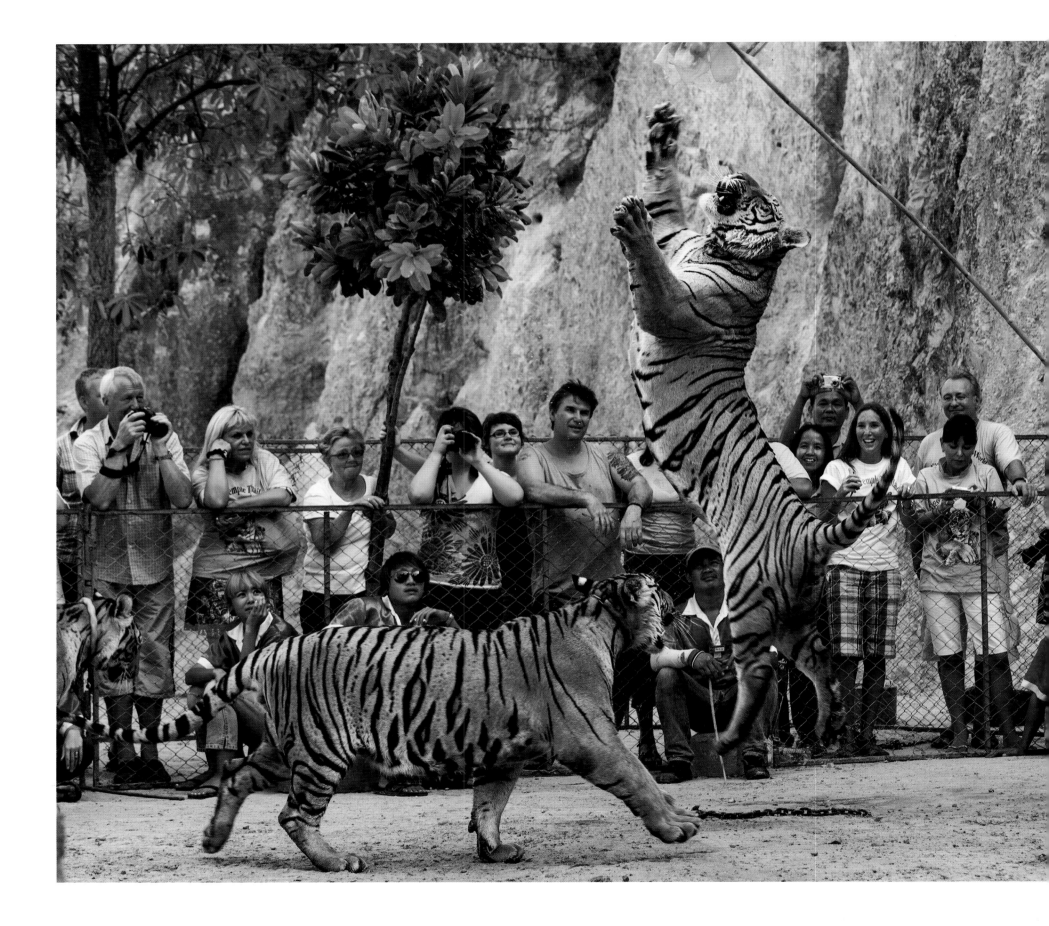

Tourists at the Tiger Temple view a "tiger enrichment" show. Young tigers entertain tourists daily, but adults rarely leave tiny, decrepit cages and are often beaten. There is documented proof of sales to tiger farms in Laos that illegally traffic tiger parts.

282 parts of tigers and other large cats were detected in markets on the Thai–Myanmar border. Some of them are Thailand's tigers. Government officials wrote in their Thailand Tiger Action Plan 2010–2022 that, "direct poaching of tigers is expected to increase." They're ultimately headed for Laos, Vietnam, and especially, China.

To stanch the flow of dead animals across the border, Lynam has spent more than a decade building collaboration between park guards and border police. There are occasional high profile arrests, like that of a woman recently nabbed by customs officials who smuggled a live cub through Bangkok airport in a suitcase stuffed with animal toys. All in all, wildlife law enforcement is patchy, and lax laws offer no deterrent. "You can be caught with a dead tiger in your trunk and get off with a $1,000 fine," says Lynam, that's made up on the next sale. "There are going to have to be some very serious changes in the way people are punished for these crimes."

Tiger farms also operate in Laos, Vietnam, and China. After China banned tiger bone trade for medicinal uses in 1993, commercial breeding boomed— despite a 2007 CITES decision to phase out tiger farms. In 1986, there were about 20 captive tigers in China; today there are 5,000 to 6,000 tigers in perhaps 200 farms, ranging from small facilities to massive breeding operations, with two of those housing more than 1,000 tigers, according to a 2013 report by the U.K.-based Environmental Investigation Agency (EIA). Many are run as tourist attractions, with some facilities even masquerading as tiger conservation sites. Under regulations introduced in the last ten years, "utilization"—aka sale—of certain products derived from captive-bred endangered species, including tiger skins, is *legal*. This trade is perpetuating demand, and stimulating poaching, says EIA lead investigator Debbie Banks.

At the March 2013 CITES meeting, tigers were given just 15 minutes on the floor. But signatories voted to speed review of efforts to combat illegal trafficking and to end trade in parts from captive-bred tigers.

The incident with the local temple prompted me to look deeper into possible connections between Thailand's Buddhist temples and the tiger

trade. That led me to the very controversial Wat Pa Luangta Bua Yanna-sampanno Forest Monastery, better known as the Tiger Temple, where I spent two days photographing. On the outside, it's a Disneyland-ish place where monks walk strangely lethargic tigers on leashes and tourists feed cubs, bathe an adult, or watch them jump after garbage bags waved on a pole. Many have pictures snapped with a tiger's head in their lap. About a dozen cubs and young tigers are trotted out for tourists each day, but behind the scenes, life for the rest is grim. The adults are crammed into tiny, decrepit cages 24 hours a day, often beaten and dragged around by their tails (which can cause spinal damage). Many are deformed from a diet of chicken and vegetables that lacks needed nutrients provided by red meat.

There are at least 130 tigers on the premises, according to Sybelle Fox-croft, a Care for the Wild International (CWI) investigator. That popula-tion grew from a few cubs purportedly rescued and donated to the temple when it opened in 1994. The temple is not licensed to breed or even keep captive tigers. In 2002, the Department of National Parks "confiscated" the cats, keeping them at the temple "temporarily" until they could be relocated to a suitable sanctuary. That day never came.

Sometimes tigers mysteriously disappear, and a 2008 CWI report exposed where some of them went. They discovered a contract signed by the temple's abbot with an illegal tiger farm across the border in Laos PDR. Laotian farms are known to breed tigers and then kill them for trade.

The Tiger Temple alleges a conservation role, claiming since 2003 that they're building "Tiger Island" to release the cats back into the wild. It's an impossible claim, given the tigers' time with humans and total lack of hunting skills. The International Tiger Coalition stated in 2008 that the temple makes "no contribution whatsoever to wild tiger conservation."

Yet the temple still pulls in a small fortune from tourists (mostly Aus-tralian tours) and donations; little of that money goes toward the tigers' care. Associated Press journalist Andrew Marshall questioned the temple vet, Somchai Visasmongkolchai, about expenditures in a 2010 interview; the vet revealed that the temple had recently "donated" 700,000 baht ($23,490) to Thai police and soldiers. He didn't say why.

I'D PHOTOGRAPHED TRANQUILIZED TIGERS and captive tigers, but no wild ones. When I came to Thailand, I'd assumed that camera trap-ping would be relatively easy. But each time I downloaded memory cards, I found pictures of other animals, of monks, or of people walking by. With many Buddhist shrines throughout the park, it was impossible to know whether those people were pilgrims or poachers. We occasionally saw tiger's pugmarks or claw marks raked into trees, and once heard roars, but I wasn't getting pictures and we couldn't figure out why.

Then a male tiger was killed, and shortly after, a tigress with two cubs. In each case, someone shot a banteng and poisoned the carcass with carbofuran, which costs just $1 for a small bag. A guard found some piles of the purple pesticide on the ground, a few entrails, and the dead cubs.

I had to leave to work on a BBC tiger film in Bhutan. I left my assistant Joe behind to run camera traps. In all, it took three months to get one great frame and a handful of lesser ones. A few months later, I heard that Smart Patrol guards had made an arrest. They apprehended Nai Sae Tao after a shootout, confiscating weapons, snares, and a cell phone that held damning evidence: photos of him with a notorious Hmong poaching ring posing proudly with a dead tiger. Researcher's camera trap photos ID'd the cat as one from HKK. In 2012, the two gang leaders were sentenced to four and five years in prison respectively for killing four tigers, though they are suspected of killing ten. These are the longest prison terms for wildlife crime in Thailand's history.

After the gang's capture, patrols were increased and there has been no known tiger poaching incidents in Huai Kha Khaeng. It highlights one of the first things Alan told me about tiger conservation: "First and foremost, tigers need law enforcement and protection." ◊

TIGERS OF THAILAND

Tigers are rarely glimpsed in Huai Kha Khaeng Wildlife Sanctuary. So when I arrived, I set up remote cameras, and then joined researchers who were working in the field studying female tigers. I placed an infrared camera on a baited trap that the "Tiger Team" used to capture and then GPS-collar a tiger to track its movements. In three months, only a few tigers walked through my camera traps; I later learned that a poaching gang working the area had been arrested.

I CHOSE TO PHOTOGRAPH in Huai Kha Khaeng Wildlife Sanctuary after hearing about the Thai Tiger Team's extensive camera trapping success there. I set up ten cameras around the park, but it took three months to get a handful of images of just three different tigers. Our disappointing results were later explained when park guards found the remains of two tiger cubs and two adults, a male and a female, killed by poachers. Two gang leaders were slapped with the stiffest wildlife sentences in Thailand's history, four and five years in prison respectively, for killing four tigers. They are suspected of killing ten.

A nine-month-old tiger cub recovers after he and his mother
were captured and tranquilized for scientific research.

FOLLOWING PAGES:
Two tigers trigger a camera trap placed at a salt lick that
draws wildlife in Huai Kha Khaeng.

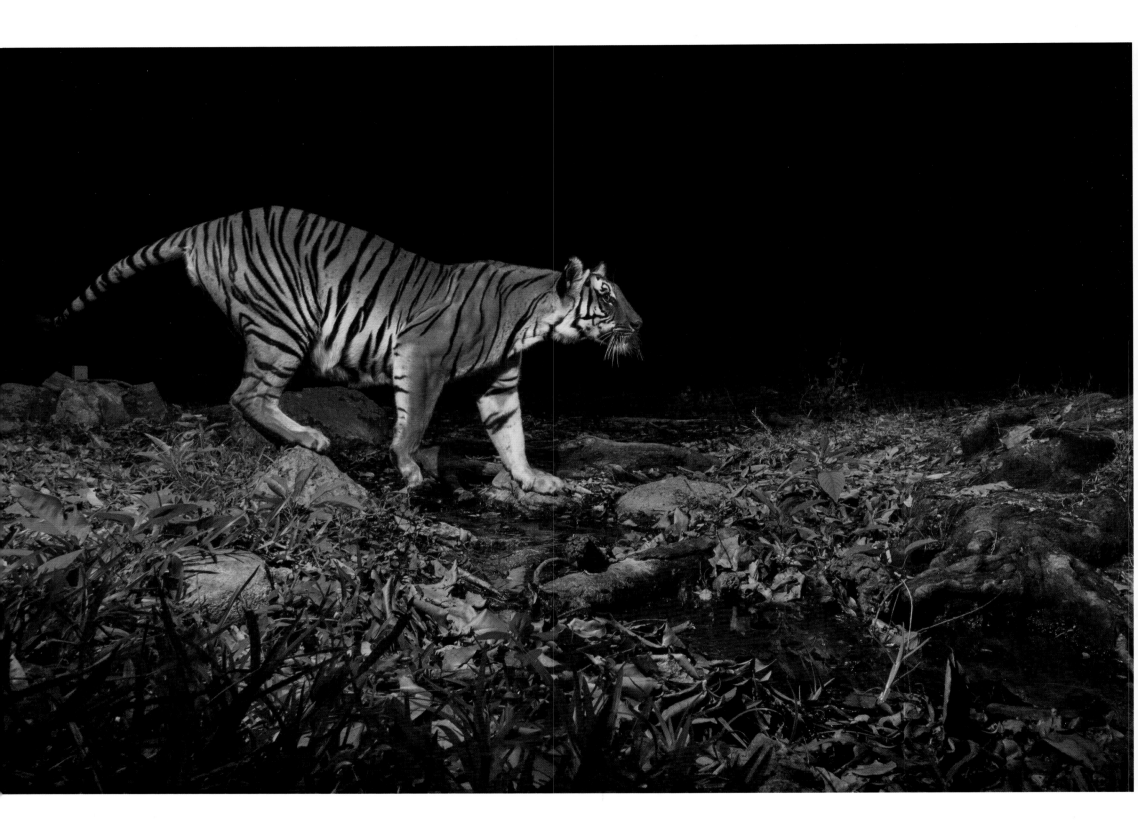

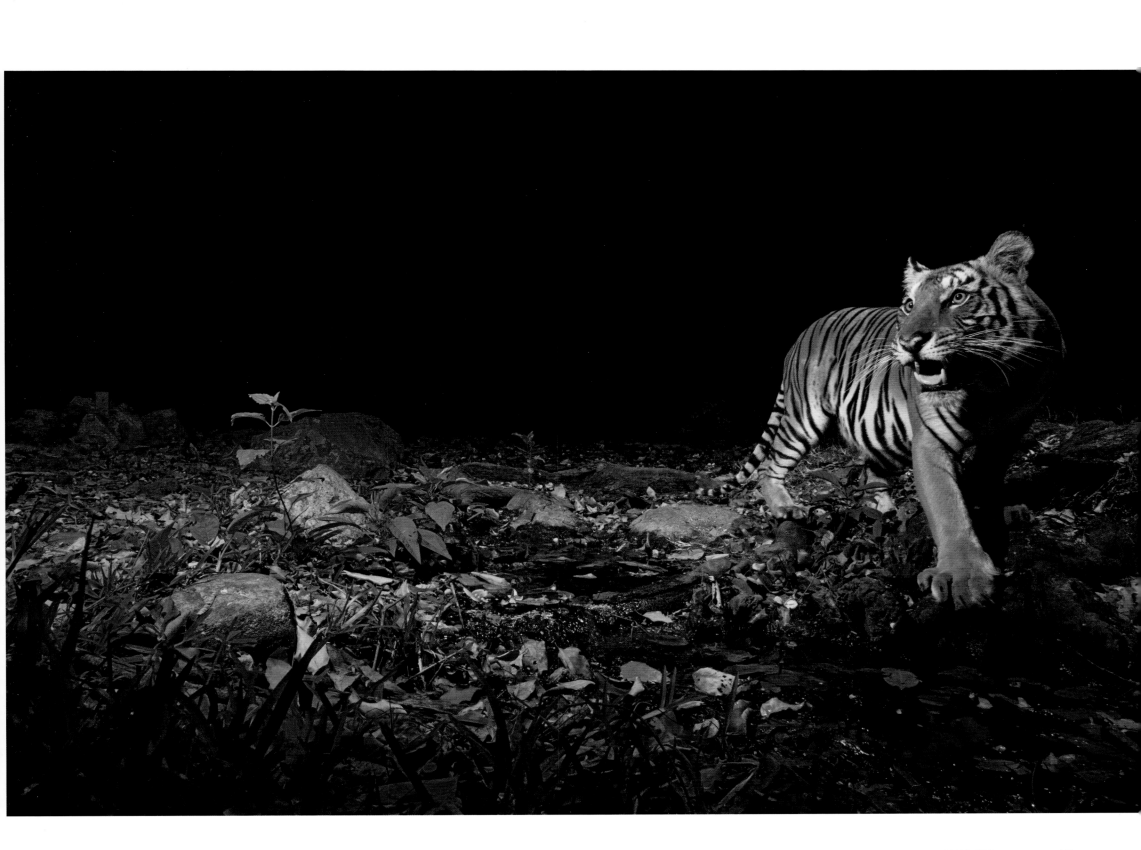

A tiger triggers a remote camera and takes a self-portrait in Huai Kha Khaeng. It's one of the park's 60 adult Indochinese tigers. A network of 17 preserves in the adjoining Western Forest Complex holds about 120 more. They are precious populations: The Indochinese is the next tiger subspecies in line for extinction.

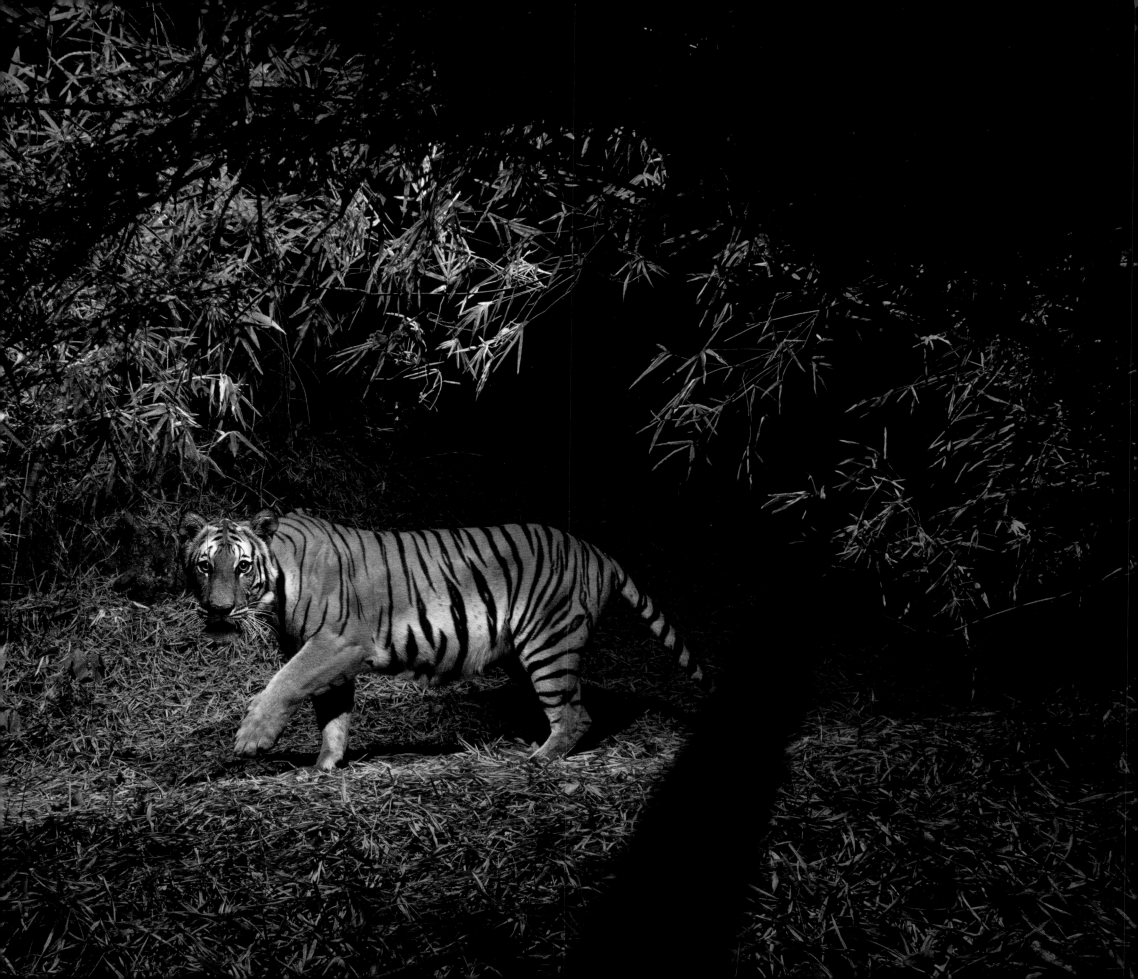

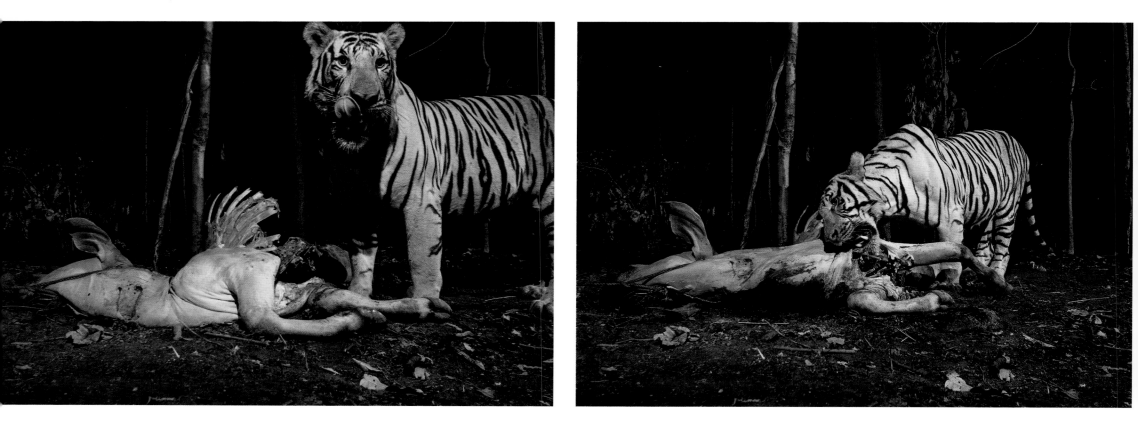

An infrared camera documents a tiger feeding on a cow. Researchers had tethered it in a clearing as bait. After the tiger had killed it, they circled it with snares to capture the cat when it returned to feed. They let it go: It was a male tiger. Had it been a female, researchers would have tranquilized her, drawn blood, collected fur for DNA tests, weighed and measured her—and outfitted her with a satellite collar that would allow researchers to track her movements on a laptop computer.

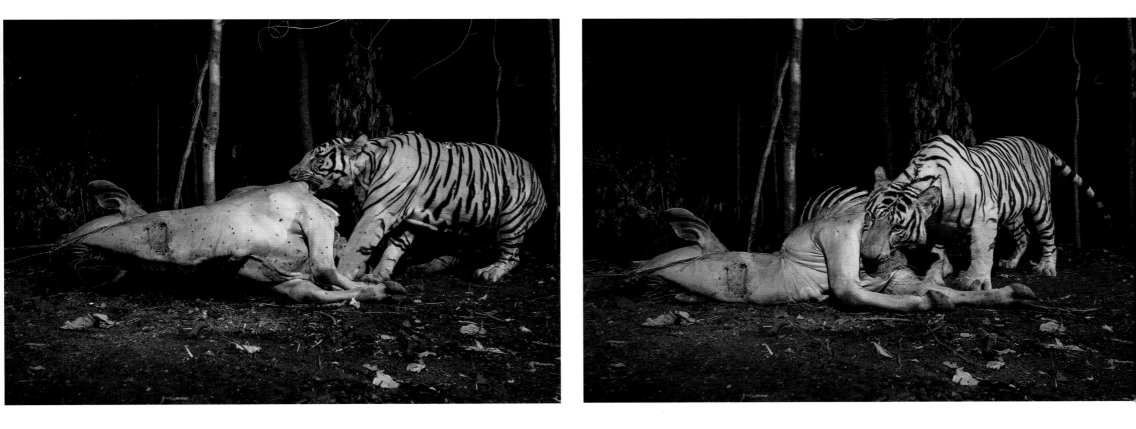

Using cows as bait, biologists captured and collared female
tigers to determine the size of their home range—and
how much prey is available for their cubs.

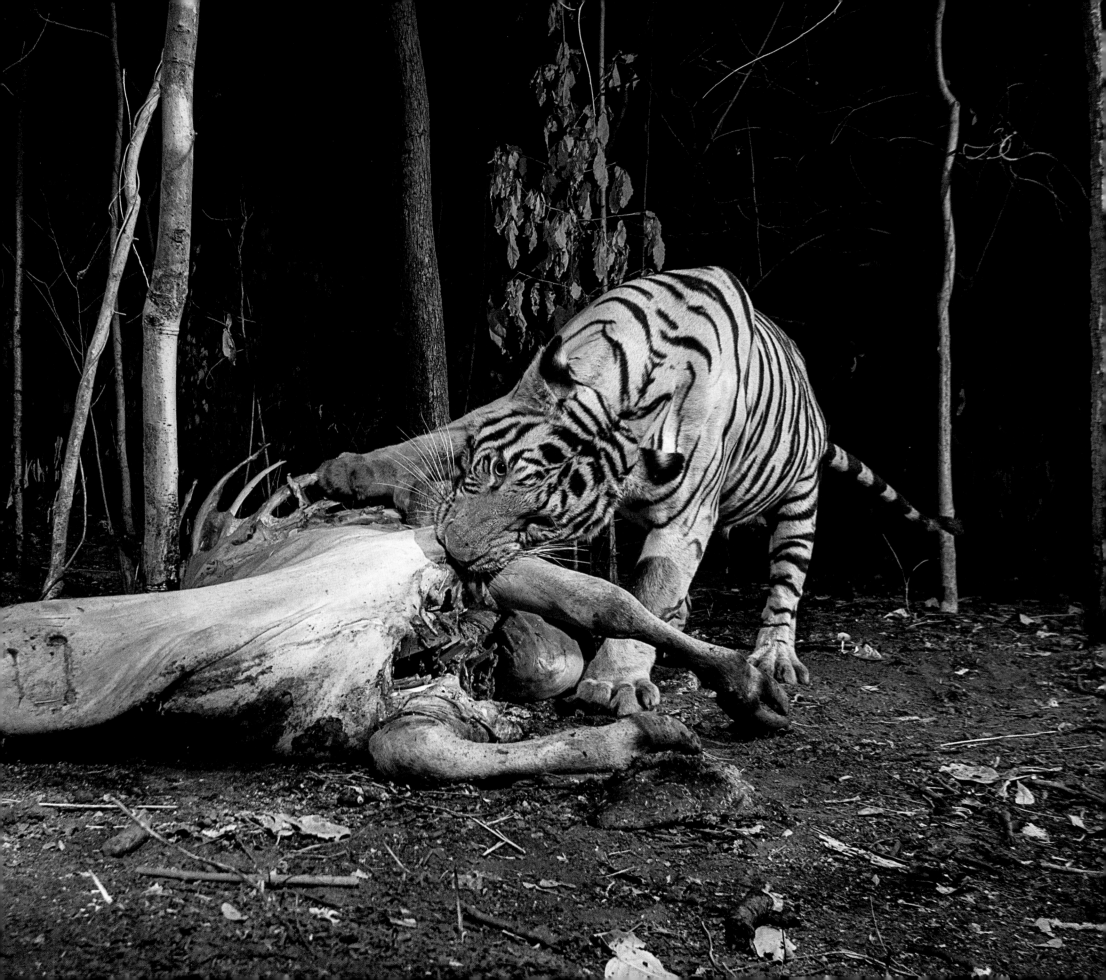

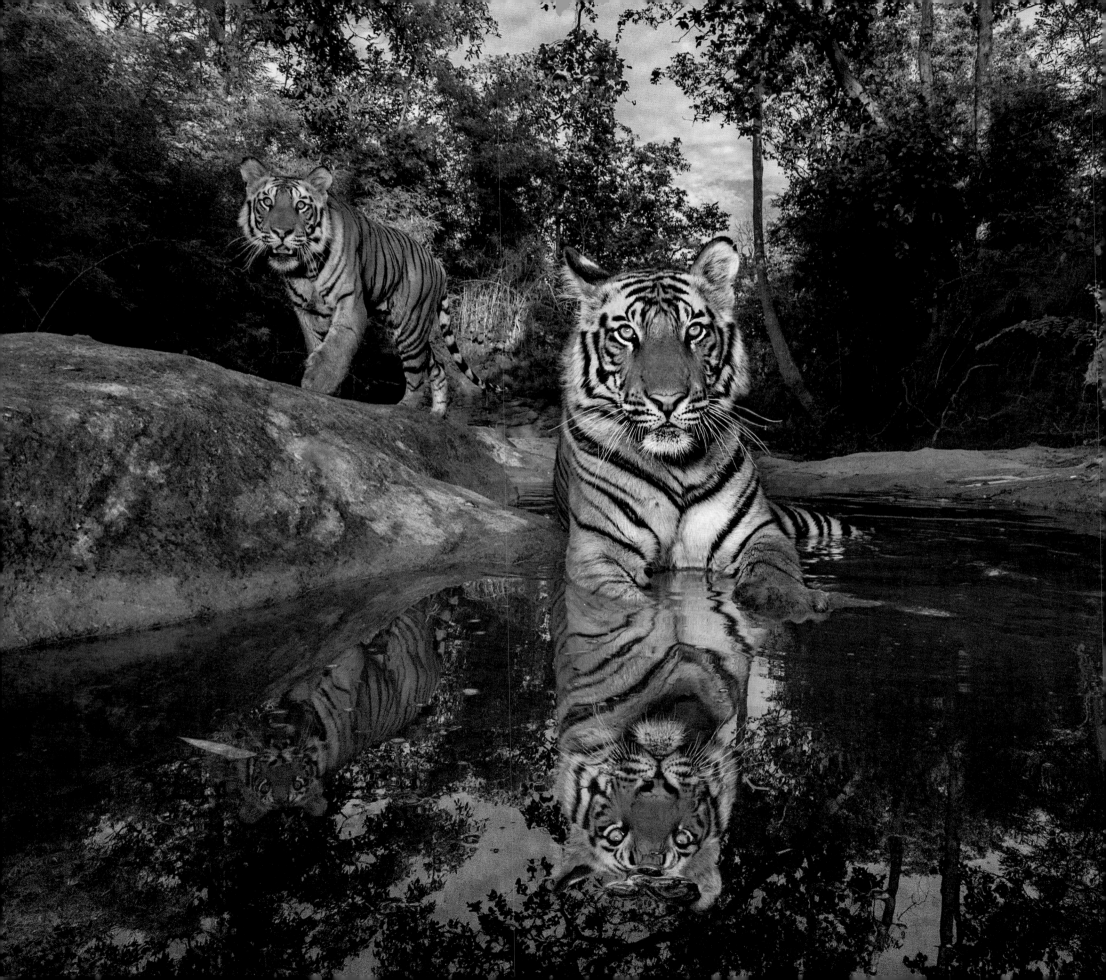

INDIA

BENGAL TIGERS

A camera trap captures 14-month-old sibling cubs cooling off in a
watering hole. Bandhavgarh National Park, India.

W e drove into the park at dawn, shivering in an open jeep, enveloped in the ghostly fog that shrouded the landscape. It was November 2010, early winter in central India's Bandhavgarh National Park. Tigers were still on the prowl this time of day and would be hunting until the sun climbed into the sky. Being out at sunrise allowed me to shoot in the early golden light. ¶ We'd had no tiger luck that day. In the late afternoon, I asked my guide, Hatsy Rathore, to take a lazy loop on the way back toward the gate. If we weren't out by dusk, I could lose permission to work there. We came upon a couple of vehicles packed with Indian tourists and pulled up beside them: It was a "tiger show." For the next hour, I photographed the three cats that lay sprawled,

napping, beside a prime watering hole, oblivious to the constant parade of some 15 jeeps that came and went. It was hard to believe these huge animals were barely over a year old. Over the next seven months, I would come to know them well.

They were still sleeping there the next morning. I snapped a few pictures, then lounged in the jeep reading a spy novel, waiting for decent light—and for them to wake. One of the two male cubs finally lifted his head, yawned, and ambled off into a meadow. His siblings stretched and followed. The female circled around, crouched behind some underbrush, and then sprang on her brother. One cat tore off, another racing behind, running along a berm above the pond. They dove in, water flying, chasing, rearing up on their hind legs, sparring. Back in the clearing, their brother leaped at them from a tree. They frolicked and pounced and played like couple-hundred-pound kittens for an hour and a half, then disappeared into a bamboo grove. After nine years of photographing in

tiger country—and glimpsing just a few of these magnificent animals—I now saw them regularly and watched them behaving like cats.

I COULDN'T HAVE DONE a tiger story without coming here: India is home to perhaps half the world's wild tigers. It's a miracle, really, that about 1,700 Bengal tigers still survive here amid 1.2 billion people and a booming, resource-hungry economy. (Most countries have lost their big predators: In the United States, we still shoot wolves and mountain lions.) With 51 babies born each minute, some 18 million a year, India should officially surpass China as the world's most populous nation by 2025. This population explosion increasingly pits human needs and the never ending push for "development" against protection of wilderness, wildlife—and tigers.

The Bengals range from frigid northern Himalayan forests south and east into jungles, deserts, mountains, and the Bay of Bengal's steamy

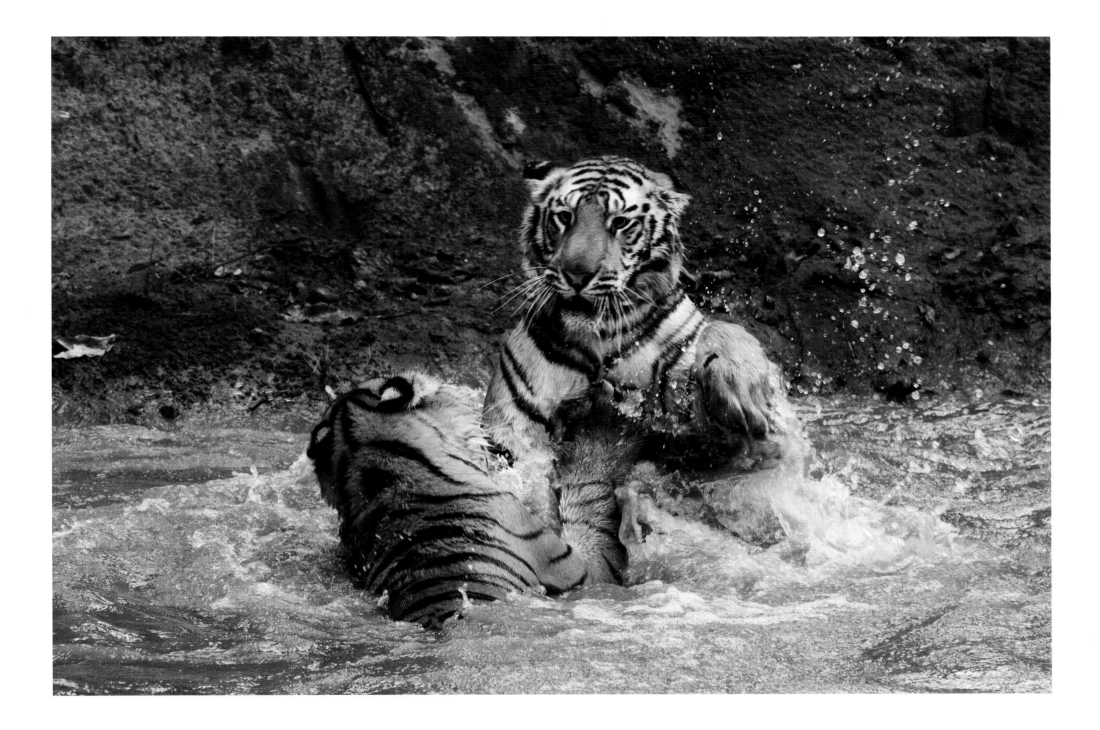

These 15-month-old cubs spar in a small pond, practicing fighting skills that will help them survive as adults.

mangroves, from India into Nepal, Bhutan, and Myanmar. Many survive in isolated pockets. But the Indian subcontinent is still blanketed with chunks of forest and 668 protected areas that run with deer, wild pigs, Asian elephants, water buffalo, and so many other species. Some parks are tiny postage stamps with small, highly managed tiger populations, much like open-air zoos. But in a few areas, reserves string together into large tiger landscapes that offer the best hope for their survival and recovery.

Here, images of tigers are everywhere, on logos, matchbooks, billboards, and advertisements. Inside Hindu temples, the warrior goddess Durga, slayer of demons, rides a tiger. The cat is, after all, the national animal and a cultural mascot. Ultimately, the future of many of the world's tigers rests with India. But saving them is a battle against time, and we are their only predator.

OUT OF INDIA'S 42 TIGER RESERVES, I chose to work in Bandhavgarh because of a dedicated field director, C. K. Patil, who understood the role of images in encouraging people to care about wildlife. He promised the special access I needed and gave me permission to put up camera traps. But the real draw was the chance to photograph two females with cubs.

I'd had to wait two years for photo permits from the National Tiger Conservation Authority—and I never would have gotten them without the help of Toby Sinclair, a close friend and tiger expert who works in natural history television and knows how to navigate a complicated system. Just after the authorizations arrived, Toby emailed me that two tigresses in Band-havgarh had birthed litters. I would have preferred to go during the scorching dry season when animals are drawn to the few water sources, making them easy to find. Though it would be harder to shoot there in winter, the lure of photographing the tiger families brought me there in early November.

When I landed in Delhi, I learned that both mamas had died. One was poisoned in retaliation for eating someone's buffalo. A park vehicle hit the other. Their four- and five-month-old cubs had been placed within large,

A tiger walks through a lush landscape in Bandhavgarh National Park in central India, one of the country's 42 tiger reserves. Though it's one of the smaller parks, these meadows, deciduous forests, and bamboo thickets are home to 59 tigers.

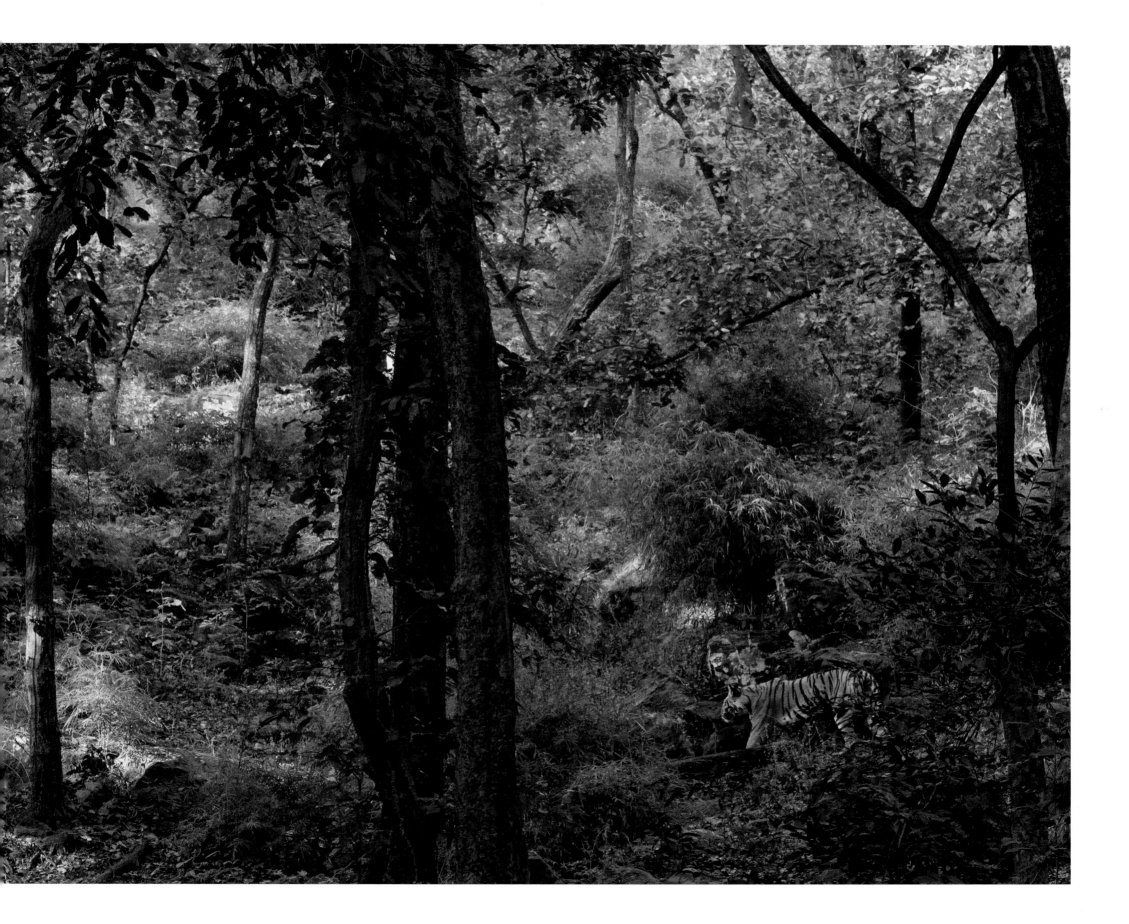

**Wildlife crime investigator,
India**

In April 1994, wildlife filmmaker Belinda Wright lived in her bungalow beside Kanha Tiger Reserve, the forest setting for Rudyard Kipling's *The Jungle Book* stories. Something was amiss. She'd been hearing gunshots, and reports were coming in from villagers and forest guards of animals being shot and poisoned. Tigers that she saw regularly suddenly disappeared—cats she'd spent years filming for her Emmy award–winning National Geographic film *Land of the Tiger*.

A shop owner approached her in town one day. "I've got four fresh tiger skins. Do you know anyone who wants to buy them?" he whispered.

PHOTO: WILDLIFE PROTECTION SOCIETY OF INDIA

She orchestrated a sting operation, coordinating "Firoz," a decoy buyer, with local police. Five people were arrested, uncovering a tiger-smuggling operation and proving what Wright had suspected: Tigers were being poached from Kanha, one of the original nine reserves created by Indira Gandhi's Project Tiger in 1973.

That summer, she and "Firoz" traveled throughout the state to gauge the situation. "To my horror," she said, "we were offered the skins and bones of 39 dead tigers with offers in practically every city and town we investigated." They identified 42 poachers and 32 dealers. Tigers were no longer just being killed for their gorgeous pelts. They were now in the crosshairs to feed a growing, voracious trade in tiger parts for use in traditional Chinese medicine.

Back home, the forest department was furious that she'd publicized the poaching problem—it was bad for their careers. After repeated harassment, she moved from the forest she loved to Delhi and launched a new career, going after poachers.

She was born for the job. As a woman and an Indian-born Brit, she could pose as a tourist and rouse little suspicion. It seemed she also had an uncanny knack for dealing with police, jailers, and prisoners. And she'd grown up around tigers. Her mother, Anne, was a founding member of Project Tiger's Task Force who first took her into tiger habitat as an infant. As a young girl, Wright roamed Calcutta's markets with her, where shelves groaned with skins headed for the United States and Europe, supplying a post–World War II fashion craze for fur. Anne notified the government that there were far more pelts than hunting or export permits that made them legal.

In 1994, Wright launched the Wildlife Protection Society of India (WPSI). Her mission was to help authorities combat the escalating wildlife crisis—and lock up people who were killing tigers, the animals she most loved. Since then, she and her colleagues have lured local tiger killers and gun-toting traffickers into custody, often placing themselves in great danger. She's established a nationwide informant network and helped expose a thriving cross-border trade of tiger skins flowing into Tibet. For nearly two decades, she's led the organization, assisting authorities in hundreds of arrests and seizures of tiger products.

WPSI investigates every Indian tiger death. Its massive crime database details 21,600 wildlife cases, with files on 16,900 offenders, including growing numbers of hard-core criminals and forest field staff attracted to the lucrative trade in tiger parts. But, Wright notes, arrests often mean nothing. An overburdened court system means that few offenders see jail time: Between 2000 and 2009, just 18 of 882 people accused in tiger cases were convicted.

"I know WPSI has played the primary role in exposing the problem, but we have not been able to stop the killings," she said. "For this I feel a deep sense of despair and failure." But, she adds, "To the day I die, I'll fight for the tiger." ◊

BITTU SAHGAL

Environmental writer, editor, publisher, filmmaker, and tiger expert, India

We know *how* to save the tiger; what we haven't effectively told people is *why* to save the tiger, says Bittu Sahgal. It's something he's spent decades trying to do.

Sahgal grew up amid the alpine beauty of the Himalayan foothills. But it wasn't until years later, on expeditions into India's national parks, that he developed his great love for the vast, silent wilderness—and the majesty of the tiger. His first glimpse came on a trip to Kanha in 1973 on an eight-day jeep and elephant-back safari. It was the same year Indira Gandhi launched Project Tiger to rescue the cat from extinction. Later that year, sitting around a campfire, he met Kailash Sankhala, the project's director, who captivated him with details about the workings of nature and his plans for tiger conservation. The man became a key influence and mentor.

Early on, Sahgal understood that you cannot save the tiger if you don't save the forest. When he discovered India's wildlands being ruthlessly leveled, he began defending them, using skills he'd gained working in advertising. He wrote newspaper articles and campaigned, sometimes successfully, against assaults on the land in key tiger habitat—particularly those near India's nine newly established tiger reserves. But it was another campfire conversation that transformed him from part-time activist into one of India's most influential tiger defenders. In 1980, Sahgal asked Fateh Singh Rathore, the head of Ranthambore Tiger Reserve, how he could help tigers. "Start a wildlife magazine," Rathore said, "so that city people learn to appreciate wildlife and do less damage!" *Sanctuary* was born ten months later, India's first environmental news magazine, which Sahgal still edits.

Then came a bimonthly kid's magazine, *Sanctuary Cub*, the 16-episode "Project Tiger" TV series (which was viewed by some 30 million people), a children's TV series on conservation, and postings to high-profile government and NGO committees.

Sahgal quickly realized that protecting tigers from poachers wasn't enough. Mines, dams, roads, chemical complexes, and nuclear reactors were creeping, like mange, into tiger habitat, he says. "Trying to protect wildlife without engaging with the people that were garroting our protected areas was not just a losing proposition, it was naïve." So he made his way onto Ministry of Environment committees regulating development. But with a booming economy, he and others who fought to protect natural resources were summarily dispatched "because our advice was found unpalatable."

His growing cynicism vanished after launching Kids for Tigers in 2002. The program has created a new generation of tiger advocates through nature walks, camps, and a curriculum used by 275 schools in 15 cities. Kids lobby at the national level. They march in the streets for tiger protection—and influence their parents.

PHOTO: PRADIP VYAS

Sahgal notes that the children seem to understand the larger rationale behind saving this iconic animal better than most adults. "By protecting tigers, India is saving forests that protect over 600 of its purest rivers, and in the process the forests sequester and store carbon in the most effective way possible," he says. "Tiger and all wildlife habitats are doing more to fight climate change and supply water than all of India's scientists put together."

Tigers are wide-ranging carnivores that need large, forested areas. Over the last century-plus, 70,000 to 100,000 tigers were shot, says Sahgal, but they kept reproducing because forests were extensive. "Today, shoot eight tigers in an area and you're faced with local extinction. They're like candles in the wind. If they're going to survive, we have to give them space. It's a space war." ◊

fenced enclosures deep in the reserve with the hope they might someday be released.

So when I got to Bandhavgarh, I set up camera traps. Over a watering hole. In a cave. On a trail. On a tree where a cat had scratched. Inside one of the cub's enclosures (using an infrared camera since I couldn't use flash). On a ruined chain-link fence where tigers left the park. I had special dispensation from Patil to get out of the vehicle to set up the traps; no one was allowed in the park on foot. We—my assistant Drew Rush, our guides Hatsy and Ramnaresh (Lala) Burman, and I—always had a ranger with us when we were on the ground. But guards in Bandhavgarh are unarmed so we needed to be vigilant. It was especially tense when cats were nearby, particularly the mother and her three big cubs.

Setting traps is always a never ending process. If a location isn't producing pictures or if I find a more promising spot, I take them down and move them. When I wasn't fiddling with traps, I photographed tigers from the jeep, or if I needed to go into the interior, I climbed on an elephant. I spent every day there from dawn to dusk. On assignment, there are no days off unless I'm too ill to get out of bed.

I regularly encountered roving tourist vehicles: Bandhavgarh's tigers draw about 100,000 visitors each year. That's both good and bad. Tourism pumps money into local rural economies and, most importantly, adds many more watchful eyes on tigers. On the flip side, there is little regulation and management so some of the parks with the best tiger sightings are overcrowded and have attracted hoteliers with little care for the environment.

Many visitors are avid amateur wildlife photographers. One of them—infuriated by my access—persistently filed complaints with the park director until I was forced to take down my cameras. Some had been up for six weeks, some for only a few days. It was a huge blow. I had just begun to understand the tigers' movements and had finally placed traps in the right locations. A call to the environment minister may have helped, but I didn't know that at the time. India's tangled bureaucracy is not easy to maneuver.

Remnants of an archaic colonial system remain. One of those relics is the Indian Forest Service that now handles tiger conservation. The British Raj established the agency in 1864 to supply the empire's timber needs for railroads and shipbuilding and the coal to power those trains and ships. Its role was resource use, not conservation. To this day, few agency employees have scientific expertise in wildlife or ecosystems. In an attempt to limit corruption, the British had placed three-year limits on job assignments; with this constant shuffling, most senior staff never get a chance to learn the workings of the environments they're charged to protect.

Under solid leadership, however, good things do happen. One example is the dramatic tiger recovery in Panna Tiger Reserve (just northwest of Bandhavgarh) from 1996 to 2002. The reserve thrived under a combination of excellent park management and intensive monitoring conducted by wildlife biologist Dr. Raghu Chundawat. During that six-year period, density increased from about two tigers per 38 square miles to seven. A more recent example is Dudhwa Tiger Reserve near the Nepalese border. In a matter of years, this tattered, defunct forest turned around and now boasts about 112 tigers.

It's not difficult to build up a tiger population, Chundawat says. Tigers breed well. The difficulty is protecting them over the long term. Gains can fall apart under a new director, especially if wildlife is low on the list for the state's chief minister (governor) who makes those appointments. What India needs is a brand-new agency, says Valmik Thapar, one of the country's premier tiger experts. He's fought for more than 20 years for the creation of a government agency mandated specifically to protect wildlife, similar to the U.S. Fish & Wildlife Service. He believes that without it, there will be little hope for both India's tigers and her wildlife.

INDIA'S TIGERS HAVE BEEN in the crosshairs for centuries. Friends in Delhi leafed through books of exquisite Mughal dynasty paintings,

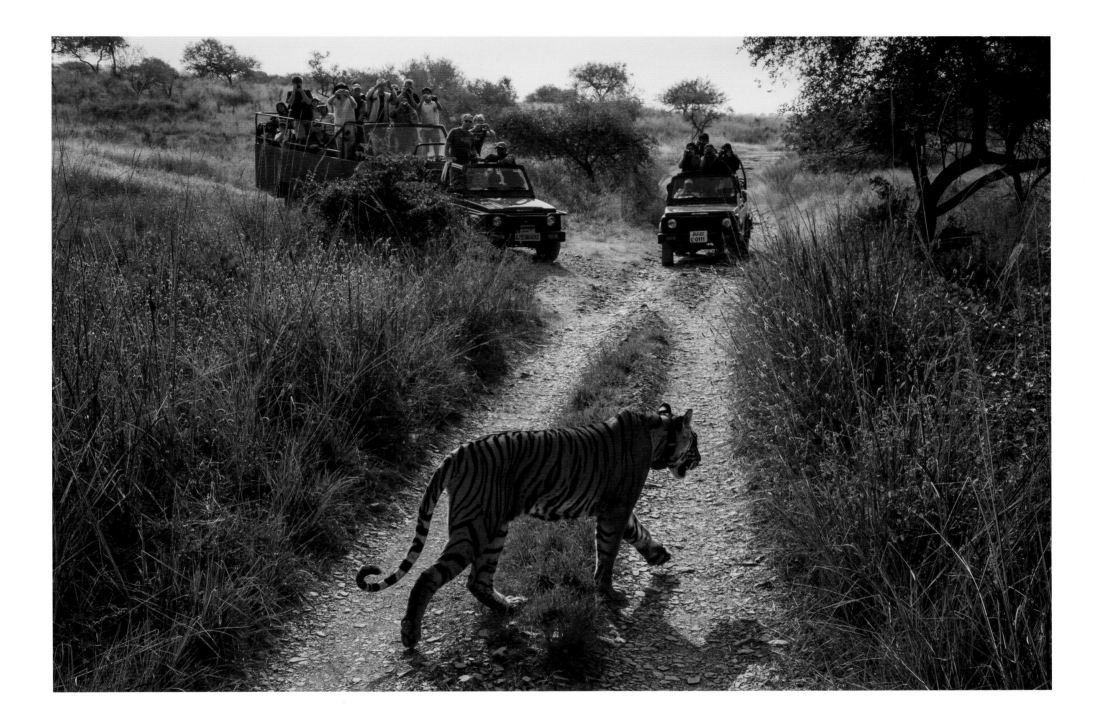

A caravan of tourists photographs a tiger wearing a satellite collar. Bandhavgarh's tigers draw about 100,000 visitors each year.

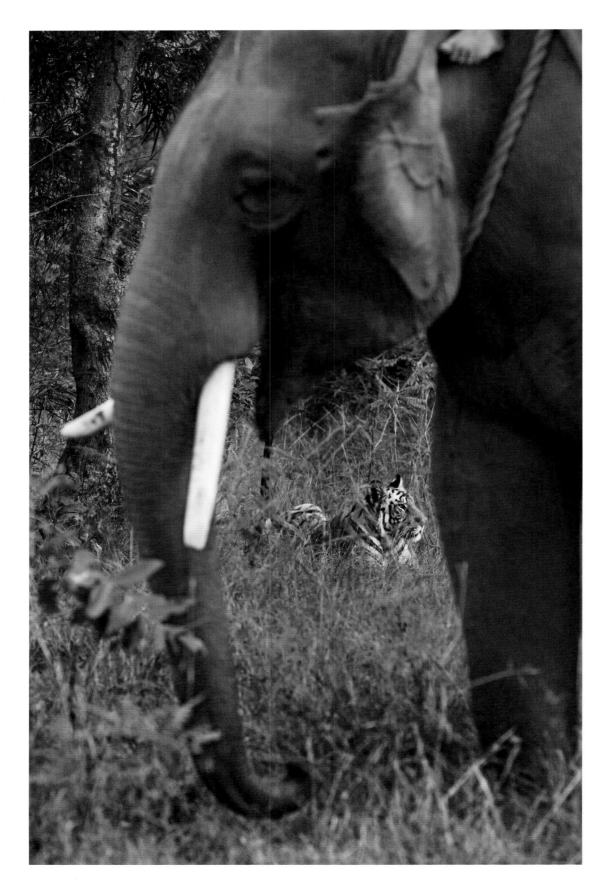

Within India's tiger reserves, guards in jeeps or on elephant backs heavily monitor tigers' movements to help protect surrounding villages.

showing me 16th- and 17th-century images of royal *shikars*, hunts that were staged as heroic sport—with *Panthera tigris* as the ultimate trophy.

After the paintings came the photographs: endless images of hunters posing proudly beside piles of cat skins and dead tigers. In some regions, they were considered vermin, exterminated as pests with added incentive from government bounties. Others were killed in elaborate hunts by Indian and British nobility. Kings and maharajas often drugged and baited their trophies before a shoot so hunters were in little danger. Historian Mahesh Rangarajan writes that "over 80,000 tigers . . . were slaughtered in 50 years from 1875 to 1925. It is possible that this was only a fraction of the numbers actually slain." Newly crowned Rewa kings in central India thought it auspicious to slay 109 tigers as they ascended the throne. Young princes killed tigers as a rite of passage. Ironically, the massive royal grounds used for these hunts are some of the largest remaining intact forests and are now some of India's most beautiful national parks and wildlife sanctuaries.

The killing escalated after 1947. Independence ushered in a hunting free-for-all similar to the 1880s shooting spree that decimated bison herds on America's prairies. Big game hunters streamed in from around the world, seduced by travel agency guarantees of tiger, rhino, and other trophies. Maharajas created staggering new hunting records: The Maharaja of Udaipur reportedly took down 1,000 tigers, and the Maharaja of Surguja claimed to have shot 1,150.

A tiger pelt cost $50 in the 1950s; ten years later, rugs and coats sold for $10,000. Western models and starlets sparked a fashion craze for fur when they draped themselves in cat-skin coats. Conservationist Anne Wright wandered Calcutta markets where shelves groaned with tiger skins, comparing them to permits. The numbers didn't add up: Export licenses had been issued for 3,000 tiger skins in 1968 against 500 hunting permits. Most were illegal.

Things changed, however, when Indira Gandhi took the reins as prime minister in 1966. She became what Thapar calls "India's greatest wildlife savior," spearheading a fight against the growing tiger crisis. She outlawed the export of skins in 1969 and appointed a Tiger Task Force two years later.

When Rudyard Kipling penned *The Jungle Book* in 1894, between 50,000 and 100,000 tigers were thought to roam the subcontinent; by 1971, about 1,800 were left alive and the task force predicted they would be extinct by the end of the century. That year, the Delhi High Court banned tiger killing, despite opposition from the trophy hunting industry that was raking in $4 million a year. Parliament passed the landmark Wild Life (Protection) Act in 1972.

Then in 1973, Gandhi launched "Project Tiger," which remains the world's most comprehensive tiger conservation initiative. Nine tiger reserves were established, guards hired to patrol them, and whole villages forcibly moved outside their perimeters. "The tiger does not exist in isolation," she said. "It is at the apex of a large and complex biotope. Its habitat . . . must first be made inviolate."

At the time of her assassination in 1984, tiger numbers topped 4,000, prey had increased, and India was recognized for creating a global model for wildlife conservation. "Tigers flourished beyond our wildest dreams," said Belinda Wright, Anne's daughter and director of the Delhi-based Wildlife Protection Society of India (WPSI).

Indira's son, Rajiv Gandhi, continued her legacy after taking over as prime minister. He passed the Environment Protection Act 1986 and amended Forest Conservation Act rules that had been designed, according to Indira, "to squeeze the last rupee out of our jungles."

The number of tiger reserves grew to 19 after he was voted out of office in 1991, but political will waned in tandem with economic growth. "The plunder of India's forests was in full swing. Laws, or no laws . . . it was all about greed now," says Thapar. Forests were razed, degraded, and submerged beneath dam floodwaters, pillaged by mining projects, and converted for industry and agriculture.

Tigers were vanishing. Rapidly. Biologists and conservationists who reported disappearances to officials were ignored. The seizure of 882 pounds of tiger bone (from about 30 animals) in Delhi in August 1993 made it obvious what was happening: Poaching for the Chinese medicinal trade had hit India. To meet this growing demand, tigers were being poisoned, shot, and snared across the country in great numbers. Wright launched WPSI in 1994 to investigate, working undercover with police to combat what was being called "the second tiger crisis."

Wildlife wardens and Project Tiger officials continued to publicly dismiss the warnings, clinging to inflated numbers based on flawed data. Their 2002 census counted a whopping 3,642 tigers. They estimated populations from paw prints, an unreliable method known to recount the same cats multiple times, at a cost of $3.4 million.

When reporter and tiger expert Prerna Singh Bindra detailed declining tiger numbers in a news story, an official called it "a figment of the reporter's imagination." But the scandal went public in June 2004, when national headlines proclaimed the unthinkable: Not a single tiger remained in Sariska Tiger Reserve, near Delhi. It proved to be true, despite government claims of 18 tigers in the park. When three men were later arrested, they described how easy it was to kill them; many of the guard's walkie-talkies were nonfunctional and few of the 300 guards were at their posts during monsoon season. A report from the Central Bureau of Investigation (CBI)—the Indian FBI—pointed to involvement by local villagers and well-established middlemen trading tiger parts out of India.

Project Tiger had become, as Thapar wrote, "a success story gone horribly wrong." A 2006 auditor's report found the project riddled with corruption and neglect. Funds had been skimmed by state governments for other purposes. Guards quit or retired and were not replaced; 30 percent of posts were vacant and the average ranger was over 50 years old. Those that remained walked dangerous patrols armed with bamboo sticks or ancient firearms, outgunned by poachers toting semi-automatic weapons.

Ultimately, the embarrassment over extinction in a premier site prompted the creation of the National Tiger Conservation Authority.

Meanwhile, Raghu Chundawat was losing animals he'd been studying for years in Panna Tiger Reserve. One of the first was a tigress killed in 2002 that left behind two orphaned cubs. When he reported missing tigers, it became a "shoot the whistle-blower" scenario. He was stripped of his research permits, kicked out of the park, and slapped with a series of frivolous charges, some of which have still not been dropped. At least 15 other top researchers have been harassed for speaking up on poaching or fighting illegal development.

The Wildlife Institute of India's grim 2008 report shocked the country and the world: About 1,411 adult tigers were left despite a $400 million investment over 34 years to save them under Project Tiger. It marked a new low. Theirs was a far more accurate camera trap census, though it omitted some key areas because of logistical or security issues. When compared with flawed estimates from six years before, most states in tiger range had half as many cats, with a stunning 60 percent less overall.

Panna lost its last tiger the next year. The forest department and state government have not initiated a CBI probe despite pressure from wildlife activists, the Ministry of Environment & Forests, and even the Prime Minister's Office. But there was some good news in 2010. A wider census raised tiger estimates to 1,706 tigers and core breeding populations had remained relatively stable.

Today, there are 42 tiger reserves, making up one percent of India's land. Some hold only a handful of tigers. "Just creating reserves is not a magic wand," says the Environmental Investigation Agency's (EIA) Debbie Banks. "We still need people, resources, and the political will to protect them." The last two years have broken records for tiger deaths from all causes: 71 in 2011 and an all-time high of 88 in 2012.

About 59 tigers live in Bandhavgarh. The reserve is essentially an island surrounded by 80 villages. The park's guards constantly track the tigers'

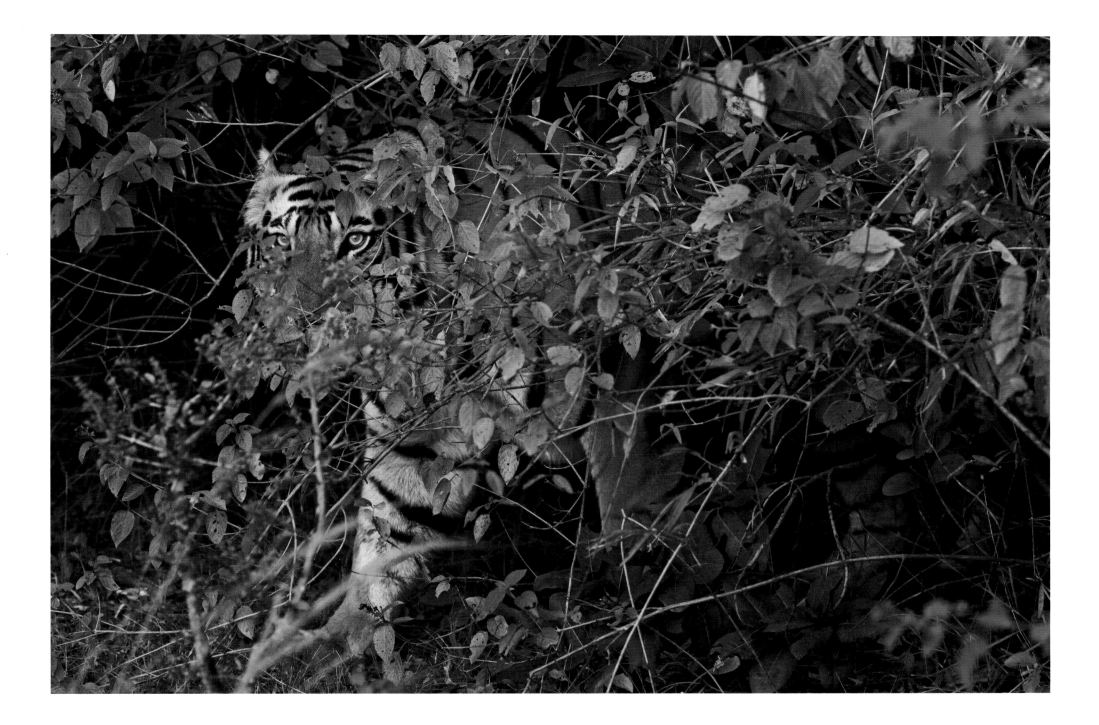

Until recently, tigers living outside of India's protected areas went undocumented and were not included in census numbers—such as this tiger, who wandered into Bandhavgarh National Park.

**Tiger biologist and
conservationist, India**

There have been a litany of conservation victories in India's Western Ghats—a mountainous area in the southwest with forests older than the Himalaya and possibly the world's largest tiger population. In 2004, India's Supreme Court shut down an iron ore mine situated inside Kudremukh National Park. A highway was rerouted from Nagarahole Tiger Reserve in 2011. The previous year, a nighttime driving ban was instituted on national highways bisecting Bandipur, another tiger reserve, sparing nocturnal wildlife. A railway line slated to slice through Bandipur was shelved in 2013, and 12 hydroelectric dam projects in pristine wilderness were canceled.

PHOTO: JOHN GOODRICH

The recent designation of new and expanded protected areas was the most impressive victory, given current conflicts over land for the country's 1.2 billion people *and* a voracious, resource-hungry economy. These newly protected tracts link 11 national parks, tiger reserves, and sanctuaries into a mostly contiguous 3,000-square-mile emerald band—the largest such initiative in four decades.

Wildlife biologist Sanjay Gubbi had a role in all. He researches tigers' interactions with other species, but also fights to protect them. He spearheaded the new forest protections and has others under consideration. "If we don't move fast and secure this land, it will be gone within ten years," he says. He wrote the road closure proposal and fought illegal tourist resorts in critical tiger corridors. He rallies public support with a constant barrage of editorials and magazine articles. Officials hastily disowned the Bandipur railway after Gubbi launched a media blitz with data on wildlife collisions with speeding trains.

Though many conservationists avoid working with government, Gubbi spends plenty of time with bureaucrats and political, social, and religious leaders. His prior career as an engineer explains his pragmatic, problem-solving methods. Much of conservation happens within the four walls of government, he says. "We need to publish our research, but we also need to market our science to key people who can implement changes on the ground." He also sits on tiger and wildlife boards in his home state of Karnataka. Part of the reason he's so effective is because he's a local boy. He speaks Kannada,

the local language, knows the landscape, and has known the area's power brokers for a lifetime. It opens doors.

He developed his love of nature camping under starry Karnataka skies as a Boy Scout. Later, he campaigned locally to protect birds and mammals. He volunteered for the Wildlife Conservation Society and was hired full time in 2001, working with Ullas Karanth, India's foremost tiger biologist. In 2011, he signed on with Panthera, coordinating India's tiger program, and as a scientist with the local Nature Conservation Foundation.

Fieldwork taught him the importance of frontline staff in protecting tigers and their prey. But park guards are poorly paid and badly equipped. Gubbi convinced the government to earmark tourism revenue for the 1,500 guards working in Karnataka's five tiger reserves. That guarantees them better gear, better education for their children, a small pension, and the medical insurance that their dangerous job desperately requires.

There's been backlash. After Gubbi and others successfully shut down Kudremukh Iron Ore Company, he was slapped with a series of frivolous charges by a forest officer who supported the company. That sort of harassment isn't uncommon. Nine years later, those charges have mostly been dropped.

Gubbi nurtures the next generation of conservationists and urges action, quoting ecologist Reed Noss: "If conservation biologists fail to respond, there will be plenty of economists, developers, industrialists, timber executives, livestock barons, and others jostling to offer their advice. Who will speak for biodiversity?" ◊

whereabouts, and for a hefty fee, will ferry tourists to see them on elephant back. Even amid what was sometimes a tourist free-for-all, I had encounters that allowed me rare glimpses into these elusive cats' lives.

On a December afternoon, when we rounded a bend and woke a sleeping tiger, I understood for a few seconds what it feels like to be tiger prey. In a split second, this 500-pound predator was up and charging flat-out at us. Then he just stopped, turned off, and walked away.

One evening a few weeks later, we heard a tiger's plaintive roar, repeated again and again, echoing through the valley. As we drove in that direction, the noise level grew into a cacophony of roars, frantic birdcalls, and the chital deer's high, chirpy alarm calls. Deer and langur monkeys blurred by, fleeing, and then we spotted the female tiger that was calling. But the light was failing and we had to be out by nightfall.

When we returned at daybreak, we found her there, still roaring. The park's dominant male, Bamera, approached her. They rubbed faces for a split second, then walked together. The female lay down and it was war: They attacked and swatted, growling and roaring, fighting until Bamera climbed over her and bit the scruff of her neck. They mated while he held her. It was over in seconds. They parted, ambled a few hundred yards off, and repeated the loud, violent ritual. Then they strode off into the brush and we listened to them scrap off and on until they were out of earshot. Hatsy told me they'd mate every 20 minutes or so, day and night, for the next few days.

There are details about mating, reproduction, and other aspects of tigers' lives that still need study. Until eminent field biologist Dr. George Schaller came to central India's Kanha National Park in 1963, much of what was known about the cats came from hunters staring down the barrel of a gun, tracking them, or watching them from a blind. "You can't protect tigers if you know absolutely nothing about how far they move, their reproduction cycle, when subadults separate from their mother, what threats they face," he says. Results of his landmark study on tiger and prey behavior were published as *The Deer and the Tiger,* research that is

still considered the gold standard for field biology. Many superb scientists, including Raghu Chundawat, Ullas Karanth, Sanjay Gubbi, Y. V. Jhala, and Bivash Pandav have since done important research.

With just 100 visitors a year to Kanha (compared with today's 140,000) and open-ended permits, Schaller could observe wildlife freely. I knew that I wouldn't have that same freedom. When I was preparing for this assignment, I'd visited the photo-engineering department in National Geographic's basement to pick up camera traps and check out what other gadgets might help me get cat close-ups. I spotted an oversize remote control car in a corner, big enough to carry a video camera. Engineers Walter Boggs, Dave Matthews, and Kenji Yamaguchi adapted it for a still camera and added a video feed with a small monitor so I could see through the lens.

The robo-camera was damaged in transit: The viewing feature was blown. My assistant Drew and I jury-rigged it and tried it out blind on the nearly grown cubs. They sniffed it, licked it, and swatted at it like house cats with a toy. We got a few pictures before it died altogether.

JUST AFTER THE NEW YEAR, we got a call from Belinda Wright. With intelligence from WPSI's network of informers, a group of men had been arrested near Tadoba-Andhari Tiger Reserve. We jumped in the car and drove 12 hours south from Bandhavgarh, checking into a small hotel near midnight. The next morning we went directly to the jail. Snipers were posted on the roof. Six men sat outside, tied together by their wrists, displayed for the press in front of a tiger skin. They ranged in age from 17 to 40, members of an extended family from a nearby village.

They were given bail after 15 days in jail. With a conviction rate of about 3 percent for wildlife crime, they didn't have much to worry about. Cases with even tiny mistakes in the police report—say, calling a skin "brown" instead of "tawny"—are thrown out. Even solid cases drag on for years. The few who are convicted usually get off with small fines or

short sentences despite the country's stringent wildlife laws. According to WPSI's records, out of 885 tiger-related incidents that went to court from 1974 to 2010, there were convictions in just 16 cases involving 41 people. Wright estimates that more than 10,000 wildlife cases are pending.

Many poachers are repeat offenders. Some are small-time locals. Others are members of professional poaching gangs who travel long distances with their families in tow. Their wives sell cheap trinkets in villages and small towns as a cover while they set steel traps in the forest—or lace an animal carcass with $1 worth of pesticide. Some, like Johru Das, are hardened criminals. He has six Sariska tiger poaching cases pending and somehow finagles bail every time he's arrested, then disappears.

Whether poachers are captured by chance or through careful sting operations, they are often the lowest, most replaceable link in the chain—the man on the ground. Those who mastermind the trade in skins and bones include a handful of kingpins operating out of major cities. One of the most notorious is Sansar Chand, dubbed "India's deadliest poacher," is thought to control half of India's wildlife trade. His first arrest was at age 16; now, at 55, he's had 57 wildlife cases filed against him and his gang members, including Sariska poaching. In 2006, during interrogation by CBI, he admitted to selling 470 tiger skins to four clients in Nepal and Tibet. Though he has no bank account, in 2010 he owned 45 properties including prime real estate in Delhi. He's currently serving a five-year sentence, but is believed to be managing his business through friends and family from jail.

Bosses like Chand direct and finance the killing and then traffic tiger skins, bones, and other parts over India's porous northern borders. They are destined for China, often via Nepal. According to Wright, contraband is taken to border communities that have traded with the two countries for centuries, often illegally. From there, the load is usually hidden in trucks with concealed cavities or carted by mules or yaks through the Himalayan foothills or across the Tibetan plateau. "They are very aware of gaps in enforcement and how to exploit corrupt officials," says Banks.

A huge Tibetan skin trade crashed in early 2006. His Holiness the Dalai Lama called on his people to stop wearing and trading in endangered animal pelts after seeing documentation sent by Wright and Banks of Tibetans wearing tiger skins at festivals—a status symbol, like sporting a Rolex. But traders diverted the trade to China into a burgeoning market for skins sold for high-end home decor.

China banned domestic trade in tiger bone in 1993, but not skins. A 1989 law encourages breeding and utilization of wildlife, including tigers. Regulations morphed over the last decade, says Banks, to facilitate domestic trade of captive-bred tiger skins. A recent undercover operation by the Environmental Investigation Agency revealed that captive-bred tiger skins cost up to three times more than wild animal skins, upping consumer demand for cheaper, wild-sourced skins. Most of those come from India and Nepal.

Other than a few merely cosmetic seizures and arrests, China has done little to disrupt international crime networks that control the trade or to eliminate the nation's voracious appetite for tiger bones and skins. And it's clear that despite stringent laws on paper, India is at a loss to stem the flow of tigers across its borders. "There are statements on 'intelligence-led enforcement,' 'multi-agency cooperation,' and 'international cooperation,' but very little evidence that any of this is happening," says Wright. She questions why professional law enforcement agencies are not sharing intelligence on the criminals involved in organized transnational wildlife crime. "Why are tiger range countries not making more use of INTERPOL and its secure communications network and massive database on known and suspected criminals? Why is it so hard to centralize records of seizures, arrests, prosecutions, and convictions on wildlife crime?" Her organization's Wildlife Crime Database is far more comprehensive than any in India. It catalogs over 22,000 wildlife cases and 19,000 alleged wildlife criminals.

Banks adds that wild tigers will recover across their range when the threat of poaching for their body parts is effectively addressed.

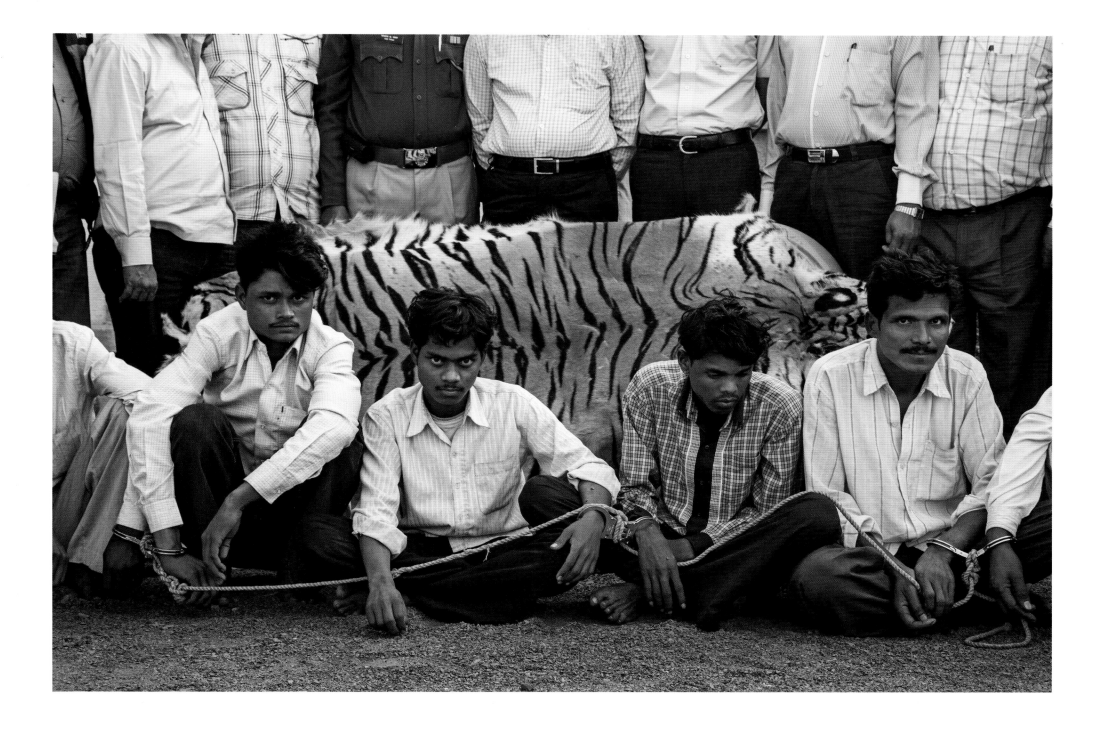

These men were apprehended in January 2011 while trying to sell a tiger skin near Chandrapur, India. Police received the tip from the Wildlife Protection Society of India, with intelligence from their informant network. They were members of an extended family from a nearby village.

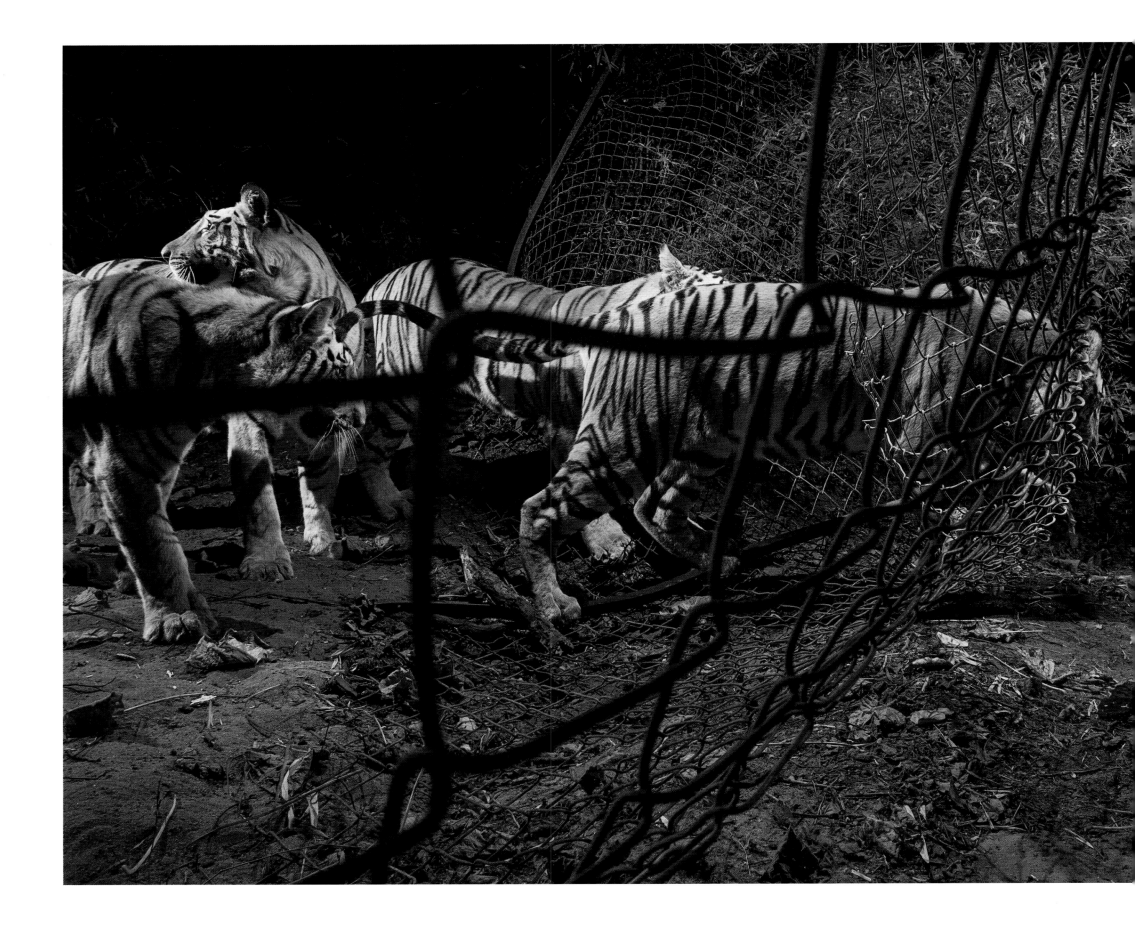

A tigress and her nearly grown cubs leave Bandhavgarh National Park through a ruined fence. The wide-roaming cats frequently move in and out of the park—and human settlements.

On the drive to Tadoba, the reality of another crushing threat flashed by out the window. It, like most reserves including Bandhavgarh, is relatively small and surrounded by a sea of humanity. Unbridled development is stripping away forests that allow tigers to move between protected areas.

About a quarter of the country's Bengals live in a string of 13 tiger reserves known as the Central Indian Tiger Landscape. The corridors that loosely connect them—which are not necessarily pristine forests—are lifelines for tigers, and they are disappearing. Much of the land we drove through was sliced and diced, scarred by mining, stripped bare for farms, towns, and cities, and crisscrossed by new eight-lane highways and railroads. It would be hard for a tiger to run that gauntlet and survive. But when cubs come of age, they must strike out on their own. It's nature's way of maintaining strong genes. Tigers within isolated preserves become inbred over time, making the cats weak and susceptible to hereditary disease. But they need safe passage to find their own territory.

The tiger's most unfortunate truth is that the ground beneath its feet is rich with minerals, says Prerna Singh Bindra, where much of the nation's coal and iron reserves lie. As a consultant with the Wildlife Conservation Society-India and a chair on the Standing Committee of the National Board of Wildlife that evaluates development projects, she sees the inexorable march of development eating away at tiger habitat. She told me of proposals that would further fragment tiger connections within this landscape, including numerous new coal mining leases. A highway that would sever links between three tiger reserves, impacting over 150 tigers. New roads cut through preserves and corridors, dividing critical habitat and turning wildlife into roadkill. Proposed hydroelectric projects that threaten to submerge prime habitats. She shared a very long list.

Pressure on tiger forests is growing, she says, but India must factor in wildlife concerns in its quest to push up its 6 percent growth rate (compared with a 2 percent U.S. rate in 2012). The debate is being framed as

environment versus growth, just as it is in the U.S. and elsewhere. In a recent *Times of India* editorial, an infrastructure specialist fueled the fight against protections that some are calling "green terrorism." "We can't let environmental precautionism be converted into environmental 'talibanism,' " said Srivatsa Krishna. "India's first priority must be taking care of the energy needs of its people, rather than taking care of sundry animals." Prime Minister Manmohan Singh has blamed "cumbersome" environmental clearances for the slowing economy. Powerful lobbies are attempting to weaken regulations even within tiger landscapes.

Meanwhile, the Ministry of Environment & Forests recently opened up 80 percent of previously sacrosanct forests to mining. In all, the country lost a quarter of its wildlands over the last 15 years. "Natural forest won't survive in India unless you have at least 1 to 2 percent which is completely inviolate wilderness," said Praveen Pardeshi, the state forest secretary in Maharashtra. "Destroying forests is no longer a viable option."

But even amid this land war, there have been some impressive victories. In the southwest state of Karnataka, Panthera biologist Sanjay Gubbi championed the largest expansion of protected land in 40 years. Important tiger reserves lie within that terrain, including Nagarahole. Over the two decades since wildlife biologist Dr. Ullas Karanth first started monitoring, tigers have been thriving and stable. Though small, Nagarahole is a model "source site" and a key part of the Tigers Forever strategy for the Western Ghats. What's happened there and in the neighboring Bandipur Tiger Reserve stands as a model of what successful conservation and recovery can look like. Young tigers have started migrating into a cluster of other preserves that straddle three states in the mountainous Western Ghats; some areas meld into huge contiguous tracts. The region is one of India's four large "tiger landscapes" that also includes the northeast (encompassing Kaziranga, Manas, and other reserves), the

Himalayan foothills along the Tibetan border (including Corbett Tiger Reserve), and the central Indian landscape. Each offers room for tigers to expand out into adjoining areas.

About 280 may live in the Western Ghats, truly wild tigers, unlike those in small parks that are tracked and managed on a daily basis. Some of the most carefully watched tigers are those that have been reintroduced to Panna and Sariska from other reserves. This is not what Thapar calls wild tigers: "Bringing tigers in helicopters, parachuting them into a forest, putting radio collars on them, following them around in a limited area. Never allowing them to leave the sanctuary. Having a hundred people watching them. These are intensively man-managed tiger populations," he says.

Much of Karnataka's conservation success can be attributed, says Gubbi, to tough government antipoaching patrols coupled with work from NGOs who are fighting pitched battles to save tiger habitat—and a nationwide strategy that voluntarily relocates villages outside tiger reserves. Even within their supposed havens, tigers are hemmed in, with millions of people living inside parks and crowding the perimeters.

A few of Bandhavgarh's villages are moving. I visited one in forest fringing the reserve as its residents were packing up. Every family and every child over 18 had received a "golden handshake" from the government, a million rupees ($18,520), a tenth of that up front to build a new home and the rest deposited into a bank account. The interest will provide more money than most had made on their farms. They'll have a better water supply, electricity, closer proximity to schools and medical care—and their livestock will be far safer.

But every management decision, even the good ones, impacts the natural order. When the people left, a tigress living nearby moved into the reserve. She'd lost her goat and cow food source. A guard heard the deadly fight that ensued in the middle of the night. She encountered a year-old cub whose mom must have been off hunting and killed her. Tigers will fight to the death over territory, and Bandhavgarh's small space is spoken for.

Author, filmmaker, and tiger expert, India

Growing up in a home with two journalist parents forged an activist's heart in Valmik Thapar, one of India's top tiger experts. The family was friends with Indira Gandhi and circulated through powerful circles that offered Thapar early insight into how government and politics worked—and didn't work.

He ignored corporate job offers post-college, began photographing, and quickly gravitated toward documentary filmmaking. In 1976, he shot *Deep in the Jungles of Rajasthan* in Ranthambore Wildlife Sanctuary. There, he met the reserve's director, Fateh Singh Rathore, who became a lifelong friend and "tiger guru." Thapar describes his first tiger sighting in Ranthambore with the rich detail of cherished memory: While sitting beside a campfire, the forest erupted with piercing alarm calls and he spied a tiger moving through the grass, dimly illumined by firelight.

From then on, he was obsessed, driven to discover and document the secret life of an animal that in those days, you never saw. He tracked pugmarks, observed tiger behavior, and studied their relationship with prey. With the institution of a hunting ban, they became less wary and their numbers grew until he sometimes observed 16 in a day.

While Singh relocated villages outside the newly designated tiger reserve (so tigers didn't have bullock carts zooming through, nor crops growing in the middle of their forests), Thapar began writing the first of his 24 books, mostly on tigers.

Once locals were resettled, he realized that they'd need incentive to respect the forest. He launched the Ranthambore Foundation in 1987, bringing schools, health care, and more to local communities. Other efforts directly protected the park. Biogas-powered stoves eliminated the need to forage for firewood, growing fodder kept cows from grazing inside the sanctuary, and 300,000 planted trees now tower 60 feet high. Thapar ran the foundation for a dozen years but grew discouraged when true partnerships with the forest department failed to materialize.

When the 1990s poaching crisis hit and tigers began to disappear, "I started shouting and screaming," he says. That landed him an unasked-for seat on the steering committee of Project Tiger, a 20-year-old conservation initiative that was then failing. In the two decades since, Thapar has fought loudly, bluntly, and honestly for the needs of the tiger on 200-plus federal and state wildlife boards. He feels that two were worthwhile: a Supreme Court advisor role on environmental cases and a state slot in Rajasthan that helped protect his beloved Ranthambore. They "delayed the damage" by stopping a relentless stream of big development projects in tiger territory and preventing exploitation of parks and sanctuaries.

He says serving on "paper committees dealing with paper tigers" was a waste of time. Few of his recommendations were implemented and he now views

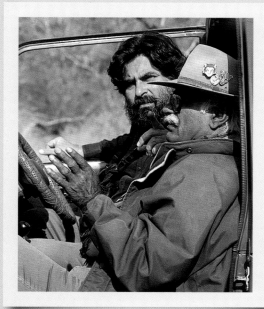

PHOTO: TOBY SINCLAIR

them as government's way of neutralizing activism.

At the core of his frustration lies the Indian Forest Service, a relic agency left behind by the British Raj, created to funnel resources to a sprawling empire. Few staff have expertise in zoology or conservation; most reserves fail to protect wildlife or ecosystems. Thapar is adamant: The best hope for stemming what he calls "India's terminal tiger crisis" is a complete overhaul of the system. That means creation of a new agency specifically devoted to wildlife—similar to the U.S. Fish & Wildlife Service—strong research, and innovative partnerships with all local players. With a population of 1.2 billion people and poachers targeting tigers for a lucrative illicit trade, it's crucial to protect the richest wildlife areas with well-trained armed patrols, he says. ◊

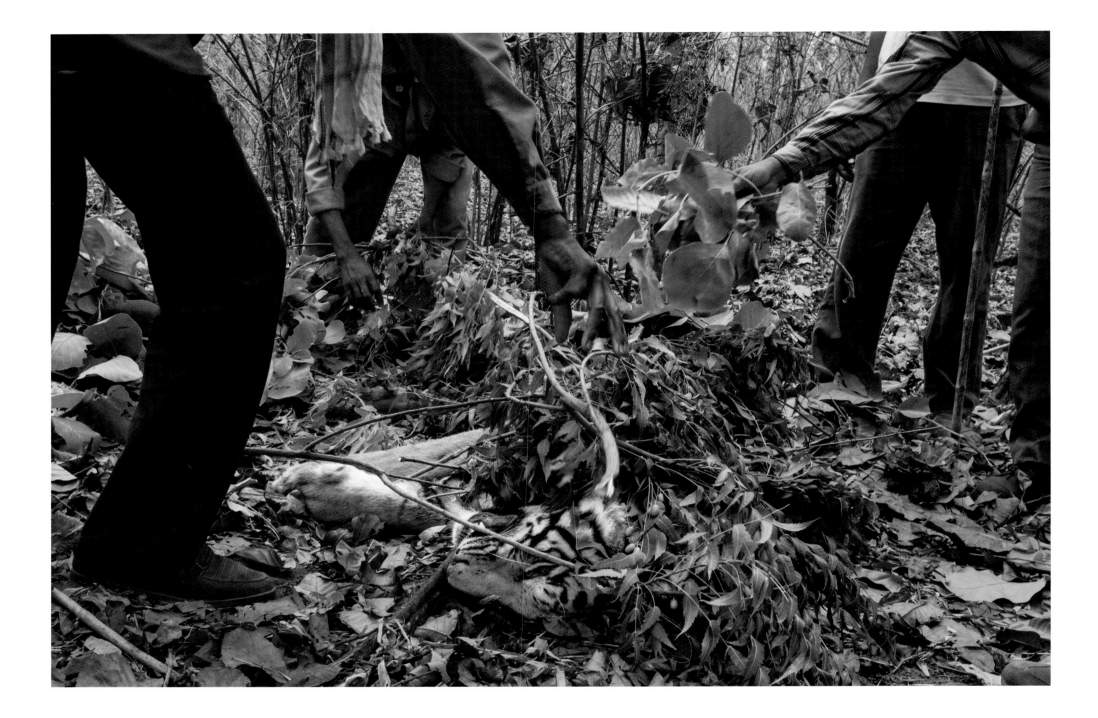

A lack of space or prey can spark territorial fights between tigers. When a migrant tigress moved into Bandhavgarh

National Park, a fight ensued with the young female pictured here, with deadly result.

Park guards cremated the migrant tigress over a funeral pyre, the only way to keep her out of the illegal traditional medicine trade. Wildlife crime is a $20 billion-a-year business, run by international crime syndicates.

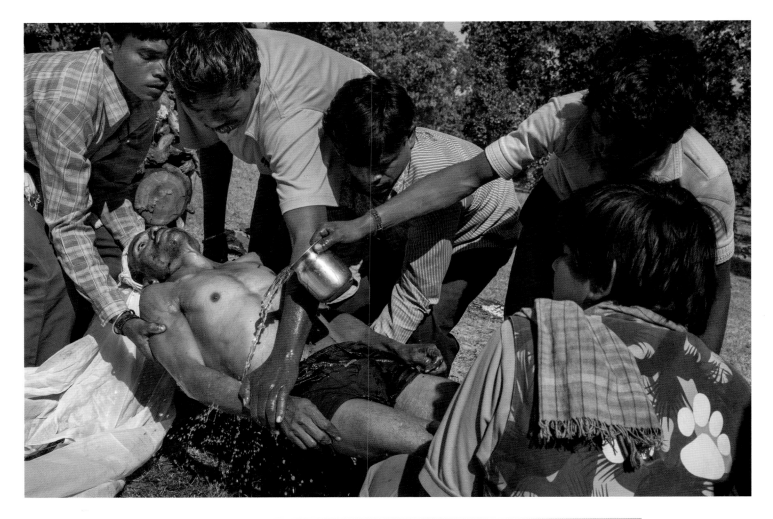

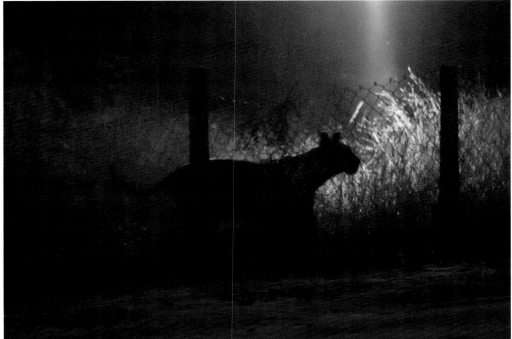

Above: Pancham Baigher's body is prepared for cremation. He was killed by a tigress in crop fields bordering Bandhavgarh.
Left: A guard on elephant back shines a spotlight on the tigress responsible for Baigher's death as he attempts to guide her back into the park.

The next morning, the rangers called me to come document the tragedy. They collected the cub's body, piled it with leaves and wood, and cremated her. It was the only way to keep her off the black market.

That wasn't the only death caused by human intervention. Park boundaries mean nothing to wildlife. Well over half of India's tigers spend some part of the year outside reserves. I'd seen how frequently they moved through buffer zones where people collect leaves, fruit, firewood, bamboo, and other forest products. Livestock grazed in parks, and tigers stalked them in pastures or wandered through the villages that ringed the reserve.

By the time I'd been in Bandhavgarh for two months, the mother of the three huge, nearly grown cubs was feeding them almost exclusively on livestock. Hunting for four had become impossible. She was injured, limping badly, and should have been tranquilized and treated. When she killed a cow near the village of Tala, the forest department buried the carcass in a desperate attempt to keep the tigers away from people. When she killed another cow beside a road near town, they loaded it into a pickup truck and dumped it into the orphan cubs' enclosure inside the park. She left the park again, trailed by her cubs. This time, the forest department sent in three guards on elephants to herd them back. We followed the tigers as they walked through crop fields, driving along a road that ran parallel. The tigress was clearly agitated, furtively glancing at the phalanx of elephants that pursued them. By now, it had been many days since she and the cubs had eaten.

She disappeared behind a thicket and I heard a scream. The tigress ran into a man walking through a field; she swiped at him, just once, and caught him in the head. He died.

He was the brother of Daya Ram, a mahout who regularly took me out to shoot. I photographed his funeral the next day, a ritual Hindu cremation on a funeral pyre out in an open field. It brought home the reality of living too close to predators.

Every time there's conflict of any kind, remaining reverence for tigers fades, and with it, tolerance. In a recent horrific incident, a mob chased down a young tigress in central India that had been preying on cattle, beat her to death, and carried her body down the street in a raucous parade.

Tigers are opportunistic hunters that will sometimes eat the cattle grazed in front of them, but attacks on people are relatively rare. As famed British bounty hunter turned conservationist Jim Corbett wrote: "Tigers, except when wounded or when man-eaters, are on the whole very good-tempered . . . Occasionally a tiger will object to too close an approach to its cubs or to a kill that it is guarding. The objection invariably takes the form of growling, and if this does not prove effective it is followed by short rushes accompanied by terrifying roars. If these warnings are disregarded, the blame for any injury inflicted rests entirely with the intruder."

That said, tigers are predators with ambush skills honed over millions of years of evolution. "Relatively speaking, the tigers' appetite for us pales before our appetite for them," writes author John Vaillant, but livestock and people do die. That's mostly because tigers have almost no place left to live. Humans are pillaging what's left of their homes and living virtually on top of them. As George Schaller notes, "We need to train people how to behave in tiger country. Don't go out at night, go out in twos, make noise and let animals know you're coming. Don't run from a tiger; talk to it and back away slowly." He says that wide public awareness campaigns would save lives.

In Tadoba, the cats have killed or injured at least one person every year for decades. A WPSI study in 2009 found that victims were mostly men herding cattle or women collecting firewood for cooking. Praveen Pardeshi told me of efforts to mitigate the problem. One initiative has helped 80,000 families convert to gas-powered stoves so they no longer have to collect wood. And now, park entrance fees go to surrounding communities and pay for increased guard patrols instead of lining state coffers. In return, locals must not log, graze, or hunt in tiger territory.

There has been no shortage of such efforts in the last 30 years, says Alan Rabinowitz. Governments and NGOs have invested in new schools, health care, jobs, anti-predation strategies, compensation for lost livestock,

and other initiatives to fight poverty and protect those living with tigers. Some have worked better than others; for example, building corrals to keep livestock from roaming at night has proved effective. But many were short-lived and most didn't make much difference. In the final analysis, the only measure of success is hard numbers: Are tigers stable or increasing?

Without the support of the people that live beside reserves, tiger expert and conservationist Bittu Sahgal predicts that neither forests nor tigers will thrive—and that requires financial incentives. He believes that the way of the future will be community nature conservancies similar to those in Africa. For example, the Maasai Mara in Kenya have formed community reserves, leasing part of their land to safari camp owners. About 2,000 families earn their livelihoods from tourists—and consequently protect the local wildlife that is now worth more alive than dead. Sahgal is currently compiling research on possible sites in India for similar reserves.

I wanted to see community programs in action, so I traveled with Wright to the Sundarbans to see WPSI's work there. It's a watery weave of mangrove forest that lies at the confluence of the Ganges and Brahmaputra Rivers on the Bay of Bengal. Sundarbans tigers have been man-eaters since time imme-morial. It may be hereditary, and not long ago they were killing 40 people a year. With newly built net fences and small aquaculture ponds dug near people's homes (so families don't have to wander into tiger territory to fish), annual deaths have plummeted by two-thirds. Wright had also helped set up a hard-cash business for the women, who embroider tiger-themed cushions and other handicrafts. Their agreement is that these families won't kill tigers.

While I was there, we went into the national park hoping to see one of the man-eaters. We cruised the "finger" channels by boat late in the day. I spotted a youngish male walking along the shoreline with my binoculars, his legs caked in mud. For the next two hours, we followed him as he moved in and out of the mangroves. He waded into chest-deep water to cross a wide, shallow inlet. From the far shore, we heard another tiger's eerie, throaty mating call. The young tiger stopped dead, listening.

He turned around. If he'd run into another male, there would have been a fight.

On the way back, we met a fisherman whose scarred face was testa-ment to an attack years before.

I FLEW TO NORTHEAST INDIA in March to begin a story on small wild cats. While I was there, I received word from Alan Rabinowitz that he and George Schaller had been invited to informal meetings in Delhi with environment minister Jairam Ramesh and other Indian tiger experts. I joined them there. Ramesh wanted fresh ideas, a huge departure from what had traditionally been an insular government approach to conservation. He was curious about Panthera's jaguar corridor initiative that linked key habitat across their range from Mexico to Argentina—and how it might be used as a blueprint for India. Because of mounting poaching assaults, George and Alan emphasized the need for intensive yearly monitoring, which in theory, is moving forward. Panthera was invited to open an office and work with tiger scientists in sites across India.

After the meeting, I returned home. Just a few days later, I learned that a litter of three cubs was born in Bandhavgarh. The mother was the female I'd photographed mating months before. I decided to return when they were eight weeks old.

On May 23, the day I flew into Delhi, one of the grown cubs I'd photo-graphed for so many months killed two people. The first victim was a woman gathering tendu leaves, which are used for bidi cigarettes. She was attacked exactly where I'd photographed the tiger family stepping through the bound-ary fence the winter before. The cat must have remained close: When the woman's brother-in-law came to identify her body, he too was killed.

It was a tragedy waiting to happen, caused by poor zoning. The only nearby water source for the animals on that side of the park was just outside the fence. A month later, officials found the body of a 30-year-old guard in the same area. He had been killed and partially eaten. The two male cubs

Two boys performing in a *Pulikali*—Tiger Dance—show off their body paint in Umaria, India. This 200-year-old

tradition revolves around the theme of tiger hunting.

were declared man-eaters, captured, and taken to the Bhopal Zoo. They were soon joined there by both sets of orphaned cubs. Some had grown too familiar with people to release into the wild. Others were too aggressive. Workers began erecting chain-link fences that eventually cordoned off 40 square miles, which altered the way animals moved and ignited tiger turf wars.

In response to a near-violent public outcry, the forest department upped patrols. They engaged all the working elephants and I was stranded. The tigress had birthed her cubs in the same cave where she was born, nestled in a narrow, secluded gorge far from any roads and the only way in was on elephant back. Each afternoon, I asked in vain if I could go out the next morning. I *had* to have cub pictures for the story, pictures I'd been trying to make for seven months. With days left, I hadn't even glimpsed them. Finally, park director Patil assigned me his best mahout, E. A. Kuttappan, an expert naturalist who'd been there 30 years. The rule: In the summer's blazing heat, we couldn't stay out past 10:30 a.m.

We went in at dawn, headed for a ridge overlooking the ravine. Directly across from us, the cubs crawled over their mother, nursing, tumbling, and playing. The early light was dim, I was on a restless elephant, and even with a near telescope of a lens, they were puny. It was a beautiful sight, but I couldn't get pictures. I had to be closer.

Next, we approached from the valley, climbing as high as the rock face allowed. Kuttappan tapped me and pointed: A cub ran out of the hollow heading for mom. It heard the elephant snort, saw us, and bolted back into the cave. No pictures.

If mom had already nursed and gone off hunting, I didn't see the cubs at all. On one of those mornings, I watched her descend to the river and pull a 500-pound sambar deer from the bushes. She eased it into the water and floated it closer to the den.

I had only three days left before flying home. When we reached the den that morning, we saw mom lying languidly out in the open nursing a cub. Just one of the cub's ears was visible. It lifted its head and walked toward us. I got off five or six frames before it ducked behind her.

I never saw the cubs again, but one of those images is the cover of this book. Seeing it lifts the spirit: That cub represents hope. A tigress breeds at the early age of three and can produce 15 cubs in her lifetime. It's a very productive species.

One thing I learned on this quest to photograph tigers was that they thrive with just the basics: food, water, and a safe home. When you add armed front-line protection, strong laws, enforcement, and careful monitoring, they bounce back. It's that simple. "We absolutely know how to save tigers," Alan says.

However, it requires the willpower of governments, benefits to communities that live with tigers, the expertise of the best scientists and conservationists—and a world that cares. "I learned long ago that conservation has no victories," says Schaller. It's a never ending process that each of us must take part in. "But," as he cautions, "if tiger conservation continues to have no teeth, then it is only a matter of time before wild tigers will diminish to the point of no return. Future generations would be truly saddened that this century had so little foresight, so little compassion, so lacked generosity of spirit for the future that we would eliminate one of the most beautiful and dramatic animals that the world has ever seen."

After working in tigerland for ten years, I believe we need to save the tiger not only because of its sheer majesty, but also because it has the right as a living being to walk the planet. Saving tigers will also help us save ourselves. Preserving the huge tracts of forest, wetlands, mountain, and jungle that this wide-ranging predator needs to survive also protects the spectrum of life that lives there, protects water needed by millions of people, and pulls carbon from the atmosphere, allowing the planet to heal from human assaults.

Only 3,200 tigers remain, scattered in pockets across Asia. That's a shockingly low number. The time to act is now. Once the last tigers disappear, no longer gliding on velvet paws through the jungle, we cannot bring them back. ◊

TIGERS OF INDIA

India's tiger reserves were the only place I saw tigers during a decade spent trying to photograph them, but I still employed camera traps to capture images of the secretive cat's behavior that I wouldn't be able to physically photograph. Park guards directed me to the favorite watering hole of a tigress and her three nearly grown cubs, and to a tree where tigers marked territory—sites that yielded key images. Driving through Bandhavgarh or exploring on elephant back, I photographed tigers feeding, stalking, mating, sleeping, each image a gift. In the Sundarbans wetlands, I photographed the semiaquatic tigers that live among the mangroves.

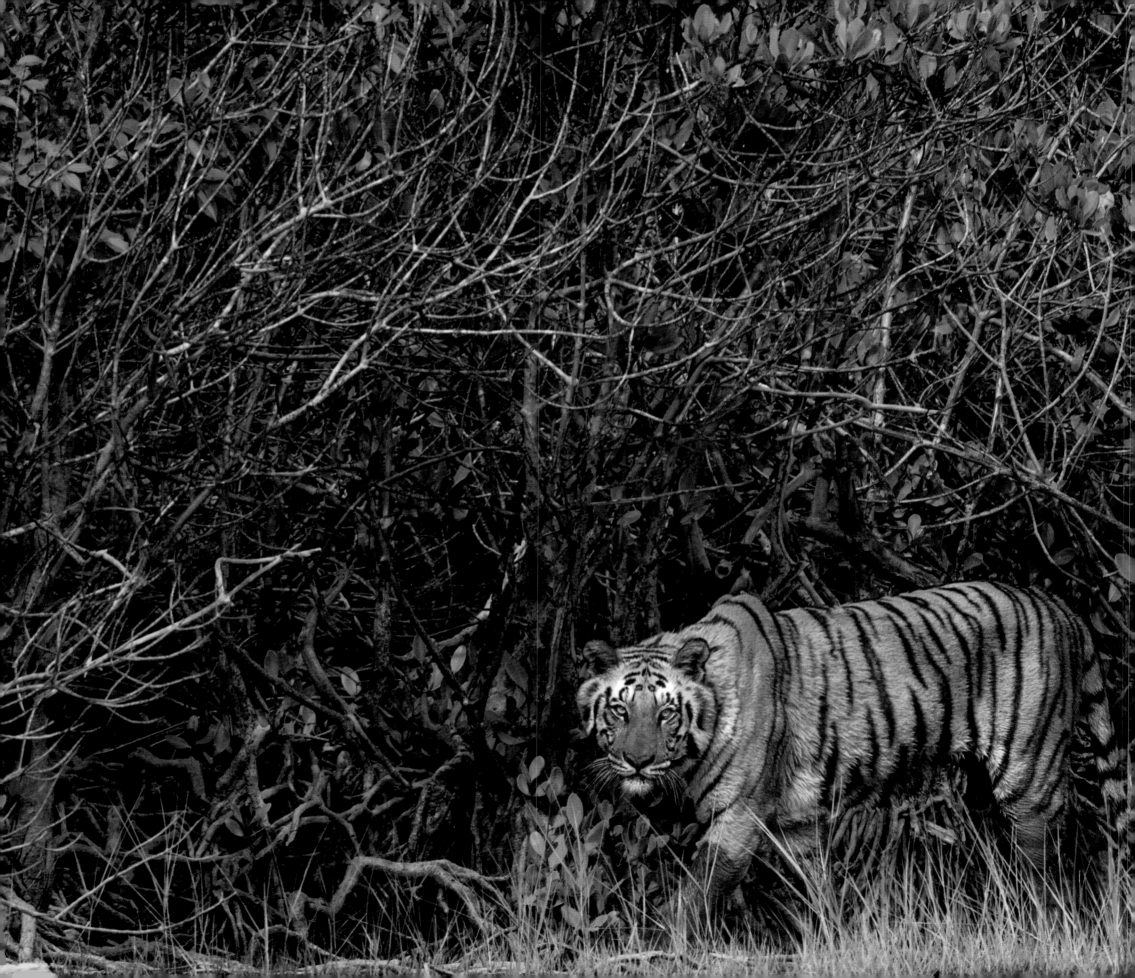

Tigers thrive amid the weave of mangroves and wetlands

in the Indian Sundarbans on the Bay of Bengal.

FOLLOWING PAGES:

A pair of 14-month-old cubs chase and play at a watering

hole in Bandhavgarh National Park.

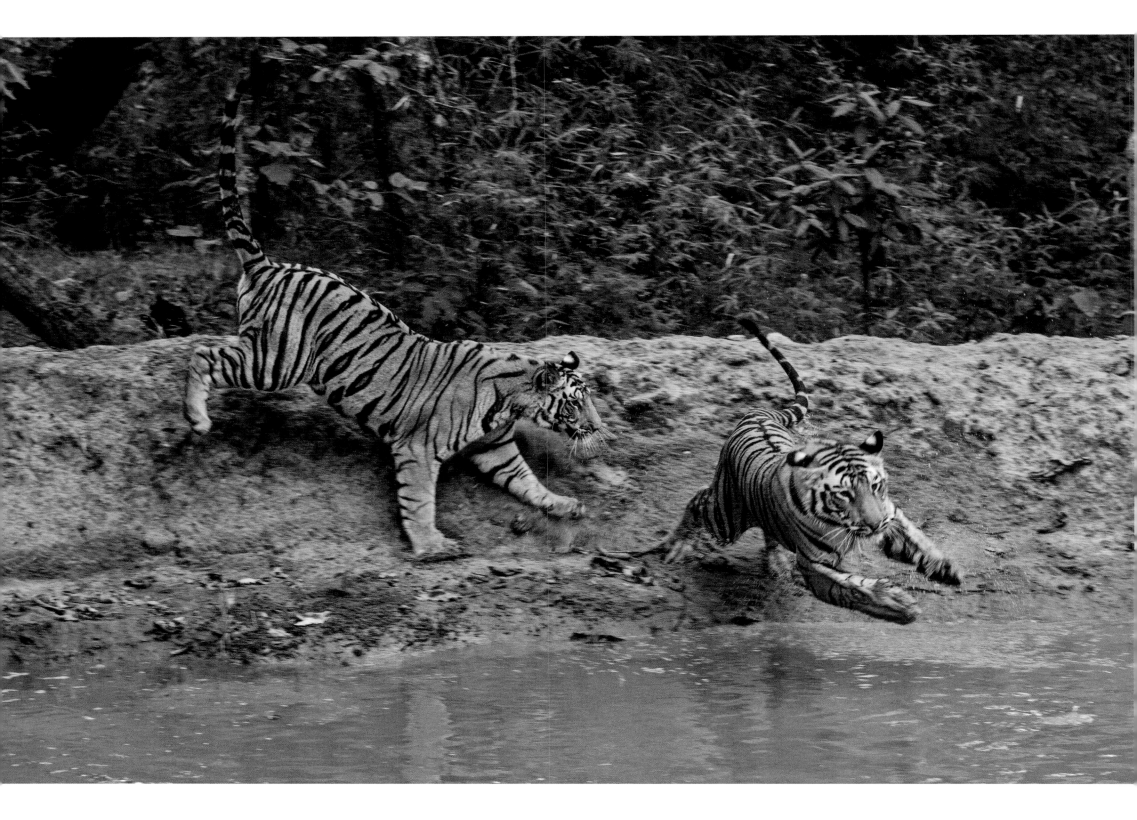

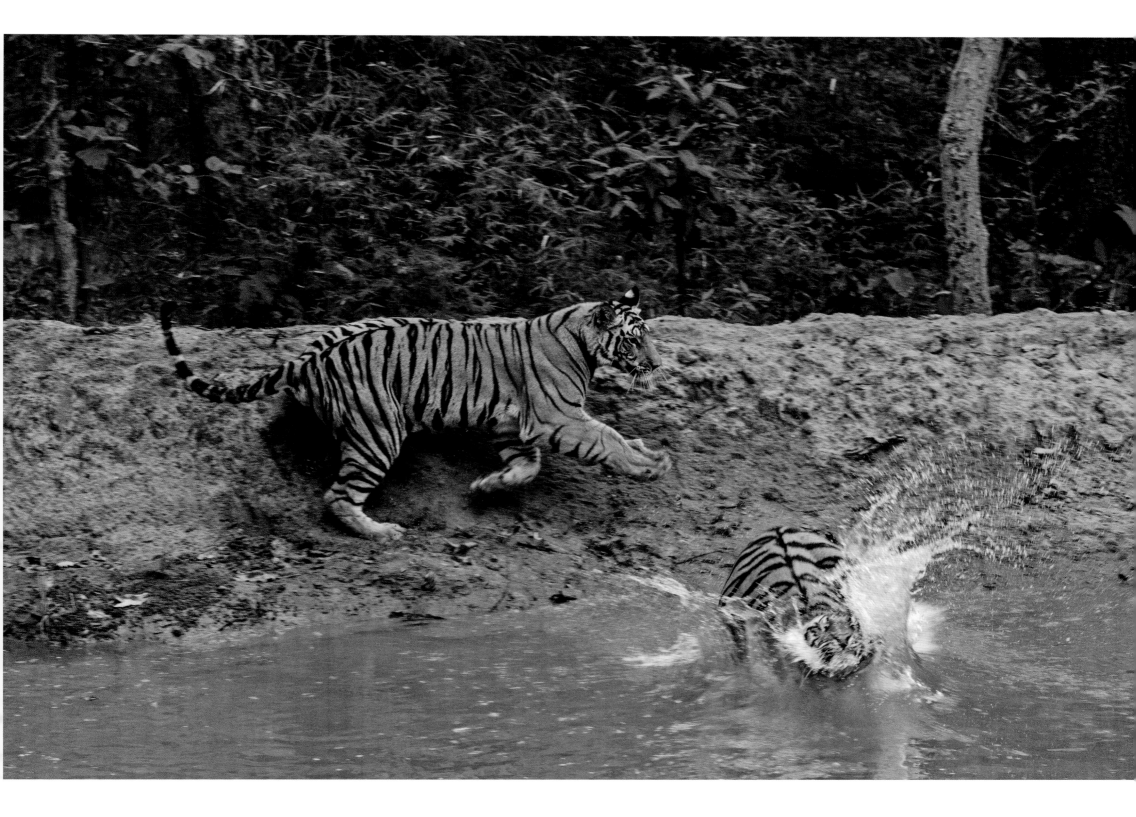

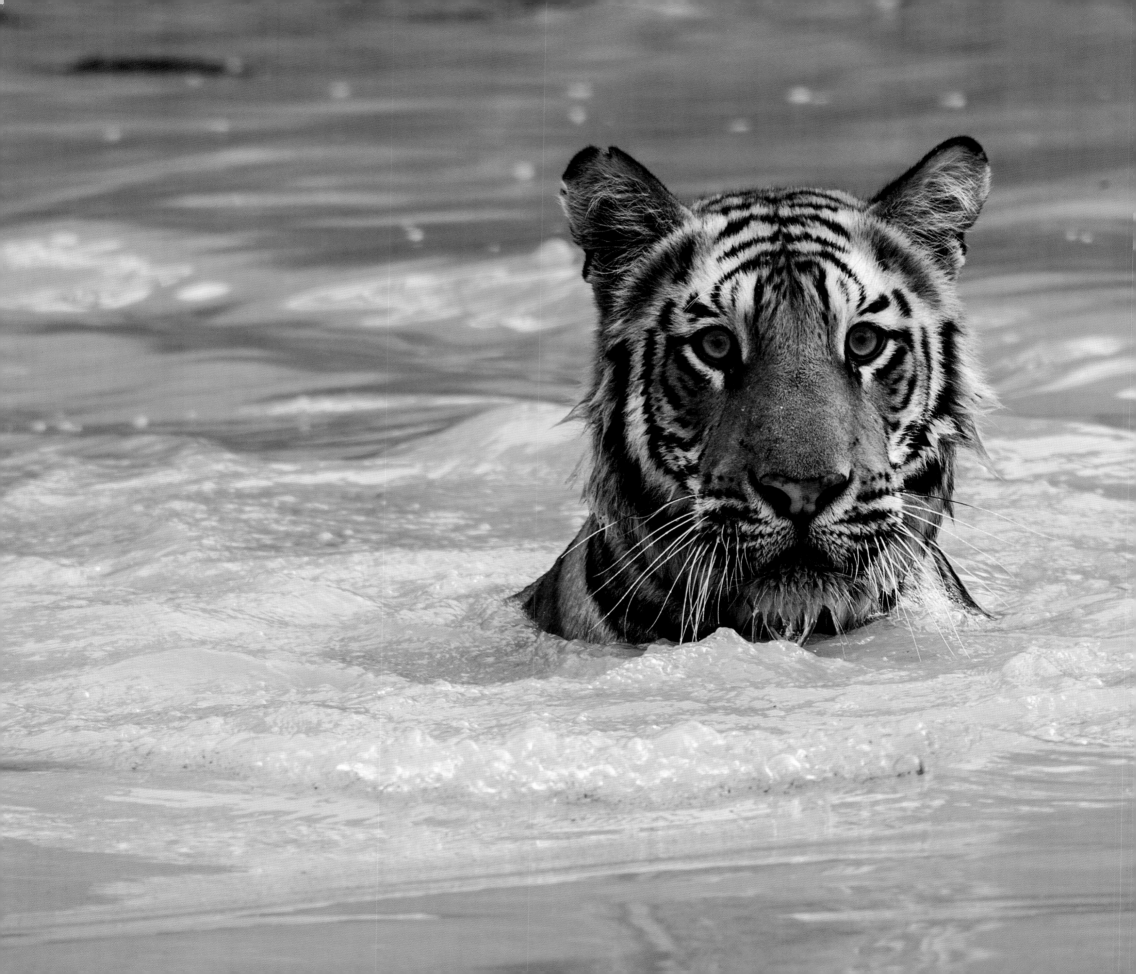

This 14-month-old cub, cooling off in a pond, is riveted by a deer that appeared near the shore. Tigers are powerful swimmers; they can easily cross rivers 4 to 5 miles wide and have been known to swim distances of up to 18 miles.

LATE ONE AFTERNOON, I photographed these three 15-month-old cubs napping beside a watering hole. I stayed until darkness fell, when I had to leave the park. The next morning, they were still there, doing what cats do a lot of: sleeping. Nearby was the mostly eaten carcass of a sambar deer their mother had hunted for them. By about 18 months of age, they will hunt on their own; until then, their mother must kill every three to four days to feed them.

These 15-month-old siblings rest during the heat of the day.

FOLLOWING PAGES:

Left: In a symbiotic relationship, langurs drop leaves and fruit that spotted deer eat, and the deer's alarm calls warn them of a tiger's presence.

Right: A tiger stalks its prey.

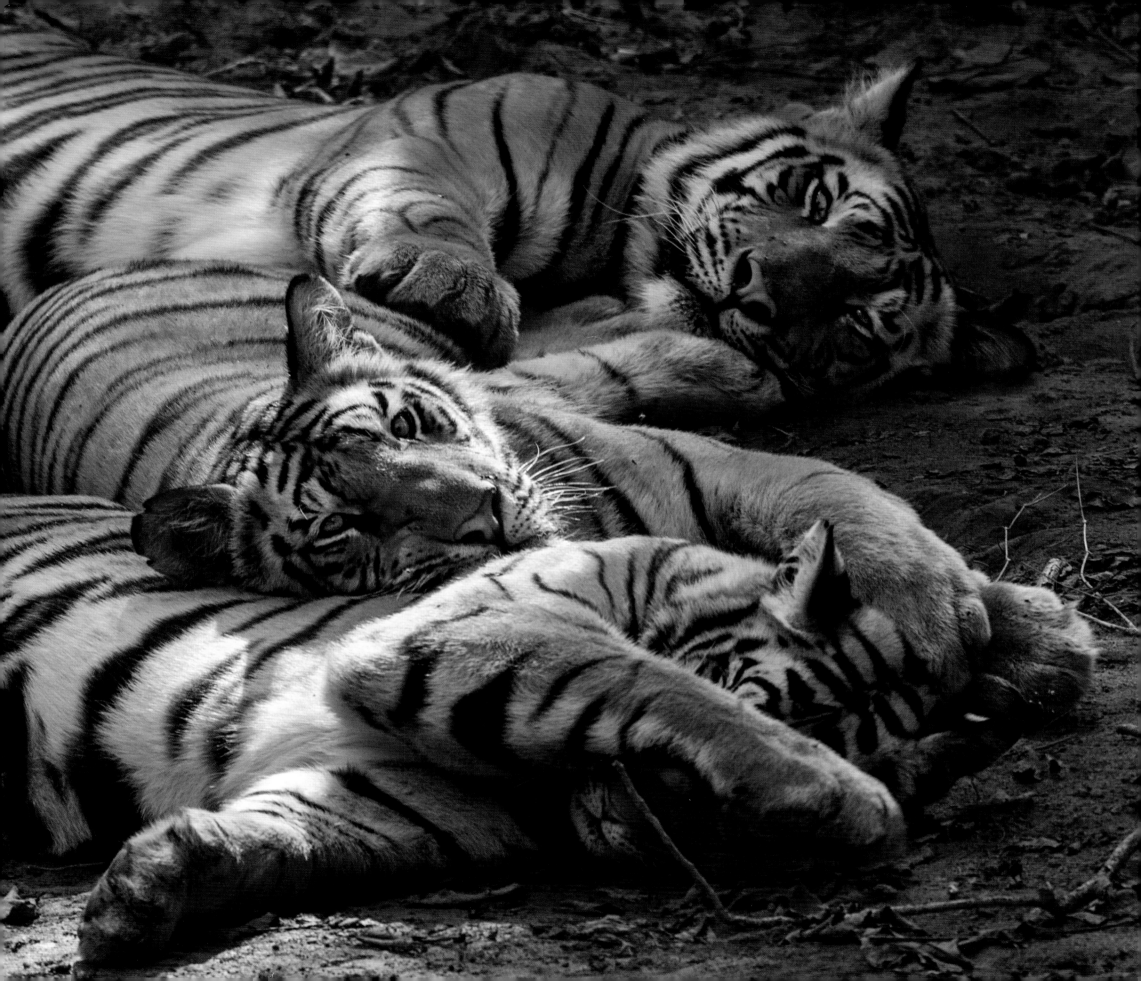

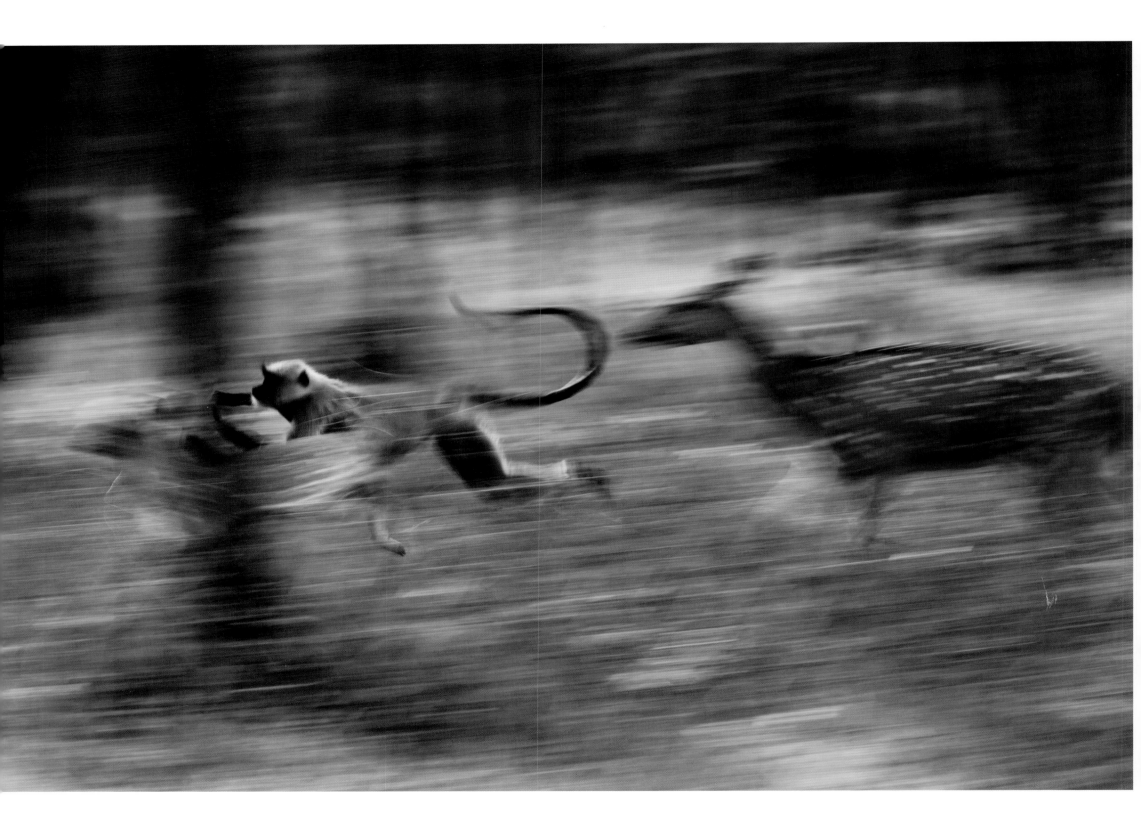

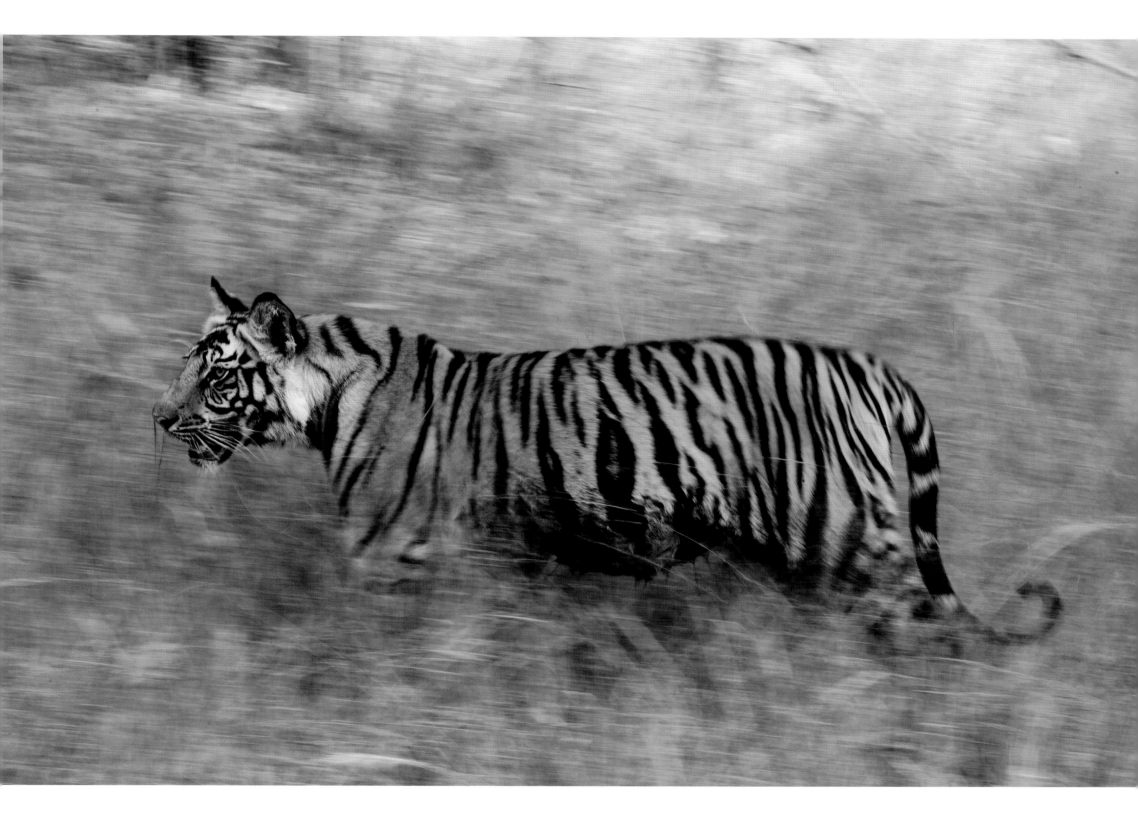

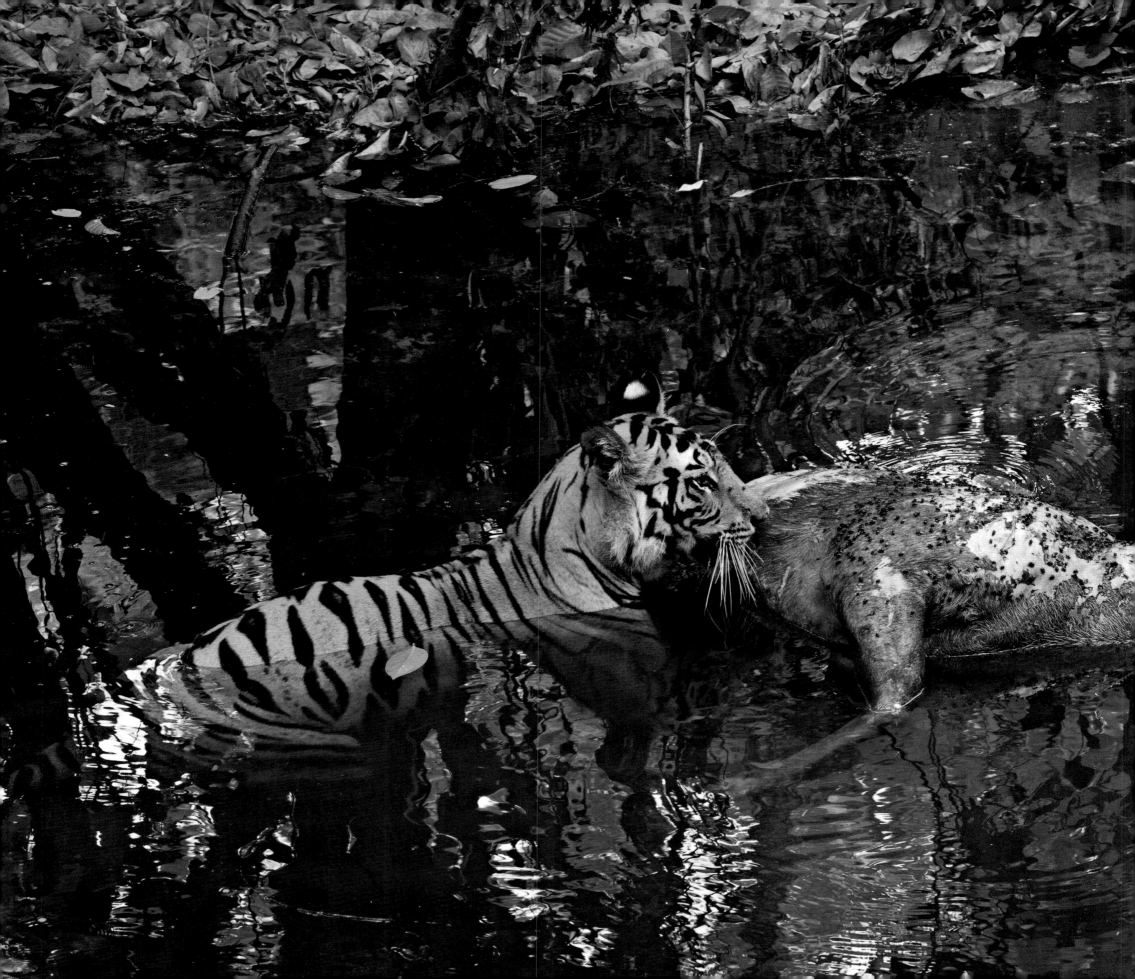

A tigress moves a sambar deer closer to her den.
The cats are stealthy hunters that kill with a powerful bite
to the neck and can take down animals twice their size.
It takes about 70 deer-size animals a year to feed
a mother tiger and her cubs.

Tigers are usually solitary animals: Except for a mother
and her cubs, tigers live and hunt alone, coming
together only to mate or occasionally to share a kill.

FOLLOWING PAGES:
After a moment of concern, this young female
tiger stalked the remote-controlled camera car
that captured these photos.

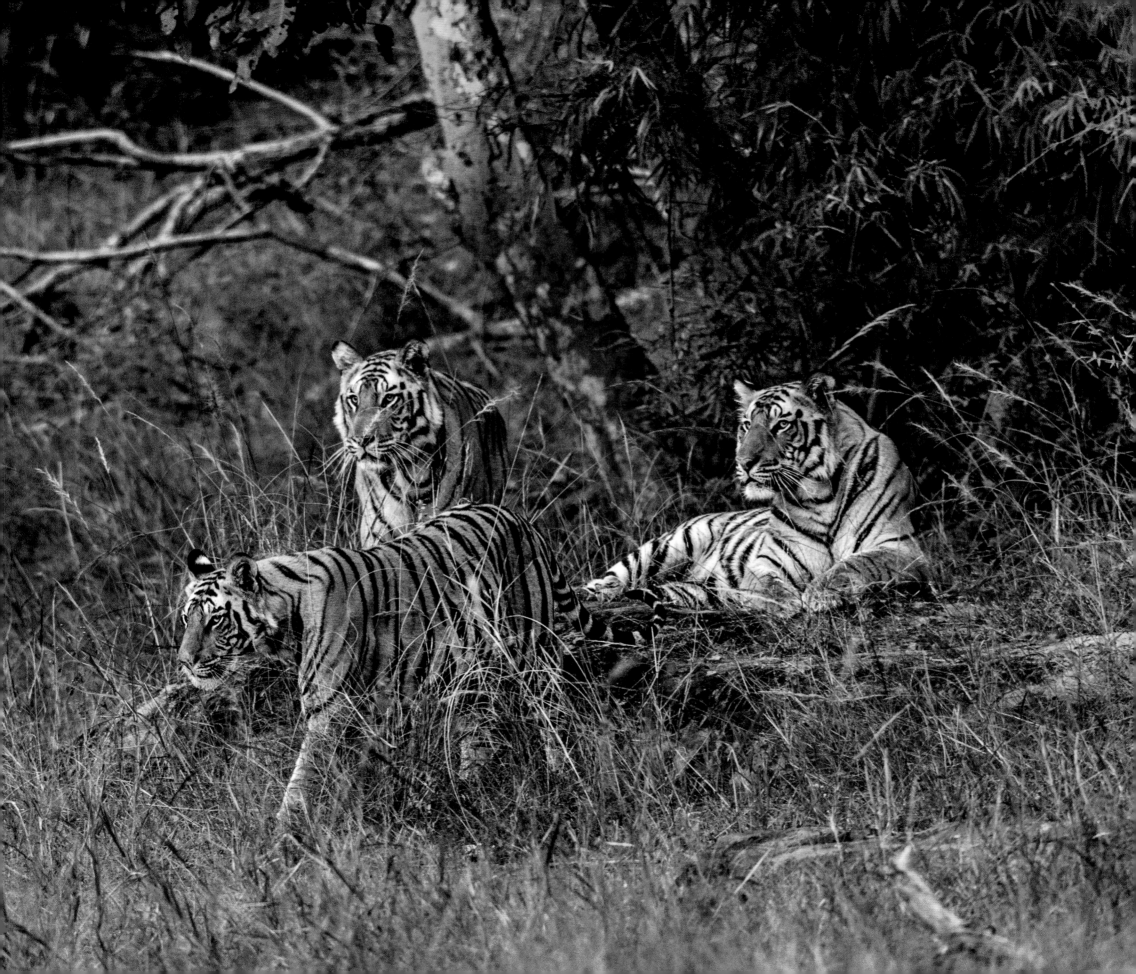

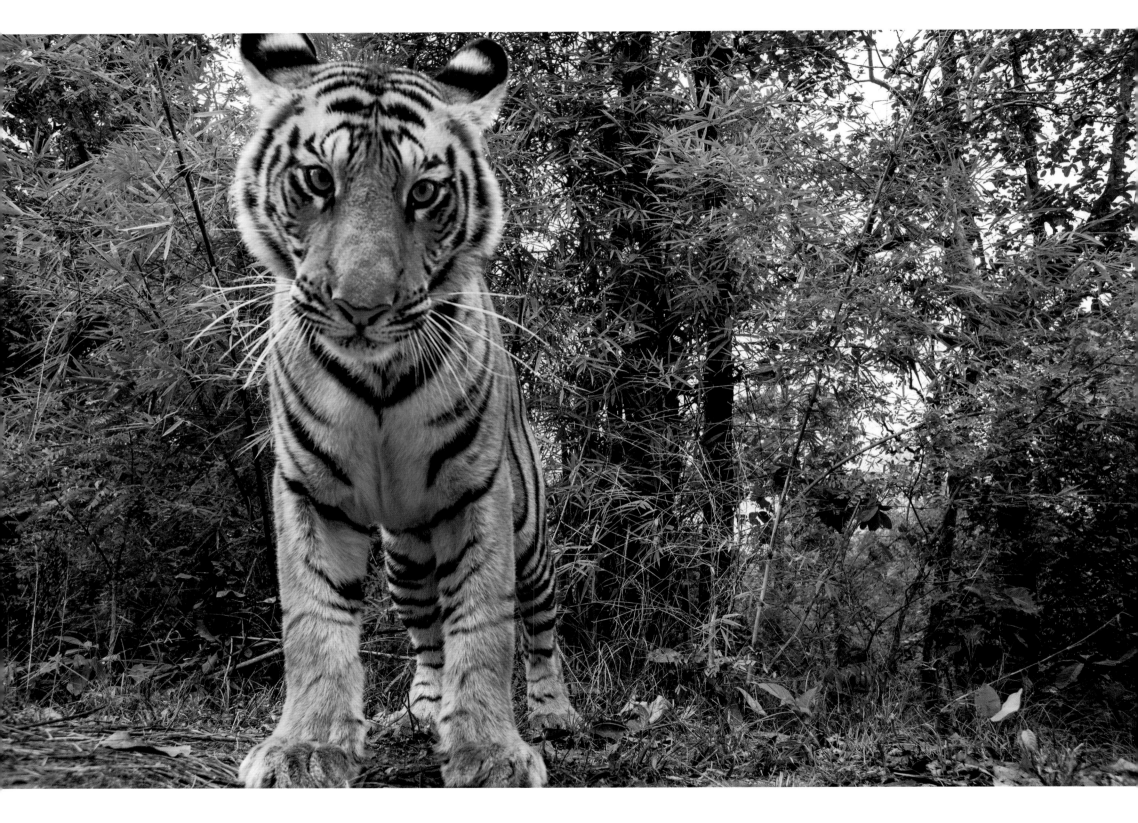

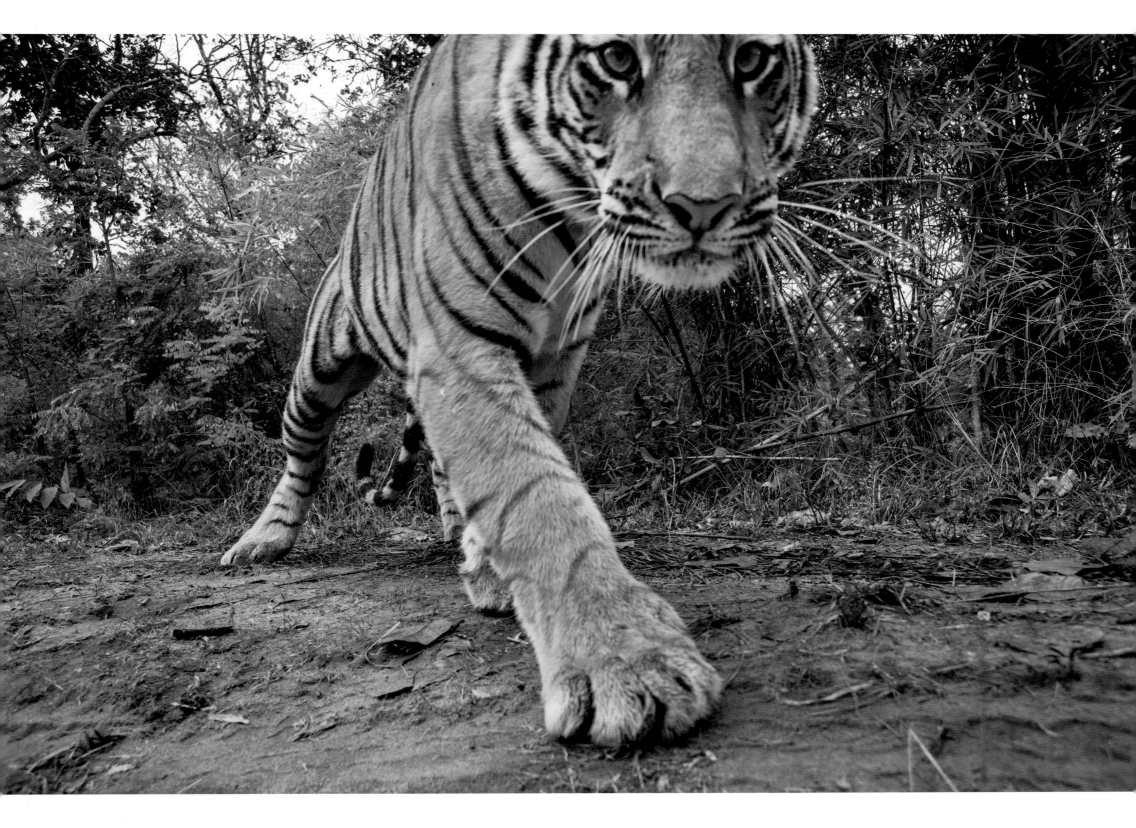

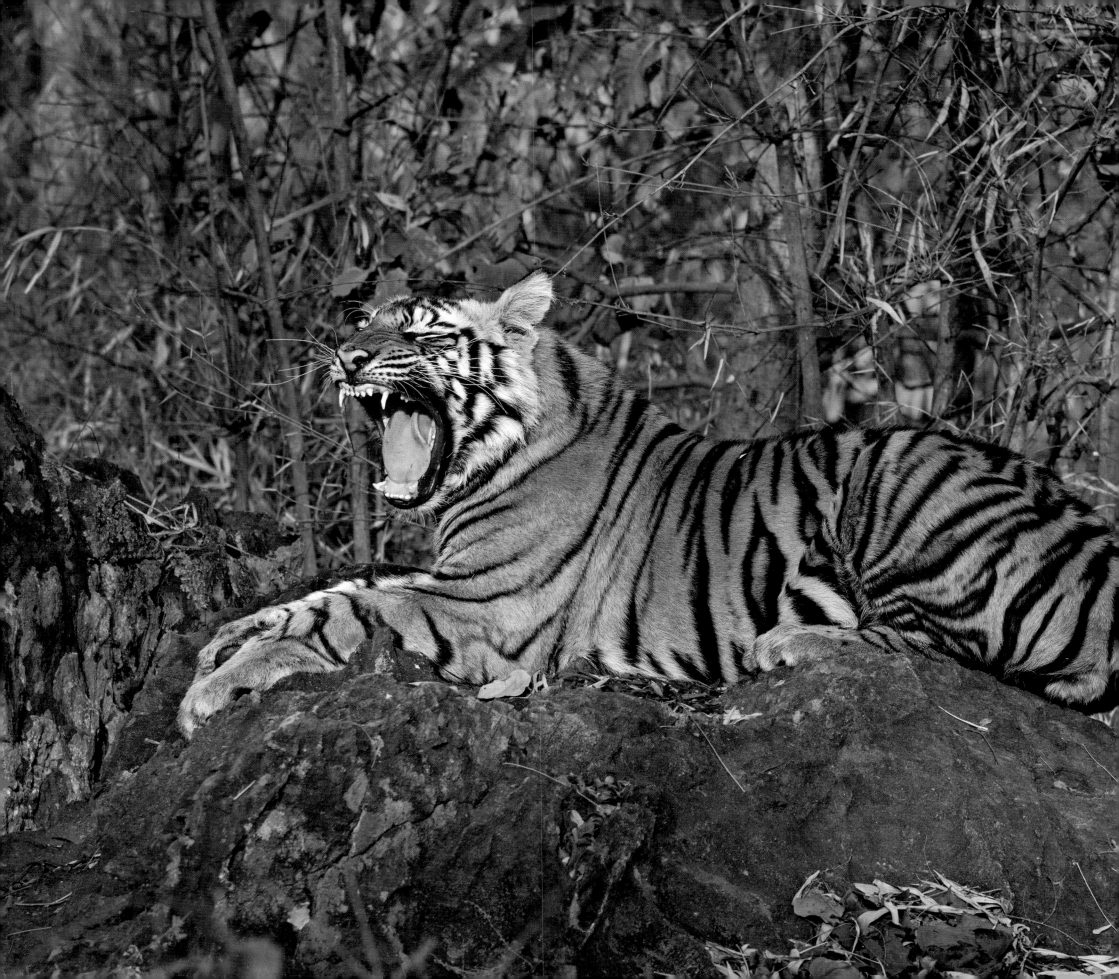

I CHOSE TO WORK in Bandhavgarh because two females had just birthed litters. My goal was to spend extended time photographing these families. When I arrived in Delhi in November 2010, one female had been poisoned after eating a farmer's buffalo; the second had been hit by a park vehicle. I finally had the chance to photograph young cubs when I returned in May 2011, when I made this book's cover image. Nearly a year later, back in Bandhavgarh, I photographed that same cub, almost grown, pictured here.

A ten-month-old cub yawns, midday. Tigers are essentially nocturnal, most active from dusk to dawn, and tend to sleep during the heat of the day.

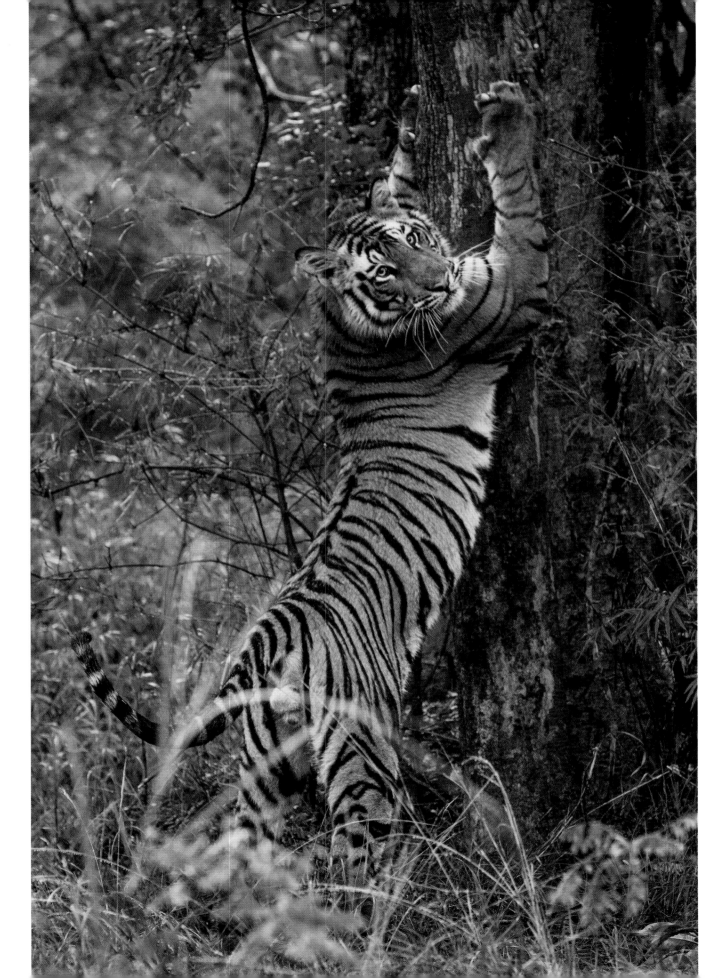

A tiger rears on its hind legs, raking claw marks into a tree trunk to demarcate territory for passing tigers.

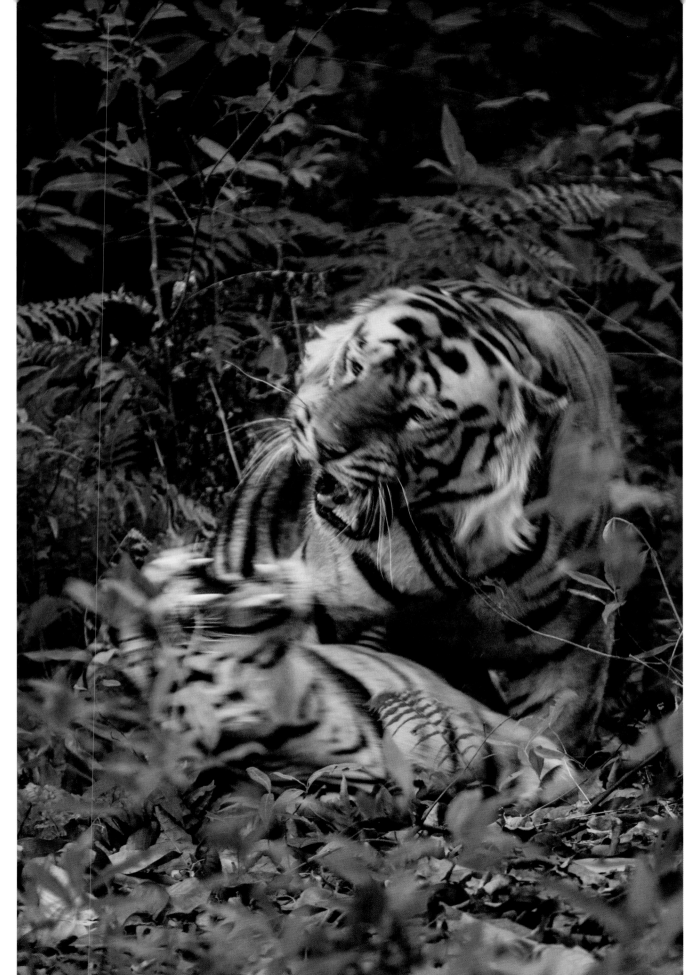

Tigers roar and engage in rough play and mock aggression during mating. They remain together for two to five days, coupling every 15 to 20 minutes, day and night.

A wary three-month-old cub briefly investigates
our intrusion before ducking behind his mother.
This tigress gave birth in the same remote cave
where she was born.

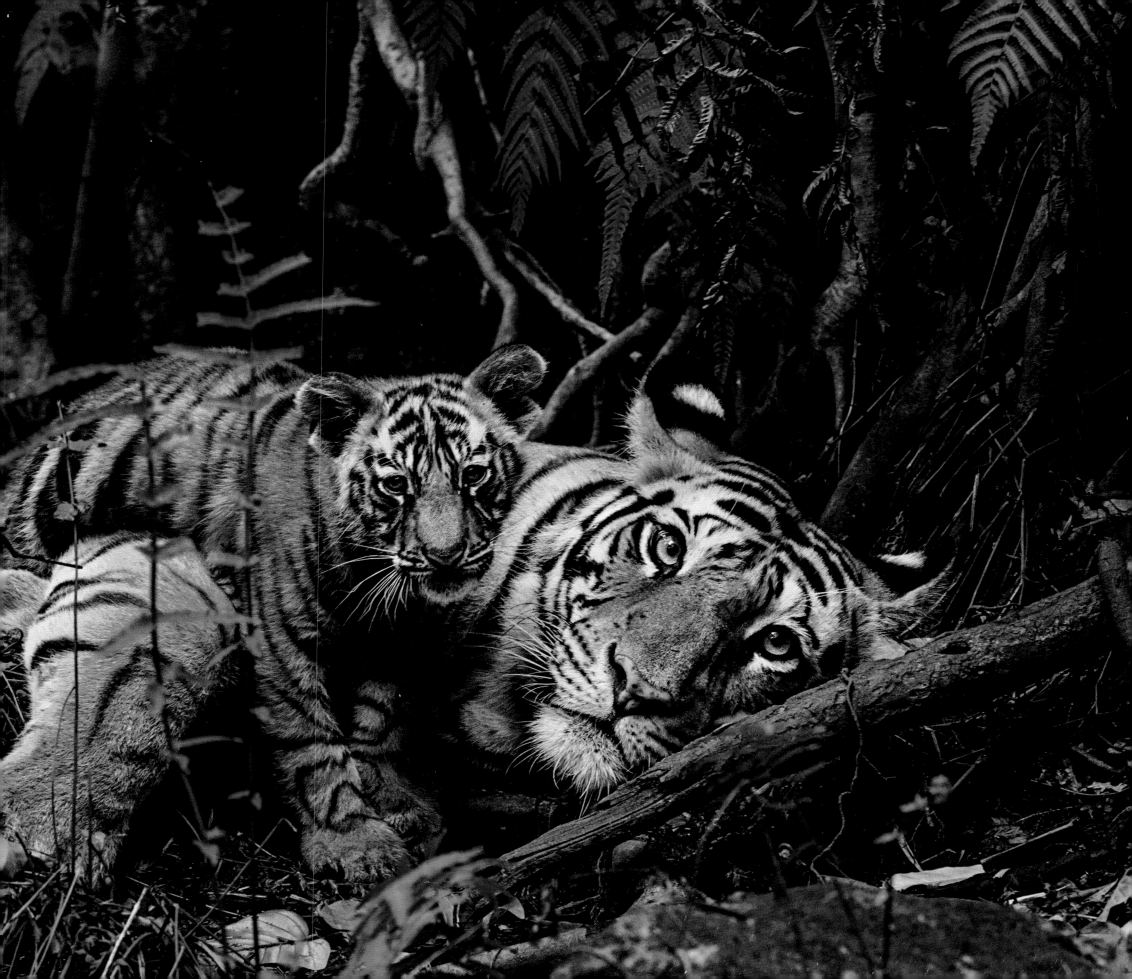

AFTER RETURNING HOME from three months' work in Bandhavgarh, I learned that the female I'd photographed mating had birthed a litter. I returned in May, when the cubs were two months old. Her den was nestled in a narrow, secluded gorge far from any roads. The only way to get there was on elephant back. It took weeks to secure a park elephant and a mahout to take me to shoot from the valley below. The skittish cubs hid; ten days passed with no pictures. I glimpsed them just twice.

A mother grooms her young cub,

one of a litter of three.

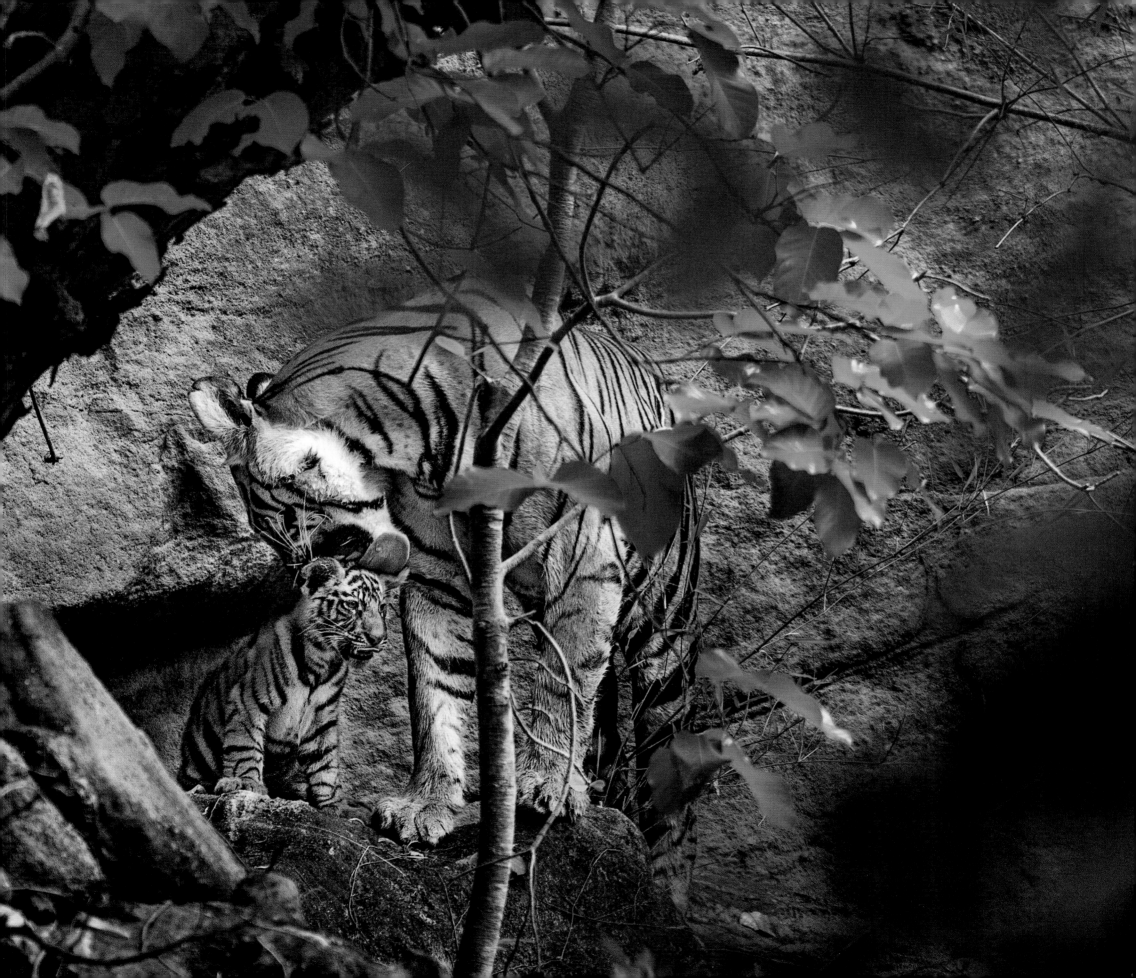

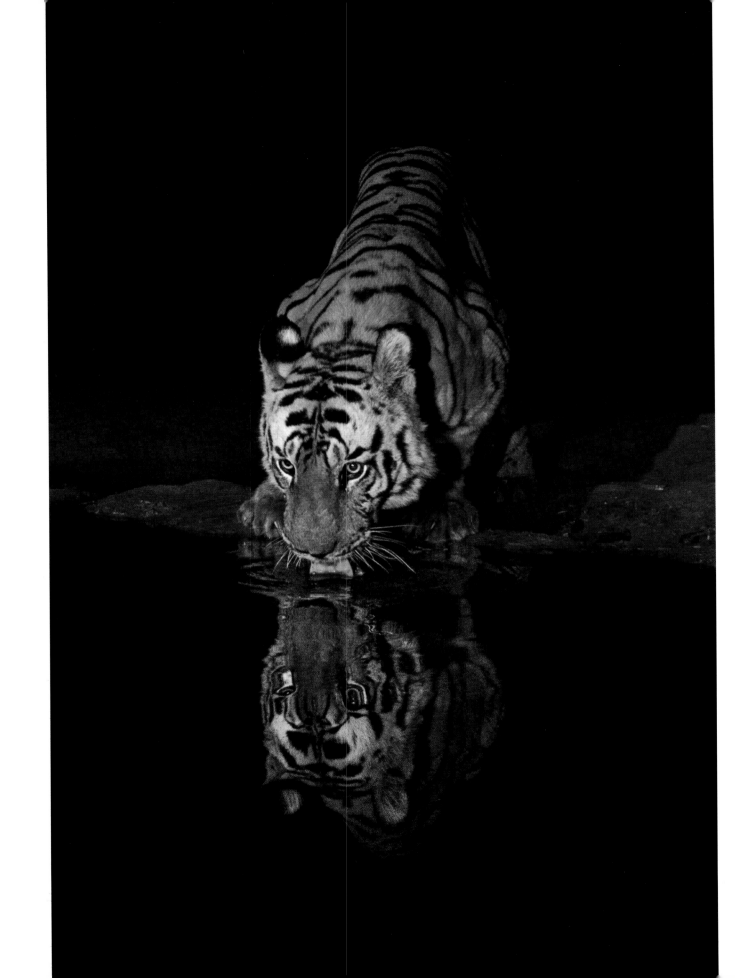

A camera trap captures
Sundar, also known as
B2, one of the most
photographed tigers
in India.

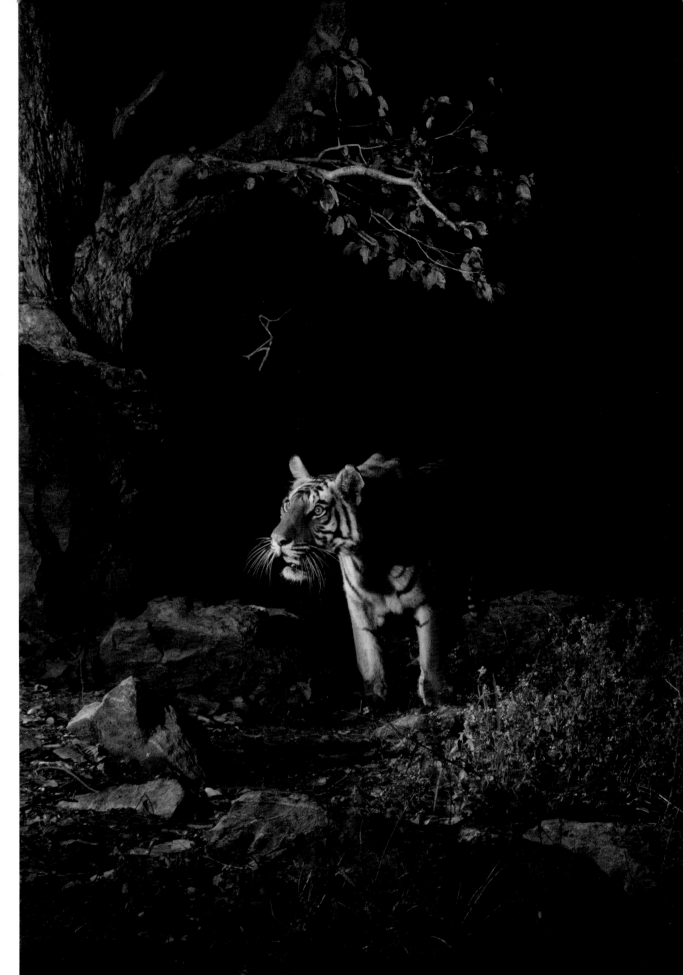

Tigers hunt mostly at night. They possess keen eyesight: Their large golden eyes are well adapted to see in the dark.

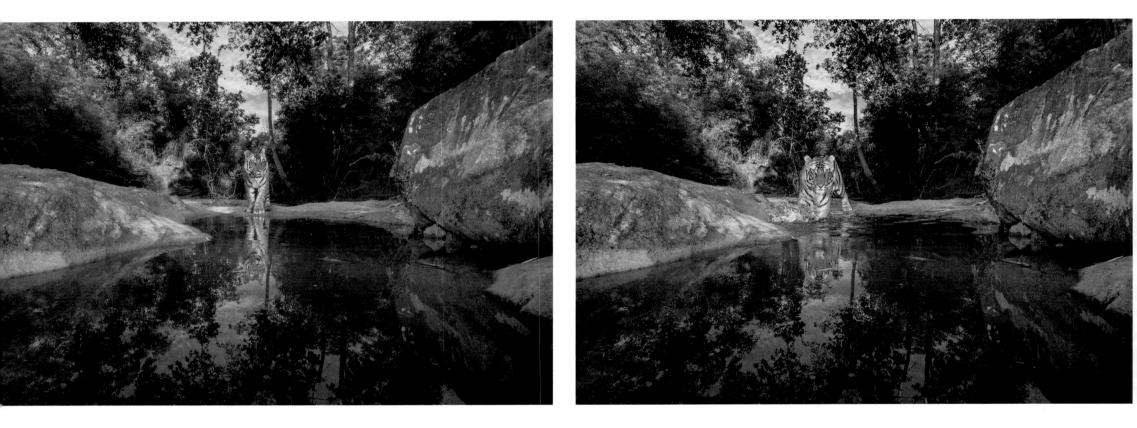

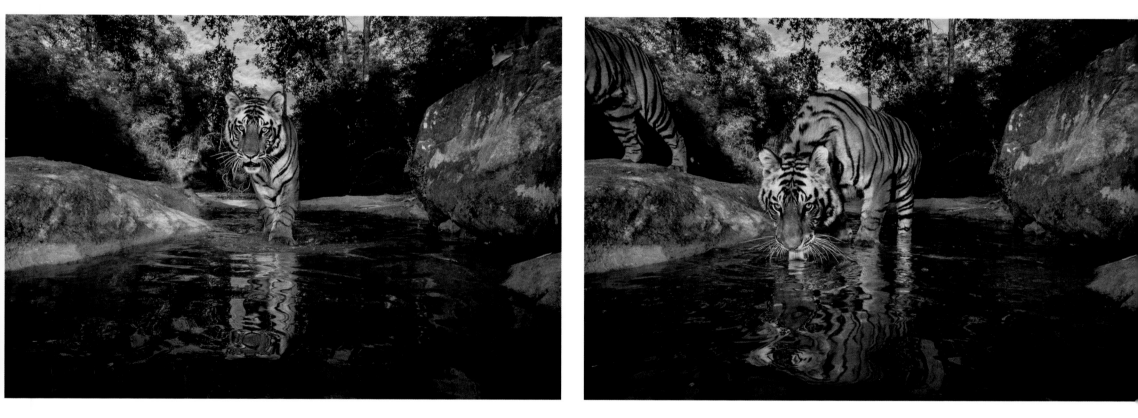

Tiger cubs photograph themselves at Bandhavgarh's Patpara Nala watering hole, undisturbed by the repeated flashes.

FOLLOWING PAGES:

They ultimately investigated the camera trap, sniffing and batting at the setup, and a male that was nicknamed Smasher repeatedly tore it down.

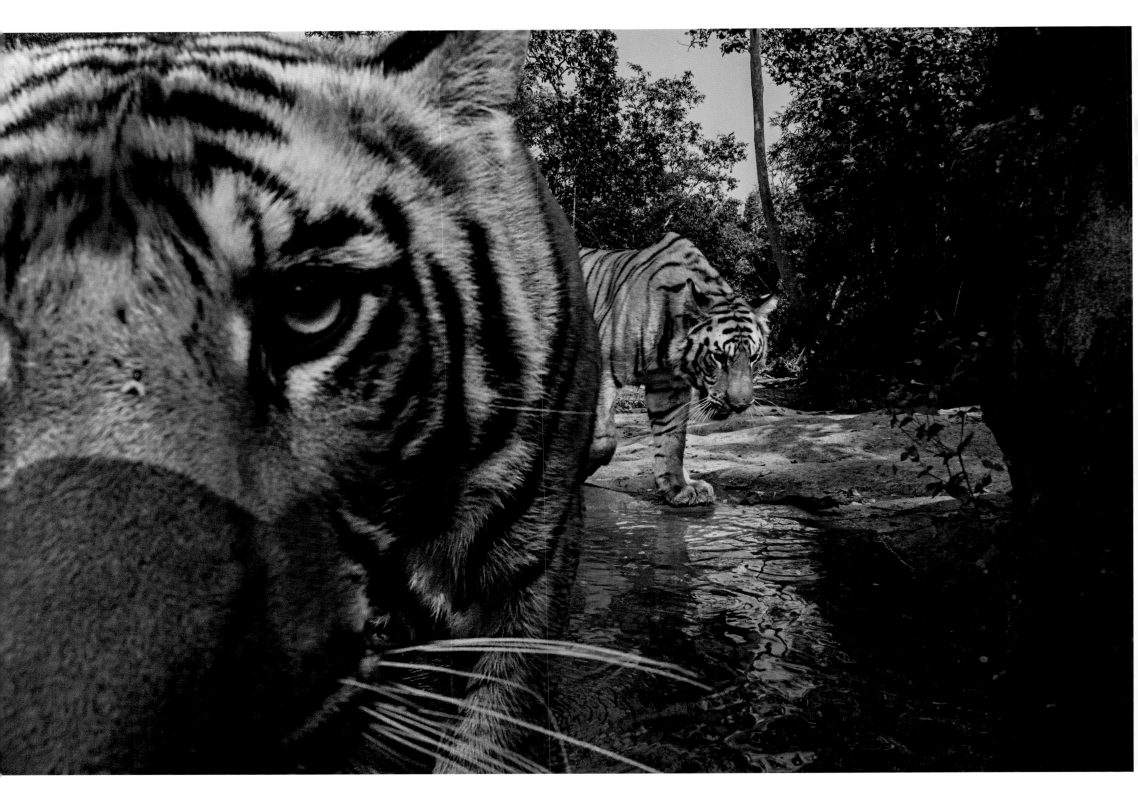

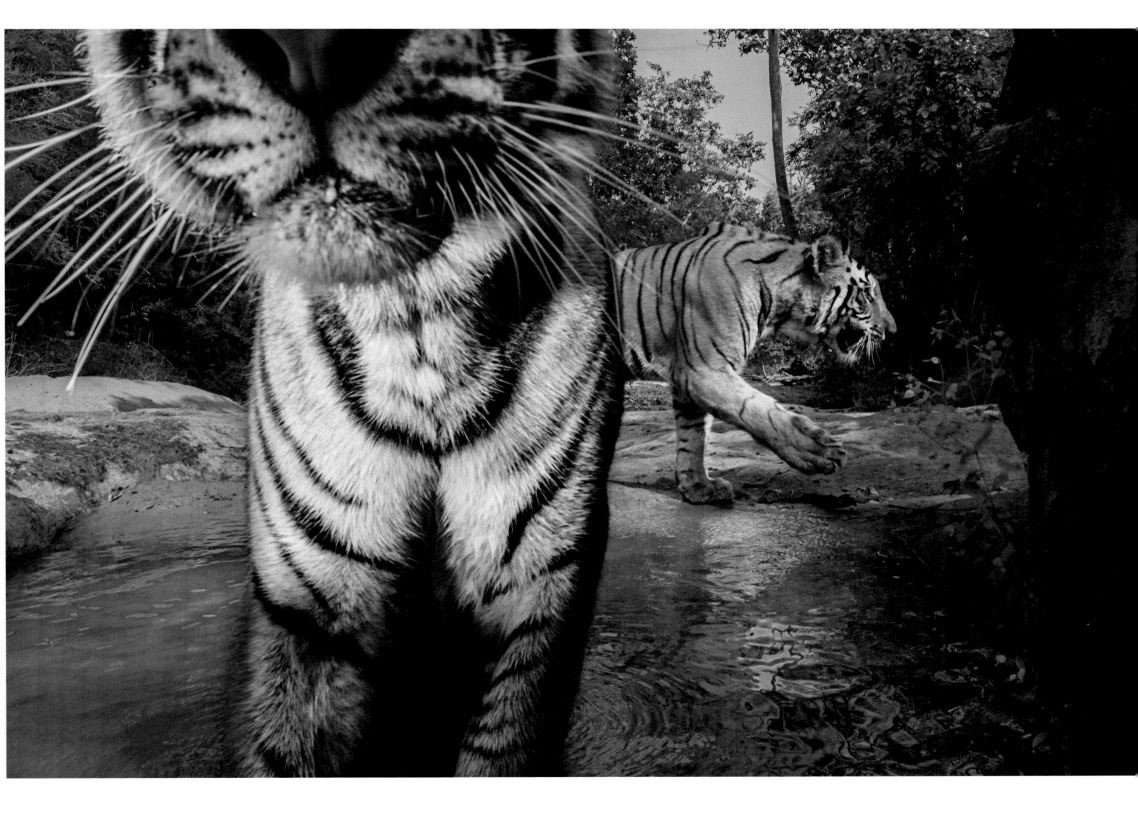

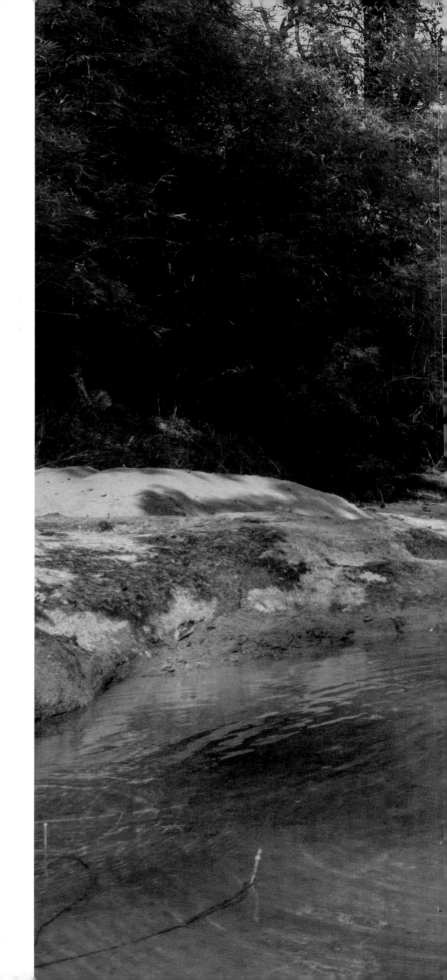

"FUTURE GENERATIONS WILL NEVER FORGIVE US IF WE HAVE SO LITTLE FORESIGHT AND COMPASSION THAT WE PERMIT THE TIGER, THIS WONDER OF NATURE, TO DESCEND INTO THE DARK ABYSS OF EXTINCTION."

GEORGE SCHALLER

A young tiger looks up at a camera trap
it set off while taking a drink.

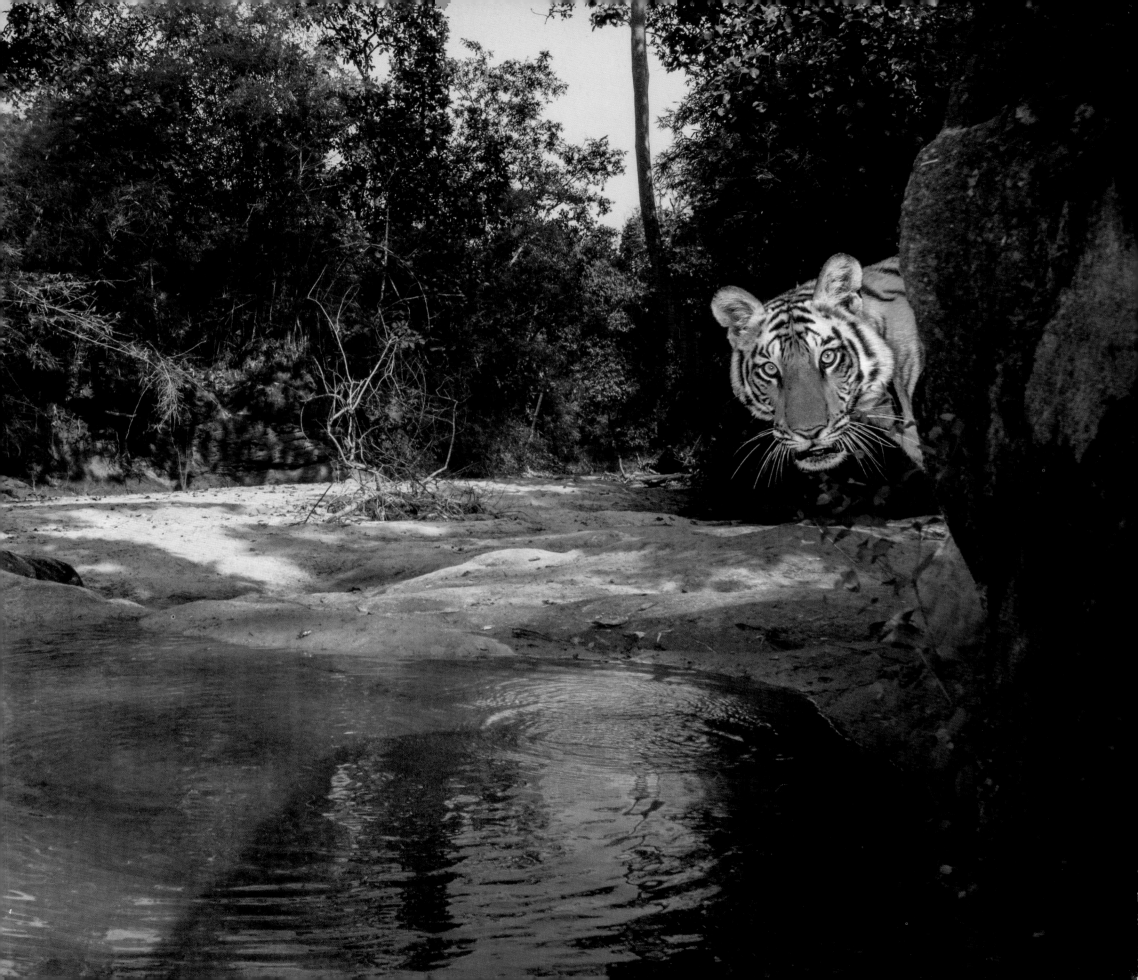

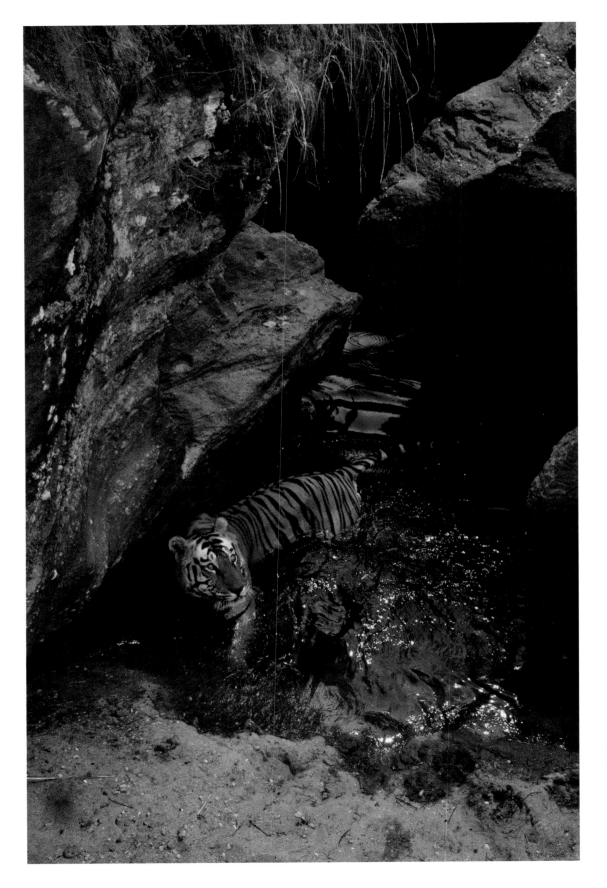

A tiger backs into a pool
of water, cooling off in a
cave in Bandhavgarh.

GOING FORWARD

AFTER VIEWING THIS BOOK'S MAGNIFICENT PHOTOS of perhaps the world's most iconic species, one can only wonder how and why we now find ourselves in such desperate straits with the tiger. Hunted mercilessly because of its strength and beauty, no other animal in history has ever been so valued and sought after for its lifeless, disarticulated parts. For over a century, we have watched the precipitous decline of the world's largest cat throughout its Asian range. Only in recent decades have there been a multitude of attempts to reverse this trend by targeting the threats that face tigers. Still, tiger numbers continue to decline, with only a few thousand wild tigers barely holding on in less than 7 percent of their former range.

But there is good news. There are extensive tiger landscapes that could be repopulated, from the cold open expanses of the Russian Far East to the steamy mangrove forests of the Bangladesh Sundarbans. And with more than 40 years of field research to draw upon, we know what tigers need to survive and we know how to save tigers. But there is a caveat. With tiger numbers so critically low, scientists and conservationists now realize that we must focus our efforts on the most important core populations remaining, eliminating *all* critical threats at these sites with a strategic, multipronged approach. First and foremost, that means effective law enforcement efforts, with rigorously trained, well-outfitted park guards on the ground. Given staff and funding constraints, these patrols must focus on locking up core strongholds within the tiger landscape, effectively combating poaching—protecting tigers and their prey—while safeguarding their habitat from logging and other illegal activities. Successful enforcement is achieved only through zero tolerance of illegal activities. At the same time, strong enforcement should not mean creating situations where tiger conservation and the well-being of local communities are at odds with one another. Programs need to be implemented that allow local communities being asked to live with and protect tigers to benefit from their role as tiger guardians. Human–tiger conflict issues must be readily and expediently

addressed in a way that values human life and welfare at least as much as that of the tiger.

However, one of the most important components of a successful tiger conservation initiative, one that has been lacking until recently, is accountability. Years of effort and millions of dollars have been put toward tiger conservation activities that never evaluated their own effectiveness by the only meaningful metric—whether or not tiger numbers remain stable or are increasing. Careful scientific measurement and monitoring of tiger populations are essential activities to determine whether the threats to the tiger are being properly addressed and funds are being well spent.

Tigers Forever, launched in 2006, is the innovative approach needed to save the world's remaining tigers. This integrated model puts into place all the pillars necessary to support the highest priority tiger sites remaining in the world. Tigers Forever brings together a global team of premier tiger experts that work in partnership with government agencies, nongovernmental organizations, and local communities. Using rigorous science, new technology, and effective law enforcement techniques, critical tiger sites are being secured. We already bear witness to such success in the Western Ghats of India and the Western Forest Complex of Thailand.

The core model and talent are in place. What we still lack are the financial resources to rapidly and extensively scale up our successful Tigers Forever program. With no more than 3,200 tigers roaming the wild, there is no more time to waste. You have already joined us in this mission by purchasing this book, but we are asking for more. Every contribution makes a difference. Go back and look at the images in this book and imagine a world when such photographs are no longer possible because tigers are gone. Help us save this living art. Without wild tigers, our individual well-being and that of our society is diminished forever. It does not have to happen. With your help, we will succeed in having wild Tigers Forever! ◊

A young cub perches high
on a rock in Bandhavgarh.

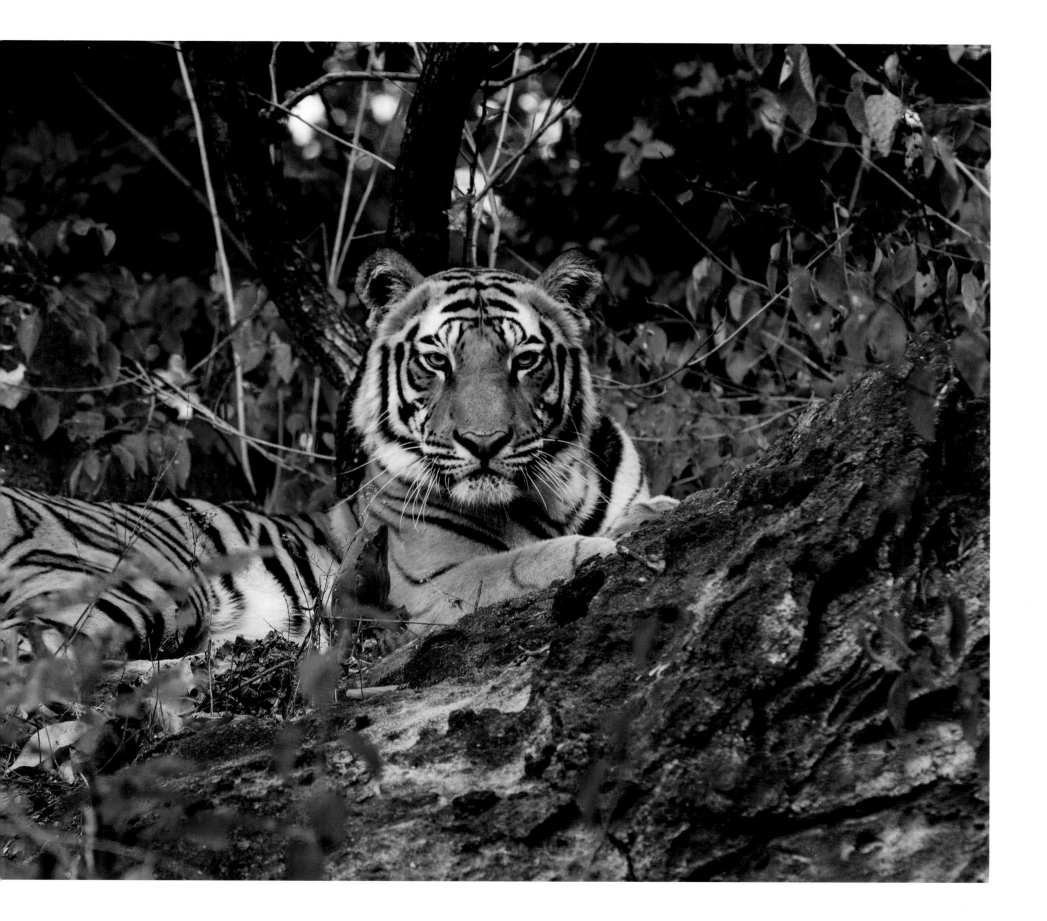

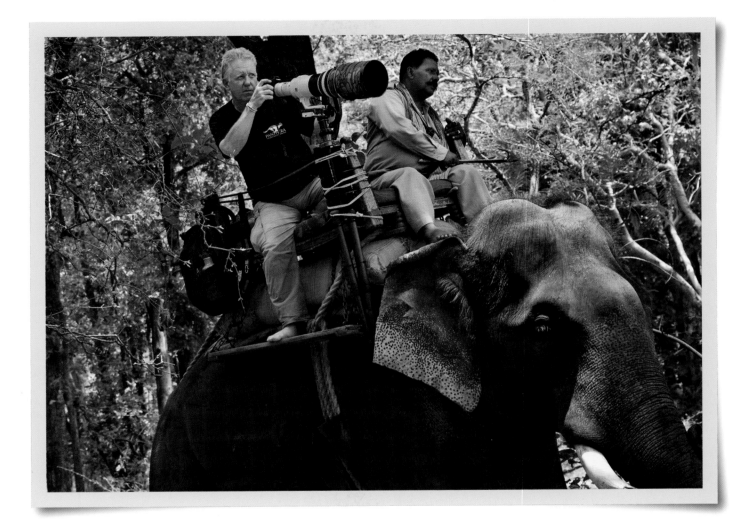

My GOAL THROUGHOUT MY CAREER has been not only to capture the beauty, intelligence, and behaviors of the animals I photograph, but also to tell their story. That includes the humans that impact their lives and the ecosystems they live in. I try to create images that move people emotionally, bring international attention to the plight of wildlife, and ultimately, help protect my wild subjects.

I began a ten-year relationship with tigers while working on a *National Geographic* story with my longtime friend, Dr. Alan Rabinowitz, in 2002 and 2003. Alan had convinced the military government to establish a massive tiger sanctuary in the remote Hukawng Valley. It was a punishing, leech-infested landscape of razor-sharp rattan, thick bamboo, and quicksand. My permits required me to be escorted by officials at all times, sometimes by soldiers. My job was to photograph the landscape and the valley's human and animal inhabitants. The WWII Burma Road had just reopened and 150,000 people had

Opposite: On an elephant
in Bandhavgarh
From top, clockwise: Photographing
burned forests in Sumatra; watching an
agitated rhino with guards in Kaziranga;
checking a camera trap with my
assistant, Drew Rush, and my guide,
Hatsy Singh, in Bandhavgarh

PHOTO: SHARON GUYNUP

streamed in—so guns, a quest for gold, and poaching tigers and other wildlife for the Chinese market became important themes.

Photographing tigers in the wild is difficult. I never saw a tiger in Myanmar and tried without success to photograph them with camera traps. But on my next story in India's Kaziranga National Park, remote cameras allowed me to make intimate images of rhinos, elephants, and other wildlife close-up—and to document the secret behaviors of tigers from three feet away without becoming their next meal. I use a TrailMaster infrared beam system, setting up the equipment so that an animal breaks the beam and fires the camera, taking their own photo within a carefully framed scene. I placed the camera traps where animals walked along trails, went to drink, and where tigers left scrape marks or scratched on trees. I positioned the cameras low, wanting to photograph animals at eye level. I also shot from an open jeep and from elephant back, ever vigilant for the 5,000-pound rhinos that regularly charged us. I was able to show

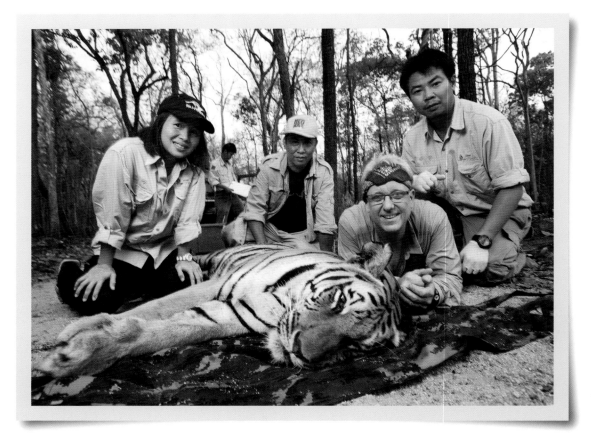

Biologists Achara and
Saksit Simcharoen (left
and center) and Somphot
Duangchantrasiri (right)
pose with me and a
tranquilized tiger just
outfitted with a GPS collar
to track its movements.

the rich assemblage of life that once roamed the tiger's realm, including huge herds of Asian elephants and water buffalo, Indian one-horned rhinos, and three species of deer. I later realized that although Kaziranga is surrounded by a sea of humanity, it's the most intact tiger ecosystem I've seen.

After discovering the cat's dire situation, I went on to photograph a tiger story between 2009 and 2011 in Sumatra, Thailand, and the two sites in India that were the only places I physically saw them. In each of these countries, I worked closely with the researchers, park guards, and mahouts who spent every day in the forest and know their habits. It can take time to get pictures with camera traps, so

I always put them up first. In Sumatra, it took over three months to get a single decent frame; in India's Bandhavgarh National Park, a young male tiger photographed himself lounging in a watering hole on the first day my camera trap was up.

Once the traps were set, I was out shooting from before dawn until darkness fell, looking for the cats, documenting their world, waiting for word from park officials of some event I needed to shoot, say, arrests of poachers or a downed deer where a tiger was feeding.

But as a photojournalist, I also needed to document the scientists who study tigers and the threats that face them: the pressures on forests from villagers

who need to eat and farm—and from illegal logging, industrial agriculture, and large-scale development, which together are shredding tiger habitat. I needed to show the conflict that arises when people and their domestic animals encroach on the tiger's home—and the continued slaughter for their gorgeous pelts and for parts used as ingredients in traditional Chinese medicine.

I hope with these pictures I'm able to share images we haven't seen before, images that capture this animal's stunning beauty and habits—and tell the story of why its existence is so precarious. I hope these pictures inspire you to act, to do something to help save tigers. ◊

ACKNOWLEDGMENTS

From Steve Winter

There are so many people who have shaped my life and work—and helped me produce the photographs that appear in this book. I wish to extend my gratitude to them all. I'd like to begin where it all started by thanking my mother who taught me to dream big and my father who gave me my first camera when I was seven and taught me photography.

Working as a photographer at *National Geographic* magazine has been my life's goal since I was a young boy. It is with great honor that I travel the world for one of the world's most distinguished institutions and for a magazine that has been one of the most respected for the last 125 years. I am a very lucky man.

I am grateful to Editor in Chief Chris Johns for the great vision, passion, and dedication he brings to the magazine, and for the insights he brings from years of firsthand fieldwork experience as a photographer. I wish to thank him for believing in me and giving me the opportunity to bring the plight of tigers and other wildlife to NGM's readers. His photography inspired me to become who I am.

I want to thank Kathy Moran, my photo editor for many years at the magazine who also picture-edited this book. Kathy has been my guiding light both in the field and in helping me select the images to best tell my stories. I do not know what I would do without her guidance, advice, and friendship. Thank you so much, Kathy.

Nick Nichols, my mentor and friend over a lifetime of photography, has been my inspiration since I was his assistant many years ago. He's taught and advised me every step of the way. The power of his images, his unrelenting pursuit of photographs in the field, and his immense dedication to conservation have stood as examples of how to do this right. I am deeply indebted to you, Nick, in untold ways. I cannot thank you enough.

To David Griffin, thank you for your help in producing many of the stories whose images appear here—and especially for your incredibly hard work and creative eye that produced the beautiful design of this book. Thank you for your patience and pursuit of excellence throughout the process.

I am eternally grateful to Tom Kennedy, who said yes to my first NGM story proposal, and to Bill Allen, our former editor who then gave me my start at the magazine.

This work would not have been possible without the help of so many at *National Geographic* who I'd like to acknowledge here: Karen Barry, Elaine Bradley, Walter Boggs, Dennis Dimick, Kate Evans, Trish Dorsey, Ken Geiger, Nikisha Long, Dave Mathews, Bill Marr, William McNulty, Kurt Mutchler, Jenna Pirog, Larry Shure, Jenny Trucano, Hans Weise, Melissa Wiley, David Whitmore, and Kenji Yamaguchi. And thank you to those at the National Geographic Image Collection who represent my work: fearless leader Maura Mulvihill, Marco DiPaul, Stacy Gold, Rob Henry, Alice Keating, Bill Perry, and Sara Snider. Thanks to the folks at NG Missions Program: Mark Bauman, Terry Garcia, Greg McGruder, and Alex Moen.

Thank you, thank you Rebecca Martin and everyone at the NG Expeditions Council for your support of my work on tigers and throughout my career at NGM.

A big thank you to Barbara Brownell Grogan who put this project together, and to my editors at NG Books, Susan Tyler Hitchcock, Carl Mehler, and Susan Blair, and to color wizard Rachel Faulise, who made these images sing.

To the family of photographers at NGM: You all inspire me every day.

Thanks to friends at Apple who helped by providing equipment, advice, and support: Kirk Paulsen, Martin Gisborne, and Bahram Foroughi. And huge thanks to Jon Golden for his invaluable technical assistance.

I could not think of working in India without Toby Sinclair: Toby, thank you for sharing your vast knowledge of tigers in India, for your friendship, and for endless logistical assistance.

Thanks to all those at Panthera for your incredible help and support over these last years: Luke Hunter, Andrea Heydlauff, John Goodrich, Marla Kabashima, Howard Quigley, Joe Smith, Margarita Trujillo, Susie Weller, Kathy Zeller, and everyone in the office!

By creating Panthera, Tom Kaplan has brought the best minds in big cat conservation together under one organization. Tom, it is an honor to know and work with you.

Thank you to Michael Cline for your generous support of this project and of tigers: You are a true savior of tigers with your innovative thinking.

And to George Schaller: You are a legend who has inspired so many the world over, including me. Reading your books started me on the road toward wildlife conservation. Thank you for sharing a wealth of information on tigers and big cats that has so helped me photograph these animals throughout my career.

Special thanks to Alan Rabinowitz, a friend I am honored to have worked with for 17 years, including time in the field in numerous countries. Alan, you've changed the face of big cat conservation, giving them the chance for a future. I look forward to continuing the fight to save them with you, and am grateful for your friendship and support.

I don't know how I would have produced these images without the help of the guys who assisted me in the field. Drew Rush is the hardest-working, most inventive assistant I have ever had the pleasure to work with. Thank you for helping me schlep our 32 bags and cases around India, for setting up and running camera traps, fixing broken gear, downloading and backing up files, and so much more. In Kaziranga, the assistance of Gabe DeLoach made a tough story successful. In addition to normal duties, that assignment required lots of creative equipment repair because of the elephants and rhinos that regularly smashed our camera traps. Thank you, Gabe, for your hard work. And many thanks to Joe Riis, who assisted me in Thailand on a tough assignment where we never saw a tiger; thanks for a great job.

I want to thank all those who helped me in the field in small and large ways. In Myanmar: U San Hlaing, Saw Htun, Bo Kyi, Tony Lynam, Myint Maung, Ambassador Joseph Verner Reed, and Zaw Win. In Sumatra: Munawar Kholis, Mahdi Ismail—thank you, Mahdi, for finding the ex-hunter who discovered the spot for our incredible tiger image—Matthew Linkie, Zamira Elianna Loebis, and Hariyo (Beebak) Wibisono. In Thailand: Anak Pattanavibool, and Achara and Saksit Simcharoen. And in India: Manju Barua, Prerna Singh Bindra, Surendra Buragohain (former director of Kaziranga National Park), Rahgu Chundawat, Sanjay Gubbi, Ajit Hazarika, Ullas Karanth, Sushil Kumar, Budheswar Konwar (the best driver in Kaziranga), Himani Pratap, Bittu

Sahgal, Valmik Thapar, Joanna Van Gruisen, Belinda Wright, and Naveen Saxena. In Bandhavgarh: C. K. Patil (former director of Bandhavgarh National Park) for your vision and support; Dhruv Singh for your help and guidance; Rajesh Tripathi; Hitendra (Hatsy) Singh for always finding the tigers with Ramnaresh Burman, Daya (Mogli) Ram, and all the mahouts in Bandhavgarh led by E. A. Kuttappan. You all made these images possible! And thanks to the staffs of both Kaziranga and Bandhavgarh National Parks.

Thank you to my doctor, Dr. Lenny Balacco for helping me sort out the health challenges that come with working in the tropics.

A big thanks to the National Tiger Conservation Authority, the Ministry of External Affairs, and Ministry of Environment & Forests for permissions to produce this work in India.

We truly could not have produced this book without Veronica Sharon, my studio assistant who has worked tirelessly for many months. Thank you, Veronica!

To my family, Sharon and Nick, thank you for your love and support throughout my career and during the long stretches away from home, which has been so instrumental to the success of this and every project. Sharon, your text brings the world of tigers to the readers of this book in such an exciting, vivid, and creative way—you knocked it out of the park.

From Sharon Guynup

I want to acknowledge the legions of people across the tiger landscape who shared their expertise with me: Anish Andheria, Debbie Banks, Raghu Chundawat, Sybelle Grace Foxcroft, George Gale, Iding Achmad Haidir, Andrea Heydlauff, Jayeeta Kar, Ullas Karanth, Jeanne McKay, Petch Manopawitr, Praveen Pardeshi, Toby Sinclair, James L. D. Smith, Belinda Stewart-Cox, Sarah Stoner, Ayako Tsuyada, Susie Weller, and Hariyo Wibisono.

Special thanks to those who spent vast amounts of time helping me understand the complexity of tiger conservation, who shared resources and details of their lives and work, and fact-checked this manuscript: M. Firoz Ahmed, Manju Barua, Prerna Singh Bindra,

John Goodrich, Sanjay Gubbi, Saw Htun, Munawar Kholis, Matthew Linkie, Tony Lynam, Debbie Martyr, Bittu Sahgal, Achara and Saksit Simcharoen, Joe Smith, Valmik Thapar, Joanna Van Gruisen, and, most of all, to Belinda Wright for months of tutelage, input, and patience with my endless questions.

Thank you to Barbara Brownell Grogan and editor Susan Tyler Hitchcock at NG Books for your help with this project, as well as Heather McElwain and Judith Klein for copyedits.

To my dear friends, thank you for the cheerleading and support that kept the wind under my wings throughout this project (who also sustain me every day): Jackie Bonnano, Nancie Celini, Jeffrey Chamblin, Laurie Fabiano, Kim Fiske, Jay Friedman, Donnamarie Grieco, Jeanne Harpster, Pamela Hassell, Jamie Hellman, Christine Heinrichs, Debbie Kaplan, Julie Jaarsma-Holdom, Heidi Katz, Laura Klein, Anne McGovern, Seamus McGraw, Melissa Miller-Young, Tracey Paradiso, Rand and Sally Peabody, Karen Phillips, Angela Resch, Glenn Scherer, Amy Weinberg, Sharon Wilson, Susanne Ziegler—and especially, to Nancy Green for daily, never-ending support. Thanks to Dale Walker for a space to write and Anita Choudhary for transcription. Thank you, thank you, Veronica Sharon, for the millions of ways, small and large, you helped this book be born.

I am immeasurably grateful to my beloved girlfriends and deeply respected colleagues, Laura Paskus and Bijal Trivedi, whose constant support, careful writerly eyes, and endless editorial insights made this an infinitely better book. There is no way to adequately thank you.

And to George Schaller (my hero), thank you for years of patient tutelage on both wildlife and publishing; to Alan Rabinowitz for so many hours spent over the last decade teaching me about big cat conservation and for scientific and literary edits to this manuscript; to William B. and Harriet McKenzie, my Poppy and Nanny who bought me a suitcase and a typewriter when I was seven and told me stories of a world beyond the Jersey suburbs. To my son, Nick Ruggia, the light of my life: Thank you for your writer's advice—and for keeping me laughing even under crushing deadlines. And, of course, to Steve for bringing me into the world of the tiger and for so many years spent caring for and inspiring each other.

From Panthera

Panthera would like to acknowledge some of our most influential contributors who continue to be our committed partners in ensuring a future for wild tigers. Tigers Forever would not be possible without the continued support from the Liz Claiborne Art Ortenberg Foundation, Save the Tiger Fund, the Woodland Park Zoo, the USFWS-Rhino Tiger Conservation Fund, and several private individuals. A special mention of gratitude, however, must be made to Michael Cline and the Cline Family Foundation, whose vision and support helped give birth to the Tigers Forever program and continues to sustain it. We are also indebted to the Robertson Foundation, whose ongoing support and commitment has been a game changer, enabling the Tigers Forever program to be implemented at a scale that is having a significant impact on the world's most important tiger populations. We would also like to acknowledge the extraordinary people from local and international conservation organizations, as well as local and national governments, who are on the front lines of defense, fighting for tigers across Asia each and every day. With growing commitment at all levels, and with the support from people like you, Panthera is confident that we can leave a real legacy for tigers.

TIGERS FOREVER

Steve Winter and Sharon Guynup

Published by the National Geographic Society

John M. Fahey, Chairman of the Board and Chief Executive Officer
Declan Moore, Executive Vice President; President, Publishing and Travel
Melina Gerosa Bellows, Executive Vice President; Chief Creative Officer, Books, Kids, and Family

Prepared by the Book Division

Hector Sierra, Senior Vice President and General Manager
Janet Goldstein, Senior Vice President and Editorial Director
Jonathan Halling, Design Director, Books and Children's Publishing
Marianne R. Koszorus, Design Director, Books
Susan Tyler Hitchcock, Senior Editor
R. Gary Colbert, Production Director
Jennifer A. Thornton, Director of Managing Editorial
Susan S. Blair, Director of Photography
Meredith C. Wilcox, Director, Administration and Rights Clearance

Staff for This Book

David Griffin, Art Director
Kathy Moran, Illustrations Editor
Carl Mehler, Director of Maps
Veronica Sharon, Photo Coordinator, Steve Winter Studio
Marshall Kiker, Associate Managing Editor
Judith Klein, Production Editor
Lisa A. Walker, Production Manager
Galen Young, Rights Clearance Specialist
Katie Olsen, Design Assistant

Production Services

Phillip L. Schlosser, Senior Vice President
Chris Brown, Vice President, NG Book Manufacturing
George Bounelis, Vice President, Production Services
Nicole Elliott, Manager
Rachel Faulise, Manager
Robert L. Barr, Manager

The National Geographic Society is one of the world's largest nonprofit scientific and educational organizations. Founded in 1888 to "increase and diffuse geographic knowledge," the Society's mission is to inspire people to care about the planet. It reaches more than 400 million people worldwide each month through its official journal, *National Geographic,* and other magazines; National Geographic Channel; television documentaries; music; radio; films; books; DVDs; maps; exhibitions; live events; school publishing programs; interactive media; and merchandise. National Geographic has funded more than 10,000 scientific research, conservation and exploration projects and supports an education program promoting geographic literacy.

For more information, visit www.nationalgeographic.com.

For more information, please call 1-800-NGS LINE (647-5463) or write to the following address: National Geographic Society, 1145 17th Street N.W., Washington, D.C. 20036-4688 U.S.A.

For information about special discounts for bulk purchases, please contact National Geographic Books Special Sales: ngspecsales@ngs.org, For rights or permissions inquiries, please contact National Geographic Books Subsidiary Rights: ngbookrights@ngs.org

All photographs in this book by Steve Winter except those indicated on the individual photograph and archival images credited on page 222.

ISBN: 978-1-4262-1240-6

Printed in Hong Kong

13/THK/1

Panthera is collaborating with National Geographic's Big Cats Initiative on saving the world's big cats through scientific research, funding, and public outreach in an effort to protect these endangered animals and to inspire action to ensure their future.

PANTHERA
LEADERS IN WILD CAT CONSERVATION

Panthera's mission is to ensure the future of wild cats through
scientific leadership and global conservation action.

If you would like to help us in the battle for saving tigers, please donate to our efforts at www.panthera.org or www.tigersforever.org